Domestic Pottery of the Northeastern United States, 1625-1850

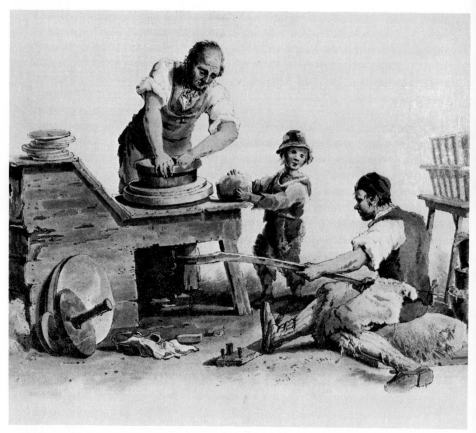

Aquatint of a rural potter at work, 1805 (Courtesy of Barbara Gorely Teller)

Domestic Pottery of the Northeastern United States, 1625-1850

Edited by

Sarah Peabody Turnbaugh

Museum of Primitive Culture
University of Rhode Island
Peace Dale, Rhode Island

1985

ACADEMIC PRESS, INC.

Harcourt Brace Jovanovich Publishers

Orlando San Diego New York Austin
London Montreal Sydney Tokyo Toronto

ACADEMIC PRESS, INC.
Orlando, Florida 32887

United Kingdom Edition published by
ACADEMIC PRESS INC. (LONDON) LTD.
24–28 Oval Road, London NW1 7DX

LIBRARY OF CONGRESS CATALOGING-IN-PUBLICATION DATA

Main entry under title:

Domestic pottery of the northeastern United States,
 1625–1850

 (Studies in Historical archaeology)
 Bibliography: p.
 Includes index.
 1. Pottery industry—Northeastern States—History.
2. Pottery—Northeastern States—History.
3. Northeastern States—Antiquities. 4. Northeastern
States—Economic conditions. I. Turnbaugh, Sarah
Peabody. II. Series: Studies in historical archaeology
(Orlando, Fla.)
HD9611.7.A115D66 1985 338.4'76663974 85-9038
ISBN 0-12-703870-1 (alk. paper)
ISBN 0-12-703871-X (paperback)

PRINTED IN THE UNITED STATES OF AMERICA

85 86 87 88 9 8 7 6 5 4 3 2 1

Studies in
HISTORICAL ARCHAEOLOGY

EDITOR
Stanley South
Institute of Archeology and Anthropology
University of South Carolina
Columbia, South Carolina

ADVISORS
Charles E. Cleland
John L. Idol, Jr.
Mark P. Leone
Kenneth E. Lewis
Cynthia R. Price
Sarah Peabody Turnbaugh
John White

Contents

Contributors

Numbers in parentheses indicate the pages on which the authors' contributions begin.

Beth A. Bower (265), Museum of Afro American History, Roxbury, Massachusetts 02119

Paul G. Chace (49), Paul G. Chace & Associates, Escondido, California 92027

Nancy S. Dickinson (189), Department of History, New York University, New York, New York 10003

Mary B. Dupré (133), New Hampshire Historical Society, Concord, New Hampshire 03301

Frederick J. E. Gorman (119), Environmental Archaeology Group, Boston, Massachusetts 02114

Richard Hunter (229), Heritage Studies, Princeton, New Jersey 08540

Meta F. Janowitz (29), Graduate School and University Center, City University of New York, New York, New York 10036

Donald G. Jones (119), Department of Archaeology, Boston University, Boston, Massachusetts 02215

Kate T. Morgan (29), Department of History, New York University, New York, New York 10009

Steven R. Pendery (67, 101), Department of Anthropology, Harvard University, Cambridge, Massachusetts 02138

Nan A. Rothschild (29), Department of Anthropology, Barnard College, Columbia University, New York, New York 10027

Justine Staneko (119), Department of Archaeology, Boston University, Boston, Massachusetts 02215

David R. Starbuck (133), Department of Science and Technology Studies, Rensselaer Polytechnic Institute, Troy, New York 12181

Barbara Gorely Teller (249), Wellesley Historical Society, Wellesley Hills, Massachusetts 02181

Sarah Peabody Turnbaugh (1, 209), Museum of Primitive Culture, The University of Rhode Island, Peace Dale, Rhode Island 02883

Fred Warner (171), Department of Anthropology, Central Connecticut State University, New Britain, Connecticut 06050

John Worrell (81, 153), Research Department, Old Sturbridge Village, Sturbridge, Massachusetts 01566

Tables and Figures

Tables

Figures

Preface

The subject of this volume is the growth and development of ceramic production in the northeastern United States and its relation to changing consumption patterns and more general cultural processes. It is an examination of domestic pottery manufacture in the Northeast from its beginning as a small, family-based enterprise in the 1620s to the entrepreneurial, mechanized mass production of wares in many communities by 1850. Major themes considered include the cultural, social, and economic significance of the domestic ceramic industry as indicated by the extent and nature of regional production in the Northeast; the relation of these production patterns to consumption, distribution, and trade with settlements along the colonial Eastern seaboard and in Europe; and the recognition of patterned cultural variation and change in the Northeast as revealed through ceramics in the archaeological and historic record.

One major theoretical orientation dominates the volume: the relevance of ceramic studies to the anthropological concept of *tradition*. After an introductory description of specific external and internal mechanisms of change that operate on all traditions, we consider archaeological ceramics in their temporal and spatial contexts as material correlates of human behavior. Patterns revealed in the archaeological record of the Northeast are viewed as suggestive of more general cultural processes operating in the region. The conservative, emulative nature of ceramic traditions initially transplanted to the Northeast is detailed, and subsequent transformations of these traditions are explored. The eventual emergence of a distinctive American industry that was nevertheless still subject to continuing nondomestic influences is also addressed.

By concentrating on domestically produced earthenware—in addition to other domestic ceramic classes such as stoneware—for cultural interpretation, we stress an artifact class that was of great importance in the Northeast, where it usually comprises upward of 80% of the total ceramic sample from typical early colonial sites. Yet, due mostly to lack of available documentation, red-bodied earthenwares in particular have been underemphasized or ignored in many historical archaeological studies of the Northeast. Here, considerable emphasis is placed on these poorly documented wares. The authors integrate recent archaeological and historical considerations of specific domestic ceramic types, varieties, forms, and functions, documentary research, and kiln

excavation data for the entire Northeast. We also compare these wares to
their European antecedents and to contemporary European and colonial
Southeastern wares to interpret their significance in colonial lifeways.

The volume is organized into an Introduction and three thematic Parts.
Largely for clarity of presentation, each Part is introduced with an overview.
In the chapters of each Part, trends in the development of the domestic
pottery-making industry are described and interpreted. Chapters are ordered
in a topical and loosely chronological way according to the thematic empha-
sis of each Part. Part I, "Transplantation: Traditional Early Regional Pro-
duction," is a consideration of the conservative, emulative nature of many
of the ceramic traditions that were transplanted initially from Europe to col-
onies in the Northeast. In Part 2, "Transformation: Access to Local and World
Trade," we define subsequent transformations of these ceramic traditions in
terms of specific external and internal mechanisms of change common to all
types of traditions, interpreting evolving ceramic traditions in relation to
changing cultural processes and also considering the impact of continuing in-
migration of European potters, techniques, forms, and influences on the bud-
ding domestic industry. In Part 3, "Legacy: Emergence of an American In-
dustry," the development of a distinctively American industry by early
Industrial Revolution times is addressed. This nineteenth-century achieve-
ment is viewed as mainly entrepreneurial and specifically American. Yet, it
still bears marks of a persistent, on-going, identifiable European influence.

This volume will be most useful to those archaeologists and ceramic his-
torians working with colonial pottery from the eastern United States. How-
ever, it also provides a theoretical, analytic, and interpretive framework for
considerations of domestic ceramics and comparable wares produced else-
where. This treatment, additionally, should serve as a model of general ap-
proach, method, and theory for discussions of tradition and the mechanisms
of change that operate on all types of traditions. Consequently, this book
should be a helpful reference for scholars and researchers working in other
regions and with later sites and comparative data, as well.

I express appreciation to all those individuals and institutions who have
given their assistance and time. Further specific acknowledgments accom-
pany many chapters in the text. A number of people and organizations, how-
ever, have contributed to the publication of this volume in a more general
way. In particular, I thank Richard Trask, Town Archivist, and the Danvers
(Massachusetts) Historical Society. They, Jeffrey P. Brain and Stephen Wil-
liams of Harvard University, and the late Lura Woodside Watkins first pro-
vided me with assistance in the early 1970s. Watkins' early studies of domestic

pottery have influenced the work of many of the contributors to this volume, and the worth of her contributions cannot be overemphasized. Stanley South of the University of South Carolina Institute of Archeology and Anthropology has provided invaluable comments, criticisms, and encouragement. His numerous publications on Southeastern domestic ceramics have been indispensable to this study. I am indebted to Jeffrey P. Brain of Harvard University and George R. Hamell of the New York State Museum for their thoughtful comments on an earlier draft of the Introduction and overviews. George R. Hamell and Susan H. Myers of the Smithsonian Institution have made accessible useful unpublished information. The editorial advisory board of the Studies in Historical Archaeology series under the general editorship of Stanley South has also made helpful suggestions. The editorial and production staff of Academic Press provided time and assistance, as did my student assistant Alicia Lato. The University of Rhode Island, the Museum of Primitive Culture, and the Town of South Kingstown Recreation Commission have provided support as well.

Thanks are especially extended to a fellow archaeologist, my husband, Bill, for his never-failing and generous advice, influence, patience, and inspiration throughout the past decade. He has made it possible for me not only to dream of editing this volume but also to make it a reality, for which I am deeply grateful. The slipware logos that open each Part of the volume are of his design. I also acknowledge my supportive parents, Dr. and Mrs. Berkley Peabody, and mother-in-law and late father-in-law, Mr. and Mrs. William H. Turnbaugh. My father's theoretical work has influenced my thinking about ceramics. Finally, heartfelt appreciation is extended to the contributors to this volume for their continuing good nature and cooperation in making revisions and meeting deadlines.

1

Chapter

Introduction

Sarah Peabody Turnbaugh

The quality of the Newburyport [Massachusetts] "wasters" is so excellent that, in spite of the redware body, question of their native origin was raised. Doubts were allayed by examination of their bases. All are flat, like the bottom of a common jug, and in no case does a rim [glazed foot] appear, as on English cups and saucers. (Watkins 1939)

In recent years, historical archaeologists have become increasingly concerned with recognizing patterning in material remains, or the tangible, physical by-products of human behavior (South 1977, 1978b). Many have worked on describing regularities in the material record in order to interpret and explain these patterns in relation to past human behaviors and cultural processes (for examples, see Carlisle and Gunn 1977; Deetz 1970; Deetz and Dethlefsen 1965; Rathje 1974, 1978; Rathje and McCarthy 1977; South 1977:34, 321, 1978b, 1978c, 1979). Despite the different data bases and specific research strategies, each of these inquiries has quantified data and the inherent variation to distinguish between idiosyncratic and patterned behaviors. In most of these examples, the patterned regularities have been used to make interpretations of behavioral variability that reflect and help to explain more general cultural processes (South 1977:34).

Ceramics are especially sensitive indicators of social and economic variation, cultural and ideological change, and chronology (Brennan 1982; Deetz 1973; South 1972, 1977). As a result, analyzing and interpreting this category of material culture can be useful for understanding changing cultural patterns more fully (for examples, see Quimby 1973).

Both European- and American-made ceramics excavated on sites in the eastern United States, comprising the Northeast (i.e., the New England and mid-Atlantic states) and Southeast regions for the purposes of this study, have become an important focus of archaeological research and anthropological interpretation in recent years, as is evidenced in the extensive literature. The European and Oriental ceramic types, varieties, and forms found on colonial sites often are well documented, and this has facilitated the delineation and interpretation of some cultural patterning. The cultural significance of comparable domestically produced wares that are generally more poorly documented is, however, more difficult to interpret. Yet, the prevalence of these domestic wares on colonial Northeastern sites—where they often constitute more than 85% of a total ceramic sample (Turnbaugh 1977, 1983)—necessarily has made them a category that historical archaeologists no longer can legitimately ignore.

This book addresses two critical needs. First, in spite of increasing interest in early American-produced ceramic wares and their Old World antecedents, the recognition of domestic similarities to and differences from European and Oriental prototypes rarely has been treated adequately. The opening quotation is from one of only a few references that explicitly address some distinctions. This volume describes, interprets, and synthesizes patterns of domestic ceramic production and consumption common to many site reports and studies of Northeast ceramics, comparing and contrasting domestic with European trends. Second, for American-produced ceramics, the diversity of technological types and functional forms and their distinctively Colonial or American as well as Old World–derived qualities seldom have been evaluated through time and space. Many of the chapters that follow explore problems both in recognizing and describing these scantily documented domestically produced wares and in interpreting patterning in social, economic, and cultural contexts.

The general purpose of this volume is to contribute to an increased understanding of the cultural growth and development of the northeastern United States. To accomplish this, the book examines the nature of mid-seventeenth- through mid-nineteenth-century regional production and world trade in the Northeast from the perspective of ceramics. The concept of "tradition" and associated mechanisms of change is critical to the pattern recognition orientation of this book, and this theoretical foundation is explored and extended in this introduction. Definitions of ceramic terms and descriptions of Old World antecedents are then presented and related to this theoretical orientation. Domestic ceramic trends and related cultural processes operating generally in the eastern United States finally are synthesized. This consideration of cultural trends from a ceramic perspective should increase our explicit understanding of the cultural growth and development of the

northeastern United States as it evolved from a conservative, derivative set of lifeways in the mid-seventeenth century to a distinctly American culture, in which traditional elements and direct European influences persisted, by the mid-nineteenth century.

THEORETICAL ORIENTATION: TRADITION

The concept of "tradition" and the specific mechanisms by which traditions change form the theoretical foundation of this volume. By definition, a tradition is the continuous passing down of elements of a culture from generation to generation. It is a set of internalized usages or customs that may be considered to be a coherent body of precedents which influence the present (see Peabody 1975:1-2, 9, 19). A specific archaeological tradition, such as a ceramic tradition, has been defined further as "a (primarily) temporal continuity represented by persistent configurations in single technologies or other systems of related forms" (Willey and Phillips 1958:37). Ceramic traditions bear many similarities to languages and linguistic traditions (Langacker 1968; Sapir 1949), oral epic traditions (Lord 1960; Peabody 1975), religious traditions (Durkheim 1915), and other types of cultural traditions (Goggin 1949:17; Willey 1945:53; Willey and Phillips 1958:37-40).

All types of traditions are composed of both synchronic and diachronic elements. These elements often are recognizable in the archaeological record and can be described. Consequently, analysis of a tradition uses methodologies that consider both the synchronic or normative view of culture and material culture and the diachronic or systemic perspective (see Plog 1975:208). Traditions are normative in that they help to create, maintain, and enhance cultural stability. Traditions are central in regulating the continuities of the culture in which they occur. To a large degree, traditions are stabilizing mechanisms; they are normative on the synchronic level and reflect regularities of the culture that nurtures them. Yet traditions are always developing, and changes occur in systemic ways on the diachronic level (see Plog 1975; Watson et al. 1971). Like culture, a tradition is dynamic and evolves unceasingly; it is never static. Consequently, a tradition generates elements that may be described synchronically or normatively, though the controlling processes are always diachronic or systemic (Peabody 1975:9; Willey 1945:53; Willey and Phillips 1958).

The relationship between tradition and culture is essentially synergistic. The forms and directions of a tradition are influenced by culture but, in turn, the elements of a tradition help to give a specific culture its particular distinctive shape. Examples of the complex synchronic and diachronic interrelationships of traditions and culture have been explored in earlier anthropological liter-

ature (see Plog 1975; Sapir 1949; Watson *et al.* 1971) and consequently are not addressed more specifically here.

The study of traditions—how they work and what they actually are—probably has reached the greatest level of sophistication in the fields of oral epic research, general systems theory studies, and linguistics. Oral epic scholars have defined tradition theoretically and have explored its nature in precise methodological ways by formulating specific tests to determine whether particular texts, such as Homer's *Odyssey,* are truly the direct products of an oral tradition (Peabody 1975:3-4ff.). General systems theory as adapted and applied to archaeology (Plog 1975; Watson *et al.* 1971) considers the systemic, processual interrelations of internalized cultural institutions that can include traditions. Linguists, in addition, have described external and internal mechanisms that affect drift, or the direction in which a language or tradition evolves (Langacker 1968).

Chapters in this volume consider such ceramic attributes and contexts as specific materials used, production technologies and sequences, forms, functions and cultural roles, and general distribution and consumption patterns. In an informal way, these five levels of ceramic analysis parallel the five types of oral epic tests, which range from the most specific, phonemic level of patterning to the most general level of cultural context, song (see Table 1.1; see also Peabody 1975:3-4). Table 1.1 compares these five levels of ceramic analysis with the five oral epic tests to provide historical archaeology with a more explicit model for studying tradition and ceramics on different levels of analysis.

The tenets of general systems theory as applied to archaeology (Plog 1975; Watson *et al.* 1971) provide the necessary theoretical linkage between the concepts of "tradition" and "culture" in subsequent discussions.

In addition, this volume utilizes linguistic concepts to define specific external and internal mechanisms of change operating on traditions (see Table 1.2). These mechanisms are later demonstrated in the chapters constituting Parts I through III.

THEORETICAL ORIENTATION: MECHANISMS OF CHANGE

Traditions can and do change, grow, flourish, or decline in specific ways. Concepts borrowed from linguistics (Langacker 1968) and oral epic studies (Lord 1960; Peabody 1975) may be used to identify specific mechanisms of change in archaeological traditions, and these concepts are discussed subsequently. Changes may be due to external influences, internal modifications, or a combination of both types of mechanisms operating within a tradition (see Table 1.2). Some of the terms provided in Table 1.2, such as *diffusion*

Table 1.1

Ceramic Tradition Analyses and Corresponding Oral Epic Tradition Tests

Ceramic analyses	Oral epic tests[a]
Materials analysis—examine specific clays, glazes, etc. (building blocks) used for patterned redundancy that has cultural significance (*see especially* Gorman *et al.*; Hunter, this volume)	*Phonemic test*—examine units of sounds (building blocks) for patterned redundancy
Production analysis—examine consistency in production sequences to consider cultural variation and change (*see especially* Worrell, Chapter 5; Pendery, Chapter 6; Starbuck and Dupré, this volume)	*Formulaic test*—examine consistency in patterns of word forms or morphemic clusters and look for repetition of phrases
Form analysis—examine consistency in patterns of materials plus production periods (i.e., completed vessel forms), both in one potter's repertoire and in those of potters in same tradition (*see especially* Janowitz *et al.*; Dickinson; Warner, this volume)	*Enjambment test*—examine consistency in patterns of syntactic periods, both in a singer's own composition and in those of related provenience
Function analysis—examine consistency in patterns of vessel functions and cultural roles, both in one community or one potter's inventory and in those of related provenience (*see especially* Chace; Turnbaugh, Chapter 12, this volume)	*Thematic test*—examine consistency in patterns of lexical clumps (or associations among lexical elements that organize paragraphs) of a singer's own composition and in those of related provenience
Distribution analysis—examine consistency in patterns of marketing, distribution, trade, and consumption used by one potter or community and those of related provenience (*see especially* Teller; Bower, this volume)	*Song test*—examine consistency in patterns of discourse (structure and mode of large passages of text) used by a singer and in those of related provenience. (Note: close repetition or similar patterning but in separate contexts is expected within a given style or tradition)

[a]See Peabody (1975:3-4).

and *borrowing,* are already shared by anthropology, while others are not. Consideration of these concepts and their application to archaeological ceramic data is useful here.

External Influence

The presence of external influence on a given tradition usually denotes the existence of some type of direct or indirect exhange—diffusion or contact such as migration, trade, or intermarriage—between two or more cultures

Table 1.2

Mechanisms of Change That Operate on Tradition

External mechanisms
 diffusion
 borrowing of individual traits
 borrowing of complexes of traits
 dispersion
 leveling

Internal mechanisms
 imperfect learning
 leveling
 innovation
 specialization
 elaboration
 permutation

External and internal mechanisms
 leveling (assimilation)
 drift

that either are following different but compatible traditions or are receptive to incorporating traits of a specific but foreign tradition into their own culture. *Borrowing* specific traits or more general patterns of one tradition and integrating them into another comparable tradition is the most common external process by which two traditions may influence one another (Langacker 1968:176, 181). Borrowing generally results from some type of *diffusion,* or expansion of a tradition into a broader geographic area. In the Northeast, the in-migration of Old World potters and technologies occurred continually. George Hamell (personal communication, 1984) refers to this process as *dispersion,* or dissemination, which is a specific type of diffusion occurring independently of any subsequent borrowing.

Borrowing takes many forms and occurs on two major levels: the borrowing of individual traits and the borrowing of complexes of traits. Specific traits often are borrowed relatively freely (Langacker 1968:176). In lead-glazed red earthenware traditions, for example, quill-applied white kaolin slip decoration was used to create a specific decorative variety of redware called "slipware." The transfer of this trait from European countries to the colonies probably was due at times to borrowing and at other times to dispersion.

Borrowing of more general patterns or complexes of traits is somewhat less frequent, however, because this type of borrowing requires the adoption of all integrated traits and rules making up the overall pattern (Langacker 1968:177). In Britain, production of white salt-glazed stoneware with debased "scratch blue" medallions and decorative elements that mimicked co-

balt blue elements on Westerwald stoneware (Noël Hume 1970:118, Figure 37) is an example of this less common type of borrowing. *Permutation,* an internal modification, also operated in this instance, and this example is discussed further below.

As chapters of this volume illustrate for the northeastern United States, borrowing of individual traits occurred frequently at all developmental stages of ceramic traditions, from handcrafting to industrial production. However, the borrowing of entire complexes of traits or patterns—which may occur less commonly because it is considerably less conservative than the borrowing of individual traits—occurred mainly in the later contexts of entrepreneurial and industrial ceramic production in the Northeast. This second type of borrowing appears to have been even less frequent in earlier handcraft stages of ceramic development, which were characterized by greater conservatism.

Leveling is a type of assimilation in which specific traits are dropped or modified. It results in overall simplification, contraction, or standardization of an existing tradition. Leveling occurs when two traditions or groups of traits, each with a distinct pattern, fall together to form essentially a single tradition or group of traits (Sapir 1949:181). This shifting occurs with a minimum loss of traditional pattern and can result from a variety of external influences, such as intercultural contact. Leveling of this type occurred in ceramic traditions throughout both Europe and the eastern United States; it is visible, for example, in an increasing similarity of wares made by two or more enclaves of potters (see Starbuck and Dupré, this volume). Leveling also can result from internal modifications and is discussed further below.

Internal Modifications

Internal modifications are somewhat more specialized than external mechanisms and have been considered less frequently in the archaeological literature. As with external influence, internal change may occur at all levels of a tradition. It can affect individual attributes as well as more general complexes of traits or patterns and the rules that govern them (Langacker 1968:181). Internal change may result in the addition or the loss of attributes or patterns of the tradition over time. Internal change may occur in at least four ways. Traits may be dropped from the tradition due to various factors, including imperfect learning and leveling; completely new traits may be invented through innovation; established traits may be combined to create newer, more complex or compound traits through specialization or elaboration within a tradition; or the use of old, well-established traits may be altered, extended, or modified and then applied to new contexts through permutation (Langacker 1968:182).

Streamlining of redware production methods and dropping of decorative traits from potters' repertoires in some areas of the eighteenth-century Northeast (see chapters by Gorman et al., Pendery [Chapter 6], and Starbuck and Dupré, this volume) include instances of *imperfect learning* and *leveling* through internal modifications. These were spurred largely by economic considerations and changing production and consumption demands.

The second type of internal change—true *innovation*—is probably the least commonly found in a tradition, since tradition-bound people usually are conservative and tend either to modify established traits or patterns that are already internalized or to borrow from other compatible traditions, rather than create completely new, untraditional material (Langacker 1968:181-182). True innovation is difficult to document, but Josiah Wedgwood's addition of cobalt to the paste and glaze of creamware to create a whiter-looking ware, called "pearlware," may be an example.

Sgraffito is a specific example of the third type of internal change—*specialization* or *elaboration*—through the combining or compounding of two decorative traits, slip application and incising, to create a new trait complex. Transfer-printed designs on refined earthenwares illustrate the distinction between the two terms specialization and elaboration. Transfer printing combined established design elements and colors with a new technique to create a new trait complex. With the introduction of transfer printing, the use of other decorative techniques on refined earthenwares quickly declined (Miller 1980, 1984b; South 1972). The widespread popularity of blue transfer printing resulted in an initial specialization within the ceramic tradition as production efforts were concentrated on making quantities of this variety at the expense of other varieties. Design elements and color choices were later expanded and the transfer-printed refined earthenwares flourished, thus constituting an elaboration within the specific tradition.

Permutation—the extension of existing traits or of a complex of traits or patterns to new contexts—may occur either alone or in conjunction with borrowing. The changeover from hand-painted "willow pattern" designs (Noël Hume 1970:129-130) on pearlware to transfer-printed equivalents may be an example of permutation. The English production of white salt-glazed stoneware with debased "scratch blue" medallions and designs that resembled cobalt blue elements on Westerwald gray stoneware (Noël Hume 1970:118) is an example of borrowing plus permutation, in which a Germanic complex of decorative traits was borrowed and adapted to a different English stoneware.

Changes in the properties or usages of specific, individual traits are often sporadic or idiosyncratic and occur frequently within the life of the ongoing tradition. Such idiosyncratic changes become important to consider in studying tradition in those infrequent cases where an idiosyncratic change is more

generally adopted as a permutation or innovation or as a specialization or elaboration within the tradition as a whole.

Combination of External and Internal Changes

Leveling may occur within a tradition as the result of either external or internal changes occurring singly or in combination (Sapir 1949:180-182). Borrowing and imperfect learning are the mechanisms that may contribute most to this occurrence. Leveling through borrowing may result in the visible conflating of two traditions so that they appear more similar to one another, as discussed above. Leveling through imperfect learning or through dropping techniques or forms from the traditional repertoire of a potter usually results in visible simplification of a tradition or of traits constituting a particular tradition. In the Northeast region, simplification of lead-glazed redware traditions through leveling often was the result of increasing economic pressures or production demands (see Hunter, Teller, Warner, Worrell [Chapter 9], this volume).

True cultural assimilation can be a result of leveling, as well. *Assimilation* is the modification of a specific trait or pattern to make it more similar to traits or patterns of neighboring cultures or traditions (Langacker 1968:163). Two or more comparable traditions may appear more similar to each other on the surface and may seem more compatible due to assimilation brought about by leveling through borrowing. As an example, chinoiserie designs on seventeenth- and eighteenth-century European delftware and hand-painted and transfer-printed refined earthenwares often clearly resemble contemporary Chinese export porcelains.

The *drift* of a tradition, which results from both external and internal mechanisms, is important to this consideration. Traditions are ever changing and, like languages, they have a drift, or direction of development, through time and to a lesser degree over space (Langacker 1968; Sapir 1949:150-155; Willey and Phillips 1958). Once a *prototradition,* or parent tradition (Langacker 1968:199-200), is broken into two or more branches that are no longer in communication with one another, each branch—in this case, usually a ceramic variety or a group of related varieties—drifts in its own direction. Drift often results in the development of regional styles over time (see Dickinson, this volume). Given receptive cultural conditions, each regional style or branch of the prototradition eventually may, but does not always, become a *daughter tradition,* or a new tradition in its own right. The direction of the drift of a specific tradition is determined by the largely unconscious selection on the part of its practitioners of specific, individual variations that become cumulative in a specific direction. External and internal mechanisms of

change, as outlined above, play important roles in determining the precise nature of a particular tradition's drift.

To conclude, a tradition is both normative and systemic in nature. The presence of patterned and customary behaviors, historical time depth, and various external and internal mechanisms of change are the three critical elements for defining a tradition. These three elements can be identified in pottery traditions of Europe and China as well as the eastern United States. As such, these criteria can be used to demonstrate that categories or groups of ceramic varieties truly constitute traditions in every sense of the definition.

A summary of ceramic terminology and European prototypes as they relate to tradition follows. This introduction concludes with a survey of changing domestic ceramic traditions in the eastern United States in order to provide a general framework for the chapters that follow. Those chapters explicitly treat specific pottery traditions and cultural developments in the Northeast region from the perspective of tradition, with particular attention to specific mechanisms of change operating on ceramic traditions.

CERAMIC DEFINITIONS AND EUROPEAN PROTOTYPES

A knowledge of ceramic types found and made in colonial America, their significant attributes, and their historical development is necessary for understanding subsequent chapters of this volume. Relevant ceramic terminology and major developments in European traditions that eventually were to be transplanted to the Eastern seaboard are discussed briefly below (see also Bower; Chace; Janowitz et al.; Pendery, Chapter 4; Turnbaugh, Chapter 12, this volume). More detailed treatments are available elsewhere in the literature (for example, Brain 1979; Matson 1965; Noël Hume 1970; Rhodes 1973; Schwartz 1969; South 1972, 1977; Shepard 1965; Spargo 1974; Stradling and Stradling 1977).

The term ceramics defines a category of objects, particularly vessels, that are formed of clay and then fired. This term encompasses both pottery and porcelain. Pottery usually refers to objects with opaque paste whereas porcelain denotes those with translucent paste (Spargo 1974:5-7). This volume concentrates on domestic pottery production and consumption prior to the Industrial Revolution in the United States. However, early domestic porcelain manufacture is also considered briefly as it relates to changing domestic production and consumption patterns (for example, see Bower, this volume).

The composition of the clay, hardness and general paste color, technique of manufacture, and temperature at which a ceramic object has been fired in a kiln determine whether it belongs to a class of earthenware, stoneware, or porcelain according to archaeological type-variety classificatory terminol-

ogy (see Turnbaugh 1983:6). The clays composing each ceramic class could be shaped into various forms by using either a single technique or a combination of several methods of manufacture, such as building rope-like coils of clay, pinching together slabs of clay, wheel throwing, drape molding, and slip casting in plaster-of-paris molds (Rhodes 1973). The wide range of possible ceramic decorative techniques and vessel forms and functions is discussed below under the appropriate ceramic class.

Earthenware

Earthenwares are made from common glacial or alluvial clays that are fired in a kiln at temperatures of up to 1100° C. Earthenware may be left unglazed, though it more usually is glazed to make its typically porous, permeable body impervious to liquids. *Paste* or body clay color after firing is generally red, brown, or buff due to the natural presence of iron oxides in the clay.

Major *types* of the earthenware class are distinguished from each other on the basis of specific paste texture and color (Munsell designations) and general glaze type (lead, salt, tin, etc.) and include either *unglazed* or *lead-glazed red earthenwares* (generically called "redwares"), *tin-glazed earthenwares* (generically called *delft* when from England or Holland, *faïence* when from France, and *majolica* when from Italy, Spain, or Portugal), and *refined earthenwares*, including creamware and pearlware (see Turnbaugh 1976, 1977, 1983:6). The lead-glazed redware type is most heavily emphasized in this volume due to the high frequency of European and colonial redware varieties in ceramic samples from Northeastern domestic sites (Deetz 1973; Turnbaugh 1976, 1977, 1983) for the period under study (roughly, 1625–1850).

Throughout Europe, as in the colonies, powdered or liquid lead oxide *glazes* often were applied to the surface to waterproof redwares. During firing in a kiln, these glazes fused to the clay body of the vessel, thus forming an impermeable, glasslike surface. Lead glazes, normally transparent, could be colored intentionally by adding metallic oxides as pigments, such as copper for green and iron or manganese for brown or black. Impurities in the clay glaze as well as firing vagaries also could affect the color of the finished vessels (see Worrell, Chapter 5, this volume). Powdered glazes were used initially in Europe. After about 1740 or 1750, the development of liquid lead oxide glazes resulted in improved, more standardized and streamlined techniques that permitted glazes to be applied more quickly in assembly-line fashion, thereby lowering production costs (Hughes 1961; Lewis 1969).

Several varieties of lead-glazed redware were produced in sixteenth- and seventeenth-century Europe prior to transplantation of the technology to colonies in what is now the eastern United States. In spite of specific local and

regional differences, considerable contact and interaction among early pottery-making centers in England, Holland, Germany, France, Spain, and Italy seems to have occurred. This interaction is largely attributable to dispersion or to diffusion and borrowing, and it is identifiable in the ceramic record due to many visible similarities in vessel forms from these countries (Beaudry et al. 1983; Janowitz et al., this volume; Noël Hume 1970; South 1972; Steponaitis in Brain 1979) and to the similar methods used to produce them (Jelks 1958; Noël Hume 1970; South 1972; Steponaitis in Brain 1979:44–73; Turnbaugh 1976, 1977).

Several distinctive lead-glazed redware *varieties,* or ceramics sharing similar specific glaze color and decorative attributes, were made in England and France and included black, ferruginous, clear (brown), mottled, and green, some of which were also slip decorated (Kelly and Greaves 1974; Noël Hume 1970; South 1972; Steponaitis in Brain 1979). In England, varieties or groups of varieties have constituted temporal ceramic traditions. Many of the early postmedieval traditions have been named and dated on the basis of their geographic centers of production, such as Wanfried and Astbury slipwares, North Devon gravel-tempered and sgraffito wares, Buckley redwares, and Staffordshire–Bristol combed or dotted yellow slipwares (Lewis 1969; Noël Hume 1970; South 1972, 1977; Turnbaugh Table 12.1, this volume; Watkins 1950; Watkins 1960; Wills 1978). This nomenclature suggests that these named traditions may have developed as drifting regional styles that had their origins in earlier, more generalized pottery-making traditions of the Middle Ages (Hodgen 1974:Table 5). This implication is an example of how a prototradition can drift and splinter over time to form newer, more specialized daughter traditions, all of which have a common origin (see Turnbaugh, Chapter 12, this volume).

Throughout Europe, lead-glazed redwares, like varieties of other ceramic types, could be decorated with colored *slips,* or liquid suspensions of clay or other materials and water. In the northeastern United States and Canada, as in Europe (Noël Hume 1970; South 1972; Steponaitis in Brain 1979:50, 64; Watkins 1959; Webster 1969), lead-glazed redware slip was commonly white kaolin clay, though occasionally it was manganese- or copper oxide-stained white kaolin clay. Slips were painted, brushed, trailed, swirled, or combed onto vessel bodies to create a wide range of surface designs. Trailing, swirling, and combing seem to have been practiced most frequently in Europe (Watkins 1950). Painted and brushed slip designs probably are examples of internal change—through either innovation or permutation—in an attempt to speed up production techniques while retaining the same traditional decorative effect. On the basis of domestic potters' kiln ceramic samples (Turnbaugh 1976, 1977, 1983; Watkins 1939:25, 1950), this internal change appears to have been a comparatively late development in the Northeast

region, which strengthens the suggestion that it may have been developed to speed up production techniques. Other ornamental effects were achieved by piercing, incising, or tooling the clay or by applying molded relief decorations called *sprigs* prior to firing.

Finished vessels were allowed to air dry and then were baked or fired in large ovenlike structures or furnances called *kilns*. In the northeastern United States, the two predominant colonial kiln types—the bottle-shaped and the beehive-shaped kilns—followed traditional English and Germanic prototypes that essentially were transplanted to colonial America (Greer 1979; Pendery, Chapter 6, this volume; Rhodes 1968:42-48; Worrell, Chapter 5, this volume). Some of the European kiln types, in turn, initially were derived from Chinese antecedents (Rhodes 1968). Close similarities between traditional European and early colonial kiln hardware also have been demonstrated in the literature (Long 1964:105, Plate 1).

Tin-glazed earthenware differs in type from lead-glazed earthenware primarily on the basis of the glaze composition. Tin-glazed varieties are glazed either with tin only or with tin plus a lead glaze over the tin glaze (Turnbaugh 1976:69; Barber 1907c). Unlike redwares, which were regularly made on both continents, tin-glazed earthenware was produced primarily in Europe. This tradition originated in the Near East and was an attempt to emulate Chinese porcelains that diffused to this region as early as the thirteenth century (Caiger-Smith 1973). Majolica soon was being traded to Europe, where it was made initially in Spain and Italy during the fourteenth century. The technology eventually had diffused throughout the Old World by the early seventeenth century (Noël Hume 1970:105-106).

During the earliest years of production, potters from Italy, Holland, and England were in close contact, and their regional styles differ only slightly (Noël Hume 1970:106-108). As the tin-glazed tradition drifted through time and across space, more distinctive Dutch, English, French, Spanish, and Italian styles evolved and were recognizable by the mid-eighteenth century (Brain 1979:34-35; Noël Hume 1970). Various schools of production in each country differed in conventional choices of enamel colors and their combinations and in selection of design elements (Barber 1907c:46-47; Noël Hume 1970:106). Both faïence and delft potters, for example, borrowed design elements from China, yet they developed distinctive polychrome chinoiserie styles by the first half of the eighteenth century (Brain 1979:35, 41-43; Noël Hume 1970:108). This outcome attests to the importance both of internal factors that give a particular regional style or tradition its individuality and of external mechanisms of change, such as dispersion, diffusion, and borrowing. In addition, the considerable influence of Chinese porcelains on seventeenth- and eighteenth-century European ceramics is evident. From about 1710 on, the addition of written slogans of a literary, religious, or patriotic

nature was also common on English delft plates and French faïence (Brain 1979:41; Noël Hume 1970:109). Perhaps due to borrowing and subsequent permutation from European traditions, similar slogans are later found on colonial drape-molded redware plates (see Dickinson, this volume).

Large quantities of plainer varieties of tin-glazed table wares were traded throughout Europe and were exported to the eastern colonies of the United States for mass consumption from the mid-seventeenth century until the mideighteenth century (Brain 1979; Noël Hume 1970; Turnbaugh 1984:86). Quality of decoration on English tin-glazed wares declined through time (Noël Hume 1970:290). In addition, this type of ceramic proved to be somewhat impractical; it was soft, porous, and easily chipped. Popularity decreased rapidly after about 1750 when more durable white salt-glazed stonewares and refined earthenwares became available. European production of tin-glazed wares virtually ceased by the early nineteenth century as stonewares replaced more fragile utilitarian tin-glazed forms and refined earthenwares became popular substitutes for the more ornate varieties of attractive but friable tinglazed table wares.

Creamware, a refined earthenware, was developed in England around 1740. At about this time, production demands and consumption patterns were changing considerably (Copeland 1982; Miller 1984a, b). Fine tea and table wares, most of which filled sociotechnic rather than technomic roles, were becoming the dominant ceramic forms. Their increasing importance plus the declining usage of utilitarian earthenware forms during this period (Deetz 1973) demonstrates changing tastes, fashions, and consumption habits, particularly as tea drinking became increasingly popular (Copeland 1982:5-7; Roth 1961). Many creamware varieties, including clouded, tortoiseshell, and Queen's wares, quickly filled the growing demand for inexpensive refined ceramics. These varieties competed successfully with more expensive porcelain tea and table wares for the popular market. At the same time, creamwares rapidly replaced most finer but less durable slip-decorated lead-glazed and tin-glazed earthenwares as table wares (Miller 1984b:2-3; Noël Hume 1973).

The fine-grained buff-colored paste of English creamware typically consists of white Devonshire clay hardened with ground flint. It lent itself well to a wide range of decorative techniques, including painted, dusted or spattered, dipped, edged, and transfer-printed elements (Miller 1984b:3; Noël Hume 1970; South 1972). Simple banded designs that probably changed slowly and varied little were most popular among rural Britons, whereas transferprinted wares, which probably were more sensitive to changing fashions and tastes, appealed to the popular culture of western Europe and North America (Whiter 1970). Due largely to effects of leveling and specialization within the refined earthenware tradition, transfer printing gradually emerged as the most

popular decorative method (Godden 1963:10; Miller 1980:1–2; Noël Hume 1973:247). Semiskilled labor could quickly and accurately decorate large numbers of ceramic forms with this technique, thus meeting streamlined mass-production goals that accompanied increasing consumption demands during the early Industrial Revolution (Copeland 1982:5). This period of industrialization began around 1740 in England with the introduction of the factory system and division of labor, but it was not achieved in the United States until almost 100 years later (Guilland 1971:31).

Pearlware, which Josiah Wedgwood developed and introduced in 1779, is essentially a whiter-looking version of creamware. The addition of cobalt blue to the paste and glaze in an attempt to emulate the appearance of Chinese porcelain glazes—probably an example of innovation (Noël Hume 1970:128)—gives this refined earthenware a slightly bluer or whiter tint than is usually observed in the yellower-looking creamware. Much pearlware was likewise blue transfer-printed in a conscious European imitation of Chinese export porcelain, which was an expensive but popular import in seventeenth- and early eighteenth-century England (Copeland 1982:7; Miller 1984a:39; Noël Hume 1970:247). As with creamware, large quantities of transfer-printed pearlwares also were made in Staffordshire especially for post-Revolution export to markets in the eastern United States between 1790 and 1830 (Miller 1984b; South 1972). Popular export designs included those with Chinese elements or the English-derived "willow pattern" or with historical, rural, or patriotic themes (Copeland 1982:7, 23, 27; Miller 1984b:3; Noël Hume 1970:130, 1973:250).

The hard, fine-grained paste of pearlware, like that of creamware, could accommodate a variety of colorful and interesting decorative techniques, including over and under glaze painting, transfer printing, slip decoration, annular banding, shell edging, and sprigging (South 1972). Consequently, through various internal mechanisms of change, particularly elaboration, the decorative potential of pearlware eventually was expanded and developed in many directions. Decorative changes in this ceramic variety appealed to consumers and at the same time stimulated more rapid change of tastes and fashions in ceramic consumption during the early years of the Industrial Revolution in England (Copeland 1982).

Stoneware

Stoneware is usually fired at temperatures between 1200° and 1400° C. It is a dense, vitrified, waterproof class of pottery with a gray, brown, or buff paste color. As discussed in this volume, most stoneware types and varieties were salt glazed and include various German-, English-, and American-made

stonewares. Undecorated utilitarian stoneware vessels, known as *grès*, were produced in France as well (Brain 1979:82), and a few French examples have been found on eighteenth-century sites in the eastern United States.

Brown slip-covered, salt-glazed stoneware was produced in Europe from the mid-fifteenth century on. These vessels were used mostly for storing and shipping commodities prior to the mid-seventeenth century, when glass bottles replaced such stonewares (Brain 1979:74). During the sixteenth through eighteenth centuries, two schools splintered from this brown stoneware prototradition and flourished in the Rhineland of Germany, the major European center of stoneware manufacturing (Brain 1979:74-77; Noël Hume 1970). The Siegburg district of the Rhineland spawned both of these sixteenth- to seventeenth-century traditions, one of which continued to use an iron oxide-stained slip plus salt glaze to make a brown stoneware, including Frechen bellarmine jugs. The other fashioned a cobalt blue-decorated, salt-glazed gray stoneware, called Westerwald ware.

The primary importance of these two traditions to this study is that they are a good example of drift. Both developed out of regional styles that branched from a common antecedent (Brain 1979:74-77; Noël Hume 1970). Over time, the quality of craftsmanship in both traditions declined as production and consumption demands increased and the market swamped the potters. For example, decorative details such as the features of bellarmine faces and the carefully incised and painted cobalt blue elements deteriorated (Brain 1979:74-75; Noël Hume 1970:55-57; South 1972). This trend eventually led to the production of stoneware forms employing debased decorative techniques that could be produced quickly with streamlined methods.

Also of interest to this discussion is the early development of the Westerwald gray stoneware tradition from the brown stoneware antecedent. Toward the close of the sixteenth century, some potters in Raeren, Germany, innovated or borrowed a trait, adding blue cobalt decoration to their brown stonewares. Shortly thereafter, potters dropped the brown iron oxide-stained slip from their repertoire and, by 1590, the new gray variety emerged. This variety took root and grew, eventually becoming established as a new tradition. The adoption of cobalt blue possibly was a response to the popularity of blue-and-white Chinese export porcelain or of ceramic varieties, such as some delftwares, that emulated this porcelain (South, personal communication, 1984). Whether the adoption of cobalt blue came about through borrowing or diffusion through the British East India Company and the China trade or through the influence of tin-glazed earthenwares with blue-and-white and chinoiserie designs so popular in Europe cannot be further illuminated at this point.

By the last quarter of the seventeenth century, potters were decorating

some wares with manganese purple along with cobalt blue (Noël Hume 1970:281). The use of manganese purple on Westerwald stoneware is a good example of borrowing of a traditional and popular English coloring agent. Manganese purple had been used as a tin-glazed earthenware enamel since the fifteenth century, and its popularity continued into the seventeenth and eighteenth centuries, exemplified in the production of English tiles decorated with managese purple and English powder purple and blue delftwares (Brain 1979:44; Miller and Stone 1970:40; Noël Hume 1970:293). The late seventeenth-century use of maganese purple on Westerwald stoneware also constitutes an adaptation of permutation of this borrowed technique. This similar type of decoration by both English and German potters again marks the extent of intercultural influence operating in Europe during these centuries.

By the 1690s, many Westerwald stonewares bore popular English decorative elements and catered specifically to English markets (Brain 1979; Noël Hume 1970). As discussed above, when consumption demand and export volume increased, quality of production and workmanship declined. Although established vessel forms and techniques of manufacture and decoration remained essentially unchanged over time, their production and execution—through modifications such as leveling and imperfect learning— became more imprecise, simpler, and sloppier in general appearance. The finely crafted hand-incised geometric or realistic designs of the early to midseventeenth century, for example, yielded by the eighteenth century to simpler stamped and cobalt blue-painted geometric designs that German potters could mass-produce (Brain 1979:77). These later, more simply decorated Westerwald wares most probably were the models for eighteenth-century domestically produced stonewares in the Northeast region, based on temporal contexts and comparison of decorative styles (compare Warner, this volume).

German stonewares influenced production in other European countries as well. During the sixteenth and seventeenth centuries, England may have manufactured copies of contemporary German brown bellarmine stonewares to sell in English markets already established by Germany. Conclusive identification of English-made bellarmines in the archaeological record has not yet been achieved, however (Brain 1979:75). During the eighteenth century, though, potters manufactured some distinctive English brown stonewares, including Fulham and Burslem stoneware mugs and Nottingham stoneware (Barber 1907b). Technologically, these wares are somewhat similar to the Rhenish brown stonewares, primarily in their use of a brown iron oxide-stained slip. Since the English wares appeared later, they may constitute an example of modified diffusion of or borrowing from the earlier German tradition.

English Staffordshire white salt-glazed stoneware was a popular ceramic

variety first made around 1720 (Mountford 1971; South 1972). It may initially have been developed in an attempt to supply a more economical or durable alternative to Oriental porcelain or Lambeth delft (Mountford 1973:201). By 1740, mass-produced, molded plates, somewhat reminiscent of early fifteenth-century Ming dynasty (1388-1644) white on white monochrome porcelains (see Grousset 1935:354-356), had become the common English table ware, thus helping to spur the decline of delftware manufacture (Noël Hume 1970:115-117). White salt-glazed stoneware combines skills of both artisans and mass producers and is an important ceramic marker of the mid-eighteenth-century changeover from individually crafted, handmade objects to industrialized, factory-made wares in Europe during the Industrial Revolution (Guilland 1971:31). In the 1760s, the English manufactured white salt-glazed stoneware chamber pots and wash basins decorated with debased "scratch blue" elements. These designs were deliberate permutations of design elements on Westerwald stonewares and helped these Staffordshire forms to recapture the English utilitarian stoneware market that had come to be dominated by the German wares (Noël Hume 1970:118). Both Staffordshire white salt-glazed stoneware table wares and utilitarian forms remained popular until about 1770, when production declined as consumers turned to increasingly plentiful refined earthenwares and porcelains to meet their needs (Mountford 1971; South 1972).

Porcelain

The paste of *porcelain*, which is fired at about 1400° C, usually looks white, vitrified, and translucent. True porcelain, which consists of a hard paste composed of kaolin clay and petuntse, is technologically the most advanced and complex class of ceramics considered in this book. Producing true porcelain required a strong economic network and considerable coordination of resources and skills at a level usually only attained in pottery workshops of communities that were beginning to organize for commercial production. In China, the ability to create porcelain was attained quite early, by 1000 B.C. By A.D. 1200, over two millennia later, traders were bringing some Chinese porcelains to Europe and the Near East, where the Oriental wares were rare, expensive, and highly coveted. Many subsequent European and Near Eastern ceramic developments were inspired by these Chinese porcelains.

As early as the Ming (1388-1644) and Ch'ing (1661-1796) dynasties, Chinese porcelain workshops were using assembly-line methods, with single objects passing through the hands of up to 70 specialized artists prior to completion (Hoover Presidential Library 1983). Consequently, speed of production increased, and volume of trade with Europe had the potential to expand accordingly. A wide range of forms and decorative techniques—including

molded, incised, and monochrome and polychrome painted methods that were later to influence European ceramics—were developed during the Ming dynasty. In the early sixteenth century, for example, the familiar *hui-ch'ing* blue, or "Mussulman blue," which had its origin in Persia (Grousset 1935:356), became the dominant variety of painted blue on white decoration. Its popular appeal continued unabated in China and Europe, to which it was exported for the next three centuries (Grousset 1935:354–362), particularly following the founding in the early seventeenth century of the British East India Company. Quantities of *famille rose* and *famille verte* polychrome and of green celadon table and tea wares also were exported to Europe (Crossman 1976).

The choice of decorative subjects used on Chinese porcelains also influenced European ceramics, particularly through the emphasis on historical legends, romances, and naturalistic elements. All of these subjects eventually found their way into European refined earthenware, stoneware, and porcelain designs (Copeland 1982; Crossman 1976). Emulation occurred in both directions. Europe influenced China in its turn through diffusion and borrowing and subsequent integration of ceramic traits (Crossman 1976; Grousset 1935:362; Noël Hume 1970). Chinese porcelains also considerably influenced the domestic ceramic industry, as subsequent chapters in this volume demonstrate (see especially Bower, this volume).

True porcelain was developed relatively recently in Europe. In Florence, Italy, *ca.* 1575, potters first developed a soft paste porcelain while trying to emulate popular Chinese porcelains. It was not until 1708 or 1709, however, that a German chemist, Johann Böttger of Dresden, first produced hard paste porcelain in Europe (see *Unearthing New England's Past* [UNEP] 1984:18). England was slower yet. By the mid-eighteenth century, England was making an artificial or soft paste porcelain that emulated Chinese wares, and the English development of hard paste porcelain followed shortly thereafter. In Europe, as in China, porcelain provided a medium that afforded a wide range of decorative possibilities, from underglaze painting, printing, or overglaze enameling to incising or molding. This characteristic gave the class of ceramic added appeal (Crossman 1976).

More extensive treatments available elsewhere (Crossman 1976; Noël Hume 1970; Spargo 1974) explicitly detail the many Chinese and European porcelain developments and explore both external and internal mechanisms of change affecting this ceramic tradition. Although further discussion is mostly beyond the scope of this volume, it is important to note that as demand for Chinese porcelains increased, quality of work generally declined, until decoration, in particular, retained but a vestige of its earlier detail by the second quarter of the nineteenth century (Crossman 1976). This trend, which also occurred in other classes of European ceramics, as discussed above, prevailed

as well in those eastern United States pottery-making communities that in-dustrialized (see Myers 1980).

To conclude, each European and Oriental ceramic tradition discussed above evolved from folk craftsmanship to industrialization in the same way, virtually without exception. Over time, artistry and quality of hand-done work grad-ually became standardized, streamlined, and simpler in content. Eventually, the effects of mass production, increased production and consumption de-mands, and industrialization led to a debased, simpler-looking version of the earlier wares in the traditions. The external and internal mechanisms by which these ceramic traditions changed and the general trends explored for Euro-pean and Oriental traditions as they evolved from small-scale, family-based craft to large-scale, entrepreneurial mass production happened in the eastern United States as well. The general occurrences from transplantation through subsequent dispersion and transformation to the emergence of a truly Amer-ican industry, in which Old World elements continually were reintroduced or reinforced (Hamell 1976:2), will be outlined briefly below to provide the set-ting for a fuller examination of ceramic developments in the Northeast region.

CERAMIC TRADITIONS IN THE COLONIES
OF THE EASTERN UNITED STATES

Ceramic historians and archaeologists generally agree that the majority of early ceramic wares produced in the colonies were traditional; the technol-ogies, forms, functions, and design elements were brought to this country from Europe and were, in effect, transplanted to the colonies in traditional ways (see Beaudry et al. 1983; Guilland 1971:1-2; Hudson and Watkins 1957:54; Jelks 1958:203; Noël Hume 1982; South 1967, 1970; Spargo 1974; Turnbaugh 1983; Watkins 1950; Wright 1957:213). Even kilns and kiln hardware in the New World appear to have been derived from traditional European prototypes that essentially were transplanted to these shores (Hud-son and Watkins 1957; Long 1964:105; Rhodes 1968:40-48). The initial colonizing populations were highly conservative (Bailyn 1955), and their life-ways (Chace, this volume) and ceramic forms (Janowitz et al., this volume) and production techniques (Worrell, Chapter 5, this volume) reflect this con-servative predisposition. Of course, some leveling occurred initially in the transplanted traditions, due to factors including more limited availability of raw materials and scarcity of labor in the colonies (Guilland 1971:1-2). How-ever, many popular pottery traditions were transplanted successfully to the Southeast and Northeast, as is indicated by pioneering studies of ceramic samples obtained from potters' kiln sites (South 1967; Watkins 1950). Suc-cessful transplantation is also indicated by the heavy demand for locally pro-

duced wares, both in the Northeast (Watkins 1950) and in the Southeast, where, for example, the local militia had to restrain overeager customers from storming the pottery shop at Old Salem, North Carolina (Bradford Rauschenberg, personal communication, 1984).

At colonial sites throughout the eastern United States, the early domestically produced wares often are virtually identical in appearance to imported English, Dutch, French, and German varieties and forms. Comparisons have been made, and Old and New World similarities of ceramic varieties, forms, and functions and the lifeways of their makers and users have been explored, in a number of historical archaelogical studies (including Caywood 1955; Deetz 1973; Jelks 1958; Kindig 1935; Schwartz 1969; South 1965, 1967, 1974; Watkins 1950).

Traditional processes affecting colonial ceramic production and consumption and internal and external mechanisms of change can be described for each class of ceramic produced in the eastern United States, including earthenwares, stonewares, and porcelains. These trends are outlined briefly below to provide a general framework for the more specific consideration of ceramic developments in the northeastern United States, which constitutes the remainder of this volume.

Earthenware

The earliest transplanted traditions in the eastern United States were those of redware. As early as 1625, colonial potters in the Southeast and Northeast regions were making coarse, utilitarian lead-glazed red earthenwares that technologically were equivalent to European counterparts (Barka 1973; Barka *et al.* 1984; Chappell 1975; Deetz 1973; Jelks 1958; Noël Hume 1970:98–101, 1982; South 1967, 1972; Watkins 1950). The colonial-made wares had the advantage of being cheaper and more readily available than European imports owing to the absence of import tariffs on the domestically produced wares and the more convenient location of nearby colonial potshops. (Noël Hume 1970:98–99). Pottery techniques, forms, and functions remained largely traditional and were European derived through the first generation or two of colonists, primarily in areas that were competing with European imports for colonial markets (see Pendery, Chapter 4, this volume).

This overview of dominant redware traditions in the eastern United States emphasizes German, English, and native or Colono influences, although other ethnic groups (Brain 1979; Janowitz *et al.*, this volume) and China (see Bower, this volume) made important contributions as well. These three general schools of redware production dominated seventeenth- and eighteenth-century manufacture in colonies in what are now the southeast and

northeast United States. However, the proportion of influence varied between these two regions, as is revealed through the visibility of ceramic traditions in the archaeological record.

In the Northeast region, which now comprises the New England and mid-Atlantic states, English colonial orientation was overwhelmingly dominant. German-derived redware traditions for the most part were established in the Northeast slightly later. Throughout the seventeenth and eighteenth centuries, they were centered largely in the eastern counties of Pennsylvania, particularly around Germantown and Philadelphia (Guilland 1971:26; Hamell 1975:1117). During the latter part of the eighteenth century, some of these Germanic traditions—most notably highly colorful sgraffito and pierced varieties—diffused west to central Pennsylvania and western New York state and south along the mountains to Maryland and North Carolina. These specialized Germanic traditions had comparatively little impact on central Pennsylvania redware and slipware traditions (Lasansky 1979:6-7, 28). However, regional styles developed shortly thereafter between the Philadelphia and the North Carolina branches, as the first became more elaborate and the second more specialized (Bivins 1972; Kindig 1975).

Native or Colono red earthenware traditions have not yet been established for the Northeast region, despite a number of excavated black and colonial Indian sites (Baker 1978, 1980b; Schuyler 1980; Turnbaugh 1984). Inexpensive, low-fired, unglazed redwares made by Native Americans or blacks and named Colono wares (Ferguson 1980; Noël Hume 1962; South 1962, 1974:181-188; Vescelius 1977) are largely absent in the colonial archaeological record north of Delaware in the Northeast. The ceramic sample of the Parting Ways site in Massachusetts contains some Colono ware examples that probably were imported from the West Indies (Deetz 1976, 1977). This material constitutes one of the few documented occurrences found in the Northeast. For the eastern United States, Colono ware seems to occur in ceramic samples in inverse proportion to English colonial redware. Both of these wares filled the need for cheap, readily available red earthenwares in their respective regions.

The Southeast region consists of two divisions: the coastal and the highlands subregions. The English-oriented Southern plantation system dominated the coastal subregion during colonial times, whereas German or Moravian settlers inhabited towns such as Bethabara and Old Salem, North Carolina, in the Southern highlands. Moravian and Colono redware traditions were dominant in the Southeast, whereas English colonial traditions were considerably less common than in the Northeast region (see K. Lewis 1984:130-36).

Initial colonization in the Southeast resulted in some conservative English-oriented production of English colonial redwares at Virginia sites, including

Jamestown (Hudson and Watkins 1957; Jelks 1958), Glebe Harbor (Chappell 1975), Yorktown (Barka 1973; Barka *et al.* 1984), Green Spring Plantation (Caywood 1955), and Martin's Hundred (Noël Hume 1982). However, the majority of seventeenth- and eighteenth-century coastal plantation culture settlers produced little redware, relying instead on cheap and plentiful English imports obtained through an extensive and active tobacco and cotton trade with the Continent (Guilland 1971:26). In the Southeast plantation system, which extended south from Delaware, Colono wares filled much of the need for economical utilitarian vessels throughout the seventeenth and eighteenth centuries (Ferguson 1980; Noël Hume 1962; South 1974:146, 181–188; Vescelius 1977). As explored in this archaeological literature, these Colono wares were made by poor ethnic groups, including both black slaves and Indians, and were used both by lower economic classes and, to a lesser extent, by planters when cheap, coarse redwares were desired. Colono wares can constitute up to 38% of ceramic samples in the Southeast plantation culture (South 1974:146, 181), yet they are virtually absent in the Northeast or in other areas, such as the Southeast highlands, that fall outside of the plantation system.

In the Southeast highlands, as in the Northeast region, European-derived colonial redwares occupied the niche filled by Colono wares in much of the Southern coastal subregion. The pioneering work of Stanley South (1965, 1967) delineates 15 distinct varieties of lead-glazed red earthenware made by the potter Gottfried Aust (1755–1771) at Bethabara, North Carolina, in the Southeast highlands. On the basis of glaze color, decorative attributes, and forms, these Bethabara wares resemble English-derived wares being fashioned by seventeenth- and eighteenth-century potters in the Northeast region (Turnbaugh 1976, 1977, 1983, Chapter 12, this volume; Watkins 1950), perhaps due to similar English influences or to similar limitations of available resources. In Bethabara, Germanic-derived sgraffito wares (Bivins 1972) and refined English-derived cream-colored earthenwares (South 1967, 1970) were made as well, and they helped to fill changing and diverse consumption demands. Finely made, molded cream-colored earthenwares, so similar to post-1760 English varieties as to be virtually indistinguishable (South 1970), attest to the continuing influence of European traditions into the late eighteenth century in this subregion of the Southeast.

To conclude, three major schools of redware production flourished in the Eastern colonies: English colonial, Germanic, and native or Colono traditions. English colonial ceramic traditions were transplanted throughout the colonies of the eastern United States during the seventeenth and eighteenth centuries. However, the extent and intensity of the development of these English-derived traditions varied between the Northeast and Southeast regions. These redware traditions changed over time through external modi-

fications, including dispersion, diffusion, borrowing, assimilation, and leveling, and through the internal mechanisms of imperfect learning, innovation, specialization, elaboration, and permutation (for the Northeast, see chapters by Dickinson, Gorman et al., Pendery [Chapter 6], Starbuck and Dupré, Warner, and Worrell [Chapter 9], this volume). Germanic and native Colono redware traditions also developed differently in the two regions. Colono ware, in particular, flourished as a full-blown set of traditions in the coastal Southeast, yet it was virtually nonexistent in the Northeast region.

Stoneware

Domestically produced stonewares were being fashioned by the mid-eighteenth century (Noël Hume 1970:100-101; Bower; Pendery, Chapter 4; Warner, this volume) and immediately began to compete with imported English and German varieties for local markets. These stonewares rapidly replaced lead-glazed redwares after about 1780, due to increasing demand for more durable vessels and the well-known toxicity of lead glazes on redwares (Guilland 1971:3; Watkins 1950). By 1800, two schools of domestic stoneware production were emerging in the eastern United States (Guilland 1971:55-56).

A northern branch of the eighteenth- to nineteenth-century domestic stoneware tradition centered around New Jersey and New York City, eventually spreading north into New England and west into upstate New York. This branch initially produced a gray stoneware that was decorated with cobalt blue elements and resembled Westerwald stoneware products. The northern branch underwent a number of transformations—specifically, elaborations and permutations—in pottery-producing communities such as Bennington, Vermont. In addition, after about 1810, interiors of vessels often were coated with Albany slip, clay stained with a dark brown ferruginous oxide (Noël Hume 1970:101). The northern branch was highly competitive and expanded into many markets. It largely replaced or superseded domestic utilitarian redwares in the Northeast region (see Warner, this volume) during the late eighteenth and early nineteenth centuries and contributed to the contemporary decline in domestic redware production.

A southern branch of this cobalt blue-decorated gray stoneware tradition was centered around Philadelphia and eastern Pennsylvania and developed at about the same time (see Bower, this volume). The southern branch shared common roots with its northern relative. Being more removed from large and ready markets, however, it developed and changed more slowly. The southern stoneware product usually was less highly decorated and was alkaline glazed (Burrison 1975; Stradling and Stradling 1977). It remained secondary

to redware traditions in this region (see, for example, Bower, this volume; Guilland 1971:54-56). The manufacture of this stoneware eventually spread from its Philadelphia center south into the Southern highlands of the Southeast region and west into Tennessee, Kentucky, Ohio, and the Ohio River valley, where it flourished quietly well into the mid-nineteenth century (Guilland 1971:55-56).

Porcelain

The first American attempt to make porcelain that was at all successful was undertaken by Bonnin and Morris of Philadelphia in the third quarter of the eighteenth century (Bower, this volume; Noël Hume 1970:100). The venture was short-lived, however, and few examples of these wares survive. The few pieces that still exist are decorated with underglaze blue floral elements that are reminiscent of English models (Hood 1972; Noël Hume 1970:100). The significance of this early attempt to make porcelain lies in the fact that it is an example of a developing American industry, one in which a truly American identity eventually would emerge in the nineteenth century (Guilland 1971), but one in which Continental and Oriental influences and elements would persist.

More permanent, successful porcelain-making ventures did not occur for almost half a century in the new nation. These developments happened only after the successful establishment of a factory system in the United States, which first occurred in the mid-1800s (Guilland 1971:66), about a century later than in England. Also important to this occurrence were a semiskilled labor force, economic fluctuations, a wage differential between the United States and England, and the presence or absence of import tariffs and embargoes (Hamell, personal communication, 1984; Myers 1980).

DISCUSSION

In the Northeast many domestic potters tried to compensate for cultural change and new consumption demands by adopting nontraditional production strategies. These trends are explored more fully in Part II of this volume, which considers transformations of the ceramic traditions initially transplanted to these shores (as treated in Part I). As Part III of this book reveals, only a small percentage of eighteenth-century potters succeeded in completing the transition from small family enterprises to industrialization by the mid-nineteenth century.

Several critical factors needed to be present to achieve this transition. Of

major importance was the relationship between market accessibility and distance between the place of manufacture and market outlets (Pred 1970:273). As in other crafts or industries, potters needed to have a strong local and regional production base with relatively easy access to local ports of trade to foster economic success. Several Northeastern communities offered this type of support base for the local developing pottery industry (see, for examples, Bower, Janowitz et al., Pendery, [Chapter 4], Teller, Turnbaugh [Chapter 12], this volume). These communities were well situatated geographically and had the potential to become major nineteenth-century pottery-making centers. Yet, for various reasons explored in Part III, only in Philadelphia and Boston did the necessary social and economic elements combine with the prime geographic location to result in a major cosmopolitan entrepreneurial ceramic industry that developed from a family-based craft and persisted into Industrial Revolution times (Bower; Teller, this volume).

Many other smaller communities were unable to support successful development of and participation in strong regional or international trade systems. Yet some tried with moderate success (Dickinson, Hunter, Turnbaugh [Chapter 12], Warner, this volume). However, many of these less cosmopolitan centers continued to enjoy a strong local clientele, often attracting regular customers from all economic brackets in surrounding towns well into the nineteenth century (Starbuck and Dupré, Teller, Worrell [Chapter 9], this volume).

Parts I through III of the volume follow. Each part is prefaced by a summary overview. These parts include specific considerations of changing pottery production and consumption in the Northeast from the theoretical perspective of tradition and its external and internal mechanisms of change. The following 14 chapters of this book treat the current status of archaeological, anthropological, and historical ceramic studies in the Northeast region of the United States from this perspective as they discuss ceramics on five levels of analysis (discussed above and in Table 1.1).

Transplantation: Traditional Early Regional Production

Part I considers the nature of the initial diffusion and transplantation of ceramic traditions from the Old World to colonies in the Northeastern region of the United States. The early New World enterprise is viewed as traditional and highly conservative, largely drawn from European prototypes. This transplantation of pottery traditions constitutes the first stage in a dynamic process of changing modes of production and consumption patterns in the Northeast that eventually transformed ceramic traditions from self-conscious, conservative family-based orientations to distinctive entrepreneurial, Americanized industries. As is explored more fully in the following chapters, these changes in ceramic production correspond closely to more general cultural changes taking place along the Eastern seaboard during these centuries.

Four chapters are included in Part I of this volume. Each of these chapters explores the traditional nature of initial transplantation in a different way. Janowitz, Morgan, and Rothschild consider forms and functions of seventeenth- and eighteenth-century domestic and Dutch redwares excavated in New York City. They then compare their Dutch typological system to that for English

wares (Beaudry *et al.* 1983) and conclude that Dutch influence remained strong, even after the English political conquests of 1664 and 1674. Chace uses Plymouth Colony probate inventories to reconstruct probable redware usage, based on room location, in seventeenth-century Massachusetts households. Trends suggest that in Plymouth Colony the early settlers were following traditional English-derived lifeways. Pendery considers mid-eighteenth-century potters of Charlestown, Massachusetts. Their propensity for manufacturing table wares that imitated English varieties in decorative and formal attributes is interpreted as a way that domestic products competed with comparable English wares for colonial markets. Worrell discusses replicative experiments at Old Sturbridge Village in which a nineteenth-century potter's space usage, kiln-stacking arrangements, and glazes and decorative methods have been reconstructed. The ability of experimental archaeology to illuminate both traditional and innovative particulars of the potter's craft is treated, and the English-derived aspects of the process are discussed from this perspective.

2
Chapter

Cultural Pluralism and Pots in New Amsterdam-New York City

Meta F. Janowitz,
Kate T. Morgan, and Nan A. Rothschild

THE PROBLEMS

Among the interesting questions that archaeologists ask of ceramic assemblages are the following: What kinds of vessels were used by people living here at some point in the past, and where were the vessels used here manufactured? While these questions overlap, and each is important, they represent different aspects of archaeological analysis. In order to answer the first, a typology is needed; typologies are used to date assemblages and analyze function or activity differences between them. Information on the place of manufacture of these wares is often hard to obtain, yet it is relevant in considering the relations between a colony and its parent country: The point at which the colony began its own production of various essential items, how this early industry tied in with trade patterns and historic events, and the degree to which production was imitative of European industries.

At this point these two questions cannot be answered fully for the coarse redwares used in the Dutch colony of New Amsterdam and New York City in the seventeenth and early eighteenth centuries, but progress is being made toward answering them. In this chapter, the complexity of these questions is discussed and a series of steps toward reaching their solution is suggested. A typology based on forms seen in seventeenth-century Dutch genre paint-

ings is proposed and evaluated with reference to an English-based ceramic typology and archaeologically recovered ceramics from lower Manhattan. The latter come from three sites excavated between 1979 and 1981 (Figure 2.1): the Stadt Huys block (Rockman and Rothschild 1980) and the 7 Hanover Square block (Pickman *et al.* 1981), both of which are large complex sites excavated prior to construction of new office buildings; and the 64 Pearl Street site (Pickman and Rothschild 1981), a small excavation across from the Stadt Huys block. The Stadt Huys block is on original land in the heart of New Amsterdam, while the other two sites are located on landfill dating from the late seventeenth century. At the time this article was written, these were the only sites excavated in New York City with substantial Dutch material.

Unlike contemporary settlements in New England and Virginia, New York was first colonized by the Dutch, and their influence remained strong throughout the seventeenth century despite political changes. Manhattan Island was settled in 1625 by the Dutch West India Company as a trading post. The town grew steadily and was governed by the Dutch until 1664 when the

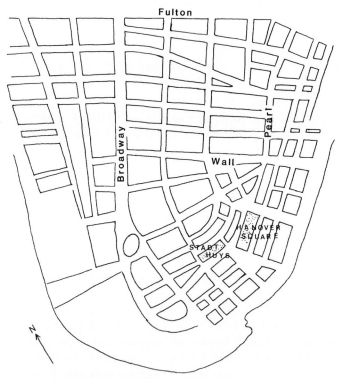

Figure 2.1 Locations of sites in lower Manhattan.

English conquered New Netherland. From 1673 to 1674, the Dutch briefly resumed control, but from 1674 to the Revolution the English ruled New York. During this time, the English passed various restrictive trade laws which were designed to keep non-English goods out of their colonies. However, enforcement of these laws was very incomplete until the 1680s; England did not have the power to implement them, and the colonists and colonial administrators did not hesitate to engage in semilegal or illegal trade, especially with the Netherlands (Ritchie 1976). Dutch goods could therefore have continued to come to New York City even after 1664. The coarse redwares under study must be considered in this historical framework.

EARTHENWARE SOURCES

Coarse red and buff-white earthenwares are known to have been made in both England and the Netherlands in the seventeenth century (Baart *et al.* 1977; Noël Hume 1970 and 1982; Rackham and Read 1924). It is also known that these wares were imported to the American colonies from the initial period of their settlement to the eighteenth century. Noël Hume cites examples of such wares being imported to the Southern colonies and New England "in vast quantities" (1970:133), but it is not clear what part of this import trade came to New York, nor what the ratio was of locally made to imported wares. Ceramics as a class are bulky, heavy, and subject to breakage. These characteristics do not contribute to an easily transported commodity. Ceramics by themselves might not have been profitable enough to stimulate trade but might have been a suitable adjunct to trade in other goods.

It still remains unclear when local production of earthenwares began in New York City and to what degree the existence of a local product would reduce the need for imports. The study of domestic redwares of this period is complicated by several factors. No kiln sites have been excavated, and local clay sources are either unknown or have disappeared beneath the city. The first potter known to have made and sold earthenwares on Manhattan Island was Dirck Claesen from Leuwerden, Holland, who arrived in New Amsterdam sometime before 1655 (Ketchum 1970:20). What is known of this potter is found in the documentation of a series of legal troubles in which he was sued for assault and battery, spouse desertion, and cutting off the nose of a neighbor. However, in 1657 Claesen became a freeman of the city and purchased land on which he lived and worked until 1686 (Clement 1947:7). Other potters are recorded on the freemen's list for 1697–1698: John de Wilde, John Euwatse, and Dirck Benson (Spargo 1974:54). Euwatse probably worked on Wall Street, where he owned property (Ketchum 1970:23), while Dirck Benson's son, Sampson, also a potter, lived and may have worked

on William Street (Clement 1947:9). It is probable that earthenware potters of seventeenth- and early eighteenth-century Manhattan were utilizing iron-bearing clay from the lands around the Collect Pond, under the present site of City Hall, where Pottbakers Hill was located on eighteenth-century maps (Ketchum 1970:32).

CLASSIFICATION OF EARTHENWARES

In order to define what kinds of vessels were used in seventeenth-century New York City, a classification system is necessary. The classification of any type of object implies first the ability to describe the variety of objects involved. There is not, as yet, a typology which encompasses the range of functional types used in New Amsterdam-New York City similar to those described for the Chesapeake area (Beaudry et al. 1983) or the Massachusetts Bay Colony (Turnbaugh 1983). While certain kinds of vessels are expected to be present, based upon documentary evidence and knowledge of ceramics from Europe and adjacent areas in the New World, early New York's diverse ethnic composition with its significant Dutch population makes the picture a complex one and suggests that typologies derived from areas dominated by British culture may not be suitable for use in New York. A further problem lies in the fragmentary and nonreconstructable nature of most of the ceramics recovered to date from the sites of this early period, which prohibits the formulation of a typology directly from excavated materials.

Methodology

In order to create a typology of coarse earthenwares which would be suitable for early New York City, an intensive survey of seventeenth-century Dutch paintings was made (Table 2.1) to see what forms of red and buff-white earthenwares were depicted and to identify their functions. Paintings were chosen because no comprehensive typology of Dutch seventeenth-century ceramics was available. These paintings were appropriate for two reasons: while seventeenth-century New Amsterdam-New York was an ethnically heterogeneous population, a major proportion of its inhabitants were from the Netherlands (Cohen 1981; Rink 1981), and there was at least one active potter of Dutch derivation in lower Manhattan during this time. It is clear that not all schools of painting would be useful as sources for accurate portrayal of everyday life, but Dutch genre paintings of this period are particularly suited to the study of material culture because they are realistic "paintings of the incidents of everyday life . . . with carefully painted details"

(Bugler 1979:38). People pursuing their daily occupations in interiors of houses and taverns and in courtyards or streets are often represented. Coarse earthenwares are generally portrayed in the context of food preparation, storage, and consumption. Two hundred paintings of interior and courtyard scenes were studied of which 69 contained examples of coarse earthenwares. Table 2.1 lists these paintings (see also Figure 2.4).

From the examination of these paintings a typology is proposed. This typology includes 11 vessel forms, each of which has a unique function or set of functions. Some of these vessel forms differ from others with respect to only a few morphological attributes, but the combination of these attributes and functional characteristics is used to establish each type. Each vessel is seen in at least one painting and most in several.

Each type defined from paintings is compared with fourteenth- to sixteenth-century archaeologically recovered materials excavated from Amsterdam to better establish certain details and observe the range of variability encompassed within a type (Baart et al. 1977). The whole typology is compared with these archaeological materials from Amsterdam in order to evaluate the reliability of paintings in documenting the whole range of forms used in seventeenth-century Holland and to see whether any vessel types are systematically ignored in the artists' versions of ceramic material culture. The verified typology is then compared with an English-influenced typology from North America (Beaudry et al. 1983), and differences between them are noted. The two typologies then are used as standards of reference for comparison with archaeologically recovered material from New Amsterdam-New York in order to determine the extent of Dutch and English influences on the ceramics used in this particular settlement.

Typology

The first two types form a class characterized by an ovoid to bulbous shape, three small, solid feet, and ear handles.

Pipkins or grapen (the term *grapen* as used by Baart et al. 1977, has no precise English equivalent) are small- to medium-sized vessels (approximately 12–15 cm diameter by 10–12 cm tall) of red or, infrequently, buff-white earthenware. The glaze appears red-orange on both surfaces. Rims have small pouring lips and flare into an ogee shape (Figure 2.2b, referred to as the "seventeenth-century rim" because of its frequent appearance on vessels in seventeenth- to early eighteenth-century contexts (Paul Huey 1979, personal communication). Handles are one- or two-eared forms set at the rim (Figures 2.3c and 2.3d). *Grapen* are shown on tables holding a medicinal mixture or broth, as in Metsu's "The Sick Child," or soup or stew in individual portions,

Table 2.1

Seventeenth-Century Dutch Genre Paintings and Their Sources

Artist	Painting (source[a])
Almeloven	Smoker (2)
Anonymous	Christ at Emmaeus (5)
ter Borch	Curiosity (5)
	Grindis Family (8)
Brouwer	The Lacemakers (5)
	The Musicians (3)
	Peasants Fighting at Cards (3)
	Scene at an Inn (8)
	The Smokers (5)
	Soldiers Playing Dice in a Tavern (8)
	Village Surgery (8)
de Brunes	Emblemata of Zinnewerck (10)
van Cleve	The Flayed Ox (9)
The Delft School	untitled (10)
Duck	Woman Ironing (10)
van Everdingen	Allegory of Winter (8)
Fabritus	The Satyr and the Peasant (8)
The Hague School	Banquet at the Hague (10)
Hals	Family Scene (7)
	Merrymaking at Shrovetide (5)
van Heemskerck	Peasant Meal (1)
de Hooch	The Bedroom (8)
	The Merry Drinker (3)
	The Pantry (7)
	A Woman and her Maid in a Courtyard (3)
	Woman Nursing an Infant with a Child (8)
Jordaens	The Satyr and the Farmers (8)
Leyster	The Merry Drinker (1)
Maes	The Blessing (3)
Metsu	The Artist and his Wife (3)
	The Sick Child (3)
van Ostade	Group of Smokers (2)
	Meal of Gruel (1)
	Peasants Merrymaking (8)
Pieters	Family Portrait (10)
van Schooten	Still Life (2)

[a]1, Braudel 1979; 2, Brongers 1964; 3, Bugler 1979; 4, Goldscheider 1958; 5, Metropolitan Museum of Art, N.Y.C.; 6, Petit Palais Musee, Paris; 7, Rijksmuseum, Amsterdam; 8, School of Visual Arts, N.Y.C., slide collection; 9, City University of New York, slide collection; 10, Thornton 1978.

Table 2.1 (*continued*)

Artist	Painting (source[a])
Sorch	Smokers and Drinkers at an Inn (2)
Steen	The Adoration of the Shepherds (7)
	The Captured Ducks (5)
	The Dancing Couple (8)
	The Dancing Lesson (7)
	The Feast of Saint Nicholas (7)
	Interior of a Tavern (5)
	Merry Company on a Terrace (5)
	The Merry Family (7)
	Parlour Scene (10)
	Le Petit Idiot Queleur (6)
	The Sick Lady (7)
	Still Life (8)
	Twelfth Night Feast (8)
	The Woman at her Toilet (7)
Teniers (the Younger)	Flayed Ox (9)
	Fumeurs et Partie de Cartes (6)
	Interior with an Old Woman Peeling Apples (9)
	Kitchen Interior (7)
	Woman Smoking a Pipe (2)
van de Velde	Still Life (1)
Vermeer	Couple with Wine Glass (4)
	Girl Drinking with a Gentleman (4)
	Girl Asleep at a Table (4)
	Girl Interrupted at her Music (4)
	The Letter (4)
	Maid Servant Pouring Milk (3)
	The Music Lesson (4)
	Soldier and Young Woman at the Procuress (4)
	Woman with Water Jug (4)
Voursse	Nursing Twins (10)
de Witte	Fishmarket of Amsterdam (8)
	Woman at a Desk (10)

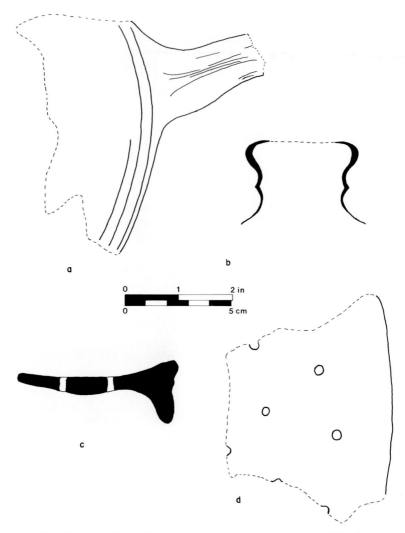

Figure 2.2 Dutch and Dutch-derived earthenware vessel attributes: a, "skillet" handle with "celery" shape; b, profile of "seventeenth-century" rim; c, colander with perforations, lobed feet, in profile; d, colander from above. (All from 7 Hanover Square.)

as in Maes's "The Blessing." They are also pictured as containers for hot coals, which then were set inside small wooden boxes placed on the floor and used as foot warmers or small area heaters, as in Ter Borch's "Woman Nursing an Infant with a Child," among others. Two unusual *grapen* with cylindrical rims are depicted in "Christ at Emmaus" (anonymous). Their function is unclear but they are located on a table.

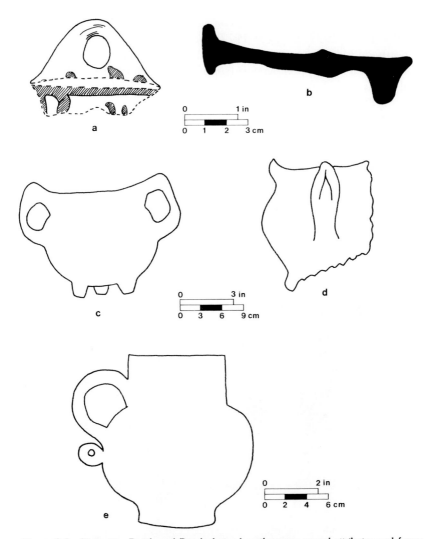

Figure 2.3 Distinctive Dutch and Dutch-derived earthenware vessel attributes and forms (a–d from 7 Hanover Square): a, horizontal handle at rim of small dish, trailed slip decoration; b, lobed footed dish seen in cross section; c, Redware pipkin or *grapen* with two ear handles; d, Ear handle of pipkin or *grapen* seen from the side; e, small jug recovered from a well on the Stadt Huys Block (second quarter, eighteenth century).

In excavations at fourteenth-, fifteenth-, and sixteenth-century sites in Amsterdam, *grapen* were the most common vessels recovered (Baart *et al.* 1977:241). Most were one-eared and undecorated but some had two ear handles and were classified as cooking pots (Baart *et al.* 1977:250). This

distinctive ear-handle form seems to be a characteristic of Netherlandish pot-
tery (Baart *et al.* 1977; de Kleyn 1977) and appears on more than one form.

Voorraadpotten (storage jars) are large tripodal vessels with two ears, sim-
ilar in proportion to *grapen,* with wide mouths and, sometimes, a short nozzle
spout. Teniers the Younger portrays such a pot twice (probably it is the same
pot used as a prop in two separate pictures, as was pointed out by Diana
Rockman (personal communication, 1983).). The vessel is on the floor of
the room in "Kitchen Interior" and also on the floor in another interior which
shows a hanging flayed ox carcass. The contents of neither vessel can be
seen, but in Vermeer's "Maid Servant Pouring Milk" (Figure 2.4), the vessel
into which the milk is poured appears to be a *voorraadpotten.* The foot of
this vessel is hidden, but another Teniers pot with a flat, indented tooled base
(for an example of this base see Figure 2.5a), two ears, and a nozzle is shown
on a low table in "Interior with Old Woman Peeling Apples."

Baart illustrates *voorraadpotten* both with and without nozzles (1977:246–
247) and classifies them as a type of two-eared *grapen* (1977:250).

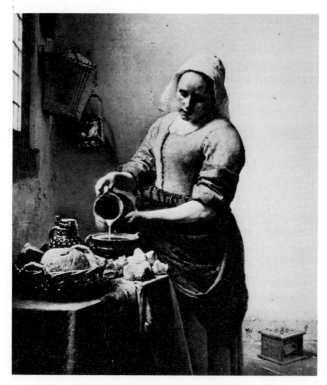

Figure 2.4 Vermeer's "Maid Servant Pouring Milk."

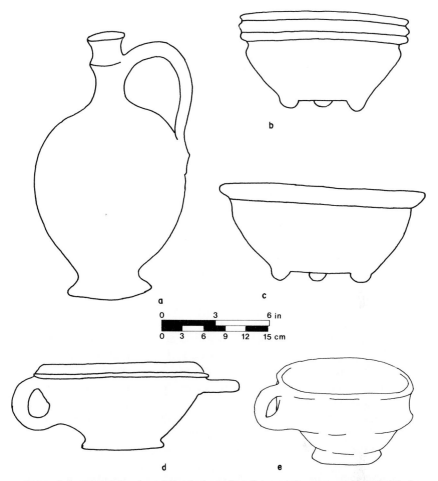

Figure 2.5 Typical Dutch and Dutch-derived earthenware forms: a, redware bottle from Lovelace Tavern (note tooled indented base); b, *bakje* with lobed feet, multiple ridges on rim; c, *bakje* with lobed feet; d, *bakje* with solid base and one vertical and one horizontal ring handle; e, cup with solid base and one ear handle.

Tobacco braziers are a specialized form of tripodal vessel. This form has a pronounced ridge at the shoulder, a diamond-shaped mouth, and one ear handle. It was used to hold smoldering peat for lighting pipes. Pipes were lit either by putting the bowls directly into the peat or by using a paper spill or sulphur match to transfer the flame to the pipe (Brongers 1964:112). Such vessels are common in the seventeenth-century paintings: "Smokers and Drinkers at an Inn" by Sorch, "Merry Company on a Terrace" by Steen, and "The Merry Drinker" by Leyster contain examples.

Similar vessels illustrated by Baart are called a "chafing dish" (1977:257) and a "fire pan" (1977:263). The handles of the first are horizontally oriented, while the second has a single rod handle.

Dishes of redware are large (approximately 30 cm diameter), shallow round vessels with two horizontally-oriented handles at the rim, although they are occasionally shown without handles. They sometimes have a small pouring lip. In van Ostade's "Meal of Gruel," a dish contains a peasant family's dinner; in both van Cleve's "The Flayed Ox" and Teniers's painting with an ox carcass, a dish is placed on the floor under the carcass, presumably to catch dripping blood; and in "Kitchen Interior," also by Teniers, a dish is on a low table holding a whole fish. A variant of this form with a squared rim and straight sides is seen in van Heemskerck's "Peasant Meal" holding another meal for a family of five. None of the bases is visible.

Baart excavated large dishes with lobed feet (Figure 2.3b). None illustrated have handles, but many have trailed slip decoration (Baart *et al.* 1977:250-252).

Plates (small dishes for individual eating) are not often shown in coarse earthenwares in seventeenth-century paintings. Plates are not uncommon, but they are most frequently made of metal and less often of tin-glazed earthenware. Individual coarse earthenware eating vessels are *grapen* and bowl types (hollowwares) rather than plates (flatwares). Only two redware plates were found in the paintings: "Smokers and Drinkers at an Inn" by Sorch shows an empty plate on the ground next to a large vessel which is probably an Iberian oil jar; in "Christ at Emmaus," a small empty plate is on a table beside two large dishes.

No redware plates are illustrated or discussed by Baart. Plates were excavated, but they were of tin-glazed earthenware.

Bowls seem to serve a variety of table and food preparation functions and fall into two general shape categories: (1) hemispherical vessels, probably with lobed feet, with rims either plain or with multiple ridges (Figure 2.5b and 2.5c); and (2) vessels with bodies sloping out from a small, solid base, handleless or with one or two ring handles (Figure 2.5d). The first form is illustrated in Brouwer's "Peasants Fighting at Cards" and de Hooch's "Woman and her Maid in a Courtyard." In both, the empty bowls are on the ground. "Merrymaking at Shrovetide" by Hals shows a large bowl occupying a central position on a table and holding a mound of pickled herrings. The second form is seen on the floor near the hearth in the etching "Emblemata of Zinnewerck." Its contents are indistinct.

Baart illustrates both of these forms under the name *bakje*, which can be translated as "cup" (Baart *et al.* 1977:248 and 261). Other bowl forms found by Baart are the *bakken* (or "bowl") and the *beslagkom* (or "batter bowl")—both large hemispherical vessels with a pouring lip, two handles, and some-

times with lobed feet (Baart *et al.* 1977:247, 254). Neither vessel was seen in the paintings studied.

Cups are single-eared, solid-based containers with a ridge below the handle and a wide mouth (Figure 2.5e). Their specific function is unclear, but they are sometimes shown with long-handled stirrers or spoons. "Group of Smokers" by van Ostade shows a cup with a spoon or stirrer on a bench.

Cups, as here defined, are also called *bakje* by Baart (1977:262). *Bajke* seems to be used by Baart as a broad term encompassing a variety of forms. Besides the cup form and the two bowl forms listed above, a tripodal, cylindrical vessel with a mouth wider than its body is also listed as a *bakje*. What these vessels have in common is not their general form or dimensions but their functions: all are listed as vessels for eating and drinking, while the *bakken* and the *beslagkom* are listed as food preparation vessels (Baart *et al.* 1977:253).

Pitchers are ovoid serving vessels with one large handle, a pouring lip, and a flat, indented tooled base. The pitchers depicted were generally red-bodied, but in addition to the usual brownish lead glaze, they were also seen with a green glaze. It is possible that this green glaze is on a buff-white body, but this cannot be determined from the paintings. Pitchers are depicted in Vermeer's "Maid Servant Pouring Milk" (see Figure 2.4), Steen's "The Captured Ducks," and Brouwer's "Peasants Fighting at Cards."

Baart (1977:234) illustrates vessels with this body shape on thick, finger-pinched bases. They are from fourteenth-century contexts and are red-bodied with brownish lead glaze.

Jugs have bulbous bodies, cylindrical necks, one handle, and bases similar to pitchers. Jugs are used both as serving and drinking vessels and are depicted most frequently in metal, less often in stonewares, and still less in earthenwares. Large redware jugs are seen on the floor in van Heemskerck's "Peasant Meal" and Brouwer's "The Smokers," and on a small side table in Teniers's "Woman Smoking a Pipe." Several small redware jugs are shown in Brouwer's "Peasants Fighting at Cards": this tavern interior has jugs on the mantlepiece, hanging on the wall, and in the process of being used to bash one of the combatants on the head.

Many jugs, in both earthenware and stoneware, were excavated by Baart. Their forms vary and they are listed as both eating-drinking and transporting vessels (Baart *et al.* 1977:261).

Chamber pots are found, obviously, in bed chambers. One is seen on the floor in de Hooch's "The Bedroom." Another sits on the floor in what appears to be a tavern in "Woman Smoking a Pipe" by Teniers. Chamber pots in earthenware are not very common; the more usual ones depicted are made of metal.

Baart illustrates two earthenware chamber pots. The one from a late

sixteenth-century context is almost identical to those seen in the paintings (Baart *et al.* 1977:261).

Colanders are depicted in only one painting, Steen's "The Captured Ducks." This concave redware dish has two horizontal handles at the rim and tripodal feet and is shown holding eggs. Colanders are not illustrated or discussed by Baart.

Comparing the typology derived from the paintings as a whole to Baart (1977), it is evident that the paintings do not provide all of the information possible about the range of ceramics. However, enough congruence exists to allow the paintings to be considered as a reliable source of information.

In addition, paintings often do not show entire vessels, but the functions can be discerned. Most of the types excavated by Baart (1977) are seen in the paintings, with the notable exception of the *bakpan*. This type of vessel, which was called a "skillet" in the initial analysis of the New York City ceramics, was the second most common form recovered in the Amsterdam excavations. It is a small- to medium-sized fairly flat vessel with a flattened rod handle. This handle, which is folded in upon itself from the sides toward the center so that it resembles a large piece of celery (Figure 2.2a), is a Dutch form (Jan Baart 1982, personal communication). Since no seventeenth-century paintings with this vessel have been studied as yet, it is not possible to determine its functions, but by virtue of its name, *bakpan,* it can be inferred that it was used in food preparation.

A COMPARATIVE TYPOLOGY

The next stage in creating a typology for seventeenth-century ceramics from New York City is to compare the forms seen in the Dutch paintings to the Potomac Typological System, called POTS (Beaudry *et al.* 1983), in order to observe similarities and differences between them. POTS is a comprehensive typology of English-tradition colonial wares in the Chesapeake region, and the comparison will offer insight into English–Dutch similarities and differences. These forms will also be compared with seventeenth- and early eighteenth-century ceramics recovered from excavations in lower Manhattan to determine the relative importance of Dutch and English influence.

It must be emphasized that the scarcity of reconstructable vessels from the sites is probably due more to the nature of many of the deposits—fill—rather than to the absence of these forms from New Amsterdam–New York. This taphonomic problem can only be overcome by excavation of more sites, preferably on original land surfaces.

Pipkins are defined by Beaudry *et al.* (1983:34) as "small bulbous cooking pots, frequently with a rod handle . . . or a cooking vessel with two ears and

three legs. While the form is a metal one, it was occasionally copied in coarse earthenwares." These English-tradition vessels differ from the Dutch pipkins or *grapen* in the following ways: their handles are more often rod-shaped than eared; the neck is less indented; and the body tends to be more elongated or ovoid. (See Greer 1981:60 for terms used to describe the body shapes of vessels.) It also appears that in the Chesapeake region earthenware pipkins were relatively infrequent, in contrast to their frequency (in paintings and archaeological contexts) in Dutch settings.

A large number of *grapen*-type pipkins, in both red and buff-white bodies, were found at the New York City sites. The frequency of *grapen* sherds does not represent "occasional copies," but points to *grapen* as an important component of the household ceramic assemblage in seventeenth- and early eighteenth-century Manhattan. Even after the English takeover in 1664, this Dutch form still seems to be ubiquitous. This could have been due to the Dutch-derived traditions of the local potters or to continued trade with the Netherlands. In any case, the continuing presence of this form implies its continuing use.

Storage vessels are represented in POTS as "Pot/Butter Pot—a large, cylindrical or slightly convex-sided vessel, taller than wide" and "Jar—a large vessel, taller than wide, with pronounced shoulders and constricted neck, bearing a heavy, rounded lip" (Beaudry et al. 1983:36). Neither of these correspond to the Dutch *voorraadpotten*. One large yellow-glazed, buff-bodied vessel of *voorraadpotten* type was recovered from an early eighteenth-century context at 7 Hanover Square. This vessel has the Dutch type ear handle and is large (approximately 30 cm diameter by at least 20 cm tall). The base is missing, so the type of foot is not known.

Tobacco braziers are not mentioned in POTS. No reconstructable vessels of this type were found on the Manhattan sites, but there are several rim sherds which are suggestive of the diamond-shaped mouth.

Dishes are defined by POTS as "serving vessels larger than 10" either in diameter or in length, with or without a footring . . . in shallow and deep forms" (Beaudry et al. 1983:33). POTS and the Dutch painting typology agree on a general level, but the variant dish form seen in van Heemskerck's "Peasant Meal" is very similar to POTS's *milkpans*. Milkpans are defined as vessels "in the shape of an inverted, truncated cone . . . used for cooling milk, as a wash basin and probably for cooking" (Beaudry et al. 1983:35). Such vessels are not depicted in dairying contexts in the Dutch genre paintings, however. The only vessels associated with dairying activities are large, bulbous-bodied metal jugs shown being used to transport milk and, in Suidjerhoff's "Adoration of the Shepherds," a large *bakje* or *bakken* is shown containing milk which is being heated over a small fire.

The dishes, none completely reconstructable, which have been found in

the New York City sites are rounded with horizontal handles (Figure 2.3a), or, more frequently, are fairly flat with a beveled rim (Figure 2.3b). Several such vessels with lobed feet have been identified as products of the town of Bergen op Zoom in the Netherlands (Jan Baart 1982, personal communication). These wares have a very distinctive red-orange sandy body and *grapen*, bowls, and dishes made of this paste have been found at the 7 Hanover Square site.

Plates are listed in POTS as "eating vessels from 7" to 10" in diameter, with or without a footring" (Beaudry *et al.* 1983:33). This definition corresponds to that derived from the paintings. No redware sherds identifiable as plate fragments have been recovered from the three sites discussed in this analysis.

Porringers, as defined by Beaudry *et al.* (1983:32), are "shallower in relation to [its] diameter than a cup or a pot . . . with at least one or sometimes two handles, either horizontal or vertical. Used for eating porridge, pottage (stew), soup, etc." This vessel is thus roughly equivalent to the Dutch *bakje* mentioned in the second bowl variety and the cup. All of the *bakjes* shown in the paintings are empty or indistinct, so it is not possible to determine their contents, but their locations point to use in food preparation and consumption. No reconstructable vessels were recovered.

Pitchers, jugs, and chamber pots as described by POTS are essentially identical to the forms seen in the Dutch paintings. Beaudry *et al.* 1983:30), however, say that jugs are "generally in refined earthenwares and stonewares" and "range from small drinking vessels to large serving vessels." The paintings show quart size, or even larger, coarse earthenware jugs being used as drinking vessels. With the exception of a small jug from an early eighteenth century well at the Stadt Huys block site (Figure 2.3e), no reconstructable vessels were found.

Colanders are listed as perforated vessels used in dairying and for washing food stuffs (Beaudry *et al.* 1983:35). Excavated materials from the Manhattan sites include a variety of colander sherds which have been identified by their round, regularly placed holes through which glaze has run (Figure 2.2c and 2.2d). Among the artifacts are sherds which, on the basis of their paste, are products of Bergen op Zoom. Therefore, even though colanders were represented only rarely in the paintings, it can be seen that the colander was also a Dutch form. The uses of these vessels have not yet been determined, but the fact that there are differently shaped vessels with colander holes might indicate multiple functions or groups of functions.

Bottles are defined by POTS as "bulbous-bodied storage and serving vessels with a neck narrower than a jug or ewer, with or without a handle" (Beaudry *et al.* 1983:31). No Dutch coarse earthenware bottles were illustrated, but tin glazed earthenware bottles were not uncommon. Five almost

identical redware bottles were found during the excavation of the Lovelace Tavern on the Stadt Huys block. The tavern, built by New York's second English governor, Francis Lovelace, was in use between 1670 and 1706 (Rockman and Rothschild 1984). The bodies are grayed in part by overfiring. The temper is not particularly fine, and there are small pebble inclusions. Each excavated bottle is glazed in a different color: green, green-ginger, clear, and both a light and a dark brown. The shapes are bulbous (Figure 2.5a), and their capacities range from 3⅔ to 4½ cups (29 to 36 oz). The handles are attached directly to the necks, no join marks are visible, and the handles end in tapers fastened to the bodies by small but deep finger or tool push marks. It is probable that these bottles were used for serving wines or other spirits which were stored in barrels or casks (Hughes 1958:136).

The most likely source for these vessels is local manufacture. One of them has kiln damage which prevents it from standing solidly, and the glazes do not appear to be Dutch (Jan Baart, 1982, personal communication). Yet, the neck form is distinctive and similar to some Dutch delftware bottles. Their uniformity of form combined with their variety of glazes suggests a local potter working in a Dutch tradition. This glaze variety also suggests that, at least in some cases, glaze color was not associated with vessel function or form.

In summary, the comparison of the Dutch painting typology and the English tradition POTS typology (Beaudry et al. 1983) showed many areas of overlap between the two. Several forms were unique to each, however: grapen, skillets, and tobacco braziers to the Dutch, and milkpans (as a functional type) to the English. Analysis of the New York City earthenware assemblages revealed that where differences occurred between the two typologies and where vessels could be reconstructed from the excavated materials, the New York artifacts were more like the Dutch forms. The single type seen in the New York vessels and not found in the Dutch typology, bottles, does not necessarily point to English influence as these bottles might well be local potters' copies of Dutch delftware forms.

This suggests that imitation and innovation were combined in making local wares. It is probable that ceramic form and decoration originally served as a signal of group membership (Wobst 1977), but new attributes evolved in response to environmental and technological conditions and new social influences.

PETROGRAPHIC ANALYSIS

The major portion of this chapter has been concerned with determining what types of coarse earthenwares were used in New Amsterdam-New York in the seventeenth- and early eighteenth-centuries. The second question

mentioned above, that of the place of manufacture of these vessels, is more difficult to ascertain for the following reasons: while there may be kiln sites buried beneath New York City, none has been excavated. Therefore, there are no uncontestable local wares available for examination. Further, the ethnic diversity and continued European trading connections of early New Yorkers make many sources possible. The problem is even more complex and confusing because it is probable that European forms were closely copied by early potters in the colonies (Noël Hume 1982:241). It is more promising, therefore, to investigate characteristics other than vessel form in order to identify place of manufacture. Petrographic analysis may be valuable in distinguishing place of manufacture (Bishop *et al.* 1982; Matson 1981; Rice 1982; Shepard 1968) on the assumption that clay sources will be significantly different in, for example, Amsterdam and New Amsterdam. Two types of petrographic analysis are under way at present. Allan Gilbert, of Fordham University, is doing a paste analysis of a series of thin sections under a polarizing microscope, looking primarily at mineral inclusions in the paste (Allan Gilbert 1983, personal communication). This analysis will be supplemented by trace element analysis. Rob van Wageningen of the Amsterdam Historical Museum has compared four sherds excavated in New York (from the tavern bottles described above) with three typical samples of known Dutch provenience: one group made on the Dutch coast at Haarlem (39 sherds); one made in the south at Bergen op Zoom (20 sherds); and one made of river clays at Utrecht (56 sherds). The results of this analysis seem to distinguish the New York City-made ceramics from the Dutch-made ceramics on the basis of grain size distribution: the difference between the sherds which were most probably made in New York and those made in the Netherlands lies in the wider range of the distribution of grain sizes of the New York group, representing the wide variation in grain sizes of the sediments (Rob van Wageningen 1983, personal communication). The reason for this wide variation may be that the sediments in the New York clay are less well sorted than those in the Dutch clays. These observations are based on a small sample and thus unequivocal statements cannot be made, but the consistency of the distributions for these sherds suggests that this line of analysis is a promising one. Replication of this technique will be attempted by Gilbert as part of his continuing analysis.

SUMMARY AND CONCLUSIONS

In order to answer the question of what kinds of vessels were used by people in New Amsterdam-New York in the seventeenth- and early eighteenth-centuries, a typology was derived from seventeenth-century Dutch genre paintings and corroborated by comparison with fourteenth- to

sixteenth-century artifacts excavated in Amsterdam. This typology was com-
pared to a synchronous English-tradition typology from the Chesapeake re-
gion (Beaudry *et al.* 1983) because the two dominant influences on the
material culture of New York City were the Dutch and the English. The forms
in this typology have also been compared to ceramics from three sites ex-
cavated in lower Manhattan. The excavated sherds are, unfortunately, not
readily reconstructable into vessels, but some vessel forms from the typology,
notably pipkins or *grapen*, "skillets," bottles, colanders, and dishes, were seen
to be present. An important conclusion derived from this analysis is that im-
itation of Dutch forms in New York City coarse earthenwares continued even
after the English political conquests of 1664 and 1674. Analysis of clay to-
bacco smoking pipes supports this conclusion (Dallal 1984). Thus archae-
ology may be able to provide information relevant to questions about which
historians disagree: for example, what happened to the Dutch and their cul-
ture after the English assumed political control (Archdeacon 1976; Good-
friend 1975; Ritchie 1976).

Another important observation is that seventeenth-century Dutch genre
paintings were found to be a reliable tool in forming a typology of ceramic
forms and were particularly useful in providing insights into vessel function.
Not all schools of painting would lend themselves to such use, but other re-
alistic schools could possibly be helpful.

While national potting traditions can be identified, the methods discussed
above do not necessarily allow determination of place of manufacture. Place
of manufacture of ceramics is difficult to determine from vessel form alone,
and it is suggested that petrographic analysis will be useful in answering the
question of where the ceramics found in archaeological contexts were made.
Once the sources of ceramics have been determined, it will be possible to
compare the types and amounts of imported versus locally made wares and
to see how these ratios changed over time.

This chapter outlines seemingly modest goals, those of establishing how
many vessel forms were used and where they were made. It is essential to
deal with the modest goals before approaching larger anthropological ques-
tions concerning interactions between new settlements and their parent coun-
tries and the process of the development of autonomy in the former. The
combination of typological and compositional analyses, however, is a prom-
ising avenue for reaching this interpretive level. Further excavations and stud-
ies of collections will, it is hoped, support the ideas presented in this chapter.

ACKNOWLEDGMENTS

We are grateful to the many people involved with the work which preceded this
chapter. Diana Rockman was codirector of the Stadt Huys block and the 7 Hanover

Square block. Arnold Pickman was codirector at 7 Hanover Square and assistant director at 64 Pearl Street. The former two sites were excavated under the auspices of the New York City Landmarks Preservation Commission, while the latter excavation was sponsored by the Landmarks Conservancy. Outstanding field and lab crews worked on all of these sites. Jan Baart, Paul Huey, Charlotte Wilcoxen, Sherene Baugher, Norman Weiss, and Eric Nooter have all generously shared a variety of types of information with us. Allan Gilbert and Rob van Wageningen have spent considerable time and effort on the various thin section analyses. Isabella Pratesi, Edie Bresler, Kate Morgan, Sophia Rubis and Bruce Abolafia did the drawings of ceramic attributes. While it is true that the present chapter could not have been completed without the assistance of these individuals, none of them is to be blamed for any flaws in this research.

3
Chapter

Traditional Patterning of Earthenware Entries and the Form of the Probate Inventory in Seventeenth-Century Plymouth Colony

Paul G. Chace

INTRODUCTION

Probate inventories for the seventeenth, eighteenth, and nineteenth centuries have been used by many researchers to document contemporary descriptions of ceramics, to illuminate the place of ceramics within the early house setting, and to supplement archaeological data on ceramic forms and functions (Beaudry 1978; Beaudry *et al.* 1983; Brown 1973; Chace 1972; Herman *et al.* 1975; Stone 1970; Stone *et al.* 1973; Teller 1968; Turnbaugh 1977; Watkins 1950). The inventory entries often include contemporary descriptions of the various ceramic wares found within the houses of those deceased whose estates were being administered through the probate courts. While focusing on the descriptive entries, many scholars have overlooked the actual form of the whole inventory, which also provides important information related to the ceramics. In this paper it is proposed that the form of probate inventories provides important information for understanding the cultural patterns of household organization in which the described ceramics were utilized. Recognition of the implicit order in the form of probate inventories

should provide for analyses explicating various cultural patterns of the historic regional traditions reflected in these primary source documents. Both the use of probate inventories and the patterning of earthenware usage for seventeenth-century Plymouth Colony are interpreted as due to transplantation of traditional English lifeways to this colony (cf. Deetz 1973).

The probate inventory is an old English tradition and was quickly codified into colonial law in America. Upon the death of the head of a household a probate inventory usually was required. In seventeenth-century New England an inventory was prepared for about half to two-thirds of the adult men who died as heads of households (Main 1975:98; Smith 1975:104). The inventory is a listing of everything in the house and estate along with the value of each item, although a number of items are often grouped in an entry with a single evaluation. The document was signed by the two or three men who acted as appraisers, and filed with the local court. For most counties there are extensive series of these dated and filed probate inventories. As primary sources, these historical inventories document the regional cultural patterns of material goods which make up estates, and they evidence changes in these cultural patterns over the centuries (Carr 1973; 1977; Main 1975; Stone 1977).

As a source on earthenware, the probate inventory has its limitations. First, the inventory is concerned with value, so the worth of earthenware and other material items is carefully enumerated while the description of each object is not very detailed. Second, since earthenware usually is of relatively low value, it is often lumped together in an inventory entry, as "in earthen ware" or "in earthen vessels," or combined with other things of small value, as "some old earthen & wooden ware" or "tinn and earthen ware." And the material (earthenware or other) is uncertain when an entry only lists objects by simple form names. For statistical analyses, the lack of enumeration is frustrating. Third, the inventories are in the language of the period and not in the taxonomies of modern archaeologists. Despite these limitations, the probate inventory is a contemporary description of earthenware *in situ*, within actual seventeenth-century houses, before it has gone through the complex processes of breakage and disposal into an archaeological context where it might again be retrieved for study.

PROPOSITION OF IMPLICIT ORDERLINESS

The key proposition advanced in this paper is that for Plymouth Colony in the seventeenth century, the form of the probate inventory is an implicitly orderly document. It is proposed that each entry in an inventory is part of an orderly sequence. Because of this orderliness, the item (or items) enum-

erated in each entry can be related to the items in the entry preceding and the entry following in the inventory. The orderly patterns recognizable in written inventories reflect the way people patterned their household organization in the seventeenth century.

Recognition of this orderliness provides the opportunity for analysis which can explicate the significance of ceramics within the regional cultural tradition and the relationships of ceramics to other aspects of the cultural tradition. In utilizing this proposition, focus is placed upon the relationship between entries describing ceramics and the tools and equipment in adjacent entries which can often be identified with specific functions and locations.

There is an obvious explicit orderliness within certain probate inventories. Some inventories list the entries under room-by-room subheadings within the document. However, a study conducted by selecting only those inventories with this explicit room-by-room form (such as Cummings 1964 or Brown 1973:53) may contain a severe bias for wealthier, larger, and later period estates, as will be demonstrated. It is proposed and demonstrated in this chapter that even those inventories lacking explicit room-by-room subheadings are implicitly ordered in the same manner, in contradiction to the apparently casual observation of Main (1975:91). And the relationship extends to an even more detailed level; within each room, the appraisers found related things together, listed them in sequence, and subsequently moved about each room enumerating the materials found in each area together in sequence.

The probate inventory, in a practical sense, is almost like the written script of a documentary motion picture. It scans continuously through the entire house, describing everything of value present. It views the items within the room, peeks into every cupboard and corner, looks through the storage chamber, and moves through the doorway to continue the operation in the next room (if the house has more than a single room). With the house completed, the survey moves on to cover the outbuildings. In some cases, it even includes the stock animals and other land holdings. For everything observed and listed in these scenes, a specific value or worth is listed on the script, like the added subtitles explaining a foreign movie (for evaluation was the original purpose of the document). As might be expected, the worth of an item is sometimes presented in more precise detail than the item is described.

Several scholars seemingly have recognized the orderly, scriptlike quality of these documents, particularly when the hints of room-by-room subheadings are explicitly provided. As expressed by Main:

> Many appraisers listed the assets . . . on a room-by-room basis, noting down each item as they came to it. The effect is to call up to the mind's eye of the modern reader the simple floor plans of the early American homes and their comfortable intermingling of furnishings for both work and rest. In his imagination the reader

moves with the appraisers through each room, pokes into upstairs closets or down-
stairs cellars, steps outside. (Main 1975:92-93)

And, Stone (1977:53) perceives this same phenomenon: "When the enu-
meration was made room by room, it is almost possible to retrace the ap-
praiser's steps around the dwelling and through the outbuildings." Indeed, it
is proposed here that even when the scripted documents omit the room name
designations as subheadings, the same orderliness is implicitly maintained in
the inventory document. As scholars, our task is to devise analytic ap-
proaches to spotlight the cultural patterns within such implicitly patterned his-
torical documents.

THE SAMPLE OF PLYMOUTH PROBATE INVENTORIES

The proposition of implicit orderliness was developed and tested utilizing
probate inventories from Plymouth Colony dating from 1631 through 1675,
as part of a thesis on colonial ceramics (Chace 1972). Transcript copies of
nearly 300 of the Plymouth Colony probate inventories have been assembled
by Plimoth Plantation, Inc., and most of these have been encoded into their
information retrieval system. This collection includes all the inventories from
the earliest of 1631 up to those of 1654 and a majority of those from 1654
through 1675. By the 1650s the number of inventories increases dramati-
cally, reflecting the growing the maturing population of the colony (Langdon
1966:31, 82-3). The study (Chace 1972) did review and include a goodly
number of transcriptions which had not been encoded into the retrieval sys-
tem. In a subsequent study, Brown (1973:43) indicates that about 110 in-
ventories remain from the period from 1654 through 1675 which have not
been transcribed and encoded into the information retrieval system at Plimoth
Plantation. The later, more comprehensive study (Brown 1973) includes,
however, two entries with earthenware from inventories not considered in
the 1972 review (the 1656 Elizabeth Poole and the 1661 Samuel House
inventories). Certainly, this chapter is based on almost all of the surviving
Plymouth Colony inventories through 1675, and in any case, an adequate
sample to demonstrate the proposition of implicit orderliness.

From the inventory records transcribed at Plimoth Plantation the obser-
vations on ceramics were developed essentially from the 63 inventories which
contain a total of 91 entries specifically enumerating "earthenware" or
"earthen" vessels. All of these descriptive entries are listed in Table 3.1. This
chapter on the inventory form is based upon these same 63 inventories. The
few inventories from the 1630s and one other are not transcribed in their
original form at Plimoth Plantation and had to be omitted from this analysis,
which considers the order of entries as well as their content. Combining se-

quential entries enumerating earthenware, there remains a sample of 68 separate cases of entries (or sequential entries) enumerating earthenware from 56 inventories upon which this analysis was developed and tested.

There is a different and difficult problem in recognizing ceramics with certainty in the entries of many inventories; but that limitation should not affect this study of the implicit orderliness and form of inventory documents, which used only those inventories specifically enumerating "earthenware" or "earthen" vessels. The only other entries identifiable with certainty as ceramics are eleven entries specifically enumerating "stone"[ware] vessels (Chace 1972:11), and these appear in the same inventories that enumerate earthenware.

The initial concern in probate inventories was with value, and some Plymouth inventories have an entry for "other small things" that might include some inexpensive ceramic items. Not many individual earthenware vessels are evaluated; most of them are listed in a group with a single total value (see Table 3.1). Up through 1650, various pots and pans are valued at two, four, and six pence. In the period from 1650 through 1675 these vessels are appraised at from two to nine pence. The median value would appear to be about four pence. These values probably apply to dairy processing vessels.

Probably many other vessels of ceramic material are represented in other inventories by entries with simple descriptions of items by their form, function, content, or color, but without specifying the material of the vessel (for example, "chamber pot," "straining dish," "pot of honey," and "white drinking cup"). In later periods, origin names, such as "China," "Delph," and "Liverpool" ware, came into use as descriptors (Brown 1973; Stone 1970; Teller 1968). Also, size descriptors, such as "pint" and "quart," were used in other regions such as the Chesapeake area (Beaudry et al. 1983:28). In Plymouth, both origin and plebeian descriptors are rarely used in the seventeenth-century inventories. The single origin descriptor in the Plymouth sample is of unusual significance. The 1654 Atwood inventory entry reads, "It New England earthen ware seaven peeces" valued at two shillings. This indicates that some local earthenware was being manufactured by that date; and it was somehow distinguishable even this early from that produced outside New England, presumably earthenware imported from England.

The terminology employed in describing ceramics reflects what could be called the "folk taxonomy" of the various seventeenth-century Plymouth men appraising the estates. The folk taxonomy is real (Chace 1972:8), but it is different from the usual technological taxonomies utilized by archaeologists or the classificatory systems employed by antiquarian collectors. The newly organized Potomac Typological System (Beaudry et al. 1983) provides a broader appreciation and archaeological application of folk taxonomic categories for ceramics, but it does not address the basic problem of recognizing

Table 3.1

Inventory Entries with *Earthen* from Plymouth County Estate Records[a]

Name	Date	Entry	Value
Mary Ring	July 1631	1 erthen platter	00.00.03
Godbert Godbertson	Oct 1633	an earthen pan	00.00.06
Stephen Dean	Oct 1634	two earthen dishes	00.01.00
William Palmer	Nov 1637	4 earthen potts	00.02.00
Thomas Pryor	Sept 1639	1 wodden kane 2 stone bottella 1 earthen warming pann	00.08.00
		leather bottle 1 earthen pann 2 dishes & spoones	00.03.06
Mr. William Kempe	Sept 1641	2 earthen potts	00.00.04
of Duxburrow		2 earthen old oyle potts	00.00.04
		5 earthen panns 1 butter pott	00.02.00
		2 latten pans & 2 earthen potts	00.01.06
		1 stone pott 8 earthen pott	00.00.08
William Swyft of Sandwich	June 1642	a prcell of earthen potts	00.02.00
Edward Foster	Feb 1643	earthen ware	03.00.00
William Brewster,	May 1644	1 earthen pott	00.00.04
gent., of Plymouth		1 earthen pott with sugar	00.01.06
John Jenney,	May 1644	8 earthen panns & potts & tubbs	00.05.00
gent., of Plymouth		an earthen bason	00.00.02
Stephen Hopkins of Plymouth	July 1644	earthen potts	00.00.06
Mr. John Atwood,	Feb 1644	6 blew earthen Dishes	00.03.00
gent., of New Plymouth		for earthen ware	00.04.00
Mr. Robert Hicks	July 1647	in earthen things	00.01.00
Henery Smith of Rehoboth	Dec. 1647	in earthen vessells	00.05.00
Joseph Holiway	Dec 1647	the manure one litle earthen pot one pitch folk one payer of tinnes	00.09.00
of Sandwidg		for a fork one frying pan	
George Knott of Sandwidg	June 1648	4 earthen pots 2 earthen pans one ould sack 2 baggs and som haemps	01.00.00
		and many other smal things of like vallew and things forgotton	
Ephraim Hicks	Mar 1649/50	4 earthen pans	00.02.04

Name	Date	Description	Value
Nicholas Robbins of Duxborrow	Mar 1649/50	4 earthen potts and 2 panns	00.03.06
Thomas Blossom	April 1650	one earthen pott and a pan	00.01.03
James Lindale of Duxborrow	Oct 1652	one letten pan and an earthen Dish	00.01.04
James Glassie	Feb 1652	in earthen ware and a letten pan	00.02.06
Rev. John Lothropp of Barnstable	Dec 1653	tinn and earthen ware	00.07.06
John Faunce	Dec 1653	trayes and earthen vessels	00.05.00
Henrery Merritt	Jan 1653	bowles trayes wooden Dishes earthen pots	00.10.12
Mis. Ann Atwood of New Plymouth	June 1654	It New England earthen ware seaven peeces	00.02.00
Thomas Gannett of Bridgwater	July 1655	3 earthen potts	00.01.06
		2 earthen pots	00.00.04
		earthen pan	00.00.09
		earthen pan	00.00.09
		one earthen pan	00.00.09
		one earthen pan	00.00.09
Edward Dotten of New Plymouth	Nov 1655	earthen potts and pans	00.06.00
Mis. Sarah Jeney of Plymouth	Feb 1655	8 peeces of earthen ware & a ston Jugg	00.04.00
Richard Sealis of Scituate	Mar 1656	some old earthen & wooden ware	00.02.00
Capt. Miles Standish of Duxbury	Dec 1656	earthen ware	00.05.00
Stephen Hopkin	1657(?)	1 earthen judg	
Mr. William Bradford of Plymouth	May 1657	4 venice glasses and seaven earthen Dishes	00.10.00
William Chase of Yarmouth	Sept 1659	in earthen thinges	00.03.06
Edward Tilson	Mar 1660/61	6 milke pans 15 trayes and three potts	00.12.00
		in some other small earthen things	00.01.00
		6 earthen porrengers	00.01.00

(continued)

Table 3.1 (continued)

Name	Date	Entry	Value
William Parker of Taunton	Nov 1661	in meale seives wooden vessells traises dishes pailes platters barrells Cheesfatts earthen potts and Juggs pans 2 leather bags 2 linnine bagges	04.04.00
Richard Sparrow of Easthan	Mar 1661/62	3 pewter dishes a quart pott 2 basons a porrenger 5 smale earthen dishes with a little old pewter & six trencher	00.16.00
John Browne of Rehoboth	April 1662	a parcell of earthen ware vallued att	00.10.00
		an earthen porrenger & a drinking cup	00.00.08
Francis Cooke of Plymouth	May 1663	1 earthen pan and 2 earthen potts	00.00.09
		4 earthen potts 1 Cupp 2 wooden trayes	00.05.00
John Walker	Dec 1663	earthen ware as dishes and drinkeing potts	00.04.04
Thomas Howes of Yarmouth	Feb 1665/66	in earthen dishes wooden platters trayes pail & c.	01.05.00
Timothy Hatherley of Scittuate	Nov 1666	five earthen vessells	00.03.00
		6 earthen potts 5 earthen pans & other earthen ware	00.10.00
Thristrum Hull of Barnstable	Mar 1666/67	3 earthen potts	00.02.00
		1 white earthen ware	00.06.00
Mr. Anthony Thacher	Aug 1667	in earthen ware and other smale thinges	00.12.00
Nathaniel Warren of Plymouth	Oct 1667	7 earthen pans & other earthen	00.06.00
Richard Bullocke of Rehoboth	Nov 1667	earthen potts and platters and two stoning luggs	00.06.00
Gabriell Fallowell of Namassakett	Feb 1667	earthen and wooden dishes	00.02.00
Samuell Sturtivant of New Plymouth	Oct 1669	earthen potts	00.02.06
Henery Howland of Duxbury	Mar 1670	To pewter and some earthen potts & cups & other smale things	01.05.00
		To earthen and wooden thing	01.05.00
Nathaniel Goodspeed of Barnstable	May 1670	tining thinges and earthen dishes	00.05.00

Name	Date		Value
Gartherew Hurst	May 1670	1 alcomy spoone 4 earthen potts and pans	00.01.00
William Lumpkin of Yarmouth	Jan 1670	2 earthen dishes	00.01.00
John Barnes of Plymouth	Aug 1671	a Chest with severall earthen potts with Divers smale thinges in them	00.05.00
		a firkin with hogsfatt and an earthen pott	00.10.00
		2 earthen potts with butter	00.05.00
		6 earthen vessells with an earthen basin	00.05.00
		2 pitchers 2 earthen potts 1 Cheesladder one roleing pin	00.01.06
		2 venice Glasses 3 other glasses 1 stone Jugg 3 earthen potts	00.07.00
		another white Gally pott a Drinking pott a pewter tunnell a little white bottle and a white Drinking Cupp and other old earthen ware	
Thomas Prence, Esqr.	April 1673	2 milke pans 9 earthen potts a Grindstone a sundiall 3 hoes	00.14.00
		4 butter potts 1 earthen pan	00.01.08
		1 Case and some Glasse bottles 1 earthen Cupp	00.03.06
Josias Cooke of Eastham	Oct 1673	in earthen ware	00.02.00
Roger Annadowne of Rehoboth	Nov 1673	3 earthen potts	00.04.00
Mr. John Dicksey of Swansey	May 1674	earthen ware	01.02.00
Thomas Willett of Swansey	Nov 1674	earthen ware & Glasses in the Glossett Great Rome	01.10.00
		dary vessells—3 Cheesefatts	00.03.00
		2 ditto	00.02.00
Capt. Nathaniell Thomas of Marshfield	Mar 1674/75	by earthen wares pailes milke vessells	01.04.06
William Blackstone	May 1675	an earthen pott and a Glasse bottle	00.04.09
Thomas Savory of Plymouth	Jan 1675	earthen ware platters and potts and scuming things 2 Glasse bottles and four spoones 2 knives 6 trenchers and 2 Iron wedges & 2 axes and one spade and 1 hoe & one bagg: and a Racke & an old hatchet and an old shovell	01.00.00
John Palmer of Scittuate	Mar 1675/76	an earthen larr	00.00.09
John Fallowell	Mar 1675/76	2 tin pans and 1 tin kettle 1 tin lanthorn 4 spoons 4 earthen platters earthen pans 3 earthen potts	00.10.00

aAfter Chace (1972:8-10).

whether an item described in an inventory entry is made of ceramic or of some other material.

RECOGNITION OF INVENTORY PATTERNS

In order to recognize the implicit orderliness of Plymouth Colony inventories it is necessary to analyze and define the patterns within the form of the inventories. The most obvious pattern was the occasional explicit use of room designations as subheadings. It also is possible to recognize patterns of sequentially enumerated groups of objects that define four specific complexes that include earthenware.

Of the 56 inventories in this study, ten appear to name every room in the house in subheadings, with the objects in each room listed beneath. Seven other inventories have one or several rooms designated but do not appear to designate all the rooms of the house in organizing the entries. The remaining 39 inventories have no room designations but are simply sequential lists of objects.

The inventory entries specifically enumerating earthenware appear under the rooms designated as "Kitchen," "Dairy," or "Parlor," or a storage area. However, these cases account for only 32% of the enumerations of earthenware, while 68% occur without explicit room designations. The earthenware entries appear only six times in inventories under the kitchen subheading, only twice under the dairy subheading (and under "Milk House" or "Wash House" in two similar cases), only four times under the designation of a parlor or parlor closet, and in eight designated storage areas in four other inventories.

OBJECT COMPLEXES WITHIN THE ROOMS

At a more detailed level of orderliness, it is possible to define four complexes of items in which earthenware was enumerated within each of the four kinds of rooms. Two approaches are utilized to define these complexes. First, in an inventory where the earthenware is enumerated under an explicit room designation, the objects listed with the earthenware are obvious. Then, in the majority of inventories in which the earthenware is not listed under a designated room, the objects which appear in the same inventory entry with earthenware, and in an adjacent sequence of entries, can be grouped. These groups of objects fall into four characteristic complexes in most cases.

In the second approach some subjectiveness is involved in the analysis. In some inventories it is obvious that several sequential entries adjacent to the entry with earthenware all belong to a single complex of items; they are all things of a similar nature, such as cooking gear or dairy processing equipment. In these cases, all of the objects in several sequential entries can be considered in characterizing the group. Also, an inventory entry often includes a number of items, but almost always they seem to be objects of a single organizational class—a single entry enumerating "4 earthen pots 1 cup 2 wooden trays" with a combined evaluation, for example. Thus, the number and variety of objects grouped with and assumed to be related to each earthenware entry is quite variable. Ultimately, the group of items that could be associated with each earthenware entry included a sufficient number of specialized items that the characteristics defining one of four complexes were apparent in all but 11% ($n = 5$) of the implicit cases (Table 3.2).

The Kitchen Complex

The complex most often distinguished by the objects associated with earthenware is the kitchen complex. Six explicit examples and 29 implicit cases can be identified with the kitchen complex for a total of 52% of the cases in the study sample. The characteristic objects of this complex are cooking utensils (bellows, fire iron, spit, pothook, drip pan, skillet, frying pan, kettle, metal pot, and metal pan) and food serving vessels (bowl, dish, platter, woodenware, and trencher). The kitchen complex also tends to include the objects for processing milk, butter, and cheese (tray, tub, trough, pail, churn, cheese vat, and cheese press) and for brewing beer (beer vessel and malt). The ear-

Table 3.2
Object Complexes within Rooms

	Number of Cases		
Complex	Explicit	Implicit	Percentage
Kitchen	6	29	52
Dairy	4	1	7
Parlor	4	3	10
Storage	8	8	24
Other	0	5	7
	22	46	100

thenware vessel forms specifically enumerated and associated with the kitchen complex are pot, pan, jar, dish, porringer, platter, and drinking pot.

It is noteworthy that often associated with the kitchen complex are guns and weapons, bibles and books, axes, and garden tools. Even bedding and spinning wheels occur with the kitchen complex. It appears likely that most of the colonial settlers' houses through 1675, the terminal year of this study, were small, with the kitchen as the principal room; and the objects for most household activities were maintained in the kitchen area. Indeed, if the house had only one room, essentially all household items would be in the kitchen complex. And, if that was the case, explicit room designations in these early Plymouth inventories would not be expected.

The Dairy Complex

Two explicit examples of a "Dairy," one "Milk House," and a "Wash House" appear in the inventories. In addition, one implicit case can be classified with the dairy complex. All together, as a separate complex, these represent only 7% of the cases. The dairy complex (and the parlor and storage complexes as well) is distinguished first by the omission of most of the principal objects which characterize the kitchen complex, the cooking utensils and food serving vessels. Interestingly, two of the explicitly designated cases do contain some cooking and food serving items, but possibly these are just odd items stored away there. Along with the earthenware vessels, the dairy complex includes the objects for processing milk, butter, and cheese (tray, tub, trough, pail, churn, cheese vat, and cheese press). The earthenware vessel forms specifically mentioned in the dairy complex are pot, pan, and basin.

The dairy complex occurs as an object group apart from the kitchen complex only in large estates. All five cases are in estates with a total value in excess of £100. It appears that only wealthier households had a dairy room or structure apart from the kitchen. In most early Plymouth households the specialized activities associated with dairy processing were carried on in the kitchen area.

Also worth noting is that the five cases in which the dairy complex was in a separate area from the kitchen occur only in the very earliest and very latest inventories. Four of these are dated from 1641 to 1647, and the fifth is from 1674, near the end of the period of study. In this sample, there are no inventories with separate dairy complexes for the entire period of the 1650s, the 1660s, and well into the 1670s. It would be interesting to see if this pattern could be demonstrated in the entire set of Plymouth inventories. It hints that in the early years of Plymouth Colony, the 1620s, a few wealthier initial settlers constructed large homes with separate dairies. Then, over the next

several decades, subsequent settlers rarely built separate dairies but conducted the dairy processing within more modest houses.

The Parlor Complex

The parlor complex with earthenware can be defined from seven inventories, or 10% of the entries. There are two explicit examples of a designated parlor—one, a "Closet in the Great Room," and one a "Little Room" in an inventory which lists a separate parlor—plus three implicit cases. These cases all occur in wealthy estates with values exceeding £150. The parlor complex commonly includes bedding, table covers (rug and table cloth), drinking vessels (glasses, jug, and cup), bottles, and often shirts; it excludes most kitchen and dairy complex items. The only specified earthenware forms mentioned in the parlor complex are pot, pot with sugar, and dish.

It is significant that several of the items mentioned as "white," including the single entry of "white earthen ware," occur in the parlor complex. These entries may represent fancy Delph (delft) ceramics, although the same description could be applied to porcelain, or even to grayish white stoneware. Neither Delph ware nor Chinese porcelain can be identified with certainty in any Plymouth inventories of this period, although the items described as white or blue probably represent Delph ware (Brown, 1973:44-48, 61; Chace 1972:5-6). Most likely this is due to lack of a term in the seventeenth-century rural Plymouth folk taxonomy for distinguished these special ceramics, which were still very rare in the region (Chace 1972:8).

The Storage Complex

The complex of items in storage with earthenware often includes containers (chest, barrel, firkin, tub, trough, and pail), woodenware and trenchers, garden tools (spade, hoe, and hand tools), and "lumber," which refers to junk. Old and incomplete tools are sometimes present. The earthenware vessel forms decribed in the storage complex include pot, oil pot, butter pot, dish, and basin.

The separate areas of storage are only rarely designated explicitly within inventories. Eight such designated areas appear in four different inventories; they are called "Inner Chamber," "Kitchen Chamber," "Stair Chamber," "Outlet Inner Room," "Cellar," and "Out Door." Eight other cases of implicit storage areas are distinguishable, based upon the characteristics of the defined complex. Together these constitute 24% of the cases. Certainly also

the kitchen area is partially utilized as a storage area in many houses, but those cases are characterized with the objects of the kitchen complex.

Other Cases

There remain five cases of entries with earthenware and with sequentially adjacent objects which are not sufficiently characterized to be assigned to any of the four defined complexes. These make up 7% of the study sample. Most of these cases have only a few items named in the adjacent inventory entries, and the series of adjacent items appears to consist of diverse kinds of things. Some cases might be odd lots in storage areas. A couple may include parts of two complexes because the earthenware was enumerated at the beginning or end of one room, so that objects from two areas or complexes appear sequentially in the inventory. These cases may represent situations where the objects were not really adjacent in the household, and no relationship is reflected. They cannot be construed as examples of storage. The storage complex is a particular defined group of materials that reflect a particular organizational situation in the household; it is not conceived as a catchall category.

THE ORDERLY FORM OF PROBATE INVENTORIES

Having defined the patterns within the Plymouth Colony probate inventories, it is possible to test the proposition that there is implicit orderliness in these inventories. The sample of 68 cases (composed of groups of objects enumerated with earthenware) can be recognized as reflecting four patterned and definable complexes. These complexes occur whether or not the inventories utilize explicit room-by-room subheadings. As shown in Table 3.3, it is possible to recognize this implicit orderliness in 89% of the cases even where room designations are not utilized. Combining the implicitly ordered cases

Table 3.3

Test of Correlation: Inventory Orderliness and Defined Patterns[a]

	Rooms designations Explicit	Object complexes Implicit
Orderliness	22	41
Not Orderly	0	5

[a]$N = 68$ cases.

with the cases that are explicitly ordered reveals that 93% of the Plymouth probate inventories are orderly, as defined by this analysis. Clearly, the form of seventeenth-century probate inventories in Plymouth Colony is very orderly, and the proposition of implicit orderliness is demonstrated.

CHANGE IN INVENTORY FORM

Demonstrating that the Plymouth Colony inventories are orderly documents raises two concerns: why all inventories do not utilize room-by-room designations, and why only some employ these explicit subheadings. In addressing these issues, two tests of correlation were developed using the same sample of inventories.

Wealth and Explicit Room Designations

When the 56 inventories in the sample are divided into two lots according to total estate value there appears to be a relationship between the use of explicit room designations and estate value or wealth. This study sample can be conveniently divided into a poorer lot and a wealthier lot with the division occurring at the estate value of £90, as shown in Table 3.4. All (100%) of the inventories utilizing explicit room designations are in the wealthier lot. Changes in the value of the pound sterling and inflation over time have not been considered for the period 1640 to 1675 (Carr 1977:65; Main 1975:95), but in this test any fluctuations do not seem to affect the correlation.

In the inventories of wealthier estates, 39% do not employ explicit room designations. However, a closer investigation of these cases shows that 73% (8 of 11 cases) are very early, dating from before 1657. Thus, in the first three decades of Plymouth Colony, even inventories of the wealthier estates rarely employ the use of explicit room designations.

Table 3.4
Test of Correlation: Wealth and Explicit Room Designations[a]

	Room designations	
	Explicit	Lacking
Value 0 to 90£	0	28
Value 90 to 900£	17	11

[a]N = 56 Cases

Table 3.5
Test of Correlation: Period and Explicit Room Designations[a]

	Room Designations	
	Explicit	Lacking
1640 through 1660	5	23
1661 through 1675	12	16

[a]N = 56 cases

Period and Explicit Room Designations

When the inventories are arbitrarily divided into two lots by period, one up through 1660 and one thereafter, it is clear that there is considerably greater utilization of explicit room designations in the later period, as shown in Table 3.5. In the earlier period only 18% of the inventories use explicit room designations, while in the later period 43% use them. The trend is toward increased use of explicit room designations as subheadings in inventories over the period of this study.

CONCLUSIONS

This study is important primarily because it demonstrates that the seventeenth-century Plymouth Colony probate inventories are patterned with implicit orderliness. Even though most inventories appear as only simple sequential lists of objects and values, they can be used successfully to provide analyses for explicating various cultural patterns of household organization. This chapter demonstrates that the Plymouth Colony earthenware ceramics are associated with four complexes within the form of the inventories. The identified complexes indicate where the earthenware items are enumerated and where they are kept within the organization of the seventeenth-century household, but they do not demonstrate as directly the functions the earthenware served in these locations.

The precise functions of earthenware ceramics remain difficult to explicate, primarily because much of the earthenware is not described by form or quantified in the inventories. In the homes of both the wealthier and poorer groups of settlers, a number of earthenware vessels are used for dairy processing. Yet the wealthier households sometimes have a separate room or structure for this operation. In many Plymouth homes the dairy processing vessels were kept in the kitchen, which seems to have functioned as the principal room in most early settlers' houses. The majority of the earthenware enumerated

in the inventories seems to have served in the context of dairy processing, which was of great importance to the English yeoman diet, a traditional emphasis that was transplanted to seventeenth-century Plymouth Colony (Brown 1973:54; Deetz 1973:26). Earthenware pots and jars are utilized for the storage of butter and oil, and some other foods. Many earthenware items simply seem to have been stored, apparently empty, in areas where chests and barrels and other things that were needed only occasionally were placed. Actual food-serving vessels of earthenware (dishes, porringers, platters, and drinking pots and cups) appear to be extremely rare in the kitchen complexes of Plymouth estates up through 1675. A similar situation is evident in the Chesapeake region (Beaudry et al. 1983:22-25). Earthenware pots, pans, and other vessels in the kitchen complex may have been used only to a modest extent in the cooking and baking of food. This has been called the Stuart yeoman pattern (Jay Anderson, in Deetz 1973:25-26), and it was transplanted to seventeenth-century colonies throughout the Northeast region, including the Chesapeake area (Beaudry et al. 1983:22-23). And, based on the demonstrated patterns, it appears that ceramic drinking pots, cups, and jugs primarily were restricted to the parlors of the wealthier, where fancy dishes were also present, all as a pattern or mark of status and wealth.

Although the form of the probate inventory can be shown to have changed in the period from 1631 through 1675 in Plymouth Colony, very little change in the patterns of earthenware usage is evident from the order of sequential entries in these inventory records. Finally, these 1631-1675 era inventories give the impression that in the early homes in Plymouth Colony earthenware was not yet recognized as an important or valuable possession, always worthy of valuation and itemization. However, the records do document awareness of a newly emerging domestic industry, for in the 1654 estate inventory of Ann Atwood of New Plymouth is entered irrefutably "It New England earthen ware seaven peeces."

4
Chapter

Ceramics and the Colonial System: The Charlestown Example

Steven R. Pendery

INTRODUCTION

In recent years archaeological and historical research has expanded our understanding of earthenware manufacture in early America. During the seventeenth century earthenware potters supplied community needs alone but by the early eighteenth century many American potters were successfully competing with their British counterparts for expanding colonial markets. Archaeology has revealed many of the changes in production that accompanied this transformation, including the imitation of specific British ceramic table ware types such as Jackfield and manganese-glazed wares as well as their respective range of table ware forms. The proliferation of earthenware potteries in or near colonial seaports suggests that intercolonial distribution of these wares may have contributed to the wealth and status of potters in Virginia, Pennsylvania, Massachusetts and New Hampshire (Barka 1973; Barka and Sheridan 1977; Giannini 1981; Myers 1977; Pendery and Chase 1977; Turnbaugh 1976, 1977, 1983; Watkins and Noël Hume 1967).

This paper evaluates the importance of table ware production in the early and mid-eighteenth-century pottery shops of Charlestown, Massachusetts, a center for earthenware manufacture in colonial New England. There are no official statistics on earthenware production in Charlestown or on most colonial pottery centers because American potters may have heeded Ben-

67

jamin Franklin's advice to "manufacture as much as possible and say nothing." Because nearly forty earthenware potters were active in colonial Charlestown there is a wealth of surviving documentary and archaeological evidence for earthenware manufacture appropriate for quantitative analysis (Watkins 1950:249–270). Study of this evidence supports the inference that imitative table ware production made a significant contribution to the success of Charlestown's potteries, possibly at the expense of British earthenware manufacturers.

HISTORICAL BACKGROUND

Charlestown, Massachusetts was prominent in the production of lead-glazed redware from soon after its founding in 1630 until the destruction of the town by the British during the Revolution. The town counted among its earliest inhabitants some of the first documented potters in North America (Watkins 1950:16; Wyman 1879:309). While these were few in number, they apparently supplied expanding markets in the Massachusetts Bay Colony area. By the early eighteenth century Charlestown emerged as an important center of earthenware manufacture in New England—a development resulting from the expansion of the town's fortunes based on manufacturing and trade in the late seventeenth century, a drop in the importation of coarse earthenwares from North Devon, and an expanded use of ceramics in colonial households. Redware was apparently manufactured in such large quantity that "Charlestown ware" became synonymous with redware throughout the Massachusetts Bay Colony (Deetz 1973:21; Dempsey 1982:28).

The focus of earthenware production in Charlestown was the town dock and adjacent waterfront districts (Figure 4.1). Abundant clay from local deposits and easy access to fuel and markets attracted several generations of master potters and apprentices to Charlestown. By 1741 the smoke and fire hazards of wood-burning pottery kilns may have inspired an act passed by the General Court "Relating to General Nusances" that restricted new potters' kilns and kiln houses to locations, such as the Town Dock, already approved for that purpose (Watkins 1950:26). Probate records and deeds pertaining to the workshops of Charlestown's master potters indicate that they owned and occasionally rented out their facilities, which typically consisted of a portion of a houselot with one or two kilns and kiln houses, work houses, clay and glaze mills, warehouses, and a wharf. Kin ties and trade associations developed within the community of potters and their apprentices which may have ensured their collective well-being (Watkins 1950:24–33).

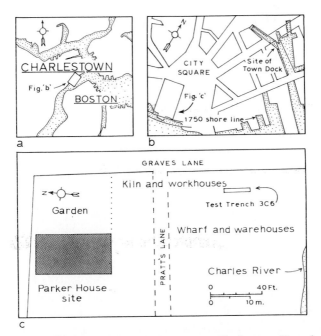

Figure 4.1 Locator map of the Parker pottery site, Charlestown, Massachusetts.

The absence of official statistics on pottery manufacture in Charlestown may be related to the reluctance of craftsmen to divulge information on production and trade to crown authorities. The colonial policy of Great Britain, following the mercantilist policies of other European countries, was to engross the trade of the colonies and to stimulate their consumption of English manufactured goods (Clark 1916:15). To this end were effected the Navigation Acts as well as laws that regulated colonial manufactures in conflict with those of the mother country (Clark 1916:22–25). While the royal governors in North America were charged with enforcing these laws they often supported the colonists and appeased the British Board of Trade by issuing reports depreciating colonial manufactures. Governor Gooch of Virginia managed to conceal the activities of the successful Yorktown potter William Rogers in his reports to the British Board of Trade in the years 1733, 1737, and 1739 (Watkins and Noël Hume 1967:79). In his report to the board, Governor Belcher of Massachusetts complained, "we cannot conceal from your lordships that it is with the greatest difficulty we are able to procure true information on the trade and manufactures of New England," suggesting less than complete compliance with his duty (Clark 1916:204).

THE PARKER POTTERY OF CHARLESTOWN, MASSACHUSETTS, 1713-1759

The Parker pottery on Graves Lane, Charlestown, Massachusetts, was operated by two generations of the Parker family, including Isaac Parker (1692-1742), his wife Grace (1697-1754) and their son John (1725-1765). The activities of the Parkers as potters are unusually well documented due to the survival of records pertaining to their experimental manufacture of stoneware in the 1740s and the preservation of John Parker's account book. Archaeological sampling of the site, initiated in 1981 by the Institute for Conservation Archaeology, Peabody Museum, Harvard University, due to proposed highway construction in the area, provided a first glimpse of the redware produced by the Parkers and an opportunity to evaluate the importance of table ware manufacture and marketing by quantitative analysis of both archaeological and documentary data.

Isaac Parker was the first member of the Parker family to produce earthenware at the site on the waterfront near Charlestown's Market Square (Figure 4.1). Parker purchased the site in 1713 and soon improved it with a dwelling house to the north, work houses toward the center of the lot, and a wharf to the south (*Middlesex County Deeds* 1713, Vol. 16:346; 1808, Vol. 167:246). The spatial organization of his houselot mirrored that of other contemporary urban potters attempting to maximize both residential and manufacturing activities on a compact lot of land (Giannini 1981; Pendery 1977).

No records from Isaac's redware pottery workshop have survived; however, the success of his enterprise may be inferred from his status and wealth toward the end of his life. Evidence from his will proved in 1742 and probate inventory of 1743 indicates Parker was able to support his wife Grace and eleven children in considerable luxury in a mansion outfitted with ample furniture, 31 pictures, 182 pounds of pewter worth £37, silver worth nearly £193, two slaves, and a total estate valued at £3128. This relatively high level of affluence is consistent with that of several contemporary earthenware potters in New England (*Middlesex County Probate* Docket 16584 (1743-1755); Pendery and Chase 1977:11; Turnbaugh 1976:209; Watkins 1950:111).

While Isaac's success was based on his manufacture of redware, he and his wife Grace were perhaps best known for their introduction of stoneware manufacture to New England in the 1740s. This was accomplished with the help of James Duche, the son of Philadelphia stoneware potter Anthony Duche (Bower 1974:12-14, Ginannini 1981:201; Watkins 1950:35). Since Isaac died in 1742, his involvement in this venture was brief. However, he

managed to acquire loans and a monopoly on stoneware manufacture from the provincial government. A partnership that included Grace Parker, Thomas Symmes, and possibly John Parker continued experimenting with various sources of clay until wares were successfully produced. The expense of importing clay from Philadelphia, injuries resulting from the stoneware experiments, a smallpox epidemic, and the return of Duche to Philadelphia were setbacks from which the enterprise never recovered. Stoneware manufacture may have continued as late as 1754, the year of Symmes's death, which was followed shortly thereafter by that of Grace Parker (Massachusetts Archives 1742 Vol. 59:332–333a, 347–349, 415–417).

John was the only offspring of Isaac and Grace to follow the potter's trade. He probably continued to operate the family pottery shop on Graves Lane after his father's death in 1742 while stoneware production continued at Thomas Symmes's shop. John Parker's activities between 1747 and 1757 were recorded in an account book preserved by the Baker Library of the Harvard School of Business Administration, one of the earliest such documents to survive from a pre-industrial pottery shop in New England.

THE JOHN PARKER ACCOUNT BOOK, 1747–1757

John Parker's account book contains daily credit and debit entries reflecting his business activities as a Charlestown potter. Parker rented his workplace and equipment to other potters and occasionally hired out his labor to them. Services performed for other potters included digging and grinding clay, grinding lead and repairing kilns and mills, splitting wood, throwing or turning earthenware, setting and drawing kilns, and picking out ware. The account book also contains entries for earthenware Parker manufactured for other potters and traders situated both locally and throughout New England from Casco Bay, Maine, to Killington, Connecticut (Figure 4.2). After 1754 he worked for others, mainly as a writer, perhaps on account of the "weakness" he contracted while working in his mother's stoneware pottery, where he was exposed to chlorine gas during the salt-glazing process. John Parker died in 1765 at the age of 40 (Wyman 1879:727).

One of the activities documented by the Parker account book is the turning of wares by John Parker for other Charlestown potters. John Larkin, Samuel Bodge, Josiah Harris, and John Harris hired Parker periodically between 1753 and 1756 to turn wares for their own pottery shops. Because Parker recorded the quantity, in dozens, of each type of vessel he produced, it is possible to identify their relative frequencies and absolute numbers. Parker marketed his own completed wares by the "parcel," a standard unit used by potters in

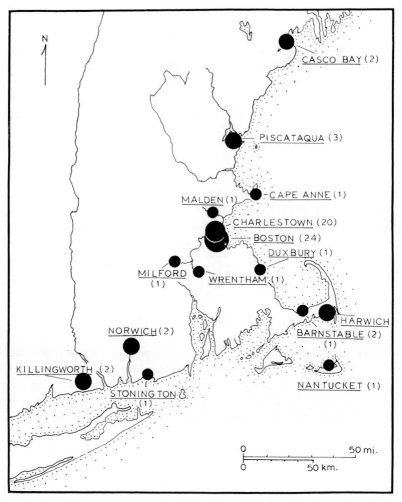

Figure 4.2 Distribution and number of customers purchasing earthenware from John Parker, 1747-1757.

North Devon, England, and in Colonial America that took into account the potter's time and his kiln and storage space without specifying the exact types of vessels it contained (Brears 1971:61; Grant 1983:68).

The frequencies for the fourteen categories of vessel forms produced by Parker for Larkin, Bodge, and the Harrises for the period 1753-1756 are shown in Figure 4.3. It is apparent that table ware forms were produced in larger quantity than non-table ware items in a ratio of nearly 7:3. Mugs alone accounted for more than 23% of Parker's entire production, followed closely

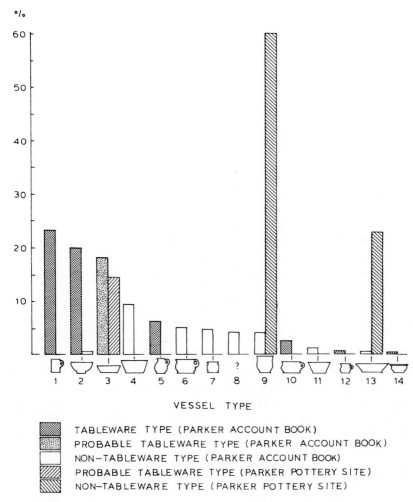

Figure 4.3 Categories of earthenware vessels manufactured by John Parker, 1753-1756, listed in Parker Account Book, and categories of wares excavated at Parker pottery site, Charlestown, Massachusetts. Vessel types include: 1, mugs; 2, bowls; 3, platters; 4, pudding pans; 5, pitchers; 6, chamber pots; 7, galley pots; 8, "jegers"; 9, common pots; 10, porringers; 11, bread pans; 12, cups; 13, milk pans; 14, basins.

by bowls at nearly 20% and platters at 18%. Pitchers, porringers, cups, and basins represented slightly less than 10% of the remaining wares produced. Food storage and food preparation containers, including pudding pans, common pots, bread pans, and milk pans, made up slightly more than 15% of the wares produced, while health-related wares, such as chamber pots and

gallipots, made up the remaining 14%. This evidence suggests that Charles-town redware potters were actively competing in markets for ceramic table-wares by the mid-eighteenth century.

Parker's separate accounts with Larkin, Bodge, and the Harrises suggest that Charlestown pottery shops may have specialized in manufacturing cer-tain types of vessels. While employed by John Larkin in October 1753, Par-ker turned 1140 vessels, nearly 25% of which were "platters," with again as many pudding pans (Figure 4.4). When employed by John Harris between August and October 1754, Parker turned proportionately more mugs and galley pots than other types of vessels (Figure 4.4). At the Josiah Harris pot-tery shop in the summer and fall of 1756, Parker was hired to produce 1344 vessels, of which the greatest proportion were bowls. On three other occa-sions Parker was hired by Charlestown potters for shorter terms, possibly to help them with specific orders for table ware. These variations in the orders placed by Charlestown pottery shops may reflect differences in patronage by coastal traders and merchants and shipping and military provisioners, as well as local taverns and households (Barton 1981:49-65; Bragdon 1981).

ARCHAEOLOGICAL EVIDENCE

The existence of detailed maps and other documentary sources bearing on the layout of the Parker pottery site on Graves Lane allowed specific site components to be targeted for archaeological investigation. The residential section, to the north of the site, was in a poor state of archaeological pres-ervation due to construction of the Waverly Hotel on the site in 1866. The middle portion of the site was well preserved and contained artifactual evi-dence of redware manufacturing at the site in the first half of the eighteenth century. The southernmost portion of the lot contained well-preserved wharf cribbing components, although the depth of deposits limited archaeological examination of this area. Subsequent discussion will focus on the potter's activity area in the middle portion of the site (Pendery et al. 1982:129-132).

The earliest evidence for the manufacture of redware at the Parker site was found stratigraphically superimposed over the footings of a structure of seventeenth-century date. Associated with the earlier footings was a heavy concentration of earthenware roof tiles. Similar tiles, showing evidence of use as potter's setting tiles, were discovered in the overlying deposits, which sug-gests that Isaac Parker, like the earlier Essex County potter James Kettle, was using discarded roofing tiles as kiln furniture (Watkins 1950:Photograph 10). This overlying deposit, Stratum 7, contained additional evidence of redware manufacture, represented by redware wasters (pots spoiled during produc-tion), redware, pottery kiln bricks, and kiln furniture. Associated imported

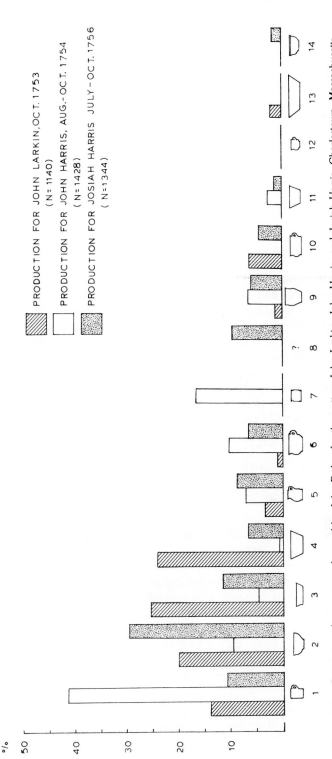

Figure 4.2 Categories of wares manufactured by John Parker for the potters John Larkin, John Harris, and Josiah Harris, Charlestown, Massachusetts, 1753–1756, listed in Parker Account Book.

PRODUCTION FOR JOHN LARKIN, OCT. 1753
(N = 1140)

PRODUCTION FOR JOHN HARRIS, AUG.–OCT. 1754
(N = 1428)

PRODUCTION FOR JOSIAH HARRIS JULY–OCT. 1756
(N = 1344)

artifacts included Westerwald stoneware, Staffordshire white salt-glazed stoneware, and combed slipware. Stratum 6 contained similar material, and Stratum 5 had identical, redeposited material. Stratum 4 included ash and cinders with artifacts of mid-nineteenth-century date, probably representing the grading of the site during the construction of the Waverly Hotel. This portion of the site was sealed by reinforced concrete flooring of twentieth-century date. Stratum 7 had the best association with the Parker family pottery workshop and analysis of this material provides the basis of subsequent discussion (Pendery et al. 1982:129–132).

CERAMIC ANALYSIS

Samples of redware recovered from the Parker pottery site were used to test two inferences derived from the study of the Parker account book: (1) that table ware production was more important than the production of non-table ware forms during the early and mid-eighteenth century, and (2) that ceramic table wares may have been produced to compete for the same markets as imported wares and might therefore exhibit decorative and formal attributes derivative from these wares. Analysis of the Parker site redware included typological classification and quantitative study of redware types and vessel forms.

Redware from the Parker site was classified by an attribute analysis approach that involved classifying and recording essential attributes of each redware sherd (Redman 1978:163). For purposes of this study, essential attributes included body wall thickness, location of glaze (interior, exterior, interior and exterior, or no glaze), presence of slip decoration, presence of plastic decoration such as tooling and incising, and glaze color. Glaze color classification had as its objective the identification of likely glaze colorants and was undertaken with the use of a glaze color reference collection specially developed for this project.

Parker site redware displayed the range in body color and hardness characteristic of New England glacial clay when fired in variable atmospheres at temperatures ranging between 700 and 1000° C. Because body color may vary considerably within single sherds and pots, this was not considered an essential attribute for purposes of this analysis. Redware wasters, or sherds exhibiting imperfections resulting from any stage of the manufacturing process, were classified according to the manufacturing defect. These and other sherds too badly fractured to permit classification of attributes were excluded from the analysis.

Attributes of body wall thickness and glaze location were cross-correlated for 134 sherds out of a total of 318 sherds recovered from Stratum 7, the

remainder being too fragmented to permit identification (Table 4.1). The cross-correlation of these attributes has been used with some success to discriminate between broad categories of redware vessels at the Marshall pottery site in Portsmouth, New Hampshire, for the period 1736-1749 (Pendery, Chapter 6, this volume). Slightly more than half of the Parker site redware sherds (54%) exceeded an average wall thickness of 7.8 mm, the limit for most redware table ware forms. Ninety-four percent of these were glazed on the interior only, another probable indicator of non-table ware status.

Of the 46% of the total number of sherds ($n = 134$) that fell within the thickness range for table wares, 63% of these were glazed on the interior only, a possible indication of such forms as custard cups and saucers. Only 10% of the identifiable sherds falling within the table ware thickness range were glazed both on the interior and exterior, possibly representing such forms as tea bowls, bowls, porringers, or toilet wares.

The decorative treatment of 116 identifiable sherds out of the total sample of 318 sherds from the site was analyzed and essential variables were cross-tabulated (Table 4.2). Seventy-one percent of the sherds showed no decorative treatment while the remainder revealed some slip trailing (1%), tooling (6%), or staining of glazes with manganese, iron, or copper oxides or various combinations of these (16%), achieving surface effects similar to those found on Jackfield-type wares, manganese-glazed wares, and Wedgwood or Whieldon-type wares, respectively (Celoria and Kelly 1973:14; Kelly and Greaves 1974:3; Turnbaugh 1977:218). Unglazed pots (7%) may represent saggars, flowerpots, or butter pots. This evidence seems to suggest that imitative table wares were being produced by the Parkers but that they accounted for a small percentage of the total production.

The Parker site ceramics were badly fragmented and reconstruction efforts yielded no complete vessels. Their forms could be identified by their distinc-

Table 4.1

Structural Attributes of Earthenware from the Parker Pottery Site

Wall thickness (mm)	Attribute ($n = 134$)				
	Unglazed	Interior only	Exterior and interior	Exterior only	Total
1.8–3.7	—	—	—	—	—
3.8–5.7	—	.05	.07	.02	.14
5.8–7.7	.02	.24	.03	.03	.32
7.8–9.7	—	.28	—	—	.28
9.8–11.7	.01	.18	.01	—	.20
11.8–13.7	.01	.05	—	—	.06
13.8–15.7	—	—	—	—	—
	.04	.80	.11	.05	1.00

Table 4.2

Decorative Attributes of Earthenware from the Parker Pottery Site

Glaze color	Decoration (n = 116)				
	Plastic and slip	Plastic	Slip	None	Total
Plain	—	—	—	.27	.27
Mottled brown	—	—	.01	—	.01
Iron brown	—	—	—	.02	.02
Manganese black	—	—	—	.03	.03
Copper brown	—	—	—	.03	.03
Two colors	—	—	—	.03	.03
Manganese and iron	—	—	—	.04	.04
Plain/green	—	.06	—	.44	.50
Unglazed	—	—	—	.07	.07
	—	.06	.01	.93	1.00

tive rim profiles, an approach that has been used with some success to characterize production at other kiln sites (Orton 1970; Pendery and Chase 1977:30; Turnbaugh 1976, 1977, 1983). Of 318 sherds analyzed from the Parker site, only 35 rim sherds could be identified (Figure 4.3). The majority of the identified sherds (31.4%) represented variants of common pots with a wide range of rim profiles. This may indicate the presence of several craftsmen at the site turning vessels of similar form. Another 28.6% of the sherds represented more standardized rim forms of the common pot, while 22.8% of the identified rim sherds represented milkpans, and 14.2% represented platters or dish forms of graduated sizes, from saucers to pie plates (11.4%).

DISCUSSION

Archaeological evidence from the Parker pottery site supports the inference that mid-eighteenth-century Charlestown potters manufactured table wares imitating specific British earthenwares types. However, the economic significance of table ware production relative to that of other types of wares is difficult to estimate on the basis of archaeological evidence alone. Sherds from the Parker pottery waster dump suggest that table wares accounted for less than half of the total production during the second quarter of the eighteenth century, while the evidence from John Parker's account book for the period 1747–1757 indicates that it was slightly more than half the total production for at least three Charlestown potteries. Two explanations for this discrepancy are proposed that concern (1) the archaeological focus provided by multicomponent urban pottery sites, and (2) appropriate strategies for sampling and quantifying wares from waster dumps.

As used by James Deetz (1977:94) the archaeological sense of the term "focus" refers to the degree to which archaeological remains may be read or interpreted according to a particular problem at hand. Visibility refers to the actual amount of physical remains present, whether or not any patterning is obvious. Waster dumps at pottery sites are often high in visibility; but their focus, or associations with specific potters or phases of production, may be weak due to mixing and redeposition of wasters and other problems associated with the archaeological context.

Our understanding of the wares produced at the Parkers pottery on the basis of archaeological evidence is perhaps conditioned by the less than perfect archaeological focus the site provides on phases of production of specific Parker family members successively working at the site and using the same kiln. This problem would be compounded in major pottery centers such as Charlestown where potters routinely rented out their facilities to each other (Parker 1747-1757). In this context, the community level of production would appear to be a more appropriate archaelogical unit of analysis than the family workshop.

The second problem concerns the quantification of ceramic sherds from kiln sites. Our calculation of original production frequencies for ceramic vessels requires the computation of their respective waster rates, since certain vessel forms are more likely to be spoiled during production than others and to be overrepresented archaeologically (Orton 1978:401). The Parker account book provides no information on waster rates, and there are no relevant replicative experiments or analogous ethnographic data to provide the basis for an estimate.

Calculation of the frequency of production of vessel types on the basis of sherd counts also requires a correction factor for differences in the size and shape of ceramic vessels. Unless adjustments are made, there will be a bias in the overrepresentation of larger vessels or vessels with greater rim diameter if sherd counts are the basis for quantification (Orton 1980:161-167). Correction factors were not applied in the study of the Parker wasters, which may explain the higher frequency of more robust, utilitarian forms such as milkpans and common pots.

To conclude, combined archaeological and documentary evidence from colonial Charlestown pottery sites indicates that table ware made up a major part of the total output of individual workshops. Decorative and formal attributes of locally manufactured table ware forms appear to have been derived from specific British ceramic types, suggesting competition with British potters for the same colonial markets. Evidence from the John Parker account book for the production and distribution of these wares through intercolonial trade networks may explain the prosperity of Charlestown's community of potters during the first half of the eighteenth century and a commensurate loss of

these same markets to British earthenware manufacturers. The absence of official documentation on production and distribution of wares may reflect concern among craftsmen that their activities might be regulated by crown officials.

The use of documentary controls for interpreting the archaeological evidence from colonial manufacturing sites may contribute to the refinement of quantitative approaches to the study of early American manufacturing. Documentary evidence in the form of account books and shipping manifests may also be used to generate predictive models for the production and distribution of manufactured goods in the past. The scarcity of reliable documentation on New England pottery production underscores the need for archaeological investigation of kiln sites and the quantitative as well as stylistic analysis of ceramic production.

ACKNOWLEDGMENTS

The author would like to thank Eric Liskin and members of the Charlestown archaeological survey team of the Institute for Conservation Archaeology, Peabody Museum, Harvard University, The Massachusetts Department of Public Works, and the Charlestown Preservation Society for their respective contributions to the study of the Parker pottery site.

5
Chapter

Re-Creating Ceramic Production and Tradition in a Living History Laboratory

John Worrell

The potter reached out and took a small lump of clay in his right hand. He squeezed it firmly into an oblong mass about one inch thick, precisely contoured to the irregular hollow of the inside of his fist (Figure 5.1). It was exactly what he needed: a custom-made piece of "kiln furniture." He knew that in loading a kiln for firing, the precise arrangement of vessels was of critical importance. Otherwise, the heat flow from the wood fires in the boxes on opposite sides of the kiln would not circulate evenly, resulting in some pots being underbaked and some overbaked.

Experience had taught him what was needed for a particular pot in that particular position, and he shaped the crude lump on the spot. It was just right, and the rim of the small vessel for which it was created pressed lightly into its surface, ready for "two days and a night, burning the kiln" (Brooks 1819).

This story is true. The time was 160 years ago; the place, a small agricultural and crafts neighborhood called "South End" in Goshen, Connecticut (Figure 5.2). The potter was a fascinating farmer–craftsman named Hervey Brooks. The shop in which this event took place is now at Old Sturbridge Village, where the kiln has been reproduced and functions as a part of the living history museum's pottery interpretation. And the hastily-formed lump

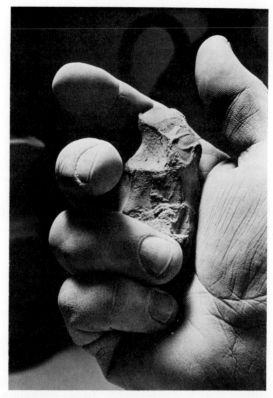

Figure 5.1 Hand-formed clay lump used in kiln stacking. Tight stratigraphy and documentary evidence assign the use of this ad hoc clay pinch to the 1819-1820 firings of Hervey Brooks (courtesy, Robert S. Arnold, Old Sturbridge Village).

of clay is now in the archaeology lab there, still perfectly recording the activity which produced it—including every detail of the palm and fingerprints of the hand which formed it, as well as the imprint of the vessel it supported in that kiln firing so long ago. The same baking which transformed the kiln load of raw clay vessels into usable redware pots hardened that throw-away clay lump into the ceramic record of a routine detail of Brooks's work, impervious to time and protected from wear. A person can still take it in hand, close the fingers around it, and feel exactly how it was created, even to the point of comparing one's own hand size with that of the potter. More than an artifact, this object describes a *kinetifact:* the fixed evidence of motion and patterned action. It is a most dramatic example of the link between the everyday processes of the past, the static artifact that these produced, and the "living history" interpretation of the present day (Worrell and Jenkinson 1981:4-6).

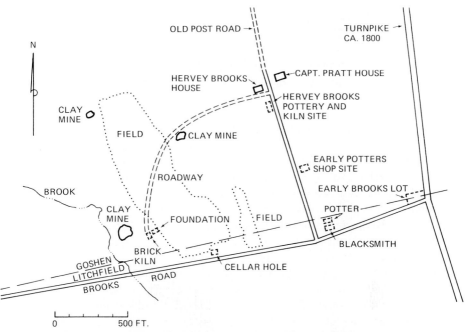

Figure 5.2 Map of archaeological features located in the crafts neighborhood of the South End of Goshen, Connecticut (courtesy, John Worrell and C. J. Pelletier).

This chapter considers the manufacture of domestic pottery and kinetifacts, which are derived by integrating static archaeological data and historical documentation with pottery replication and experimentation. The research objective from the outset has been to utilize every material and kinetic resource available to understand the many unrecorded details of the potter's craft. The technologies and forms used by the domestic potter Hervey Brooks are reconstructed in this way. They then may be compared and contrasted with the British pottery traditions from which the domestic technologies derived. The synergism of combining these diverse approaches into an integrated research strategy compounds the reliability of data derived from the individual resources and frequently suggests interpretive possibilities that were not evident from the resources in isolation. Historic reenactment provides the dimension of motion that is necessary for testing processes and for fitting them into interacting systems of behavior like those for which they were originally constructed. It permits researchers to study kinetifacts, rather than mere artifacts, as they attempt to reconstruct cultural process systems. This makes an otherwise static interpretation dynamic.

EXPERIMENTATION AND LIVING
HISTORY INTERPRETATION

Rural farmer-craftsmen like the potter Hervey Brooks, who plied his craft in Goshen, Connecticut, from 1795 to 1867, were a regular component of the local economic system throughout all of rural New England from the time of settlement until well into the nineteenth century (Barber and Hamell 1974; Lynn 1969; Stradling and Stradling 1977; Watkins 1945, 1950; Worrell 1983; Worrell and Jenkinson 1981). The commodities that they provided were necessary to domestic and agricultural life and are often among the most numerous artifacts to be retrieved from historic archaeological sites. However, rural potters were so taken for granted that only the sparsest evidence for them exists in primary documentation (Barka 1973:291; Friedman 1978:15–16, 52; *Old Sturbridge Village Curatorial Files* [OSV] 1961; Worrell, Chapter 9, this volume), and virtually none of this information includes technical production data. Consequently it is difficult to document the extent to which the early American potters followed European-derived traditions and the extent to which they diverged from the traditions as initially transplanted.

The Brooks Pottery Project of Old Sturbridge Village demonstrates the value of an integrated research methodology for reconstructing and evaluating past human behavior on a variety of levels, ranging from the examination of an individual's technical performance or energy expenditure and efficiency to more general observations regarding social and cognitive values. The complementary advantages that result from combining the comprehensive techniques of archaeological investigation with exhaustive analysis of primary and secondary documentary sources are amply testified to in the archaeological literature. Yet, imitative experimentation with past technologies only recently has begun to be established in the discipline of historical archaeology (Ingersoll *et al.* 1977). The re-creation of past material culture (experimental archaeology) and the reenactment of past cultural behavior in an interactive context (living history) are essentially two sides of the same coin. Both components have been used at Old Sturbridge Village in combination with archaeological and historical data to reconstruct a valid early nineteenth-century cultural setting. The reconstructed organic community in this type of setting re-creates the dynamic relationships between social, economic, and technological processes. In this way, the broader cultural units of neighborhood and community also can be considered, as can the smaller unit of a specific production craft (Friedman 1978:1–12).

Despite these advantages, the living history museum context is not an unmixed blessing to the researcher. Reenacting past cultural behavior for public interpretation is not the same as re-creating past material culture for pure research into technics or historical fabrication processes. Nevertheless, re-

search into the re-creation of low technology production at Old Sturbridge Village has proven the value of museum experimentation. It has also demonstrated some of the perils in evaluating historical or archaelogical experimentation done in any context (Worrell 1979:4-6).

Perhaps the most important category of information to be learned from re-creation of the historic process derives from developing and understanding appropriate patterns of motion. The human interaction with equipment that produces a product most efficiently develops habits over time which leave their tracks in the use environment and in the artifacts themselves. Observing what is done with regularity, and how that affects the facilities used and the products created, allows for the construction of testable patterns to be identified in the materials from a historic or archaeological context.

Such kinetifacts have been observed in the dynamic system of pottery production in the re-created process at Old Sturbridge Village and have been used to interpret the work patterns and probable motions of a historic practitioner, Hervey Brooks. The grammar of this potter's gestures, the demands of his craft as they abet or conflict with other demands in an agricultural neighborhood, the orchestration of form and function in the manufacture of a desired commodity within his social and economic unit, his spatial or structural world—all these concerns are provided with data for testing through reenactment.

CERAMIC PRODUCTION RESEARCH AND EXPERIMENTATION: THE INTEGRATED METHODOLOGY

Extensive excavations (1978-1981) at the Brooks production shop and kiln site (ca. 1818-1867) in Goshen, Connecticut, have provided the basic data for broader research into earthenware manufacture in small-scale agricultural contexts. Survey of four other sites in the Goshen area, along with that of several ancillary sites including clay pits, brick kilns, and the neighborhood agricultural network, has been set in a well-documented historical framework (Figure 5.2). Other sites in central New England, removed from Goshen but sharing the temporal and economic parameters of late eighteenth-century agricultural community settings, have been investigated archaeologically for comparative data (Worrell and Jenkinson 1981; Worrell 1983). Details of materials used in production, glazing, stacking, and firing are being analyzed and compared with the materials from Goshen. The processess and procedures and then tested in museum reenactment and reproduction.

Historical documentation of local ceramic processes and facilities is lamentably sparse (OSV 1961; Worrell, Chapter 9, this volume). This dearth of

documentation appears to be the general situation for the eastern United States (Barka 1973:291). Some comparative documentation can be gathered from Great Britain where the extensive ceramic industry is somewhat better known for the period (Brears 1971:137). Though many British pottery-making traditions were transplanted to this colony, regional variations in rural America are strongly suggested by available data, and to extend the comparative context beyond New England strains the already tenuous state of comparative inference. The problem of improper comparisons is exacerbated by the fact that the better-known English examples derive from larger industrial sites, while we have been researching the small part-time farmer-potter. The latter was a regular phenomenon of the scattered agricultural crafts neighborhoods which populated rural New England and the American frontiers well into the nineteenth century (Watkins 1945, 1950). So in many respects these rural American data are not comparable to the more complex British industry.

The primary source literature relating directly to earthenware kilns of the agrarian New England landscape includes land deeds, inventories, tax records, census records, town ordinances, letters, diaries, books of trades, encyclopedias, travel accounts, and the like. Searching the documentation is often unproductive, but it has produced valuable information concerning social history. However, only the most limited and sporadic documentation of the structure of kilns or production processes has been located in these documents (Friedman 1978:15-16). The limited documentation that is available is often inherently biased. It is of radically uneven quality, and reference must be made to widely diverse times, cultures, and economic situations to collect enough even roughly to generalize (Friedman 1978:52). Data can be amassed to present a convincing picture about a rural New England potter's farmyard, household, and neighborhood; but the documents describe virtually nothing of his shop, his kiln, or his craft.

To fill this void in the documentary record, researchers at Old Sturbridge Village have combined archaeology, materials study, and considerable experimentation to obtain a reliable understanding of the technical and processual details. Potters began in 1975 to experiment with a variety of materials and techniques in an attempt to understand the principles of the basic process before moving on to the complex reconstruction of facilities, materials, and actions necessary for the historic reenactment of earthenware manufacture.

They began to study different glaze combinations and to prepare them in the glaze mill. They varied stacking techniques in the kilns and recorded the results. They explored varying methods of working, preparing, and aging the clay. They then began to compare their conclusions with assumptions derived from the study of the social history of the period and they related their data to other cultural contexts. Most important, the questions about late eigh-

teenth- to early nineteenth-century ceramic production in rural New England became less and less confined by technics. As the research progressed, its strategy came increasingly to be framed by the situation of the craft and its product within the neighborhood exchange network of the agrarian economy (Worrell, Chapter 9, this volume). And the product itself, the pottery, was considered in the context of foodways—preserving, cooking, and serving in these vessels—as a complement to the research questions about the farmer-potter's craft (Friedman 1978:8-9).

The experimentation at Old Sturbridge Village began with small-scale kilns in order to acquaint the potters with the properties of the materials involved and the effects of different strategies of construction and firing. The potters first used primitive sod and clay kilns having prehistoric prototypes, kilns of early Mediterranean types made of brick and potsherds, and small beehive kilns of Roman period prototypes known from English remains. They then moved to scale model kilns, resembling early New England beehive and bottle kilns, on the way to using full-scale reproductions of kilns based on archaeological data from rural New England sites.

The systemic nature of the process was gradually unravelled. Variations in size and shape of the stacking chamber, fireboxes, flue, or mass of unfired ceramics necessitated other adjustments in firing time or temperatures, types of fuel, stacking arrangements, and vessel characteristics. It gradually became clear that only a complex blend of technical, material, and procedural factors could produce optimal efficiency or superior products, and the individual craftsman's "feel" for his work was a determining component. This complexity of the craft, no doubt, helps to explain the diversity of physical attributes that often can be observed within historic ceramic types made by a single artisan. Yet, it remains to be ascertained exactly how much of this variation might be intentional and how much inadvertent.

While the potters were undertaking the initial experimental replication, researchers began the multidimensional investigation of early nineteenth-century redware manufacture, focusing on Hervey Brooks and the crafts neighborhood of Goshen's South End. All personnel were involved in as broad a range of the several approaches—archaeological techniques, documentary research, and experimentation—as was feasible. Potters, for example, dug in the dirt and researched deeds as well as experimenting with kilns and clays. Insights derived from turning an eye that was skilled in one aspect toward a different medium of research in the company of one trained in that medium proved invaluable.

For example, the brief notation in Brooks's account book to the credit of Norman Wadhams, May 19, 1827, "By a Stone for a Clay Cellar" was puzzling. Yet, it gave a hint about one unrecognized feature of his production shop. No one knew what a "clay cellar" was, nor what was meant by the

"stone," for documentation and actual examples were not found to exist. Our potters surmised the function from a need they found in their own operation. It must be a facility, they thought, for storing prepared clay in an appropriate climate, ready to throw on a wheel. But was the "clay cellar" outside, or was it a basement in Brooks's work shop?

Excavation of the Brooks site provided the answers. We discovered a "clay cellar" located near a lime-plaster pad which we determined to be for drying the moist clay fresh from the pug mill. Excavation also revealed a huge dressed stone that still had balls of prepared clay upon it as well as the remains of lower courses of the brick sides of the cellar. Only the account book entry plus our potters' knowledge allowed us to identify this feature. In turn, knowing its size, position, and facilities provided an important key to the flow of materials, the work patterns, and the sequencing of activities in Brooks's shop. The space-use and work-flow information then helped us to determine the probable location of Brooks's turning wheel and other features of the process. This synergistic methodology allowed us to reconstruct activities which left evidence too sparse to be recognized by using only a single independent approach. And these interpretations provided a kinetic system that our own potters could comfortably and reliably reproduce in a living history context.

Reconstructing more general neighborhood features has been as important as reconstructing the potter's workspace in order fully to understand and interpret this craft (Figure 5.2). A synopsis of major events in Brooks's career helps to illustrate this point. In 1818, in partnership with another potter named David Vaill, Brooks fired seven or eight kiln loads of ware—a prodigious feat. By 1819 he was using his own shop as a kiln shed, though he continued to make the pots in Vaill's shop. Brooks made and fired eleven loads of ware in 1819 and 1820, having rebuilt the kiln after nine firings. Archaeological and historical information regarding this rebuilding is conclusive and provides a rare absolute date for a distinct archaeological separation. A terse comment in Brooks's ledger fixes the date as September 1820; the archaeological scatter of dismantling and construction debris provides a clear stratigraphic separation. Combined, these have allowed us to sort the residues from the respective firings virtually by month.

Following that burst of activity in 1818-1820, Brooks's potting slacked off. He may not have fired another load of ware until after 1827, by which time he had moved all of the pottery manufacture into his original kiln shed and had rebuilt the kiln elsewhere. Brooks normally fired his kiln only once per year thereafter.

An insert of pages loosely sewn into Brooks's early account book is headed "An account of my expenses in and at the Shop for 1819." It spans the period of the eleven kiln firings and lists only those expenditures of work and money that directly pertain to potting, including digging clay, cutting wood, pugging,

turning, glazing, stacking the kiln, firing, "drawing" the fired vessels from the kiln, and hauling loads of ware to various specified points. No other such production account is known to exist. None of the records in any way provides technical or material information about his work, so all inferences of process and product must be derived from the archaeological and experimental resources.

The only kiln of ware that Brooks ever itemized completely, so far as existing records show, was his first, in 1802. It included 767 pieces. The kiln used in 1802 was not the same one used for the eleven firings of 1819–1820, which we excavated, but it would appear to have been of similar size and capacity, judging from theoretical and experimental reconstructions. That would suggest a total production of between 8000 and 9000 vessels for the eleven firings during the two years 1819 and 1820. Adding the 1818 production with David Vaill would raise the three-year total to between 14,000 and 15,000 vessels. This appears to have provided an inventory overstock from which Brooks sold without further production until 1828. Thereafter, he seems to have regarded himself not as a potter but as a farmer who, among other things, usually produced a kiln-load of ware each year (Worrell, Chapter 9, this volume). Archaeology has provided the details of the shrinking of his enterprise into the more compact, small-scale operation of the rural farmer potter.

These data illuminate aspects of Brooks's life in Goshen, Connecticut. In relation to more general cultural trends, Hervey Brooks appears to have made an untimely attempt to enter the ranks of large-scale ceramic production. His prodigious surge of productivity in 1818–1820 came just at the advent of what was to be a permanent decline in demand for domestic earthenware. A complicated convergence of technical and economic factors relating to foodways, agricultural economics, and available products in the early nineteenth century caused local rural ceramic production to be obsolete by mid-century (Worrell, Chapter 9, this volume). The availability of tinware and stoneware, particularly, altered the market, and only those centers of the craft which moved into ware diversification (i.e., including the much more difficult stoneware manufacture) and mass production usually survived.

RE-CREATION OF THE HISTORICAL PROCESS

As the interpretive craftsman tests his tools and raw materials, he likewise is gaining experiential judgment regarding the type and level of skill demanded by any particular effort in which he is engaged. And in reproducing the inventory that his prototype would have made (Figure 5.3), he gains an appreciation for the self-understanding of his historical counterpart. Pride and

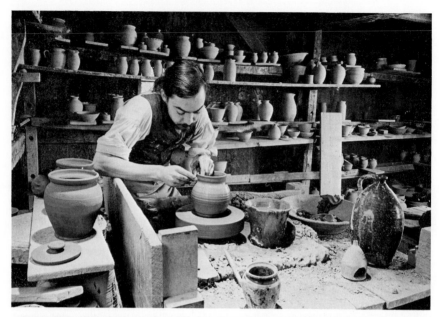

Figure 5.3 The arrangement of the workspace at Old Sturbridge Village reconstructs the pattern discerned through excavation of Brooks's shop. Process reenactment moves materials through space, reconstructing the kinetifact (patterned action) of the historic potter (courtesy, Robert S. Arnold, Old Sturbridge Village).

monotony, satisfaction and fatigue, skill and technique all become a part of the perception of another era that can only be learned from performance in the appropriate manner and context. These are nonmaterial aspects of history which are every bit as urgent for authentic interpretation as are the artifacts. The potter who digs the clay and moves it through every stage of its treatment until he loads a cart with fragile ware and transports it clanking down the road develops an enhanced perception of the reasonable rhythms and consequences of his work that will never issue from the diligent digestion of data gleaned from documents, excavations, or artifact analysis.

Techniques of firing earthen materials with wood were commonplace for millennia. During the past 150 years they have become very uncommon. The age-old and intimate knowledge of wood as a source of concentrated energy, and the eccentricities of its combustion upon "the delicate and brittle material combinations of sand and clay and the thinnest surfaces of iron, copper, lead, antimony, zinc, cobalt" and manganese, had to be arduously relearned (Friedman 1978:2). Therefore, in 1979, using early nineteenth-century building techniques and materials and following archaeologically derived structural information, a full-scale replica bottle kiln was built near Brooks's restored shop in Old Sturbridge Village (Figure 5.4).

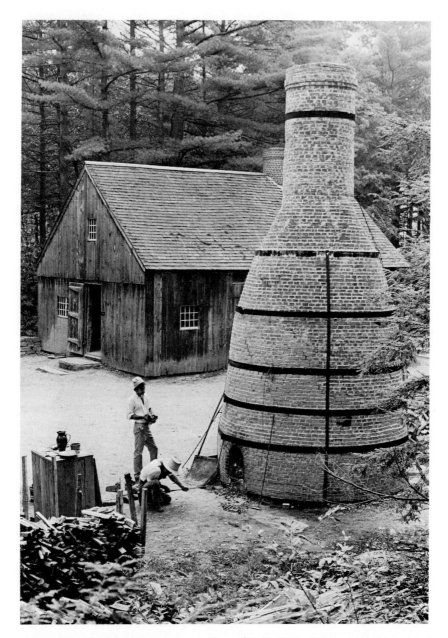

Figure 5.4 The full-scale reproduction kiln at Old Sturbridge Village, located in front of Hervey Brooks's restored shop (courtesy, Robert S. Arnold, Old Sturbridge Village).

This reproduction is faithful to the design, shape, size, and materials of the kiln excavated in Goshen, so far as those details could be determined. But only nine courses of brick remained from Brooks's kiln, so the superstructure was conjectured from period depictions of kilns elsewhere. That it was a bottle kiln is evident from its placement inside a shed, necessitating a smokestack. We added a damper and iron bands to control damage from expansion and contraction. Both are known to have been used in commercial potteries during the period. But that a small producer like Brooks would have had them can only be surmised as probable based on our replicative experience, which has demonstrated both to be important if not vital features. Adding a stack to a kiln of this size and configuration inevitably produces drafts that are too strong, once full firing in the opposing fire boxes is begun. Only reducing the size of the throat opening in the stack by adding a damper will allow the heat retention necessary to induce a regular temperature increase. The iron bands help control uneven expansion of the structure during firing and prevent drastic collapse (Jenkinson 1981:2-3).

At this writing, the kiln has been fired more than sixteen times. The procedure has settled into predictable patterns which make the work move smoothly, allowing increasingly better understanding of the process for both the potters and the visiting public. We begin the slow and progressive temperature rise with hardwood fires, watching carefully for tangible physical signals of change by which to govern the stoking. Although modern devices such as pyrometers and clocks are used in the monitoring, the potters have come to understand and interpret clues to their senses—the feel of the outside of the kiln, the color of the wares and of the atmosphere in the kiln, the escaping steam from the walls, the volume and pitch of the sound of the fire, among others—which add up to a system of process-evaluation. Once this "feel" for the process becomes "natural" to them, the modern craftsmen find themselves relying on these sensual cues to the exclusion of the modern devices—undoubtedly re-creating the same patterns of empirical awareness and response by which Hervey Brooks and his contemporaries plied their craft (see Lasansky 1979:9).

As the temperature approaches 550° C (1000° F), steam escapes from the outer layers of brick of the kiln, and the hardwood is split to smaller sizes to increase the burning. Next the change is made from hardwood to pine, which burns much faster and generally generates a temperature increase of about 65° C (150° F) per hour. Weather conditions can very this considerably, it has been found. Peak temperature, sufficient to set the glaze on the hardened pots, is in the 980-1040° C (1800-1900° F) range. The glow in the kiln is the primary evidence relied upon, but one or more small vessels is usually withdrawn and plunged into water to verify that the glazing process has climaxed satisfactorily. To allow for a slow temperature decline, and so

not induce crazing or cracking from too precipitate a drop, pine is stoked slowly for about an hour, followed by hardwood for at least twice that amount of time. The fireboxes are then bricked up and the period of slow cooling begins, to take a minimum of 24 hours. An average firing converts about one cord of hardwood and three of pine to the energy necessary to bake the clay and melt the glaze (Jenkinson 1981:1-5).

While this process runs fairly smoothly, it is not without complications. The kiln, for instance, suffers some heat deterioration each time it is fired—just as Brooks's did. So it must be regularly repaired. Heat damage to various parts of the kiln structure differs dramatically. Most of these variations follow predictions we had derived from observations of Brooks's kiln remains (Worrell 1982b:55, 67-71) and from consultation with modern ceramics production personnel, including engineers. During excavation, we had sectioned portions of Brooks's firebox, stacking platform, and kiln foundation, carefully recording the precise location of all materials removed. We then analyzed types and degrees of heat alteration. The careful monitoring of changes in materials throughout our modern structure, when compared with data from the analysis of the historical fabric, allows us to evaluate how closely we are reproducing the same effects.

Conversely, by watching those effects transpire in our reenactment, our potters develop a much fuller understanding of the historical craftsman's problems, and our interpretations of events represented in the archaeological record are refined. The most drastically affected areas, for example, are those points of the stacking platforms nearest the firebox. We need to repair or replace materials in that vicinity after no more than two firings. Brooks's structure in that area showed multiple rebuildings, including repositioning altered brick from the exposed surfaces into the protected interior.

Maintenance and repair was certainly an important constituent of the potter's workload. Predictable and preventive maintenance and repair would be scheduled into his regular work routine, and he had some flexibility in working it in. Weather and other demands on the potter's time would be the major external influences on that work. Although many kinds of maintenance and repair are regular and predictable, under even the best of circumstances firing is a perilous enterprise, not entirely subject to human control. Consequently, some unanticipated collapse occasionally requires emergency repair.

It is not possible to ascertain from the existing material evidence whether or not Brooks used any form of temporary baffles or bag walls during firing. Our experimentation has shown that this practice can greatly vary the normal heat patterns. The hot spots that cause the most trouble, especially in the vicinity of the fire mouths, can be considerably alleviated by baffling, and heat flow currents can be redirected according to interior placements. However, there is no evidence to suggest that Brooks used firebrick of any sort, and

regular brick is subject to the same deteriorative effects from heat as the vessels and shelves.

Our excavations in 1981 at the James Moore pottery site in Brimfield, Massachusetts, (ca. 1793-1828) and at the kiln site of an anonymous mid-to late eighteenth-century potter in Woodstock, Connecticut, and 1984-1985 excavations at the kiln of eighteenth-century potter John Hinds in Holland, Massachusets, have all produced heat-altered flat stones which may have been used for temporary baffling (Worrell 1983). The firing ejecta recovered in the Brooks excavations contained numerous large chunks of what appear to be thoroughly vitrified brick, leading to the suggestion that he may have found it worthwhile to sacrifice some brick for temporary baffling. Our experimentation with baffling using regular brick has demonstrated it to be of sufficient help and limited enough peril that it might have been considered worth the sacrifice, especially to a potter who made his own brick.

Examination of materials scatter from our reenactment site has been compared with that excavated and recorded in situ at the Brooks site. Some virtually identical assemblages have occurred. These include materials left by glazing the pots in front of the kiln, from the bricking and unbricking of the loading door, from the ad hoc production of wedges and gobs for leveling vessels during stacking, and residues from firebox cleanout both during and after a firing. These assemblages join the ceramics, the stacking furniture, and the alterations to the kiln itself in providing reliable interpretive data for the firing process and its results. These artifacts and kinetifacts, so understood, bear considerable interpretive potential for data from other sites that might otherwise remain unidentified or be regarded as insignificant. The vitrification of bricks and of pots in various parts of the kiln and that caused by over- or underfiring due to collapse can likewise be assessed empirically, as well as by relying simply on documentation (Watkins 1945:36).

Whatever the specific cause, Brooks lost a great deal of ware due to overheating and cracking. His accounts show that he regularly sold warped and kiln-damaged wares, always at reduced prices (Worrell 1982b:94-97; Lynn 1969:32). The fact that there was a steady market for these lower-priced but serviceable "seconds" demonstrates the primary utilitarian function of the commodity in the economic structure. But the last firing of the kiln we excavated appears to have had more than the usual degree of problems and may have contributed to Brooks's decision to remove the kiln from the building. It left slag, damaged vessels and furniture, and heat-altered kiln components in great abundance. Our own efforts fortunately have not yet resulted in such extensive damage.

As process reenactment continues, so does the experimental variation. Changes are made in ware inventories, glazes, stacking furniture and arrangements, and wood-burning schedules. Our first full-scale reproduction

firing based the contents of the kiln on a period inventory. Large vessels pre-
dominated, including milkpans, half-gallon and two-gallon jugs, pie pans,
and straight-sided storage jars in three sizes. While the inventory listed vessel
types, it gave no characteristics other than "small, middling, large." The sizes
and formal details were therefore copied from items in collections. Subse-
quent firings have included larger amounts of smaller vessels such as mugs,
inkwells, and small beanpots, and have also presented the opportunity to
experiment with the effects of varying stacking placements and arrangements.
As with Brooks's wares, modern smaller pieces are often glazed both on the
inside and out, while the large ones generally have only interior glaze (Jen-
kinson 1981:3). Placing smaller vessels inside larger ones, introducing baffles
near the fire mouths, and placing similarly glazed vessels at different points
in the kiln are among several techniques that we have used to gain experi-
mental information.

Modern safety considerations have occasionally intruded into our repro-
duction of the historic processes and materials. Glazing provides one ex-
ample. Traditionally a lead-glaze coating was applied to the ware to render
it impermeable to liquids. A common formula was four parts lead oxide, two
parts clay and one part sand. The ingredients were pulverized together in a
hand-operated stone mill and then mixed with water (Jenkinson 1981). The
pottery was coated with liquid glaze by pouring or dipping prior to stacking
it in the kiln. This was usually done immediately in the vicinity of the kiln
loading area (Worrell 1982b:34-35, 69-70; 1983). The lead fluxes the sand
into an even silicate glaze at a temperature between 925-980° C (1700°
and 1800° F) which is low enough to avoid damage to the clay vessels,
shelves, and brick. Although we have used lead glaze for experimental pur-
poses, virtually always with great success, the toxicity of lead makes the
vessels produced unusable according to modern safety laws. Despite exper-
imentation with various safer alteratives, such as borax or frits (Jenkinson
1981), we are still faced with the major problem of finding a nontoxic glazing
compound that will set at a low enough temperature in a kiln atmosphere
containing variable quantities of impurities such as wood ash and water va-
por.

Experimentation has further demonstrated that decorative glazes increase
production difficulties in ways that were not suspected and to degrees that
are not yet fully understood. We knew that the addition of manganese, iron
compounds, and other metallic coloring agents might increase the temper-
ature necessary for successful glazing and for gaining the desired coloration.
However, we have discovered that the intricacies of the process involve far
more complex interactions than simple temperature variations and chemical
ratios might suggest. As examples, a manganese compound that regularly
produces a lustrous black glaze has occasionally become bright green, and

iron additives have glazed irregularly in different spots on the same vessel. This is a fertile field for further careful testing. The experimental data provide information about the historic process and an otherwise unattainable understanding of the vicissitudes a craftsman necessarily confronted.

Experimentation with different stacking arrangements in the kiln has provided another interpretive resource. Milkpans, for example, may have made up the most frequent single vessel type in a typical rural potter's production inventory, just as they did in traditional English lifeways (Anderson, in Deetz 1973:25–26). The low, sloping sides of the fragile raw pans make it difficult for them to support much more than their own weight. Therefore, arranging them conveniently to allow firing hundreds at a time without their breaking, warping, or fusing together presents a critical challenge to the potter. The triangular shelves that Brooks used provided a solution to several related problems in this regard. They allow each pan to be independently suspended. The separation between them approximates that minimally needed for air flow.

Such efficient space usage was crucial to the potter whose time and energy expenditure in firing was appreciably lessened by adding more pots to the kiln rather than having to make additional firings. Furthermore, the stacked columns of shelves themselves form sturdy supports that do not collapse easily. Experimentation with similar materials and arrangements has shown us that an individual pan may collapse during firing with no damage to vessels other than itself and perhaps those immediately adjacent. This drastically reduces the likelihood of the "chain-reaction collapse" which must have been the nightmare of every potter (Lasansky 1979:9).

The use of nested pans supported by columns of stacking shelves in the fashion described has been found to allow virtually no tolerance for size variation or asymmetry. Both pan and shelf must be true, and the stacking itself has to be done with precision (MacFarlane 1951:42), often necessitating the use of small ad hoc clay wedges and pinches (Figure 5.1) that have been found in kiln ejecta (Worrell 1982b, 1983).

Most vessels other than milkpans and platters do not share the leverage disadvantage in stacking caused by shallow, sloping sides. They therefore allow much more flexibility in stacking. There is a direct correlation between the degree of verticality of the side of a vessel and its supportive strength. Vessels with vertical sides have been found to allow stacking as high as desired in the kiln with minimal external support.

The prodigious quantities of the same vessel that Brooks records throwing on a given day argue for his having developed a routine consistency in stacking. On July 13, 1810, he lists turning ten dozen milkpans and another eight dozen the following day (Worrell 1982b:24). Full appreciation of the near-Herculean effort such productivity involved issues from those who have attempted to emulate it in modern replications. They have also learned that

consistency in the product results from concerted effort of that sort. A cognitive template may have developed from those repetitive efforts, rendering any mechanical measuring device unnecessary and assuring sufficient standardization for true stacking.

Study of the excavated materials and the experience with variation in our own firing have combined to convince us that a great deal of precision is involved in the successful loading and "burning" of a kiln of ware. The potter must necessarily construct the composition of raw vessels and supporting furniture in the kiln with skill and urgency and must orchestrate each stage of the firing with sensitivity.

CONCLUSION

The tough task of all archaeology is to interpret *process*, using primarily artifactual data that are *static*. The dimension of motion usually is missing. Kinetic considerations of cultural processes can be achieved, however. Documentation, excavation, typological analysis, materials studies, model building, experimentation and replication—all of these considerations carry their own advantages, limitations, and biases when treated independently. But collectively, in a sensitively designed research strategy that uses each approach, they allow researchers to describe not only mere artifacts but kinetifacts. Resulting kinetic interpretations can then be tested in a living history context.

This synergistic type of approach limits the options for interpretation to only those conclusions that best fit *all* of their respective perspectives and controls. By thus defining the possibilities and refining the probabilities, both inappropriate hypotheses and flawed or inaccurate interpretations are severely limited. An integrated research methodology enhances the reliability of any conclusion. The Brooks Pottery Project has demonstrated the value of this multifaceted type of approach and has illuminated comparisons of domestic rural pottery making and lifeways with British counterparts.

Historical reportage suffers from the biases of manuscripts. The artifactual record is likewise biased by factors ranging from economics to researchers' interests to the caprice of preservation. Experimental and replicative studies often lack the accuracy provided by documentation and time depth of traditions. Combining Brooks's kiln and shop records with artifacts excavated from the same site filled two very different information sets, adding depth to an otherwise two-dimensional picture. Then, by transforming these historical and archaeological data into hypotheses about function and placement and by reenacting the processes that they suggested experimentally, the interpretation has become not only more valid and multidimensional but also dynamic!

Transformation: Access to Local and World Trade

Part II addresses the transformation of early ceramic production in the Northeast from its transplanted traditional origins. As with most types of traditions—including oral epic, linguistic, and other cultural types—these early Colonial ceramic traditions were dynamic. Once brought to the colonies in the eastern United States, many of these traditions took root. They subsequently drifted in various directions over time and, to a lesser degree, through space. Specific types of external and internal change common to traditions in general affected these domestic ceramic traditions. These transformational processes included dispersion, borrowing, leveling, assimilation, imperfect learning, innovation, specialization, elaboration, and permutation.

Relative degree of access to or isolation from local marketing outlets and cosmopolitan ports of trade, as well as a variety of socioeconomic considerations, affected the direction and extent to which these ceramic traditions drifted in different communities of the Northeast. In some cases, the ceramic traditions degenerated or became simpler due to various socioeconomic factors and processes, such as imperfect learning and leveling (see Pendery, Chapter 6; Gorman *et al.*, Chapter 7). In others, particularly the more isolated, rural towns where life moved at a slower pace, transplanted ceramic traditions remained virtually unchanged in appearance and stayed fairly true to the initially transplanted technologies and forms as self-consciously traditional production was perpetuated through several generations of potters (see Starbuck and Dupré, Chapter 8; Worrell, Chapter 9). In still other instances,

the repertoires of potters appear to have flourished. They became more elaborate, specialized, or complex than their transplanted antecedents had been (see Warner, Chapter 10). Regional styles developed in some drifting traditions and dispersion and cross-fertilization of ideas occurred as well (see Dickinson, Chapter 11). These processes lent still more complexity to the transformation of ceramic traditions that had been initially transplanted.

Six chapters are included in Part II. Each explores the transformation of the drifting ceramic traditions from a different perspective. Pendery examines the increasingly simplified production sequence of redwares made in eighteenth- and nineteenth-century New Hampshire to define the effects of both gradual industrialization of redware manufacture and participation in world trade systems on traditional, family-based pottery manufacture. Gorman, Jones, and Staneko consider possible standardization and streamlining of production of redware products that were sold in bulk to a late eighteenth-century domestic labor force. They interpret leveling in morphological and functional attributes as necessitated by increasing demands for ceramic provision and consumption at the glass factory.

Starbuck and Dupré consider a typical nineteenth-century redware manufacturing community. The authors discuss the potters' self-conscious attempts to prolong production of traditional ceramic techniques and forms despite overwhelming pressures of cultural change. Worrell considers the integral participation of a single nineteenth-century potter, Hervey Brooks, in the traditional barter and exchange system of an agricultural crafts community. The socioeconomic interaction of Brooks with his rural community is examined from the town's efflorescence to its eventual dissolution.

Warner examines change over time in the production inventory of the nineteenth-century Goodwin potters of Connecticut. In order to remain economically viable in light of changing tastes, cultural needs, and fashions, these potters shifted from the production of utilitarian redwares to slip-decorated table wares before finally expanding into stoneware technologies and the manufacture of industrial forms. Dickinson discusses drape-molded, coggle-edged slipware plates and platters and describes 15 varieties of linear decorative elements that form 12 separate decorative groups which may constitute distinct regional styles or possibly traditions. She then examines possible late eighteenth- and early nineteenth-century production loci for these decorative groups and considers the dynamics of regional interaction between Northeastern potters working in Connecticut, New Jersey, New York, and Pennsylvania.

6
Chapter

Changing Redware Production in Southern New Hampshire

Steven R. Pendery

INTRODUCTION

The manufacture of pottery in Great Britain and her North American colonies was radically and permanently transformed during the course of the eighteenth century. New levels of prosperity among middle classes brought an unprecedented propensity for acquiring consumer goods, and popular acceptance of new foodstuffs and beverages generated new ceramic needs (McKendrick 1982:9-145; Roth 1961:74, 80). The accommodation of these expanding consumer needs, which included the consumption of tea, chocolate, and coffee, was a major impetus for stylistic and technological innovation and industrial organization of ceramic manufacture in Great Britain (McKendrick 1982:100-145; Weatherill 1971). North American potteries pursued a parallel but more modest course of production of imitative table wares in pottery centers such as Yorktown, Virginia (Barka and Sheridan 1977; Watkins 1950:56; Watkins and Noël Hume 1967) and Philadelphia (Giannini 1981; Myers 1980). More poorly documented, and more poorly understood, is the response by local New England potters to the competitive edge gained by early industrialized British and American potteries (Turnbaugh 1976, 1977, 1983; Watkins 1950). The investigation of earthenware manufacturing in southern coastal New Hampshire between 1740 and 1860 is undertaken to help address this question.

This study is based on the results of archaeological research conducted at the Marshall pottery site (1736–1749) and the Bennett–Dodge pottery site (1789–1864) located in Portsmouth, New Hampshire (Figure 6.1). Both urban sites yielded well-preserved evidence of family-based pottery manufacture and are among the first systematically excavated pottery sites in New England (Pendery and Chase 1977). The typological classification of lead-

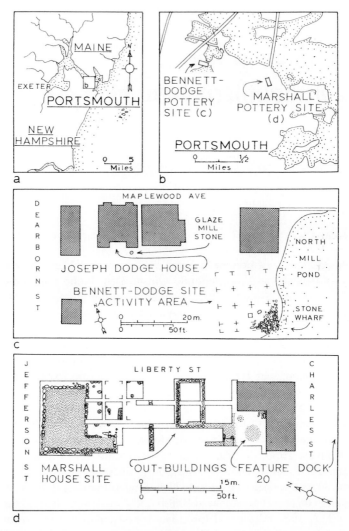

Figure 6.1 Locator map of the Marshall pottery site, (1736–1749) and the Bennett–Dodge pottery site (1789–1864), Portsmouth, New Hampshire.

glazed red earthenware (redware) ceramics and the study of manufacturing methods revealed by excavation and site documentation allows the reconstruction of the sequence of production operations for each site (Rye 1981:5). This information suggests that two successive strategies of redware production and marketing were followed before the ultimate demise of local potting in New England in the late nineteenth century. These included imitative stylistic replication of European imported wares during the eighteenth century and limited adoption of some European manufacturing methods in the early nineteenth century.

HISTORICAL BACKGROUND

Portsmouth, New Hampshire, is located on the southern bank of the Piscataqua River, 3 miles from the Atlantic Ocean (see Figure 6.1). The site was settled in 1630 as a trading post for the Laconia Company, but during the early eighteenth century the town emerged as a major New England seaport. Several shipyards, the mast and timber trade with England, and the West Indies trade contributed to the town's expanding colonial-period economy, which attracted craftsmen from throughout New England (Hugo-Brunt 1961:69, 84; McKinley 1931, Pendery 1977:29).

The local availability of raw materials, an urban labor force, and urban consumer demands contributed to the early development of manufacturing in North American colonial seaports such as Portsmouth (Bridenbaugh 1961:69, 84). The development of a vigorous tradition of brick and earthenware pottery manufacture in the Piscataqua region was based on an inexhaustible local supply of wood and clay and rapid expansion of housing and domestic needs. The manufacturing activities of Samuel Marshall, the first documented Portsmouth potter, must be considered in this context.

The Marshall Pottery Site, 1736-1749

In 1736 Samuel Marshall, the son of a local sailmaker, established a pottery shop and residence on the "Creek," a tidal inlet in Portsmouth. There are no surviving account books or other records from the pottery shop, but the enterprise must have been of modest scale given the restricted dimensions of the site. The March 1750 probate inventory of Marshall's estate indicates that his workplace contained earthenware, potter's working tools, a warehouse, and a canoe and barges that may have helped transport raw materials and finished wares on local river systems. That Marshall was involved in coastal wholesale trade in redware is indicated by his purchase of earthen-

ware from the Charlestown, Massachusetts, potter John Parker in 1749 (Parker 1749). The 1750 probate inventory of Marshall's Portsmouth estate totaling £2228 and his position in the third decile of Portsmouth taxpayers for the years 1740 and 1745 indicate a level of affluence comparable with that of other earthenware potters in New England (Daniels 1973; Turnbaugh 1977:210; Watkins 1950:50).

The Bennett-Dodge Pottery Site, 1789-1864

After Samuel Marshall's death in 1749 Portsmouth may have been supplied with earthenware by local potteries in Exeter, New Hampshire, and Essex County, Massachusetts. In 1789 Winthrop Bennett established a redware pottery shop on the North Mill Pond in Portsmouth (Figure 6.1). Bennett's career was short-lived and poorly documented. By 1796 he had moved to Moultonborough, New Hampshire. In that year his Portsmouth property, improved with buildings, was purchased by Joseph Dodge of Exeter, New Hampshire (New Hampshire Deeds [NHD] 144:149).

The history of the Dodge pottery shop mirrors the fate of many domestic pottery shops in nineteenth-century New England. The founder of the pottery business, Joseph Dodge, was able to maintain his livelihood as a potter until his death in 1850, although his sons were not so fortunate. Two of Joseph's sons, Joseph Jr. and Jabez, were employed at the pottery in 1821; by 1830 the pottery was producing $1200 of earthenware a year. By 1840, however, Joseph Jr. had found new employment and his brother was exploring alternate employment as a cordwainer. Jabez returned to the full-time manufacture of pottery after the death of Joseph Dodge in 1850, but between 1860 and 1864 he closed down the family pottery shop and resumed work as a cordwainer. After the Civil War, pottery was no longer manufactured in Portsmouth, although the Exeter potteries probably supplied the town's diminishing redware needs (Portsmouth Annual City Tax Records [PACTR] 1830, 1835, 1840, 1845, 1860, 1865; Portsmouth Directory [PD] 1821, 1827, 1834, 1840, 1850, 1856, 1861, 1864; New Hampshire Probate Records [NHPR] 1850: Docket #15964).

ARCHAEOLOGICAL EVIDENCE

Investigation of the Marshall and Bennett-Dodge pottery sites was prompted by the imminence of construction activity. Archaeological work was initiated at the Marshall pottery site in 1975 by Strawbery Banke, Inc., an outdoor museum encompassing 10 acres of downtown Portsmouth, New

Hampshire. Study of the Bennett-Dodge site, privately owned, has been conducted by the author since 1980. A multiplicity of funding sources for the Marshall site and complete accessibility have permitted more extensive excavation than at the Bennett-Dodge site. The following analysis focuses on Feature 20, a waster dump and possible kiln site in the Marshall site, and Strata 4 and 5 of the Bennett-Dodge site, sampled by a single excavation unit, from which wasters and kiln furniture were recovered. The redware manufactured by Winthrop Bennett could not be distinguished from that of the Dodge family, and it has been grouped to represent the combined period of production of 1789-1864 (see Tables 6.1 and 6.2).

Classification

The criteria for the typological classification of earthenware from the two pottery sites were (1) that the system could be easily applied and replicated; (2) that it could be used to classify all redware pottery from both sites; and (3) that it should order the ceramic data in a way that would be most useful for testing specific conjectures about redware production.

Under the proposed classification the redware sherds are subsumed under a "ware" category consisting of red earthenware. This category includes both lead-glazed and unglazed ceramics with porous red earthenware bodies. Redware fired under reducing conditions may also be included.

Redware types are represented by groupings that are based on consistent patterning of attributes. Attributes used in typological constructs need only

Table 6.1
Attributes of the Marshall Pottery Site Vessel Forms

Vessel Form	Attribute (%)[a]					
	Wasters (untyped)	Interior glaze (Type 2)	Interior and exterior glaze (Type 4)	Unglazed (Type 1)	Slip-decorated (Types 3, 5, 6)	Total
Pots (14)	7.3	21.1	—	6.9	0.5	35.8
Pans (13)	4.5	14.2	—	0.9	—	19.6
Jar (1, 5)	1.7	3.7	0.9	1.2	—	7.5
Mug (8, 9)	0.3	0.5	0.9	—	—	1.7
Bowl (2, 7)	1.7	4.9	1.3	—	1.3	9.2
Plate (4, 12)	3.7	11.4	1.3	—	8.6	25.0
Pitcher (6, 15)	0.4	—	—	—	—	0.4
Chamber pot (3)	—	0.4	0.4	—	—	0.8
	19.6	56.2	4.8	9.0	10.4	100

[a]From Feature 20 rim sherds (n = 248).

Table 6.2

Attributes of Ceramic Types of Marshall and Bennett-Dodge Pottery Sites

Attribute	Ceramic type							
	1	2	3	4	5	6	7	8
Unglazed	X							
Interior glaze		X	X				X	
Interior and exterior glaze				X	X	X		
Slip decorated		X			X	X		
Plastic decoration						X		X
Glaze colorant additive							X	X

have some measurable quality. Although the range of ceramic attributes used in typological classification may be greatly expanded by the application of materials research techniques, this approach is not included in this study (Kingery 1981:459).

The redware typology used in this study incorporates a hierarchical ordering of attributes that may be correlated with specific operations in the manufacture of redware pots. After a wide range of attributes was initially examined against several external frameworks to determine which attributes were subject to variation, five variable attributes were selected for constructing the typological classification, including the presence, location, and composition of glaze and presence or absence of slip decoration and plastic decoration. Body composition, a temper-free red earthenware fabric, was constant for vessels at both sites, although the fabric hardness often varied within single pots that were overfired. Sherds that lacked adequate information for classification were assigned to a separate group not included in the analysis.

Classification of sherds from the two pottery sites yielded eight redware types. Six of these, Types 1-6, were present at the Marshall site and two types, 7 and 8, occurred exclusively at the Bennett-Dodge site. Redware Types 1 and 2 were common to both sites (Table 6.2). Fifteen vessel forms were identified at the Marshall site, while only eight were detected at the Bennett-Dodge site (Figures 6.2 and 6.3). Comparison of these types indicates that several important manufacturing and stylistic changes in redware occurred in southern New Hampshire during the late eighteenth and early nineteenth centuries.

A large proportion of the ceramic vessels recovered from Marshall's waster dump consisted of decorated table wares that imitated fashionable English

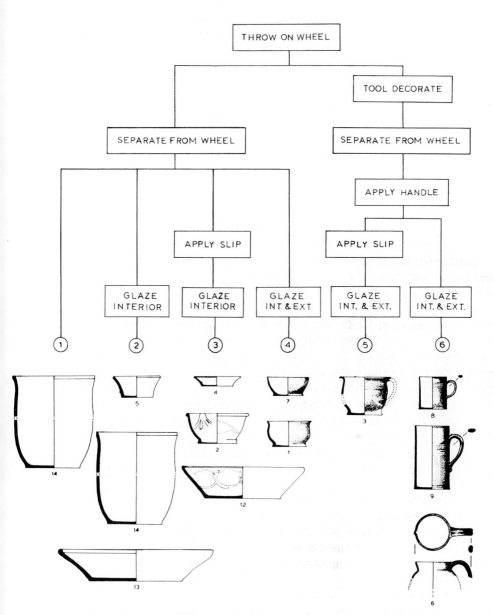

Figure 6.2 Production sequence for the Marshall pottery, showing manufacturing operations (in rectangles), ceramic types (circled), and vessel form types.

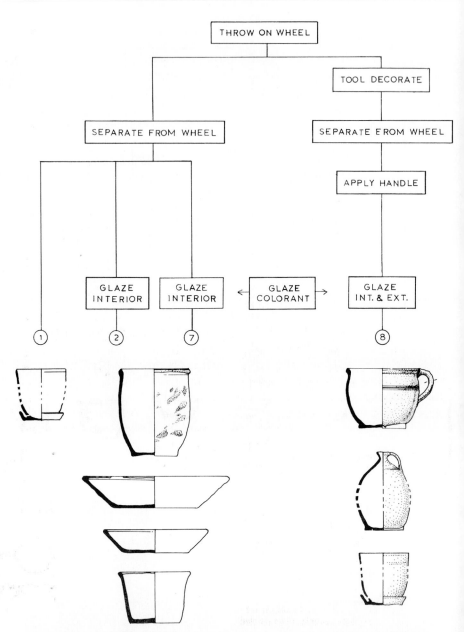

Figure 6.3 Production sequence for the Bennett-Dodge pottery, Portsmouth, New Hampshire, showing manufacturing operations (in rectangles), ceramic types (circled), and vessel form types.

ceramic types of the early eighteenth century (16.6% of the rim sherds.) Tooled mugs and pitchers with iron-stained lead glaze (see Figure 6.4), accounting for 2.1% of the identifiable rim sherds from Feature 20, were directly inspired by English manganese-glazed wares (Kelly and Greaves 1974:3). Fired in a reduction atmosphere or slightly overfired, Marshall's table ware forms resembled the Jackfield-type wares of North Staffordshire and Shropshire of the same period. Basins, deep dishes or platters, and chamber pots were all decorated with brushed or trailed white slip in free-form imitation of coarse English and possibly Philadelphia slipwares. Utility wares, or non-table ware forms such as the custard cup, milkpan, and the common pot (Figure 6.2: Forms 5, 13, and 14) accounted for the majority of vessels represented in Marshall's waster dump (83.4% of the rim sherds).

The two new types of redware that occurred at the Bennett-Dodge site, Types 7 and 8 (Figure 6.3), were distinguished by their glaze additives, the only stylistic innovation represented in the ceramic assemblage. Glaze additives appear to have been adopted by New Hampshire potters somewhat later than their Massachusetts counterparts (Turnbaugh 1983:14). Slip decoration, elaborate tooling of wares, and table ware forms overtly imitating British imports were absent from the Bennett-Dodge assemblage.

A helpful framework for the comparative study and explanation of typological variation between the kiln assemblages is the production sequence (Rye 1981:5). The production sequence, or sequence of operations involved in ceramic manufacture, may be based on direct observation or reconstruction of operations on the basis of ceramic attribute analysis. The production sequence for any manufactured item may involve both essential and nonessential operations. The former will have a fixed chronology, such as selecting and obtaining raw materials, transporting them, and preparing them for use (for pottery this would also include the forming, drying, and firing of wares),

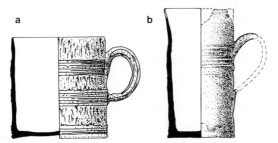

Figure 6.4 a. Manganese- and lead-glazed mug. Staffordshire, England, ca. 1700-1730 (after Kelly 1975); b, Buckley lead-glazed earthenware mug, Buckley, Wales ca. 1700-1750 (after Davey 1975).

while the latter may include special decorative treatment. Identical sequences of similar operations generally result in ceramics with similar manufacturing attributes; ceramics that result from a different sequence of operations generally reflect attribute variation. The degree of relationship between different production sequences is reflected by the similarity of techniques at comparable stages (Rye 1981:5).

The Production Sequence

The production sequences for the Marshall and Bennett-Dodge sites were reconstructed on the basis of archaeological and documentary evidence. Because of the dearth of information on redware manufacture in early New England, regional British earthenware manufacturing operations and their archaeological correlates served as comparative evidence in interpreting the archaeological data from Portsmouth. Refinements in interpretation were based on replicative experiments. Eight production operations were identified for the Marshall pottery site, six of which were represented at the Bennett-Dodge site, including obtaining and preparing materials, forming, decorating and glazing the ware, setting the kiln, and burning the ware. Operations associated with the distribution of ware were not considered in this treatment.

Obtaining Materials

Red-firing glacial clay was locally obtained and used for the manufacture of wares at both the Marshall and Bennett-Dodge potteries. Substantial deposits of clay suitable for pottery manufacture underlie each site, although actual mining was undertaken elsewhere. The Dodges probably exploited the clay from their brickyard on the North Mill Pond. Visual and preliminary petrographic analysis failed to detect any discriminating attributes of the clay used at either site.

A slip prepared from a white firing clay was used by Marshall for decorating certain of his vessel forms (Figure 6.2: Forms 2, 3, 4, and 12). There are no documented sources for this type of clay in southern New Hampshire; Martha's Vineyard and southern Long Island were likely sources (Bassett 1965:7). Turnbaugh (personal communication, 1983) has evidence of a closer residual kaolin clay source located in West Kent's Island, Newbury, Massachusetts. There is no artifactual evidence for the use of white slip at the Bennett-Dodge site. Comparison of the production sequences of the two sites indicates the extent to which slip decoration introduces complexity into the production sequence (Figures 6.2 and 6.3). The abandonment of slip decoration by south-

ern New Hampshire potters reduced material expenses and accelerated production of wares.

While there is no specific documentation for the source of lead used at either the Marshall or Bennett-Dodge potteries, red lead or litharge was commonly used by New England potters for this purpose (Watkins 1950:6). The Exeter, New Hampshire, potter Samuel Philbrick, an uncle of Joseph Dodge, acquired a hundred pounds of both red lead and "tea chest" lead in 1814 and 1815, presumably for glazing his redware (Branin 1978:109; Philbrick 1815:180). This may further substantiate the difficulty that other New England potters, such as Daniel Clark of Concord, New Hampshire, had in obtaining bar lead due to wartime shortages (Watkins 1950:125). Copper, manganese, and iron oxide used in proportionately small quantities for staining lead-based glazes could have been obtained locally from recycled metals.

Preparing Materials

During the late eighteenth and early nineteenth centuries the redware potters of southern New Hampshire abandoned traditional methods of preparing clays and glazes. The methods they adopted ensured greater consistency in the end product while accelerating production time. Comparison of the methods used to prepare materials at the Marshall and Bennett-Dodge potteries suggests the specific advantages of these changes, their possible origins, and the nature of their impact on earthenware manufacture in New Hampshire.

While New England glacial clay is often free of sand and large inclusions, it was usual processed by potters by one of two methods. The method first used by coastal New Hampshire potters involved grinding the clay with millstones after it had weathered for a winter season. Millstones similar to horizontal gristmill stones may have been used (Watkins 1950:5), an example of which was discovered at the Marshall pottery site. Vertical millstones, similar to those used for crushing tree bark, could have been used as well. These methods may have had a regional British origin, although postmedieval techniques of clay preparation are poorly documented (Brears 1971:88). Horse-powered cylindrical millstones were used in the Buckley potteries as late as 1798, while a levigation system was used in North Staffordshire in 1686 without milling (Brears 1971:89, 90).

By the early nineteenth century most New England potters had switched to using a horse-powered pug mill (Watkins 1950:5). This type of mill consisted of an iron-bound wooden tub, down the center of which was extended an iron shaft with protruding iron blades. Clay introduced at the top would be mixed and forced through the tub by the rotary action of the blades. Pug mill technology represented a considerable savings in energy over the earlier

method of grinding clay. This type of pug mill was introduced to the south of England in the early eighteenth century and may be of Dutch origin (Brears 1971:92; Hammond 1981:3, 5). The pug mill was used by the Exeter, New Hampshire, potter Jabez Dodge in 1804, and we may assume that his son Joseph Dodge used a similar device at his Portsmouth pottery (Philbrick 1804:119). The use of the pug mill may have diffused westward from coastal New England; and Concord, New Hampshire, potter Daniel Clark switched from stone grinding clay to using a pug mill in 1817 (Watkins 1950:125).

The second important transformation in manufacturing involved a switch from the use of powdered lead glaze to liquid lead glaze. During the period 1736-1749 Samuel Marshall glazed his wares by a traditional British and continental European method of sprinkling powdered galena over the wet surfaces of recently turned vessels (Brears 1971:125; de Brouard 1974:76). The results are distinctive because of the patchiness of the glaze, particularly near the rims of interior-glazed vessels. Powdered lead oxide was probably used as a base for a more refined glaze for tea bowls and saucers. Marshall successfully imitated manganese-stained wares of the period by retaining the natural iron impurities of his lead glazes (Celoria and Kelly 1973:14; Kelly and Greaves 1974:3). More thorough mixing of the iron and lead may have resulted in a solid brown color (Swift 1977).

In the last quarter of the eighteenth century, earthenware potters in coastal New Hampshire abandoned using powdered lead glaze and switched to using a liquid lead glaze containing a clay slip. As Enoch Booth demonstrated at Tunstall, England, in 1750, wares could be easily dipped into the slip, thereby producing superior, predictable results (Weatherill 1971:30). Solid color manganese-stained glazes and refined lead glazes of this type were used at the Bennett-Dodge site. A healthier work environment and accelerated production were some of the advantages of this new process, which was later adopted by American industrial potteries.

Forming the Ware and Tooling

All the wares produced at the Marshall and Bennett-Dodge pottery sites were wheel-thrown, or "turned." While four of Marshall's table ware and toilet ware forms were decorated by tooling, only two types of vessels made at the Bennett-Dodge site were tooled. Marshall's cylindrical mugs were carefully tooled by use of a rib with prepared profile, or template, that produced cordoning nearly identical to that of English manganese-glazed ware and Fulham and slip-dipped Staffordshire white stoneware mugs (Figure 6.4).

Evidence of semimechanized production, such as extruded handles or jiggered or trimmed vessel bodies, was absent from ceramic assemblages from

both sites. Both sites revealed similar methods of detaching vessels from the stationary wheel or bat by wire. Large milk pans may have been lifted from the wheel with a mechanical aid.

Slip Decoration

Slip-decorated redware was represented at the Marshall pottery site by Types 3, 5, and 6 but was absent at the Bennett-Dodge site (Figure 6.2; Table 6.1). The ceramic evidence from Portsmouth supports the observation made by Lura Woodside Watkins that slip decoration was practiced more infrequently in New England potteries after 1800 (Watkins 1950:7). The popularity of Marshall's slip-decorated redware may be linked to that of combed, trailed, and dotted slipwares from North Staffordshire imported in large quantities to North America between approximately 1680 and 1780 (Deetz 1973:2; Noël Hume 1970:107). These wares are encountered more infrequently after 1760, although it is apparent that their popularity did not fade altogether after the introduction of creamware and pearlware in the late eighteenth century. Also, Marshall's slip-decorated ware may have drawn their inspiration from Philadelphia wares imported into New England during the early eighteenth century (Massachusetts Archives 59:332-333a).

Kiln Settings

Setting a pottery kiln involved loading pots into the kiln before firing. The placing or setting of ware was important since improper settings resulted in the loss of pots. Settings affected both the circulation of heat in the kiln and the direction of glaze flow during the flux. Evidence from both the Marshall and Bennett-Dodge sites supports the conjecture that New Hampshire potters fired their wares in a single firing, as no bisque wares were found (butter pots, flowerpots, and saggars were intentionally manufactured as an unglazed type of ware). The relative positioning of wares in a kiln may be determined by examining wasters, kiln furniture, and the shadows and glaze scars left on pots. Early New Hampshire potters such as Marshall used kiln settings and props that differed little from those used in medieval and postmedieval regional British potteries (Brears 1971:130). Marshall used two types of kiln furniture, the setting tile and stilt, and he often improvised saggars by using inverted butter pots and common pots as containers for wares during firing. Table wares were supported by trivets or stilts under inverted common pots. Because of the problem of sulphuration of glazes fluxed in an unvented space, and because Marshall did not vent his saggars as the Charlestown, Massa-

chusetts, redware potters did, he may have used lead oxide for glazing table ware items fired under these conditions (Brears 1971:126-127; Pendery in UNEP 1984:55). Milk pans were set on edge on flat setting tiles toward the top of the kiln, as indicated by those that accidentally fused together as a result of overfiring.

During the late eighteenth century several new types of kiln furniture were introduced to New Hampshire potters, the use of which subsequently diffused westward. These included the glaze gutter or trough and a variety of other setting tile forms (Barber and Hamell 1971:35; Watkins 1950:Figures 6, 7, and 8). Glaze troughs were specially made to support pans resting on edge, ensuring that glaze would not drip on underlying pots after the flux and pans would not roll off. In later years, when milkpans made up a greater proportion of wares fired by rural potters, they were separated in nested position by triangular pan props (Branin 1978:35; Worrell in UNEP 1984:58). Wedge-shaped setting tiles were also used as replacements for parting sherds. By the early nineteenth century stilts were manufactured in a more robust shape and size with increased surface area and shorter legs to improve stability and durability. By the middle of the nineteenth century these were produced in molds (Lamson 1978:51). Such improvements in kiln furniture helped reduce pot wastage; often they left distinguishable marks on successfully fired vessels which can assist in identifying the approximate period of manufacture.

Burning the Ware

The pottery kilns used at the Marshall and Bennett-Dodge sites are poorly documented, as are those from most New England potteries. In northern New England, kilns were often enclosed by kiln houses or work houses and did not elicit commentary by potters, local historians, or travelers. The very few nineteenth-century New England pottery kilns that have been recorded reflect the influence of regional British and continental European post-medieval kiln design and various New World syntheses of these (Barton 1975; Greer 1979; Musty 1974; Norton 1932).

A demolished kiln of Musty's Type 3 design may be represented by Feature 20 at the Marshall pottery site (Figure 6.1). This feature consisted of a circular, flat-bottomed pit, 3.30 m (10 ft) in diameter, containing more than 20 bushels of kiln brick, slate, redware wasters, kiln furniture, clay, and charcoal. Ceramic cross mends from different fill levels suggest short-term deposition of the rubble. The absence of subterranean structural remains or flues is consistent with the design of a Type 3 kiln of Musty's classification system, which may be constructed entirely above ground. This type of kiln was prev-

alent in northern England during medieval and post-medieval times (Musty 1974:46).

No kilns have been discovered at the Bennett–Dodge site, although they are likely to have been similar to the type of kiln used by Joseph Dodge's father and brother in Exeter, New Hampshire (Figure 6.5a). This rectangular kiln was recorded in detail by Frank Norton of the Massachusetts Institute of Technology in the early part of this century (Norton 1932:34). This type of kiln was of parallel flue design similar to the Sussex type, or Type 4a of Musty's classification (Musty 1974:47). It is similar to continental European or New Castle or German Cassel kiln types (Greer 1979:142), and its use in New England may have accompanied the spread of stoneware technology from the mid-Atlantic colonies into New England during the eighteenth century. The updraft bottle kiln may have been reintroduced to coastal New Eng-

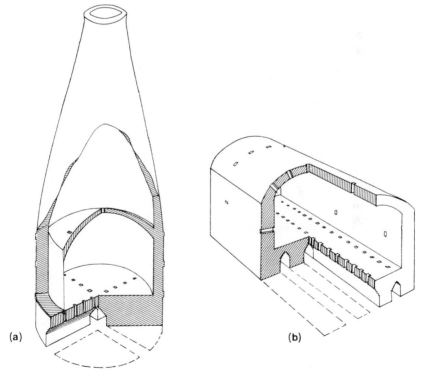

(a) (b)

Figure 6.5 Reconstructions of (a) Frank Lamson's pottery kiln, ca. 1880, and (b) Jabez Dodge's kiln, ca. 1805, the Exeter Pottery Works, Exeter, New Hampshire (after Norton 1932).

land by early nineteenth-century industrial potteries and adopted for use by local potters later in the century. An example of this type of updraft bottle kiln was recorded at the Exeter, New Hampshire, pottery works by Norton (Figure 6.5b; Norton 1932:24).

DISCUSSION

Archaeological and documentary evidence suggests that local Portsmouth potters followed two successive strategies of pottery production that included the stylistic imitation of British wares and limited technical improvements to help streamline production. These changes each represent belated responses to similar developments in incipient industrial European potteries that occurred in the early eighteenth century (Weatherill 1971:145–146). Unlike the enterprising potters of North Staffordshire, who promoted the specialization of labor and the workplace, Portsmouth local potters shunned modernization and simply elaborated or eliminated operations of domestic pottery production while leaving its organizational features intact. During a period of rapid industrialization in other areas of local manufacture, pottery production retained its preindustrial, traditional character. This is reflected in the organization of work and limited acceptance of technological change as well as in the stylistic behavior of the potters expressed by their products.

The domestic context of manufacturing conditioned both the organizational structure of the workshop and the performance of pottery making within. The workshop and all production facilities were generally located on the residential estate of the potter. Investment capital was often provided as a result of such events as marriage, inheritance, and mortgage—as happened for the potter Samuel Marshall in 1736, 1740, and 1743 respectively. Like a majority of local potters, Marshall was restricted to using a single kiln located to the rear of his houselot, and the number of sequential firings was determined by his storage facility for greenware and finished products, which consisted of a single warehouse. Marshall is not documented as ever being a member of any partnership, nor were any other members of his family employed as potters. To adjust to peak demands for redware, Marshall apparently established himself as a wholesale dealer of wares made by other potters, such as John Parker of Charlestown, Massachusetts (Parker 1747–1757; Pendery, Chapter 4, this volume). This wholesale business, and not the manufacture of pottery, was continued by Marshall's widow after his death in 1749.

The Bennett-Dodge pottery reveals the flexible side of domestic pottery manufacture. The Joseph Dodge pottery shop in Portsmouth was one of several run by members of the Jabez Dodge family based in Exeter, New Hampshire. Joseph Dodge's father, three brothers, two sons, and two neph-

ews and their children were potters in Exeter and Portsmouth, New Hampshire, and Portland, Maine (Branin 1978:43). An extended kin network such as this offered possibilities for the exchange of technical and stylistic information and for the pooling of labor and production facilities that local account books from the period suggest potters took full advantage of (Parker 1747–1757; Philbrick 1796–1820). The emergence of residential enclaves of related potters often resulted and further facilitated these exchanges.

In addition to technical information, design competence was also transmitted between generations of master potters, apprentices, and coworkers. This competence, or ability to compose (Glassie 1972:17), accounts for the potter's design ability and consisted of rules that facilitated decision making. The typological classification of Portsmouth red earthenwares was undertaken to help identify some of the structuring principles of this competence, although they may only approximate the principles that the potters themselves would have recognized (Glassie 1972:116–117; Norton 1932).

The design competence guided suboperations in the production sequence from the selection of a ball of clay of appropriate weight for a pot to final application of glaze. Design competence was of course conditioned by the essential production sequence and the constraints of technology: Pots ultimately had to be fired in the kiln with a minimum of waste. The lack of storage facilities for stockpiling ware meant that all pots destined for a kiln firing had to be simultaneously generated by sequentially performed operations. Supplemental, nonessential operations for certain types of pots, such as slip decoration, could result in delayed firing of the entire kiln load of ware. Perhaps as a result, supplemental decorative operations tended to be additive in nature and rapidly performed. Subtractive operations, such as sgraffito decoration, trimming, or lathe turning, were uniformly rejected by northern New England potters, perhaps for this reason.

Each operation had a fixed place in the production sequence and the option to use any operation was determined by the particular vessel form. Two broad groups of ware are reflected by the hierarchy of manufacturing operations: those with handles and tooled decoration and those without. The former category was always glazed on both interior and exterior surfaces, while the latter was always glazed only on the interior. These two groups were further subdivided into a table ware and chamber pot group which was slip decorated (Marshall site) or decorated with stained glaze (Bennett-Dodge). Interior or exterior surface glazing was further determined by the specific vessel form: Butter pots (Form 14) were left unglazed; milkpans (Form 13), common pots (Form 14), and miscellaneous bread pans, pudding pots, and custard cups (Forms 5, 13, and 14 respectively) were glazed on the interior only. Open table and kitchen ware vessels, including platters (Form 12), basins (Form 2), and saucers (Form 4) were slip decorated on the in-

terior, while tea bowls (Form 7) and small food and drug storage jars (Form 1) were not. Mugs and pitchers were not slip decorated but received careful tooling. By the early nineteenth century careful cordoning of the midsection of vessels had been discontinued or replaced by the incision of lines (Figure 6.3: Type 8).

Contrary to prevailing opinion, archaeological research indicates that even local New Hampshire potters participated in the Industrial Revolution despite their adherence to a traditional organization of the workplace (Myers 1984). The potter Samuel Marshall emphasized the manufacture of decorated table wares that forced him to expand operations within his traditional production sequence. Bennett and Dodge cautiously accepted technical innovations that allowed them to accelerate their production in order to remain competitive. Each example reflects a process akin to "bricolage" whereby a new idea "is broken down and compared with the old one and a composite idea is developed to suit the artist's psychobiological nature and his social and physical environment. The synthetic idea may be a compromise of fashion and unfashionable ideas" (Glassie 1972:260). Paradoxically, this application of ingenuity and resourcefulness during a period of industrial expansion helped New Hampshire local potters meet the needs of their traditional handicraft production and their established way of life.

ACKNOWLEDGMENTS

The author wishes to thank Dr. Stephen Williams, Dr. Jeffrey Brain, and Dr. Ian Brown of the Department of Anthropology, Harvard University, and Sarah P. Turnbaugh for their helpful comments on an earlier draft of this paper. The support of Strawbery Banke, Inc. of Portsmouth, New Hampshire; the Youthgrants Program of the National Endowment for the Humanities, Washington, D.C.; the New Hampshire State Historic Preservation Office; and the National Park Service is gratefully acknowledged.

7
Chapter

Product Standardization and Increasing Consumption Demands by an Eighteenth-Century Industrial Labor Force

Frederick J. E. Gorman,
Donald G. Jones, and Justine Staneko

INTRODUCTION

Much of our knowledge about eighteenth-century earthenwares in New England pertains to the pottery used by individuals or families in an informal or domestic setting. These people were able to control their ceramic inventories by selecting some earthenwares, stonewares, or porcelains and rejecting others. Such patterns of preference were usually conservative or traditional and are documented in diaries, probate inventories, and so on. Recorded information of this sort has been supplemented by archaeological investigations of the ceramic remains at historic farmsteads and urban houselots (Baker 1980b; Moran *et al.* 1982; Schuyler 1974; Stone 1970).

In contrast, much less is known about the contemporary earthenwares of

formally organized groups in the military or industrial sites of New England during this era. Eighteenth-century soldiers and factory workers could not be as selective in their choice of earthenwares because vessels of this type were usually supplied in quantity by local potters whose production was constrained by factors of bulk in raw materials, manufacture, and shipment. Moreover, records of earthenwares supplied to historic forts and factories are scarce, which implies that archaeology may be the primary source of this information (see Barton 1981).

In this chapter, we study 2303 sherds of American earthenware vessels that were recovered from the New England Glassworks at Temple, New Hampshire, during excavations which lasted from 1975 to 1978 (Starbuck 1983). These vessel fragments constitute part of the inventory of domestic and foreign ceramic containers used by more than 30 glassmakers who resided at this isolated rural factory from 1780 to 1782. The patterning of the domestic earthenware remains is analyzed in terms of product standardization together with aspects of vessel usage and discard on the factory lot.

The standardization of domestic earthenware products is assessed in terms of the strength of association of different types and varieties of containers with variable aspects of vessel morphology, such as temper, method of manufacture, container size, decoration, and surface finish. The standardization of kiln firing practices is evaluated in terms of the consistency of ceramic body paste and wall surface colors. Standardization of product quality is studied in terms of the incidence of manufacturing defects, such as kiln spall, body warp, crazed glaze, and so forth.

Different kinds and numbers of domestic earthenware vessels that were used and discarded by management and labor in separate residential sectors of the factory compound are compared to the inventory composition of foreign earthenware, foreign stoneware, and porcelain containers from the same areas of the industrial complex. Comparison permits the identification of utilitarian versus socioeconomic factors which governed selectivity in the supply and use of domestic earthenwares. Pattern analysis of vessel use-wear damage by the glassmen yields additional information about their valuation of domestic earthenwares in relation to the foreign-made ceramics.

HISTORY OF THE NEW ENGLAND GLASSWORKS

Information about the glassmakers and their ceramic provisions is derived from records that are either incomplete or ambiguous (Shadel 1970). The history of the New England Glassworks is divided into two periods. The basis of this chronology is discussed below.

The first period dates from May of 1780, when the glasshouse and related

facilities were erected near Temple, New Hampshire, by Robert Hewes with the assistance of approximately 32 German-American glassmen. The glasshouse burned shortly after its completion around September or October of that year, but it was quickly rebuilt by November or December. A small amount of glass was made before the blast furnace collapsed 10 days after production commenced (Blood 1860:36; Brown 1882:183; Hewes 1780, 1781a, b, 1782a, b; Shadel 1970:142; Woodbury 1966:12).

In December 1780, Hewes began to raise the capital necessary to rebuild the furnace and to pay his glassmen (Hewes 1781a; Wilson 1972:41, 54). In January 1781, Hewes asked the selectmen of Temple to credit him with victuals to support the glassmakers and their families while the furnace was being rebuilt (Hewes 1781c). On March 5 Hewes's resident superintendent of the glassworks asked the Temple selectmen if the "Glass-makers might be supplied with Provisions &c., &c." (Blood 1860:168).

Between the middle of March and the beginning of May Hewes obtained a loan against the proceeds of a lottery to be conducted as security. During this period Hewes mentioned that his workmen were idle at the factory and that he "should be glad if the Necessities of my Glass-makers might be looked to and supplied" (Hewes 1781c). The blast furnace was rebuilt during the summer of 1781, which marks the end of the first period.

The second period dates from August or September of 1781, when full-scale production of glass began (Hewes 1781d, e). Production continued through March 1782, when the lottery failed because of inflation caused by the revolution that was still in progress (Shadel 1970:144). Hewes was unable to repay his debt and the New England Glassworks closed. The workers were banished by the selectmen of Temple so that the town would not have to support them (Brown 1882:187; Shadel 1970:145).

It is not known whether the various requests for "provisions" and "necessities" included ceramics. If so, the glassmakers could have been supplied with earthenwares by one Nathaniel Griffen, identified on the Temple town monument as a potter who moved into the town in 1780. Evidently, Griffen moved away from Temple by 1784, because he was not listed on the town's tax roll thereafter (Blood 1860:172). His period of residence coincides with the life span of the glassworks. Furthermore, kiln waster fragments of earthenware recovered from the alleged pottery of Griffen compare favorably with the morphology of the earthenware sherds excavated from the glass factory lot. Though neither the documentation nor the archaeological evidence is conclusive, when taken together they strongly suggest that Griffen provided the glassmakers with their earthenware. Since nothing more is known about Griffen, he is simply called the "local potter" in the remainder of the chapter and his products are identified as either "domestic" or "local" earthenware unless specified otherwise.

THE DOMESTIC EARTHENWARE ASSEMBLAGE

The domestic earthenware assemblage was recovered from two soil strata that constitute part of the archaeological record of the glass factory lot. Each of these strata is a discrete soil zone of the factory lot. Both were identified by shovel tests and soil chemistry analysis of more than six hundred 9-m square grids that span the 2.5 acres of the compound (see Starbuck 1977). These strata are equated with the two documented periods in the history of the New England Glassworks.

The domestic earthenware assemblage was recovered from six sectors of the industrial compound. The sectors are identified in Figure 7.1 as the glasshouse, the west, east, north, and south terraces, and the midslope. The glasshouse was the locus of manufacturing operations. The superintendent of the factory resided in a house on the west terrace while the glassmen and their families lived in barracks on the south and east terraces. Industrial activities that were ancillary to glassmaking occurred on the midslope. Oxen may have been quartered on the north terrace.

Excavation of each of these sectors is delineated in Figure 7.1. A total of 2308 domestic earthenware sherds was recovered. Of this number, only 5 sherds were from the earlier period. Of the 2303 sherds of the later period, 84 were recovered from the glasshouse, 318 from the west terrace, 4 from the east terrace, 1 from the north terrace, 1772 from the south terrace, and 124 from the midslope.

Because of their paucity, the domestic earthenware fragments from the first period are excluded from further analysis here. It is unlikely that they are underrepresented as the result of inadequate archaeological collection techniques; rather, it is more likely that the glassmakers curated their domestic earthenware vessels from the first period into the second, or perhaps the labor force was not provided with these containers until the second period.

Quantitative bias is inherent in the domestic earthenware sample. This source of potential distortion depends on the degree to which the excavated sample of sherds from the second period represents the site universe that consists of both recovered and unrecovered domestic earthenware remains of that period. The ceramic fragments were not uniformly or homogeneously distributed within each sector; rather, they were concentrated in and around the foundations of buildings and other architectural units shown in Figure 7.1. For this reason, the estimates of quantitative bias are based upon intuition or judgment instead of probability. On this basis, we estimate that the recovered quantities of sherds represent about four-fifths of all domestic earthenware that was discarded by the glassmakers on the north, south, east, and west terraces. Likewise, at least two-thirds of all domestic earthenware fragments

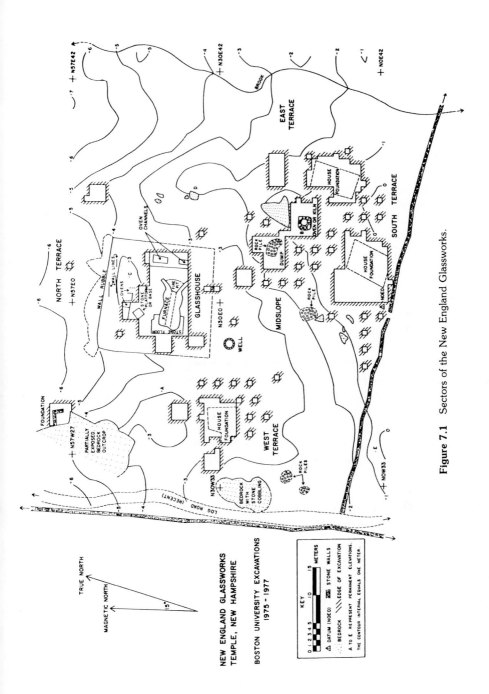

Figure 7.1 Sectors of the New England Glassworks.

that were deposited in the glasshouse and on the midslope is represented by our sample.

Attributes of Domestic Earthenware Provision and Consumption

Two groups of variables, derived from Shepard (1965) and Kane (1977b, c), are used in our analyses of domestic earthenware provision and consumption. One group identifies the physical attributes of domestic earthenware in terms of 10 morphological variables: (1) The type of nonplastic material used by the local potter to temper the clay of these containers is magnetite or sand or grog or a combination of sand and grog. (2) The method of manufacture involved wheel-thrown rather than rolled-slab or coiled construction. (3) There are several categories of vessel size. Containers 8 to 14 cm in diameter range in height from 5 to 30 cm, while those having a diameter of 20 cm vary from 20 to 60 cm in height. Wider containers of 26 to 32 cm are 20–60 cm tall, and the largest vessels, 44–50 cm wide, are 40–50 cm tall. (4) Decorative techniques involved the use of slip, incision, indentation, and freehand modeling of the surface. (5) Major decorative motifs are nonhuman fauna, flora, geometry, or any combination of these. (6) The placement of lead glaze or slip on the interior or exterior surfaces of earthenware vessels exists in 15 combinations. (7) The color of the clay body paste is assigned a value and chroma by reference to the Munsell Soil Charts. The spectrum includes light, medium, and yellow red, and plain brown with admixtures of red and yellow in some instances. (8) The colors of the interior and exterior surfaces of vessel fragments were noted. The preponderant color spectrums of clays on both surfaces are identical and include light or medium red, yellow red, brown, red brown, and yellow brown. Blue purple, white cream or gray, black, or any combination of these are infrequent colors in the series. Interior and exterior colors are evident either on the unglazed surface or under transparent lead glaze. Here, too, color value and chroma were coded by reference to Munsell Soil Charts. (9) Ceramic defects were observed as the result of either manufacturing mistakes (spalls caused by air pockets or coarse temper) or kiln firing errors (crazed glaze or warped and distorted walls of containers). (10) Consumer use-damage of domestic earthenware vessels was identified in terms of chipped or cracked walls, chipped or flaked glaze, or intensive abrasion.

The second group of two variables identifies the functional attributes of domestic earthenware: (1) The historic types of local earthenware were identified (Kane 1977 b, c). The series of types recovered from the factory lot include domestic unglazed redware, domestic glazed redware, domestic slip-decorated redware (slipware), domestic yellowware, and locally made mot-

tled, or tortoiseshell, ware. (2) The functional forms of vessel remains were identified (Kane 1977 b, c). The series of vessel forms includes round, oval, or rectangular plates, deep-dish plates or milkpans, teapots, mugs, small bowls or cups, chamber pots, and jars or jugs. Our codification of the morphological and functional characteristics of domestic earthenwares from the New England Glassworks is based on an extensive ceramic classification devised by Kane (1977a, b, c) for this purpose.

Qualitative bias is inherent in our classification of the sherd sample. Evaluation of qualitative bias requires an assessment of the validity and reliability of our variables. We believe that the variables are valid or sensitive archaeological indicators of domestic earthenware provision and consumption at the site, but this cannot be demonstrated empirically because nearly all of our nominal data measurement scales are inappropriate for the metric analysis that is required for this purpose (see Carmine and Zeller 1978; Gorman and Childs 1981). The reliability of our variables depends on how consistently they were observed in the sample of 2303 sherds of domestic earthenware. For example, decorative technique, motif, glaze and slip placement, historic type, and vessel form are quite reliable because every sherd could be categorized in these terms. Other variables, such as body paste color and surface coloration, have only a fair degree of reliability because such observations could be made respectively on 82% and 84% of the sherd sample. Temper, manufacturing techniques, ceramic defect, and consumer use-damage are less reliable because only 40-52% of the sherds could be classified. Vessel size is unreliable because only 3% of the sample could be categorized.

Analyses of the Domestic Earthenware Data

Our analyses of the ceramic data are arranged in two subsections as these pertain to the provision of domestic earthenwares to the labor force of the New England Glassworks and the consumption or use of these ceramic containers in the factory compound. The analysis of each topic involves cross tabulation of morphological and functional variables that are indicative of ceramic provision and consumption practices at the factory during the period of full production from August 1781 until March 1782. The joint frequency distribution of sherd data in each cross tabulation is analyzed by a measure of association to determine whether or not the morphological and functional variables are statistically independent. Each frequency distribution is summarized by the lambda statistic (Blalock 1972; Nie et al. 1980). Symmetric lambda is used because it does not entail assumptions about the causal status of morphological variables in relation to functional ones. The maximum value of lambda is 1.0, which signifies that prediction of association can be made

without error. At the other extreme, a value of 0 means that prediction without error is impossible.

A lambda value of .66 is an acceptable level of significance in our analyses because it indicates that correct prediction of association is made two out of every three times.

Earthenware Provision

The archaeological remains of the historical production of earthenwares have been studied in the Central Atlantic region (Kelso and Chappell 1974; Outlaw 1974) and in the Northeast (see Beaudry 1982). Yet, little is known about aspects of earthenware provision. We assume that earthenware was provided in bulk to the factory and that the production of these ceramics was standardized. For this reason, the patterning of the earthenware is analyzed in terms of product standardization. The standardization of local earthenware products is measured by the strength of association of various types and functions of these earthenware containers with four different aspects of ceramic production, namely, raw materials, vessel shaping, surface finish, and kiln firing (see Gorman 1982). The lambda strengths of association of earthenware type or variety with these aspects of ceramic production are listed in Table 7.1.

One indication of standardization in the raw material composition of ear-

Table 7.1
Lambda Strengths of Association of Earthenware Type or Variety with Aspects of Production

Production	Type	Variety
Raw materials		
temper	.04[a]	.10
Vessel shaping		
manufacturing technique	—	—
container size	.20	.20
Surface finish		
decorative technique	.46	.59
motifs	.03	.01
slip–glaze	.31	.24
Kiln firing		
body paste color	.01	.01
surface colors	.34	.41
ceramic errors	.10	.14

[a]A lambda value of .66 is the lowest acceptable level of significance.

thenware is the consistency of nonplastic ingredients added to the pot clay (Shepard 1965:18, 27, 29, 126, 223, 369). Different types and functional varieties of domestic earthenware might be expected to contain different types of temper. However, cross tabulation of the various types of local earthenware provided to the glassmakers with the different tempers refutes the expectation (table not shown) because lambda has a value of only .04. Cross tabulation of temper by functional varieties of earthenware (not shown) also yields insignificant results because the value of lambda is .10.

Standardization of vessel-shaping practices is measured by the consistency of manufacturing technique and container size according to the type or functional variety of domestic earthenware made (Shepard 1965:59, 393). Evidence of the manufacturing techniques could be observed on only 52% of the local earthenware sherd sample. In each of these cases, however, wheel-thrown shaping is indicated irrespective of the historic type or functional variety of vessel produced. Cross tabulation (not shown) of the variable of size with the different types and varieties of local earthenware yielded statistically random results (lambda is approximately .20 in both instances). Both tests of significance are tenuous because container size is an unreliable variable, as was noted in the previous section.

Standardization of vessel surface finish is reflected in the consistency of decorative technique, selection of motifs, and the placement of slip and glaze on different types or varieties of earthenware (Shepard 1965:183). Cross tabulation of decorative technique with local earthenware type and variety (not shown) indicates that these variables are statistically independent at lambda levels of .46 and .59 respectively.

The association of decorative motifs with the various types and varieties of domestic earthenware is also weak because 96% of the earthenware sample is undecorated. Cross tabulation of the symbols listed in the previous section with the types and varieties of decorated sherds that comprise the remaining 4% of the earthenware sample yields lambda values close to 0.

Cross tabulation of the placement of slip or lead glazes on the interior or exterior surfaces of container fragments with the historic types of domestic earthenware represented in the sherd sample indicates that both variables are statistically independent (not shown). The value of lambda is .31. Cross tabulation of slip or glaze placement with container variety (not shown) yields even weaker results, for the value of lambda is only .24.

Standardization of kiln firing practices is reflected by the consistency of ceramic body paste color and consistency in the colors of the interior and the exterior surfaces of vessels that either are unglazed or are coated with transparent lead glaze (Shepard 1965:103-105, 219, 388-389). Even though they are related, ceramic body paste color and vessel surface color are treated as separate variables in order to facilitate discussion of their consistency. Cross

tabulation of historic types and functional varieties of domestic earthenware with variable color of body paste (not shown) yields statistically random results because the value of lambda is nearly 0 in both instances.

Cross tabulation of the historic types of local earthenware with their combinations of interior and exterior surface colors indicates that these variables are statistically independent (not shown). The value of lambda is .34. The association of container variety and surface color (not shown) is also statistically insignificant because the value of lambda is .41.

Earthenware manufacturing defects are also evaluated in the context of kiln firing, even though such mistakes may originate with raw materials (Mellor 1935; Shepard 1965:23, 81, 92, 103, 214, 371). Nevertheless, commercial potters (unlike their industrial counterparts) are able to control ceramic errors by adjusting their firing schedules to the defective characteristics of the pot clay (Shepard 1965:81). From this perspective, the consistency of ceramic error is a partial measure of the consistency in kiln firing. The subject of ceramic error deserves more comprehensive treatment than can be given here (see Gorman 1982; S. Lewis 1984).

Because of their problematic nature, all of the ceramic errors are grouped to form one category and contrasted with another category which is defined by the absence of errors. The result is a dichotomous variable which distinguishes defective versus error-free sherds in the sample. Cross tabulation of historic types and varieties of domestic earthenware with this dichotomous variable (not shown) yields statistically insignificant results. Lambda has a value of .10 in the context of type and .14 in the context of variety. Inference from both measures of association is tenuous because the ceramic error variable has only a moderate degree of reliability.

Earthenware Consumption

To our knowledge, nothing is known about the consumption of domestic earthenwares by eighteenth-century communities of industrial workers in the Northeast. We shed some light on this problem by examining the types and varieties of domestic earthenware that were used, damaged, and discarded by the labor force of the New England Glassworks from 1781 to 1782.

Certain types and varieties of local earthenware were consumed in greater proportion than others at the New England Glassworks. Yet, cross-tabulation of historic types and functional varieties of domestic earthenwares (not shown) yields statistically random results because the value of lambda is .15. The weak association of type and variety initially suggests that the glassmakers were either unable or unwilling to select specific varieties of functional containers in different types of locally made earthenware.

Further insight into the apparently random pattern of domestic earthenware consumption is provided by an inventory analysis of the remains of foreign earthenware, foreign stoneware, and foreign porcelain vessels that also were used by the glassmakers in the factory compound. Inventory analyses of these three imported wares permits identification of utilitarian versus socioeconomic factors that actually seem to have governed selectivity in the consumption of the locally made earthenwares. A separate sample of 1012 fragments of foreign-made ceramic vessels was recovered in the factory compound from the soil stratum that dates to 1781–1782. All of these sherds are remnants of imported European earthenwares, including creamware (59%), delft (26%), and Jackfield (1.5%); Rhenish and Westerwald stoneware constitutes an other proportion (7%), as do Chinese and European porcelains (9.2%).

The relative frequency distribution of these foreign sherds among the variety of container functions is complementary to the relative frequency distribution of functionally diverse sherds in the sample of local earthenware fragments. This can be seen in Table 7.2, which shows the relative frequencies of domestic and imported vessel fragments by function. For example, jar and jug sherds make up only 1% of the fragments of all imported vessels. This miniscule percentage is complemented by the strong (62%) representation of jar and jug sherds in the sample of locally made earthenwares. In a similar vein, 71% of all sherds of imported ceramics are either cups or bowls; this high degree of representation is offset by the smaller percentage (23%) of cup and bowl sherds in the sample of local earthenwares. Finally, 28% of all fragments of foreign-made vessels represent shallow or deep-dish plates and pans; this makes up for the paucity (2%) of plate and pan sherds in the local earthenware sample.

The complementary distributions of plate and pan sherds, cup and bowl

Table 7.2

**Relative Frequencies of Domestic
and Imported Vessel Fragments by Function**

Function	Sherds (%)[a]	
	Domestic	Imported
Jar or jug	62	1
Cup or bowl	23	71
Plate or pan	2	28
Other[b]	13	0

[a]Values rounded to the nearest percentage.
[b]Chamber pots and teapots.

sherds, and jug and jar sherds strongly suggest that the vessels which they represent served different purposes. The imported earthenwares, imported stoneware, and porcelain may have been used to consume foods at the table, while the locally produced redwares were probably used mostly to prepare and store foods. Perhaps this functional distinction can be explained by reference to the market structure of ceramic production here and abroad during the late eighteenth century. American potters could not capture the colonial market for durable and refined table wares in the Northeast because bulk importation of European creamware, delftware, and stoneware adequately supplied the demand (Noël Hume 1973). Northeastern potters could and did compete successfully, however, in the colonial market for food preparation and storage containers, as is suggested by the large number of earthenware kilns that flourished in the Northeast during this period (Watkins 1950). For this reason, utilitarian factors rather than socioeconomic motives may have governed selectivity in the use of locally made red earthenware vessels at the New England Glassworks.

The glassmakers and their families subjected some local earthenware containers to fairly rough usage through excessive abrasion and by chipping or cracking vessel walls. Glaze coats suffered the same kinds of chip and crack damage. Because variable damage is only moderately reliable, all of the forms distinguished above are grouped into one category and contrasted with another which is defined by the absence of use-damage.

Cross tabulation of this dicotomous variable with the types and varieties of domestic earthenware yields statistically insignificant results (not shown). The value of lambda is only .37 in the first instance and .44 in the second.

We assume that the glassmakers discarded their locally made earthenware vessels in the various sectors of the glass factory compound where the ceramic containers were used. This premise is based on the absence of a central domestic dump and the fact that most of the fragments of local and foreign pottery were recovered (together with the remains of food animals) from the residential sectors of the industrial compound.

Yet, this spatial pattern of ceramic discard proves to be statistically insignificant when types and varieties of domestic earthenware sherds are cross tabulated with the various sectors in which they were found. In both instances, the value of lambda is close to 0.

CONCLUSIONS

We have demonstrated that no statistically significant relationship exists between attributes of the local potter's raw materials, vessel manufacturing techniques, or kiln firing practices and the types or varieties of earthenware which

he produced. We attribute the lack of significance to one of five possible factors. It is possible but unlikely that our variables are invalid dimensions of pottery manufacture, because statistical manipulations of some of these indicators by others have yielded significant results (see Ferguson 1977; Gorman 1982; Otto 1977). Neither is it likely that inclusion of pottery from different periods is responsible for the lack of significant results, because the entire sample of sherds (excepting five) was recovered from the second and last period of the factory's existence, which spanned only 14 months. Nor is it likely that the local earthenware sherd sample contains the products of different potters, since only one local potter, Griffen, is believed to have supplied the glassworks during the brief period of its operation. The possibiltity that the statistical tests are inappropriate can be ruled out. The lambda statistic is perhaps the most powerful and incisive nonparametric measure of the association of nominal scale variables. Finally, it is possible that our definition of standardization is an inappropriate indication of consistency in the historical production of domestic earthenwares. In every stage of our analysis, we have assumed that pottery production consistency is indicated by the interdependence of ceramic variables whereby the attributes of one covary with those of another. This definition is derived from the twentieth-century systemic concept of a multivariate "organization of diversity" (see Cortes et al. 1974). The absence of statistically significant interdependence in our findings vitiates this idea. Perhaps the eighteenth- and nineteenth-century univariate concept of the "replication of uniformity" is a more appropriate conceptual basis of ceramic standardization (Blalock 1972; Thomas 1976). Uniformity simply depends on the degree of homogeneity or redundancy that is attained through the control of only one ceramic variable at a time.

When the variable frequency distribution of the attributes of each ceramic variable is examined in its own terms, we see that the local potter exerted substantial control over his raw materials and manufacturing techniques. Product standardization and streamlined production seem to have been important considerations. For example, 82% of the local earthenware sherds were tempered with sand. This is evidence of very consistent selection of raw materials. As far as can be discerned, the potter shaped all of his products on a wheel. The relative lack of surface decoration and finish also can be construed as redundancy or control of ceramic production (96% of the sample was undecorated and 67% was plain or unslipped and unglazed).

From a similar perspective, the kiln firing practices of the local potter were fairly consistent, because the vessel body paste of 52% of the sherd sample is colored light red and 34% more is light yellow. The close proximity of these hues in the spectrum of red earthenware firing colors indicates that most of the potter's products were fired in a narrow range of kiln temperatures. The local potter's control of ceramic errors was somewhat relaxed because only

67% of the sherd sample is free of manufacturing defects. On the basis of the relative frequencies of vessel type and variety represented in the domestic earthenware sherd sample, we estimate that one-half (51%) of the local potter's products were of only one type and variety, namely, plain redware jars or jugs. Most of his other products consisted of three groupings that included only one additional type and variety of redware, namely, plain cups and bowls (11%), glazed jars or jugs (11%), and glazed cups and bowls (12%). This consistency of production was a function of the specific ceramic needs of the labor force at the New England Glassworks from 1781 to 1782. The glassmakers required locally made earthenware jars, jugs, and cups and bowls primarily for the preparation and storage of their foods. Apparently, ceramic production was streamlined to supply the bulk demand for these containers. The local potter, probably Nathaniel Griffen, seems to have met their requirements by application of the "replication of uniformity" principle as the means of standardizing his ceramic provisions.

ACKNOWLEDGMENTS

Part of this research was supported by grants from the Historic Preservation Program of the National Park Service to Boston University and the State of New Hampshire. Electa Kane designed the ceramic classification. Justine Staneko, Ellen Savulis, and Jill Saunders codified the ceramic data. The authors are responsible, however, for errors of data classification, analysis, and interpretation.

8
Chapter

Production Continuity and Obsolescence of Traditional Redwares in Concord, New Hampshire

David R. Starbuck and Mary B. Dupré

INTRODUCTION

It has been written that there were over 250 potters at work in New England before 1800 and more than 500 before 1850 (Watkins 1950:2). Given the prominence of potters in nearly every town, it is quite remarkable that potteries have rarely been noted in historical documents. Census records did sometimes record the occupation of "potter," but such records were inconsistent, and many known potters were just as commonly listed as "farmers" by the census takers. Such inconsistencies are especially apparent in the *New Hampshire Census: Industry* (NHCI) (1850, 1860), in which potters were listed in some towns and not in others.

Archaeology provides one means of answering questions about potters, although the utility of this technique is rather limited when dealing with the scant physical remains left behind by pot shops. Kiln bases are easily the most durable evidence for a potter's operation; built of stone and brick, kiln remains do not deteriorate in the same way as wooden shop buildings. Associated dumps of wasters, the potter's discards, furnish additional clues to

the vessel forms that were made and give an indication of the technological problems that were encountered. However, they fail to demonstrate the amount of production, the percentages of each type of vessel to be manufactured, and the quantities and types that were actually sold.

The primary uses of archaeology on pottery sites, then, must include the acquisition of technological information that is not revealed in documentary sources; testing of the accuracy of diaries, deeds, and town histories; and the definition of spatial patterning in work areas, artifact distributions, and architectural units. Neither archaeology nor documents alone can provide a complete history of the redware industry, but site-specific research has the potential to answer questions about production, imitation and technological innovation, and information exchange among potters.

This study has selected a district of potters in Concord, New Hampshire, and analyzes it first through historical records and then through the excavation of one unusually intact site. The district will be examined with respect to how it related to other pottery-making districts within the state, how potters interacted and intermarried within the district, and how external factors caused production to change through time.

NEW HAMPSHIRE POTTERS

Pottery-Making Districts

The earliest New Hampshire settlements were on the seacoast, and consequently the first potteries—those of Samuel Marshall in Portsmouth and Henry Moulton in Hampton—were located in these coastal towns (Watkins 1950:110-111). Several centers of pottery production subsequently developed in the interior of New Hampshire, most notably in Exeter with the Dodge-Lamson pottery from 1771 to 1895 (Lamson 1978); Concord, with the Clark family and others from 1790 to 1885; and Boscawen, with the Gill, Burpee, and Osborn families from approximately 1813 to 1876. Pottery making in New Hampshire tended to be family oriented, with production continuing through several generations; and marriages were often between members of potting families.

Perhaps the largest concentration of redware potters was located in Exeter, where Nathaniel Libby was in operation by 1742 and Daniel Edes by 1743 (Watkins 1950:111). After these early potters there was a hiatus until 1771, when Jabez Dodge arrived in Exeter and began a long family tradition of pottery making that saw frequent intermarriages with the Philbrick and Lamson families. The Dodge-Lamson association finally ended with Frank H.

Lamson in 1935 (Lamson 1978:16). Other potters were also active in Exeter, including members of the Osborn family, Samuel Leavitt, Samuel and William Philbrick, and John Donovan. This large concentration of potters had a significant impact upon the region because many potters served their apprenticeships here before going on to establish their own shops in frontier communities (Watkins 1950:112).

Smaller but perhaps more typical was a community of clay workers that appeared near Harrisville, New Hampshire, by approximately 1795. This industry became so important that the area received the name of "Pottersville" (known today as "Chesham"). Production from these kilns was sold throughout New Hampshire, Vermont, and Massachusetts. At times redware in this area was a form of currency and was exchanged for grain and other products (Watkins 1950:113). Eight to ten shops were operating here in 1812, but with the increased adoption of English whiteware and the greater availability and low prices of tinware, the business declined to just the manufacture of flowerpots.

Characteristics of New Hampshire Pottery Making

There are notable similarities in the manufactured products sold by these New Hampshire potters because all served their communities by making simple utilitarian wares needed in the kitchen, pantry or dairy, and bedroom. Probate inventories and bills of sale indicate that most New Hampshire potters made lard pots (storage containers), milkpans, bread and pudding pans, mugs, jugs, chamber pots, bean pots, and plates and bowls. Some of these vessels had lids or covers, and some had handles.

Potters very rarely signed or dated their ware, with the occasional exception of a "presentation" piece or gift. Therefore it is difficult today to attribute redware to a particular potter unless the potter came from an unusually distinctive family tradition. It has been argued that sometimes the idiosyncratic methods of a certain potter in making the rim, foot, or handle of vessels can be a reasonable means of identification (Stradling and Stradling 1977:17). For example, Lamson descendants identify Lamson pottery made in the latter part of the nineteenth century by the thumb- or fingerprints left on the base of handles. Lamson workers left a forefinger impression or even a double or triple finger impression which served to identify the potter while firmly attaching the handle to the piece. (This means of identification applies only to handled pieces such as jugs, bean pots, and pitchers.) Frank H. Lamson, the last potter of the Exeter business, used his thumbprint as the signature on his work (Lamson 1978; Karl Lamson, personal communication, 1982). How-

ever, the vast majority of redware sherds found within archaeological sites are so fragmentary that no reliable attribution is possible, and production appears to have been sufficiently similar among rural New Hampshire potters that even whole vessels are not easily attributed to a particular potter.

INDUSTRY IN EARLY CONCORD

General Trends

Concord began as a community dependent upon husbandry and grew from 30 settlers in 1730 to 2052 in 1800 (Lyford 1903:614). There was very little employment outside the farm, and families raised their own food, cut firewood, and made clothes from the flax they grew and fleece from their sheep. Surplus farm products were exchanged for salt, molasses, iron, and other indispensables that could not be raised on the farm.

Concord's location was excellent for transportation, and by 1806 the first stage lines and toll roads radiated outward to Portsmouth, Lebanon, Haverhill, Londonderry, and on to Lawrence, Massachusetts (Winship 1965:46). Later, by 1815, canal boats were rowed down the Merrimack River to Charlestown, Massachusetts, taking their 20-ton loads of lumber, granite, and other freight to the coast. Light industry, trade, and the professions continued to be served by the canal boats until the railroad was built in 1842. With the coming of the railroad the population of Concord doubled between 1840 and 1850 (to 8534 persons), and 37 new buildings were constructed during the first year of the railroad.

The town directory published in the early 1850s lists the following businesses and professions: dry goods, hardware, crockery, paper hangings, dentist, barber, tailors, marble works, jeweler, periodicals and newspapers, hatter, a daguerrean gallery, stoves, tinware, hats, gunsmith, clothing, furniture, sign and ornamental painter, building mover, drugs, harness maker, picture frames, agent for Boston friction matches, steam printing, printer, dressmaker and milliner, and boots and shoes (Watson 1850). Prominent local firms included Concord Harness, Concord Coach, Prescott Pianos, Blanchard Churns, Durgin Silver, Page Belting, the Ford Company (furniture makers), iron foundries, hub and spoke manufacturers, and others, but none of these was large. Concord, despite its location on the Merrimack River with abundant waterpower, never became a mill town. Concord's industrial policy leaned toward diversity rather than relying upon one or a few large employers.

Redware Potters

This economic situation, specifically the reliance upon the self-sufficient farm and the exchange of surplus produce for manufactured goods, was a congenial environment for the development of numerous redware potteries on the outskirts of Concord. The potters themselves were also farmers (NHC 1850), growing potatoes, beans, squash, hay, and corn and raising cows and pigs; their probate inventories list farm equipment and horses. In a barter or exchange economy based on self-sufficient farms, the demand for utilitarian redware was always strong. For example, in the year 1814 the potter Daniel Clark I made enough milkpans for 25 kiln loads (Clark 1814:274). If those did not sell within the year, they could simply be held in reserve for future sales because their fragile nature and constant use ensured a continuing market. And because Concord farmers cultivated a variety of crops, the failure of any one crop could still mean a surplus of another, so the exchange of crops for redware would still be possible.

This sort of barter was noted by Clark in a journal entry dated September 26, 1810, when he wrote that he "took paper rags mostly this season . . . for ware" (Clark 1810:218). In fact, William Flint, in an article printed in *Old-Time New England*(1927), noted that Daniel Clark I had a store on his property through which he sold the surplus goods he received for his redware. However, the existence of this store has not been verified.

Although the demand for traditional, imitative redware in the community of Concord continued at a steady level for a long period, it was finally interrupted by the final quarter of the nineteenth century when English whiteware and longer-lasting tinware became available at low prices. This, rather than a lack of raw material (clay) or fuel (wood), seems to have caused the decline of redware utilitarian manufacture and the eventual switch to the production of flowerpots and shelf ornaments. Finally, by the end of the nineteenth century, the decline in demand for redware of all types reached the point where the descendants of potters no longer chose to go into the industry, and pottery making ceased in Concord altogether.

HISTORY OF THE MILLVILLE POTTERS

Setting

Millville is an area that developed on the western edge of what became the city of Concord (Figure 8.1) It began as a small hamlet surrounding a primitive gristmill erected on a grant given to Barachias Farnum for 140 acres

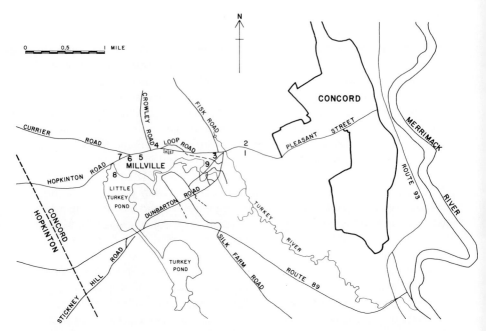

Figure 8.1 Pottery sites in the Millville District of Concord, New Hampshire: 1, Clark pottery shop and first Clark house; 2, second and third Clark houses; 3, Flanders pottery; 4, Whittemore-Clark-Hazeltine pottery; 5, Furber-Bradley-Clark pottery; 6, Peter Whittemore's farm; 7, brickyard; 8, clay beds; 9, St. Paul's School.

of land (Amsden 1950, Chapter 1:1). A dam constructed on the Turkey River in 1732 became the nucleus for other mills and farms that were settled over ensuing years.

It was here in Millville, together with an adjoining district known as "Fush Market," that a series of potters produced redware for markets in Concord and surrounding towns throughout the late eighteenth and nineteenth centuries. The origin of this peculiar name is a mystery, but "Fush" appears to be an old term for the area, not particularly genteel, that meant "petered out." It might have been used as early as 1780 in reference to this area and possibly described the short-lived existence of some of the businesses located here, including the potteries (John Rexford, personal communication, 1983).

Requirements for the manufacture of redware pottery are simple; most important are a source of good clay and an abundant supply of wood, coupled with access to markets. Secondary requirements are a shelter within which to work the clay into vessels and space for a kiln to be built for firing the product. South of the roadway that ran through Millville and Fush Market were good clay beds (Figure 8.1: Site 8), and these became the source of

raw material for more than a dozen different potters who lived here for a time and for others who were short-term employees of the permanent craftsmen. Wood was also abundant in the vicinity of Concord, and one of the chief cargoes on the southbound canal boats leaving the city was lumber and cord-wood (Winship 1965:64).

The first pottery in Millville was probably that of Nathaniel Furber, in operation before 1790; successive potters worked in this district until the death of John Farmer Clark in 1885. (See Figure 8.2 for a listing of Millville potters. Site numbers in Figure 8.2 correspond to site locations in Figure 8.1.) Little information remains for most of these potters, and in 1850 and 1860 the *New Hampshire Census: Industry* failed to list potters in the towns of Concord and Boscawen, even though potters were active there at that time. Surviving historical records document only the Clark family in detail; of the others, several appear to have worked for or were apprentices to the Clark family (Watkins 1950).

The Daniel Clark Diary

The lack of historical documentation for potteries is somewhat alleviated by the survival of business records and by the existence of a remarkable diary kept from 1789 until 1828 by Daniel Clark I, who was the first of several

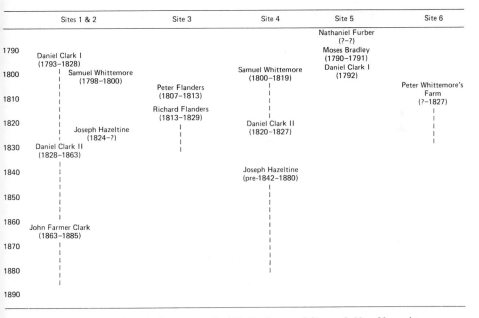

Figure 8.2 Distribution of potters in the Millville District of Concord, New Hampshire.

Clarks to manufacture pottery in Millville. The diary entries were generally brief and terse, and they include many abbreviations that require deciphering. However, the diary does give much insight into redware manufacturing and clues to what other potters were doing, at least within Concord and surrounding towns. From the diary we learn that Clark (and presumably the other Millville potters) dug his clay nearby and ground it in his mill (Clark 1795:20). He then turned his ware, leaded it, burned it, and carted it off to be sold. These successive operations went on throughout the year, even while he carried on his farming activities.

Although Clark clearly did not record all of his pottery-related activities in his daily journal, he nevertheless listed enough that it is possible to derive a sense of what his primary tasks were, at what times of the year they were performed, and with what frequency. Table 8.1 summarizes Clark's references to pottery making during three years of production: 1795, 1810, and 1825. These years represent the beginning, middle, and end of his career as a potter and suggest that he dug his clay during the summer, turned his ware during the summer and early fall, and burned (fired) his kiln and sold his wares throughout the year. Clark also left a wealth of quantitative information on how many loads of ware he turned during specific years, how much wood he cut, how many kiln loads he burned, and even what the prices were for some raw materials and finished products.

The terms Clark used to describe his activities were somewhat different from those in use by potters today, and this suggests that regionalisms in pottery styles and techniques may potentially be identified by comparing the terms in common use by each potter. For example, while Clark wrote of turning, leading, and burning ware, we now commonly use the term "throwing" for the making of the pot; "glazing" for leading; and "firing" the kiln instead of burning it. In addition, while we term the product redware because of its soft brownish to reddish coloring (determined by the natural elements in the clay and glaze and by the heat of the firing), the original makers of this ware often called it brownware (e.g., Merrimack County Register of Probate [MCRP] 1827, Vol. 1:513). The systematic establishment of folk taxonomies based upon pottery-making terms commonly cited in primary documents should demonstrate which potters were in active communication with each other and perhaps what the geographic origin was for any given potter.

From the diary and other sources, we have evidence of three generations of Clarks carrying on the pottery in Millville, a common occurrence among New Hampshire potters. Daniel also used apprentices, including his own sons, Daniel and Peter. Pottery-making families often intermarried, evidenced by the Burpees and Gills marrying each other in Boscawen, the Philbricks and Dodges in Exeter, and the Dodges and Lamsons in Exeter (Watkins 1950). There is no evidence of this in the Clark family, although several members

Table 8.1

Three Years of Pottery Making as Recorded in the Diary of Daniel Clark

	Dug clay	Hauled clay	Ground clay	Bought lead	Ground lead	Turned ware	Leaded ware	Cut wood	Split wood	Hauled wood	Burned kiln[b]	Selling
1795												
January										3		3
February		X		X							X	
March								2	X	2	X	3
April				X					3		X	2
May						X	X				X	3
June	X		X	X		X					X	3
July						X					X	2
August			X				X				X	X
September						X						
October			X			X		X		X		
November				X	X		X			X	X	
December											X	
1810												
January											X	2
February										X[c]	X	
March				X							X	X
April												
May	X						X				X	3
June											X	X
July											X	X
August						X						X
September												
October						X						
November											X	
December				X								

(continued)

Table 8.1 (continued)

	Dug clay	Hauled clay	Ground clay	Bought lead	Ground lead	Turned ware	Leaded ware	Cut wood	Split wood	Hauled wood	Burned kiln[b]	Selling
1825												
January												
February												X
March												
April												
May	X										X	
June											X	
July											X	
August												
September						X						
October											X	
November											X	
December				X							X	

[a]Numbers (e.g., 2) refer to the number of times an activity was recorded in the Clark diary for that month.
[b]Clark burned kilns for his brother Benjamin in February, May, and August of 1795.
[c]Clark hauled a total of 90 loads of wood this month.

(as well as another Concord potter, Joseph Hazeltine) married women from the Whitmarsh family of Lyndeborough where the Clarks had lived before moving to Concord.

The Clarks were the best-known potters in Millville, and more of their production is known to have survived than any other Millville potters. The Clarks made utilitarian ware for the kitchen, dairy, and bedroom; these were pieces of simple design, sturdy and serviceable. Early in this century William Flint (1927:104) wrote that Clark pottery was made of ordinary red clay and glazed with lead, and it commonly included milkpans, lard pots, mugs, plates, bean pots, bowls, and pudding dishes. Flint added (1929:105) that the Clarks had seven glazes and surface effects. He also wrote that John Clark had stopped making milkpans by 1876 when tin milkpans had come into general use. Flowerpots subsequently became his principal source of income until his death in 1885.

Daniel Clark's diary records the purchase of lead from as far away as Boston. The lead was obtained in various forms, from shot to bars, and it was purchased by the hundredweight and by the ton. There is no record of oxides purchased to make different colored glazes, but surviving examples of the Clarks' ware indicate that they sometimes used a clear glaze and at other times glazes with iron added to make brown and manganese added to make black. Variations in color were also caused by impurities in both the clay and glaze and by varying conditions inside the kiln during the firing process.

Other Millville Potters

In addition to the Clarks, a series of other potters operated in the Millville District, although for shorter periods of time (Figure 8.2). Historical records are especially poor for Israel Dimond, who lived near Millville. He may have had a pot shop here in the early 1800s before operating a pottery in the town of Warner, about 15 miles to the west. His son Timothy then continued the business in Warner.

Peter Flanders was apprenticed to the Clarks from 1795 to 1805, at which time he moved to Lyndeborough to work. He returned to Concord in about 1807 and worked his own site (Figure 8.1: Site 3) until 1813 when he moved to Plymouth, New Hampshire, where his son George also became a potter. On this same site (Site 3) Peter was followed by Richard Flanders, who had apprenticed with the Clarks for 6 months after 1805 and later bought Peter Flanders's pottery (1813).

A still earlier potter was Moses Bradley (Figure 8.2: Site 5), who had purchased the Nathaniel Furber property by 1790. Furber then resumed oper-

ation in Pottersville (Chesham), New Hampshire. After Furber's departure, Bradley used the site briefly (1790-1791), followed by Daniel Clark I (1792).

Another potter, Samuel Whittemore, had already worked as a potter in Lyndeborough before moving to Concord in 1798. Samuel worked for the Clark family as early as 1796 and then had his own pot shop in Millville (Figure 8.2: Site 4) from about 1800 until 1819. His son, Peter, worked as a potter both for the Clarks and for his father (Watkins 1950:126), finally establishing his own business somewhere in the vicinity of his farm (Figure 8.2: Site 6). At the time of his death in 1827, Peter left "1 green kill of ware leaded—25..00" and "about 5½ kills of green ware—77..00" (MCRP 1827, Vol. 1:513).

While redware production by the Clark family was quite stable, continuing over several generations, clearly most of the other potters of Millville were highly itinerant, changing shop locations frequently and rarely producing wares for more than a few years before moving on to other pottery-making districts. This commonly took the form of a period of apprenticeship, followed by a few years of production in Millville, and then by movement to a more distant community where business was perhaps more advantageous. While an apprentice was typically bound to a master potter for 7 years in order to learn all aspects of production (Watkins 1950:2, 1959:2), it appears that most of those who began as apprentices in Millville did not last for more than several months. One of the few who apprenticed himself to Daniel Clark I for a more lengthy period was Joseph Hazeltine. He was a successful Millville potter who did not come from a pottery-making tradition yet continued as a Millville potter over most of his lifetime.

A PROMINENT MILLVILLE POTTER: JOSEPH HAZELTINE

Historical Background

Joseph Hazeltine was not the most prominent potter in the Millville area nor was he the last to be working the clay beds there; however, his site is the most intact known to have survived in Millville. His business was located on the north side of the present Hopkinton Road (Figure 8.1: Site 4), and according to Watkins (1950:127), his shop operated four wheels and had the kiln located behind it. Hazeltine was a native of Concord and appears to have worked for Daniel Clark I because Clark recorded in his diary the date of Hazeltine's marriage to Abigail Whitmarsh in 1824 and the births of several of Hazeltine's children in the following years (Clark 1824:359, 1826:363, 1827:366).

Hazeltine taught from 1820 to 1824 in the Iron Works School, not far from

the Millville area, and then he turned to pottery (Amsden 1950, Chapter 16:6). This period of time matches the first mention of him in Clark's diary and may indicate his first work at the Clark pottery. He bought the former Whittemore place from Clark's son, Daniel Clark II, in 1842 and lived there until his death in 1880. Hazeltine's children did not continue in the pottery trade, and after his death the property was sold. Later his house and barn were torn down or moved, and another house and barn were built on the site (see Figure 8.3). Today the property is owned by St. Paul's School.

Like many of the other redware potters, Hazeltine does not appear to have marked or signed his products. Consequently, the only example of his ware that is commonly accepted as genuine by historians is a stew pot that was donated by a member of Hazeltine's family to the New Hampshire Antiquarian Society in Hopkinton. The inventory taken of the estate at the time of his death listed as stock in trade some 662 pieces of redware with a total value of $61.80. These were described as lard pots of three different sizes and were priced at $.12½, $.10, and $.06¼ each; two sizes of bean pots at $.12½ and $.08 each; and jugs, chamberpots, milkpans and bread pans, all at $.08 each (MCRP 1880, Vol. 258:201). While Hazeltine most likely produced many other types of vessels during his lifetime, it appears that these traditional, imitative wares were the types that could still compete most successfully and most economically with the inexpensive ceramics produced by urban centers late in the nineteenth century.

Watkins described Hazeltine's operation as being of "some importance" (1950:127), but little remains in collections to prove this statement. Upon his death his homestead was valued at $1300, his household furniture at $102.07, his farming utensils and mechanic's tools at $81.75, his provisions and produce at $60.12, and his livestock at $25.40. No reference was made to any pottery-making equipment (MCRP 1880, Vol. 258:201).

An undated picture of the Hazeltine house has appeared in an unpublished manuscript by Grace Page Amsden (1950) showing a set of buildings much in need of repair. The buildings were replaced in 1881, just after Hazeltine's death, and this would reinforce the interpretation that their condition had greatly deteriorated. While Hazeltine's business may once have been substantial, by the time of his death it appears to have declined.

The Excavations

The historical record for Joseph Hazeltine is much more complete than for many of the other Millville potters, but at the start of this study there was extremely little information describing the physical layout of his workplace, the quality and quantity of his manufactures, the vessel forms being made

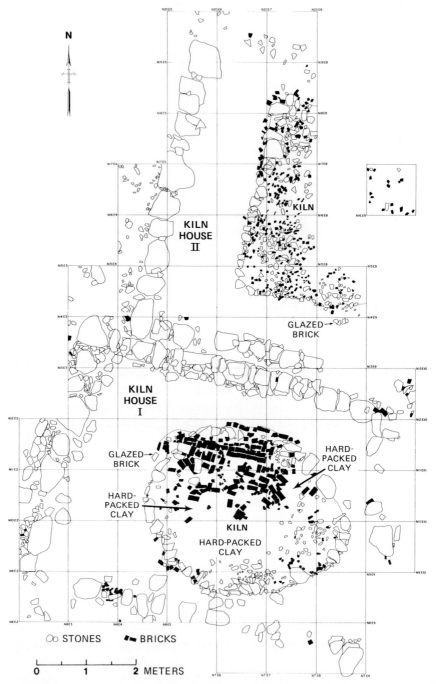

Figure 8.3 Foundations of the kiln houses exposed at the Joseph Hazeltine pottery site.

and the types of decoration, the placement and design of his kiln(s), the location of his waster dumps, the number of assistants or apprentices he had, the technological problems he had to deal with and how he overcame them, and the extent to which he imitated the products of other potters as opposed to originating his own designs. It was decided that a formal excavation of the remains of Hazeltine's pottery would be conducted to address these problems, recognizing that questions directly involving site layout and products would be much easier to answer than those pertaining to labor utilization or technological innovation.

Oral tradition placed the site of Hazeltine's shop on the edge of a field just north of Hopkinton Road (Figure 8.1: Site 4), and a small earthen mound was identified as the exact shop location (John Rexford, personal communication, 1982). Limited archaeological testing in the spring of 1982 confirmed the presence of large quantities of bricks and redware wasters, and extensive excavations throughout the summers of 1982, 1983, and 1984 opened a broad horizontal exposure across the surface of the mound. Cultural deposits were shallow, rarely exceeding 30–40 cm, and 103 excavation units were completed, each measuring 1 m square. Initial testing was done in the form of alternating squares, adjoining squares being opened whenever foundation walls were encountered.

Features

Two kiln houses were located and then exposed by this method, and waster sherds, kiln furniture, and bricks were found to be densely packed across the floor of each structure. Interspersed with these were building materials (nails, window glass, a single doorlatch) and domestic refuse (imported ceramics, bottle glass, food remains, carriage bolts, buttons and buckles). These kilns are pictured in Figure 8.3. The remains of each kiln house consisted of dry-laid stone foundation walls piled two to three stones high, and within each foundation was open working floor with a substantial stone kiln base in the center.

The first kiln house that was encountered, Kiln House I, has been completely exposed, together with nearly all of Kiln House II. Each was a distinctively different style of kiln, although the similarity of artifacts excavated from each makes it impossible at this time to distinguish between the dates of construction of the two. The base of the kiln in House I consisted of large granite cobbles, tightly joined together, with a layer of smaller stones and brick rubble across the surface. This was topped with a layer of fired clay which was noticeably reddened in several areas, possibly indicating that the fireboxes had been directly above.

The first kiln excavated was roughly oval in outline, measuring approximately 4.2 m east-west by 3.4 m north-south. While no direct evidence was left for the design of fireboxes or chimney, this style of kiln appears to be either round simple updraft or bottle simple updraft (Greer 1979:139). On each side it was surrounded by approximately 0.5 to 3.0 m of working floor, with the largest working space located on the west (suggesting that the kiln was loaded on this side). The outline of the surrounding foundation is somewhat irregular, but foundation evidence suggests a structure that was ca. 7 m east-west and ca. 4.9 m north-south.

House II could not be completely excavated because a retaining wall had subsequently been built atop the eastern side of the foundation. That portion of the building which was excavated contains the base of a square or rectangular simple updraft kiln (Greer 1979:136), measuring ca. 3.6 m north-south and at least 3.6 m east-west; the surrounding house foundation measures ca. 5.9 m north-south by at least 5.8 m east-west. This may have been the square kiln mentioned in the Daniel Clark diary: "May 19 1823 . . . Daniel began to build his square kiln" (1823:356). This second kiln house appears roughly similar in size to the first, but some of the foundation stones forming the northern and southern walls have been removed, making it difficult to interpret the total configuration of the structure. The kiln in House II has a less intact surface than the kiln in House I because the capping of fired clay has largely been removed so that the underlying layer of small stones and bricks forms the present surface. The excavation of a doorlatch from the south-central part of the foundation suggests a possible door on this side of the kiln house. The location of two kilns and kiln houses on the site was totally unexpected, particularly in light of Watkins's statement that the "kiln" was behind the shop (1950:127).

Excavations were also conducted to the south, between the kiln houses and Hopkinton Road, in an effort to locate Hazeltine's pot shop. A single east-west line of foundation stones was located ca. 9 m south of Kiln House I and roughly parallel to the road. The excavation of 14 test pits in this area in 1984 produced much window glass, some glass bottle fragments, gunflints, kaolin pipe fragments, coins (dated 1853 and 1865), buttons, nails (chiefly cut nails, but including some wrought nails), and only a few redware waster sherds. Nearly all of these were found within a thick lens of gray clay which may have been the floor of the pot shop. However, there has not yet been time to analyze this material adequately, and additional confirmation will be required to demonstrate that this was, in fact, the shop where Joseph Hazeltine made his pottery.

Preliminary efforts were also made to locate the waster dumps for Hazeltine's pottery, and a small number of nonsystematic shovel test pits were excavated elsewhere on the site. It was already known from talking to the current

tenants of the property that scattered wasters had been located during gardening and other digging activities in practically all areas of the site. What was lacking was a clear indication of where Hazeltine had established formal dumps for the disposal of his rejects. Given available time, digging could not be sufficiently thorough to test more than a few locations, but a sizable dump was located approximately 35 m to the south of the kiln houses, on the south side of Hopkinton Road. This was tested with four shovel test pits, each 50 cm in diameter, revealing wasters and kiln furniture in a lens approximately 20 cm in thickness. No significant differences were observed between these wasters and those found within the kiln houses. Because one of this project's primary objectives is to demonstrate quantitatively how Hazeltine's vessel forms, designs, and product quality varied through time, extensive future testing is planned in order to locate systematically all other waster dumps.

Artifacts

While artifact analysis has not yet been completed on the hundreds of thousands of wasters excavated from the Hazeltine site, some preliminary observations may be made. It is now possible to expand upon the listing of products in Hazeltine's inventory and state that in addition to lard pots, bean pots, jugs, chamber pots, milkpans, and bread pans, he was also producing porringers, cider or ale mugs, and possibly flowerpots (see porringer and jugs in Figure 8.4). Of these, milkpans and lard pots were easily the most common, and some of the others—such as porringers and flowerpots—are present only in negligible quantities. While bean pots may have been represented here, there was only indirect evidence of these in the form of lids that may have fitted on the pots. Especially enigmatic was the suggestion, both from the inventory and the excavations, that flowerpot production was not significant at the Hazeltine pottery. Whereas most other potters had switched from diversified production to a major dependence upon flowerpots by the late nineteenth century, the wasters within the two Hazeltine kiln houses—presumably some of the last of the pottery he produced—included so few flowerpot rims that they may even have been intrusive here. Artifactual evidence for innovation is minimal, and it appears that Joseph Hazeltine continued with very traditional forms and techniques until his death in 1880.

Several glaze colors were represented among the wasters, the most prominent being (1) clear, ranging from brownish-red to orange; (2) dark brown; and (3) black. None of the wasters had been slip decorated, and incising was rare; however, jugs had typically been decorated with two to three concentric incised lines located midway between the rim and the shoulder. Many of the pieces showed evidence of why they had been discarded, with many vessels

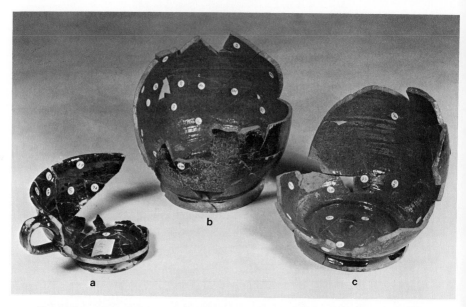

Figure 8.4 Traditional forms excavated at the Joseph Hazeltine pottery: reconstructed por-ringer (a) and jugs (b and c). The porringer has a dark brown glaze on both the exterior and interior, while the jugs have a black glaze on the exterior and a clear glaze on the interior.

having slumped and contorted during firing (probably as the load shifted within the kiln). These were intermixed with large quantities of kiln furniture, in-cluding hundreds of setting bars, stilts, wedges, and stackers, many of which had broken during use. While small quantities were dispersed throughout the two kiln house foundations, they were chiefly centered in the area between the two kilns.

Neither Hazeltine's inventory nor the excavation of his kiln houses revealed any evidence of his tools, and the excavation also failed to locate any iron bands, grates, or other evidence of iron components in the kilns. Numerous artifacts were recovered that were not production related, including a great many cut nails, a few wrought iron nails, remains of tin boxes, carriage bolts, buttons, buckles, bottle glass, window glass, glass lamp chimneys, whiteware sherds, yellowware sherds, and small quantities of porcelain. Most of these date to Hazeltine's period of production, although some may have been thrown into the foundations after Hazeltine's death and the removal of the kilns. No significant differences have thus far been detected in the ages and types of artifacts found in the two foundations. This suggests that the foun-dations may have been filled in (or even used) simultaneously.

CONCLUSIONS

Historical and archaeological research on the Millville potters reveals small groups of potters who continued to produce traditional redware technologies and forms during a comparatively late period from approximately 1790 until the close of the nineteenth century. This district of potters did not show evidence of the frequent intermarriages that characterized many of the other pottery-making families in New Hampshire, but the craft of potting was very much a family business, commonly being passed down through several generations in the same family. In Millville this was best exemplified by three generations of potters in the Clark family. Joseph Hazeltine stands out as a clear exception to this pattern.

The potters of Millville, like many others of the period, are all known to have been farmers when they were not making pottery. The self-sufficient farming society of early Concord and the diversity of light industry most likely contributed to the trading or bartering of redware for the produce and other goods the potters could not raise themselves. They formed a close-knit society and often helped each other during illness, times of increased production, or during the firing period when kilns required a close watch and constant replenishing of fuel. Cooperation of this sort is well described in many of the passages in the diary kept by Daniel Clark I (1789–1828).

No tools are known to have survived from any of the Millville potters, and the only primary source that mentions tools is Peter Whittemore's inventory: "a sett of Potters tools . . . 20 . . 00" (MCRP 1827, Vol. 1:513). Primary sources have also proven inadequate as a source of information on kiln design and construction, prompting the excavation of the kiln houses that have been described in this study. It is now clear from Joseph Hazeltine's pottery that the kilns on a single site could be both round and square, even though it is not yet possible to demonstrate whether this is evidence for changing kiln styles through time in the Millville district.

The potters in Millville, like their counterparts throughout New Hampshire, produced vessels which, though simple in design and serviceable, were sufficiently fragile to create a continuing need for replacement. This resulted in constant demand throughout the nineteenth century, but once more durable tinwares and whitewares became inexpensive enough to replace them (Cushion 1976:130), potters then turned to the making of flowerpots and shelf ornaments. It is unclear whether Joseph Hazeltine was atypical in avoiding this general trend and continuing with the production of more traditional vessels, but testing at additional pottery sites in Millville should help to clarify this point.

There is at present little evidence, historically or archaeologically, for

changes in Millville products until late in the nineteenth century, making it difficult to date these vessels or to argue for subtle responses to changing market conditions. The excavation of waster dumps deposited by several of the Millville potters may help to answer these questions, but dumps with very narrow time distributions have yet to be located. There is also no direct evidence to indicate how many assistants worked in any of the Millville shops, although Daniel Clark's diary gives much information on the arrivals and departures of apprentices who apparently did not plan to continue as potters.

The problem of continued employment in the pottery industry was clearly of major significance, and the children of the potters in Millville all moved into other trades and professions. No descendants of the Millville potters practice this craft in Concord today, but the rural location of most of the nineteenth-century potters has helped to protect many of their sites from serious modification or destruction. Archaeological research and systematic comparisons among many of these sites is thus possible and is being contemplated for the future.

ACKNOWLEDGMENTS

We wish to thank the New Hampshire Historical Society and the New Hampshire Historic Preservation Office for their continuing support of the fieldwork at the Joseph Hazeltine Pottery site. Thanks are especially due to Kathryn Grover, formerly of the Historical Society, and Gary Hume, State Archeologist, for their help in initiating this project. We also would like to thank St. Paul's School and the Thomas Champagne and Harold Denoncour families for allowing us to excavate on their property. This research could never have been completed without help from many volunteers, especially John Rexford, Dorothy Purington, Philip Hendricks, Dennis and Antonett Howe, and Win Robinson.

9
Chapter

Ceramic Production
in the Exchange Network
of an Agricultural Neighborhood

John Worrell

INTRODUCTION

Low-technology production forms a necessary component of the basic economic unit of an agricultural society. For early rural New England, that basic unit was the neighborhood. The production took the form of goods (e.g., ceramics, bricks, wrought iron hardware, vehicles, and barrels) and of specialized services (e.g., grist- and sawmilling, carpentry, and masonry) in complement to agriculture. Every community needed access to those goods and services; few neighborhoods supported any of them as full-time professions. Thus, each was usually provided as the specialized contribution of one or more members of the neighborhood whose principal occupation was "farmer." The crafts goods, specialized services, agricultural produce, and farm labor therefore formed the basic medium of exchange which mixed and circulated freely throughout the neighborhood.

Hervey Brooks was a nineteenth-century farmer-potter in one such neighborhood, South End, in Goshen, Connecticut. Using archaeology and materials studies in concert with analysis of his account and daybooks and public documents, researchers are unraveling the complex system of production and exchange in which Brooks participated. He produced earthenwares to secure

153

his place in the agricultural exchange economy of the neighborhood. This chapter details some of the research related to Brooks and his earthenwares, pointing out broader implications for understanding both crafts production and exchange economics in a rapidly changing milieu.

Hervey Brooks was born in Goshen, Connecticut, October 26, 1779, and died in a community called "South End" in that same town 93 years later on February 17, 1873. Seventy-two of those years intervened between his 1795 arrival in South End to apprentice the potter's craft (Brooks 1858:5) and the last sale of ware recorded in his daybook in September 1867. During that period, the regular production of earthenware for household usage virtually passed from existence in America. At the beginning of his career, the demand for the product was ubiquitous. But changes in technology, coupled with economic readjustments, saw that demand filled by other products manufactured according to very different standards of industry and commerce than had been in effect when the farmer-potter was a fixture throughout the preindustrial nation. As an apprenticed craft in an agrarian social structure, redware production left behind very little documentation with which to reconstruct either its technology or the fit of its practitioner into his community. It rests among a complex of low-visibility features which together constitute the lamentably underinvestigated "culture" of early rural America (Worrell 1980).

Great frustration has accompanied our attempts to understand the material details of potteries and potters from existing documentary evidence. We have laboriously pieced together the neighborhoods of various potteries from throughout central New England using deeds, inventories, and other documents. Though we know a great deal about a respective potter's farmyard, his household goods, and his neighborhood, usually the records are virtually silent about his shop or his kiln (Friedman 1978:16). The legacy left by Brooks, in the form of a nearly complete set of daybooks and account books and a work site virtually undisturbed for archaeological investigation (Worrell 1982b), is therefore most fortuitous.

Lura Watkins (1940:29) refers to South End as "a trading post for craftsmen and peddlars" and continues on to mention several potters of Goshen and Litchfield, towns which she terms "early centers of the potter's trade." While our reseach describes a somewhat different model for South End than that of a craft center, we have located several persons in land and accounting records who were at least occasionally doing some potting on their farms. It is Brooks's transactions, primarily, which have led us to those names, as well as to a better understanding of the tangential nature of the craft to their agricultural economic base. Neighborhood reconstruction from public documents and archaeological survey has allowed us to situate those persons and functions within the community both temporally and spatially (Figure 9.1; see Worrell, Figure 5.2, this volume).

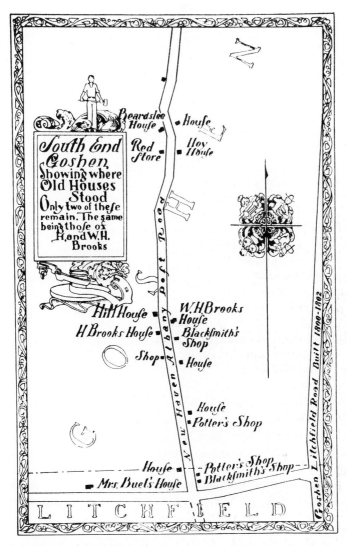

Figure 9.1 A map of South End, after one drawn by Hervey Brooks to accompany his *History of South End* in 1858 (courtesy, Old Sturbridge Village).

HISTORICAL BACKGROUND

The earliest of Brooks's existing records is an account book begun in 1802. Entered on a page near the back of his new book is an entry headed simply "Goshen June 1st 1802, First Kiln," followed by a list of pieces and their

value. This heading may mean that it was the first load he produced and sold on his own. The following entry on that page is headed "Second Kiln" and dated "October 1803" with no itemization or value given. What follows instead is "Jesse Wadhams, debtor, To half bushel sand for Norton—To one peck sand for Pitt Buell—to 50 lbs. Red Lead, Credit by 15 lbs." The relationship of these potters' supplies to the "Second Kiln" notation is uncertain. They may have none. The "Second Kiln" heading may have been written in anticipation of an event that did not occur, failed, or was instead recorded elsewhere, if at all. The front of the account book has numerous entries to fill that 16-month span, few of them directly related to ceramic production. Many of them involve exchange of commodities derived elsewhere, including his selling a great deal of rum. Brooks's most frequent customer for the rum was Jesse Wadhams, the farmer-potter with whom he had just completed his apprenticeship and for whom he continued on occasion to perform various ceramic production services.

The "First Kiln" of wares produced in 1802 is alone among more than 60 that Brooks is known to have fired during his career in having been itemized in the existing records. It lists 25 dozen milkpans, $8\frac{1}{2}$ dozen large pots, $4\frac{1}{3}$ dozen small pots, $2\frac{10}{12}$ dozen pudding bags, $2\frac{1}{2}$ dozen large pudding pans, $1\frac{1}{2}$ dozen small pudding pans, $2\frac{1}{2}$ dozen chamber pots, 7 dozen middling platters, 2 dozen large platters, 2 dozen gallon jugs, $2\frac{3}{12}$ dozen half-gallon jugs, $2\frac{11}{12}$ dozen quart jugs—a total of 765 vessels for which he lists a value of £23 12s. 6p.

Hervey Brooks married Polly Taylor on April 24, 1803. She was the granddaughter of Captain Isaac Pratt, who owned a large house and also kept a tavern directly across the road from what would become Brooks's house and shop at a later time. References in Brooks's accounts and probate information also show Pratt to have done blacksmithing, probably at the shop located just south of his house on the old map (Figure 9.1). Brooks's accounts of farming and keeping a tavern-store are frequent during the next few years, and blacksmithing is occasionally evidenced. But references to potting are scarce, although he continued to sell ceramic items from time to time in small lots. The strongest indication of any potting activity by Brooks during this period is in the huge quantities of wood that he was purchasing from neighbor Heman Beach during the winter of 1806-1807, including one marked "slabs" and another "potting wood."

There are no clear records of Brooks's firing for himself between the "First Kiln" listed in 1802 and his move to New York in 1811. However, in 1807 his work with other potters, especially Jesse Wadhams, is clearly documented. A small separate blotter in the family collection lists without specification such services as "turning, glazing, setting the kiln, painting platters"

and providing sand, slab wood, and use of his wagon to haul wares to Watertown, all provided by Brooks to neighboring farmer-potters.

In 1810, Brooks again mixed up a variety of accounts with Jesse Wadhams. He did considerable turning and glazing. Some of his efforts appear Herculean, a fact most appreciated by those who have attempted to emulate his production in modern times. On July 13, 1810, Brooks lists turning 10 dozen milkpans and another 8 dozen the following day. He also records turning 9½ dozen jugs of various sizes on one day. Other single-day efforts recorded include 14 dozen small platters, 12 dozen middling platters, 10½ dozen large platters, 10 dozen bowls, 9 dozen chamber pots, and mixed production, such as "5 dozen large pudding pans, 4½ dozen small pudding pans, 2 dozen milk pans." Although these examples were chosen because they are among the largest outputs he recorded, regular daily production was not a great deal less. Only once in 1810 did Brooks mention setting the kiln for Wadhams. He also charged him for "carrying ware to Litchfield" and "bringing white clay from Troy." The white kaolin clay was used for the slip-trailed decorations employed in "painting platters." Regularly, throughout 1808-1810, Brooks continued to bill Wadhams for a number of days "boarding myself." This busy state of ceramic activity was destined by technical and socioeconomic transitions to decline quickly, however, as the tight agrarian neighborhood economic fabric unraveled over ensuing decades, putting the local farmer-potter at a fatal disadvantage (Brooks 1802-1873; Worrell 1982a).

Brooks moved to Granville, New York, in 1811, where his accounts detail only farming transactions. He returned to Goshen in 1814, moving into the property that he was to inhabit for the remainder of his long life, across the road from Captain Pratt's farm. Brooks apparently resumed the management of the old man's affairs. He recorded no pottery sales between his return and 1818. The only ceramic activity noted in his documents is nine times that he turned for David Vaill during October and November, 1814.

Brooks's resumption of potting in 1818 was in partnership with Vaill. They undertook this venture in grand fashion, firing at least seven or eight kiln loads between May 26 and November 28. That year apparently launched Brooks into full-scale potting, which was to extend to 11 more firings during the following two years at his own shop. Entries for the year of 1818 make the last mention of Vaill in the ranks of active potters. Within two years Brooks himself ceased producing for a number of years (Brooks 1802-1872).

The most informative single document about this pivotal year with Vaill is a little blotter which Brooks reserved for potting accounts. It is the same one in which he recorded the work for Jesse Wadhams during 1807-1809. There are no entries in the book between the last item charged to Wadhams on July

8, 1809 ("To 2 Doz. Large pots—0.3.0; To 3 Doz. Middling do. @ 1/—
0.3.0"), and the account headed "May 22nd 1818 began work in the Shop
with David Vaill." There are two pecularities about this latter account which
are indicative of the nature of the enterprise. First, the heading denotes the
partnership. No place else in his accounts does Brooks have a section cap-
tioned "work with" someone. For Jesse Wadhams, Pitt Buell, and others in
various kinds of enterprises for whom Brooks performed a service, the nature
of the task and the indebtedness is spelled out clearly. The second peculiarity
is the form of the account itself. The format is simply a running listing, by
date, of the work done by Brooks for his part in the project, *with no price
stated.* The only other place in his voluminous collection of blotters and ac-
count books in which this format is used is in a set of insert pages loosely
sewn into his earliest account book which contain what he calls "an account
of My expenses in & at the Shop for 1819," continuing through 1820.

The 1818 account of work with Vaill covers a span from May 22 to No-
vember 28. It itemizes predominantly turning on the wheel, but also lists glaz-
ing, setting, "burning" the kiln, "drawing the kiln and loading ware," hauling
a load of ware to a given town, digging clay and splitting wood. There are
seven (possibly eight) dates listed on which a kiln load was fired: May 26,
June 6 and 20, July 1-2 and 16, September 3, October 2, and November
28. Brooks also itemizes large expenses, this time giving a cash value:

Lead	$78.25
Sand	5.08
Clay	3.00
Wood	45.00
Shop	10.00
Carting clay	25.50

The item for "Shop" makes it probable that this structure was already the
property of Brooks at the time. Both the shop and Vaill's house belonged to
Brooks by the following year, as deeds testify (*State of Connecticut Registry
of Deeds* [SCRD] 1819, Vol. 13:197). We have been unable to locate the
transaction by which Brooks came into possession of it. It may have involved
the settling of accounts with Jesse Wadhams, former owner of the shop, who
moved to northwestern New York state in 1811 and signed over his clay pits
to Brooks in 1818. No specification of the nature of the indebtedness is de-
tailed in the list of expenses. Perhaps it was shared by the partners. On Jan-
uary 1, 1819, the account closes with the following entry: "David Vaill to H.
Brooks, Debtor, to work in the shop 4.12.4." Brooks's regular account book
continues to show entries with David Vaill after their 1818 partnership. There

are 26 in all, extending into 1821. Not one of them is related to pottery or any of its attendant activities. The surge of 1818 apparently ended Vaill's days as a potter, while launching Brooks on his own.

Brooks made and fired 11 kiln loads of ware, some of it contracted in advance, during 1819 and 1820. This attempt at entering merchant-scale production was apparently not satisfactory, however, as he followed it with six or seven years in which he seems not to have fired a single load, while continuing to sell sporadically what must have been a large backlog of stock. In the traditional environment of agrarian South End, Brooks's venture was both ill timed and commercially impropitious. But the agricultural exchange complex in which Brooks functioned, while situating the ceramic production enterprise at a commercial disadvantage in those changing times, nevertheless provided the continuing mix of other occupations to which a versatile farmer-craftsman could turn for a viable livelihood.

THE EXCHANGE NETWORK

The account book for the years 1819-1920 continues to show Brooks providing agricultural and teamster services and trading in the familiar store and tavern commodities in addition to providing ceramics. As is standard procedure in this accounting system, only items for which others are in his debt are fully accounted in his book, their credit in exchange being subject to their own record keeping. Although there are some exceptions which allow us better to reconstruct the full pattern of exchange with his neighbors, we are generally only clear about what Brooks provided. Thus, it is seldom certain which of the commodities for which he charged others was originally received by him in trade for pottery or for other goods and services. What is sufficiently clear is that the network of exchange was elaborate and complex and that it was common for numerous transactions between several parties to figure into the ultimate settling of accounts. Cash, however, was a minor component— basically figuring no more prominently in the system than did a milkpan, a pound of cheese, or a half-day of his son's time haying. Large consignments of pottery were another matter, it would seem, and figured into his efforts quite differently. They were not a part of the neighborhood exchange network, were not itemized in the account book, and were either settled with cash or with consignments of the goods for which he is later found debiting his neighbors.

During the years of extensive potting activity, Brooks himself did not engage in as much service (e.g., farm work or hauling for others) as in the years preceding and following, but such activity did not cease entirely, even during the season of peak potting and firing. The insert sewn into his account book

lists only those expenditures of work and money that directly pertain to potting, including digging clay, cutting wood, grinding clay or glaze, turning, glazing vessels, stacking and unstacking the kiln, firing, and hauling loads of ware to various specified points. It begins with March 29 and 30, 1819: "To Watertown Woodbury and Washington 2 days making contracts for ware etc. Expenses $1.50." It ends with the entry of December 6, 1820, of "1 day burning," the eleventh firing of the list. A kiln "repair" intervened between the ninth and tenth firings. Brooks recorded no turning between October 15, 1819, and the following June 2, but setting, firing, hauling ware, making contracts, and getting wood were undertaken during that production hiatus. He appears to have been cutting all of his own wood, probably assisted by his sons, as no expenses for wood purchases are recorded. In subsequent years, Brooks frequently bought slabs and other unspecified wood for firing. There is no record of his having had any assistance in any of the potting or related work during this or any other period apart from the indirect reference of his later accounting the indebtedness of his son Isaac for apprenticeship. The single exception comes very late in his career, when Brooks mentions in his blotter for 1851 a "Mr. Zebulon M. Hubbard" being paid $25.50 for "turning for me," working in the shop 25½ days. Brooks was 72 at the time and continued to work at his craft for another 15 years, apparently unassisted. Isaac assisted him during the period of prolific activity (1818-1819). It apparently did not suit the younger Brooks, who, while hauling a load of clocks, ran away from home never to return. Hervey assessed him $133.00 on the apprenticeship plus $147.76 for the clocks and $37.00 for the wagon. He never paid. Eventually, however, the father canceled the debt.

The kiln used by Brooks during the 1819-1820 firings was not the same one employed in the itemized firing of 1802. Deeds and the archaeological record make that point clear. However, there is no archaeological, historical, or replicative evidence to suggest any great difference between their capacities (see Worrell [Chapter 5], this volume). We have no way to assess differences in sizes of unspecified vessel types for which Brooks contracted and which he listed in his accounts only as "lot of ware." However, we may presume some vessel count per load resembling that of the 1802 listing, stacking variations he might have developed with experience notwithstanding. That would indicate a total production of between 8000 and 9000 vessels for the 11 firings of 1819-1820. Adding the 1818 production with David Vaill would raise the three-year total to between 14,000 and 15,000 vessels. This appears to have provided a backlog stock from which Brooks sold without further production until 1827 or 1828. His blotters, accounts, and the archaeological evidence combine to confirm that sequence. The demand for the product may have been increasingly outstripped by the demands of its

production, frustrating his aspirations to be a commercial potter. Brooks fit the pattern that we are coming to understand to be the rule regarding crafts and low-technology enterprises in agrarian society in general: He was a farmer whose specialized contribution to the neighborhood was earthenware. He did not make the production shifts that enabled early nineteenth-century industrial centers to continue competition in the national and world markets. It was only because of his varied involvements in the agricultural exchange network that potting remained a viable component for him.

Brooks resumed potting in 1828. That is the first mention in his records of any firing of his kiln after 1820, and it follows immediately the conversion of his former kiln shed to a production shop and his relinquishment of the shop that he had formerly worked with David Vaill. The archaeological record is extraordinarily clear and datable for the changeover (Worrell 1982b). He tore down the kiln in the shed, leaving only nine courses of brick which served to support flooring in that bay, and moved in fill dirt to level up the remainder of the shed floor to prepare a suitable working surface. This process made a clean stratigraphic separation between the residues of the kiln-use phase and the production phase of the building. The change was dated by an account item for May 19, 1827, to the credit to Norman Wadhams, a farmer-stonemason, "by a stone for the clay cellar" (see Worrell [Chapter 5], this volume).

Beginning with 1828 and continuing for the next 36 years, Brooks regularly made and fired one kiln load of ware per year, while devoting the remainder of his efforts to farming and a wide range of other activities of value in the agrarian economy. During only four of those years do his records indicate that he fired a second kiln in a given year. In 1839, 1840, and 1842, he fired twice per year, but with no recorded firing in 1841. The other double-firing year was in 1851, the only time he is on record as having had assistance in the shop.

Brooks was just a few days shy of 85 when his accounts record his firing for the last time, September 23, 1864. The wording of the record suggests that he knew it would likely be his last firing. It appears on a page containing the accounts for his wife's funeral, and reads: "It may be remembered that I have made a kiln of ware this summer, consisting of Milkpans, some Pots, Pudding pans & Wash bowls, but mostly of Stove tubs and Flowerpots, and have this day finished burning the same. Hervey Brooks." It is of more than passing interest to us, as it obviously was to him, that right up to the end Brooks continued to produce some of the traditional forms which were largely passé long before that time as well as the routine utility items, such as flowerpots, which were about the only earthenware for which there remained a notable market.

THE PHENOMENON OF THE FARMER-POTTER

The phenomenon of the farmer-potter dates to biblical times and beyond. Earthenware production as a necessary, but usually part-time, activity in rural agricultural communities continued through medieval Europe and into seventeenth- to early nineteenth-century America before being rendered obsolete. The numerous volumes on American ceramics that have been published treat largely, if not exclusively, artistic wares and high-fired stonewares. That preoccupation is due to the fact that the common utilitarian redwares, which made up the overwhelming preponderance of historical production, broke during use or were overlooked by collectors and art historians whose fixation with high style and things unusual is endemic. Evidences from the Brooks site have, therefore, given us technical information about the craft which was otherwise unattested or at best poorly documented. At the level of the production site, data have been collected regarding materials, organization of the work area, changes through time, product types by period, physical demands of the work, and the skills which it required. These have come from the excavations and materials analysis and from the experimentation which has followed (Worrell and Jenkinson 1981).

Because he was a farmer, much of the record of activities in Brooks's accounts and daybooks is seasonally predictable. However, there is considerable year-to-year variation in the potting activities. Through the years, he records "burning" his kiln at least twice in each month from June through November, but September firings are more numerous than those for all other months combined. He records sales of wares during every month, although very few during the dead of winter, and a surge of sales immediately followed each firing. Wood supply generally occupied the coldest months, although it is not possible to distinguish wood supply for kiln firing from wood supply for domestic heating and cooking fuel. May or June usually provided the first reference for grinding the clay for a given year, with turning scattered throughout the summer. Glazing and setting the kiln for firing took place in the days immediately preceding each firing. Late summer and early autumn were the usual times for digging clay for the following season's use (Brooks 1802-1873; Lynn 1969:37-38). That time was probably chosen because the swampy area in which the clay was naturally deposited was more accessible then, and the farming work load was not so great as it would be in spring and early summer.

The Biographical Review: The Leading Citizens of Litchfield County, published in 1896, did not remember Hervey Brooks as a potter at all, but simply "as engaged in agricultural labors" (1896:286). Posterity, however, remembers him as a potter. His family and the local historical societies have displays of his wares and take pride in his career in the craft. He features prominently

in the literature of pottery production in historic New England (Watkins 1940, 1945, 1950). But it appears obvious from his own records that Brooks principally regarded himself as a farmer. This preference to be considered a farmer, rather than a craftsman, was not unusual. Traditionally, in agrarian society, "yeoman" held higher social status than artisan, and Goshen adhered to traditional social values. The implication of land ownership in the designation of farmer was doubtless a matter of pride as well as of practical economic and political standing. Neither the standing nor ownership was a necessary implication of being a craftsman, however, no matter how proficient one might be.

This social appraisal began to alter irregularly throughout the nineteenth century, owing to a complex of economic and demographic shifts. The increase in crafts specialization and technology is one important consideration in that change, and the increasing percentage of landless population is another. Both of these trends accompanied industrialization. Previously, the only option open to most younger sons in an agricultural household was to have an ancillary craft or service specialization, tied into the neighborhood exchange economy through the family farm. It was, therefore, clearly preferable in the agrarian system to be a landed farmer than to be simply an artisan.

In addition to farming his own farm and making pottery, Brooks's accounts show him functioning as a brickmaker, blacksmith, sawyer, teamster, carpenter, merchant, entrepreneur, and as teaching singing school and taking in boarders, pasturing others' cattle, hauling several loads of cheese to Georgia, and hiring out the services of his ox, horse, wagon, self, sons, and others in his debt. They also show him operating in the neighborhood farm labor exchange, both doing and receiving a wide range of agricultural tasks from plowing and breeding to grafting, butchering, and harvesting. In dealing within this exchange network, his provision of the necessary commodity of earthenware vessels to his neighbors was not construed by him or by them as being any different in kind from the provision of other agricultural specializations.

A letter in the family papers from Hervey Brooks to his son Watts, dated May 14, 1833, portrays the concern of the farmer-potter:

> My health for several weeks past has been remarkably good for me, except very lame in my shoulders and arms with rheumatism. I have been able to work almost every day this spring, have got the old orchard planted, and I perceive to day the corn is coming up. Many people have not yet planted, it is now a fine growing season and all things look promising. I went to Avon the first day of May and got 5 cwt, of Plaster, which I have been sowing on the meadows, and the prospect for grass is now good. . . . I calculated to begin work in the shop this week, but as yet it is so rainy and wet that we cannot grind the clay. Mr. Sanford has undertaken to sell the ware until haying, he pays me one dollar for Doz. at the shop, in such pay as he can get for ware, and I am at no expense for transporting.

THE ECONOMIC FABRIC OF THE AGRARIAN CRAFTS SYSTEM

A great deal of the information that has been gathered speaks to larger levels of analysis, such as the agriculture-crafts production complex and the neighborhood economic network in which it functioned. The potter's lot, its relation to his house and barn and to supporting facilities such as clay deposits and transportation routes, the clustering of small-crafts neighborhoods, and the flow of materials between production sites and within the agricultural exchange are likewise questions addressed by the data.

As a farmer and craftsman in an era of changing economic bases, Brooks was a participant in both an agrarian neighborhood exchange economy and, increasingly, in a cash and market economy. His daybooks and account books reveal the duality, but they also demonstrate a surprising continuation of the older order into later times.

Evidences of this conservatism, as well as of the nature of exchange, are found in the accounting system itself. Throughout all the earlier years, and to a degree diminishing only slowly as time progressed, there is scarcely any mention of cash in transactions or settlements. In order to keep track of obligations to ensure balancing with goods or services, some monetary value needed to be assigned. Until his return from New York in 1814, Brooks's accounts are kept in the British system of pounds, shillings, and pence, even though we know that British coinage was not among the several widely circulating forms of legal tender. This retention of an archaic system is undoubtedly to be attributed to the fact that its utility was for recording purposes only in any event; hence, there was no need to convert to any other system. The clearing of the books occasioned by the moves, however, encouraged the bookkeeping shift to the dollar-and-cents convention of the U.S. monetary system.

One difference between potting and most crafts in agricultural neighborhoods has to do with timing. While most other such enterprises can be largely accommodated in the agricultural off-season, pottery has a disadvantage that it shares primarily only with small-scale waterpowered industries: It competes with farming for agricultural "prime time." A potter cannot turn a vessel with cold-stiffened fingers, and frozen clay will not be worked at all. The accounts of Brooks show that this problem was resolved by an intricate and elaborate exchange of goods and services (Lynn 1969:7), often involving multiple parties, and only rarely settled with cash. The complex web of indebtedness was capable of absorbing and discharging the goods and services at the season in which they were demanded, but doing so frequently involved extended and multiparty transactions in order to satisfy the total complement of the needs and provisions of all parties in the network.

For example, the Sanfords down the road from Brooks were clockmakers.

He occasionally exchanged a "lot of ware" with them for a clock which he eventually sold or exchanged for other goods or services. The Sanfords did not use all that pottery themselves, but likewise passed it on during their sales and delivery trips to other communities. Amos Sanford regularly rented Brooks's team and wagon for those trips and he occasionally carried along some of Brooks's wares for sale on commission. Similarly, Joseph Beardsley, another neighbor, was a tanner. Brooks as a potter sold him wares, as a farmer sold him hides, and received tanned leather and farm labor to settle the balance.

The dual exchange of goods and labor from both farming and potting even extended to other farmer-potters like himself. Brooks ground glaze for Jesse Wadhams, for instance, and recorded in his daybook for June 10, 1808: "To pulverizing 113 lbs of Lead for which I am to have 3½ bushels of Rye per cwt." And, although he sold large lots of wares to stores and dealers (more than 75% of the cash value listed in his daybooks between 1822 and 1860; see Lynn 1969:41), the most frequent exchange out of the shop itself was with neighbors and townspeople who regularly traded agricultural produce or labor on the farm for small quantities of pottery for their own use (Brooks 1802-1873; see Worrell 1982b:10-11, 30-32).

There are numerous entries in Brooks's daybooks which were never transferred into his more formal account ledger. They were probably balanced out before that recording exercise was necessary. Exchange in kind at an informal level is also indicated. One example is a loose scrap of paper tucked into the 1830 daybook listing respective "pounds of pork lent" to each of nine neighbors. Eight of those are crossed out, apparently signifying repayment in kind at a later date, probably as each in turn did his own butchering. The only entry not so canceled was eventually entered in the account book to that party's indebtedness along with other commodities provided by Brooks, including pottery. Even the large lots of wares which Brooks produced for merchants were likely balanced by payment in merchandise. He makes frequent entries listing his providing to neighbors commodities ranging from tea and salt to textiles and ladies' garments. One of the most usual was rum.

GOSHEN'S SOUTH END AND
NINETEENTH-CENTURY ECONOMIC RESTRUCTURING

Recent studies by scholars in the various disciplines of cultural geography, social history, and anthropology have focused on patterns and stages by which the development of New England towns may be analyzed and understood (Handsman 1981a,b; Larkin 1978; Wood 1978). South End in Goshen presents an interesting divergence from the successful patterns of nucleation by

which dispersed agricultural neightborhoods were drawn into the valence of urbanization with the development of center villages (Larkin 1978) or industrial villages (Worrell et al. 1980). It included some of the earliest houses to be built in the town in the late 1730s and early 1740s (*History of Litchfield County* [HLC] 1881:324-327). Between the time that the first white child to be born in Goshen saw the light of day in a house situated where Brooks was later to build a barn (Brooks 1858:9-10; HLC 1881:324) and the time about a century later when his pottery was the only remaining commercial feature on the road, South End was host to several potters, blacksmiths, shoemakers, clockmakers, carpenters, stonemasons, taverns, stores, a sawmill, a tannery, and brickyards, among others (Brooks 1802-1873, 1858:4-16; Hibbard 1897:seriatim). Curiously, in his own *History of South End*, Brooks identifies most of the crafts and their practitioners that our research has documented, with the exception of the several potters and blacksmiths. Those persons are mentioned, but not their trades (Brooks 1858:5-16).

South End represents a cul-de-sac on the way toward nucleation. By tracing land transactions for this area throughout the late eighteenth and early nineteenth centuries, we have been able to chart and pattern the alterations in the physical and economic landscape. Census, genealogical, and tax records on file at the Connecticut State Library have allowed us to reconstruct the population and to identify the participants in Brooks's activity network. Locating the sites on the ground and on maps has produced an appreciation of the spatial, temporal, and social dimensions of that functional primary economic unit—the agricultural neighborhood network.

South End exhibited some conservative proclivities which allowed it to maintain that older economic order somewhat longer than was the norm, as is exhibited by Brooks's accounts of his and others' dealings, and even by his continued production and sale of earthenware types which served a life-style that was increasingly obsolescent elsewhere. During the Federal period, as center village formation burgeoned (Larkin 1978), South End waned toward abandonment. It never actually surpassed the description of the dispersed settlement in which "dwellings . . . are not generally within hailing distance of more than two or three other dwellings" (Wood 1978:2).

It is beyond the scope of the present chapter to analyze the causes of South End's development and demise. However, two general factors may be mentioned which combine with the universal, and drastic, decrease in demand for earthenware from the third decade of the nineteenth century onward. These factors bear directly on Brooks's potting career and may have close parallels in other neighborhoods in which the farmer-potter disappeared. One was the building of a turnpike less than half a mile east of the road on which South End was located. While this was not a major inconvenience to the potter, whose sales out of the shop were overwhelmingly local in any event

(Lynn 1969:57-63), it tended gradually to disperse the neighborhood further and to remove other crafts from the cluster. South End experienced the double-sided change that turnpikes regularly introduced into agricultural settlements during that period of rapid improvement in transportation. Turnpikes opened the prospects of more remote markets for those equipped for larger production but diminished local sales prospects as neighborhood cohesion was lessened and through-traffic became for the first time a primary consideration.

The second factor is population shifts. Records on file at the Connecticut State Library indicate that Goshen's population peaked early in the nineteenth century before falling into steady decline. Litchfield, whose border South End abutted, peaked in population at about this time with a population larger than Hartford, and then went into decline. The population decline, the dissolution of the neighborhood economic cohesion, consolidation of manufacturing for broader markets, and technological changes were among the cardinal factors which interacted to dissolve the agricultural crafts community of South End and to alter the career intentions of Hervey Brooks.

CONCLUSION

Brooks's records indicate that he fired at least 19 kiln loads of ware in the three-year period 1818-1820. Most of this ware must have been intended for sale in large lots to jobbers and merchants. But Brooks apparently backlogged quite an inventory, for there is neither documentary nor archaeological evidence of his producing another kiln of ware until 1828, by which time he had considerably consolidated his operation. His accounts, however, record that his sales to neighbors in the exchange system continued apace throughout that period. From that time on, for nearly half a century, Brooks continued the mix of activities described above. In a normal year, he would produce only one kiln load of ware, while pursuing a diversity of complementary farming, production, and mercantile services.

Brooks's brief entry into major ceramic production did not continue, but his integration within the neighborhood agricultural exchange network with its diversity of activities and products remained operative to a time so late as to be largely an anachronism in New England. That anachronism is our present good fortune, for it has helped preserve a documentary and material legacy for us to study and interpret. One important understanding derived from this research is the extended viability of the agricultural exchange economy into the mid-nineteenth century in South End. Such remote rural neighborhoods successfully continued to employ the older barter exchange system as a local alternative to the cash and market economy which had become

standard throughout the increasingly industrialized and urbanized Northeast (Worrell 1983:3-12).

The duration of Brooks's career in traditional potting—nearly three-quarters of a century into the late 1860s—is unusual in the extreme. And many aspects of South End's history as a traditional agrarian crafts neighborhood extend well beyond the recognized pattern for nineteenth-century New England in general. Nevertheless, our comprehensive study has led us to the conclusion that, in the framework of preindustrial New England agricultural neighborhood systems as they generally persisted for more than a century, Brooks is not a lone eccentric nor is South End unique. To the contrary, this case study points up some factors that are usually beneath the threshold of documented visibility but which appear to have general applicability toward understanding the phenomenon of the farmer-potter and the nature of agricultural crafts within their indigenous economic matrix.

Watkins (1945, 1950) and others identify significantly more potters in the rural landscape at the end of the eighteenth century and the beginning of the nineteenth than at any other time. Our investigation of South End has turned up at least seven members of that agricultural neighborhood who at least occasionally were making earthenware during a decade on either side of 1800. None of those men was designated as a potter in any existing public records or histories, and only two, Jesse Wadhams and Hervey Brooks, have been so identified by Watkins or any other students of the craft. Our research into ceramic production in rural New England generally, as well as specific investigations of sites in Massachusetts and Connecticut, also supports the conclusion that there was an efflorescence of the craft on an occasional or part-time basis on farmsteads throughout New England at that time. This trend was followed shortly by the disappearance of the farmer-potter phenomenon as both the demand for the product and the agrarian crafts economic structure drastically altered. Factors including available new commodities, population shifts, burgeoning new technologies, industrial centralization, transportation improvements, and pervasive social and economic transitions—all generally viewed as part of an "industrial revolution" and attendant community nucleation—combined rapidly to render the agrarian crafts system obsolete.

The utilitarian redware that Brooks produced did not alter appreciably in its shapes, forms, and technical characteristics throughout his long career. Two tightly defined corpora from excavations at his production site (one from the 1818-1820 surge, the other from very late in his career, ca 1860) as well as other stratified materials demonstrate the absence of identifiable changes in those traditional forms. Utilitarian redware, produced for the agricultural and domestic requirements of rural society, probably made up more than 95% of the farmer-plotter's output throughout early New England, judging

from excavated materials from both domestic and production sites (Worrell 1982a, 1982b, 1983). Personal communications from archaeologists and collectors agree with our findings consistently and indicate that Brooks's situation was typical in that respect. This was not art pottery nor was it produced for aesthetic motives. It was made according to conventions dictated by pragmatic functional needs of the clientele, and those slight variations of form that can be determined are attributable to an individual craftsman's preference rather than serial change (Worrell 1982a).

The distinction of Hervey Brooks and Goshen's South End, therefore, lies not in characteristics of uniqueness. Rather, it is singular in having provided better archaeological and historical resources for investigation, due largely to the caprice of preservation, and therefore to having been more thoroughly and comprehensively researched than numerous counterparts from throughout the rural New England landscape which remain less completely visible, if at all. This case study, therefore, presents evidences of cultural transitions that are not confined to a single craft or to a specific community. It speaks not just of transitions in ceramic technology and commerce, but of the evanescence of a way of life: the neighborhood agricultural crafts economic system.

10

Chapter

Eclecticism as a Response to Changing Market Conditions in Connecticut

Fred Warner

INTRODUCTION

During the course of a 1977 archaeological investigation of the Sarah Whitman Hooker house in West Hartford, Connecticut, a surprisingly large number of utilitarian redware sherds was recovered. In attempting to account for this it was discovered that a late eighteenth- to early nineteenth-century pottery had operated within a quarter mile of the Hooker house. Further inquiry revealed that, although the pottery buildings had burned over a century before, the property was still intact and essentially undisturbed. It was then established that this was, indeed, the Goodwin pottery (ca. 1796-1847) mentioned by Watkins in her discussion of Connecticut potters (1968:192). In 1978 we were granted permission to excavate the pottery, contingent upon the pending sale and development of the property. Our investigations were concentrated on the Goodwin pottery and its place among the Connecticut potteries. As is discussed below, our research indicates that these potters were both adaptable and eclectic, changing production technologies and their ceramic inventory through the years to stay economically viable in light of changing tastes and market conditions.

HISTORICAL BACKGROUND

In 1795 Seth Goodwin moved to the West Division of Hartford and pur-
chased 4 acres of land on the north side of what is now New Britain Avenue
for "60 pounds lawful money" (West Hartford Land Records [WHLR] 1795,
Vol. 20:97). On this piece of property Seth built his pottery. Less than a year
later Seth purchased two other pieces of property in West Hartford, including
one next to Zadock Hinsdale, the owner of a local brickyard. It is quite prob-
able that Seth purchased the land next to the Hinsdale property to obtain a
supply of clay, since good clay pits were located here (Burr 1976:38ff.; West
Hartford News, June 3, 1954:6D).

Evidently Seth underwent some financial reverses soon after this because
within a year he had sold all of his properties, including the 4-acre plot with
his "Potters Shop thereon standing," for $400 (WHLR 1796 Vol. 21:142).
Given the going rate of about three dollars to the pound and subtracting the
price of the original 4 acres of land, the value of the pottery buildings would
have been approximately $200. Whether he continued to operate the pottery
is not known, but nearly two years later, on November 8, 1799, Seth re-
purchased ½ acre of land and the pottery for £60 (WHLR 1799, Vol.
22:198). Three years after this Seth repurchased the remaining 3½ acres
and again owned the entire 4-acre piece with the pottery (WHLR 1802, Vol.
24:174).

When Seth's son, Thomas O'Hara Goodwin, was about to get married,
Seth sold him the 3 acres next to the pottery for a houselot, reserving for
himself only the 1 acre containing the pottery. Thomas built the house and
got married in 1821 (Pitkin 1918:87). He then went on to become one of
the most influential men in the community. It was his great-granddaughter,
Mrs. Marion Craig, who was living in the house during our excavations. After
Seth died in 1828, Thomas purchased the last half-acre and the pottery from
the estate and operated the pottery for a number of years until it burned about
1847 (Marion S. Craig, personal communication, 1978). It was never rebuilt.
By this time, however, Thomas had many other interests, including a large
farm which he ran for more than 30 years before he died in 1880 (Pitkin
1918:87; Watkins 1968:192).

There is not a great deal of information available about either Seth or
Thomas O'Hara Goodwin. We do know that Seth was born in New Hartford,
Connecticut, in 1772 (Pitkin 1918:84). His family had lived in Hartford for
five generations before Seth's father, Ebenezer, packed up in 1762 and moved
20 miles west to the village of New Hartford. Seth was born and lived there
23 years before he moved to New Britain Avenue in what was then Hartford's
West Division. By 1833, the date for which we have one of Thomas's bills,
(see Figure 10.2) the area was being referred to as West Hartford, even

though this was well before the official incorporation date of 1854 (Crofut 1937:336).

We have no evidence that Seth's father, Ebenezer, was ever a potter or that any kind of pottery was ever established in New Hartford, so it is not known where Seth learned the potter's trade. Ebenezer did, however, have 12 children, and Seth, the fifth born, was not the only one to become a potter. Ebenezer's tenth son, Horace, went into partnership with Mack Webster to run the Goodwin & Webster potteries in Hartford (Watkins 1968:195) and, although the ninth son, Pitts, apparently never took up potting himself, his son Harvey started a pottery in 1832 (Pitkin 1918:87), quite possibly after learning the trade from Seth or his son Thomas. After Harvey's pottery burned in 1867, the business was turned over to his two sons, H. Burdette and Wilbur E. They immediately built a larger pottery and operated as the Goodwin Brothers Pottery for approximately 40 years before that pottery was also destroyed by fire (Hall 1930:177).

Seth and his son Thomas were the only two potters who have been identified as having worked at their pottery. As mentioned, it is possible that Seth's nephew, Harvey Goodwin, worked at the pottery for several years while learning the trade but, even if true, this apprenticeship could not have lasted for more than two or three years before Harvey became established as a potter in his own right (Burr 1976:38). If Seth and Thomas were, in fact, the only potters employed at the pottery, then clearly the Goodwin Pottery was one of the smaller potteries in the Hartford area, but certainly no smaller than many other New England potteries (Watkins 1968).

The supposition that the Goodwin pottery was always a one- or two-man shop is strongly supported by all of the available historical and archaeological evidence. As mentioned, Seth sold the pottery in 1798 for approximately $400 and repurchased it in 1799 for roughly the same amount. At the time of Seth's death in 1828, the pottery shop, including the land it stood on, was valued at $200. The pottery had, in fact, suffered a 50% decrease in value in the 30-year period of operation. By contrast, the more successful Staats (States) pottery in New London was sold for $4440 in 1826 (Connecticut Historical Society, ms.) and the Stedman pottery in Hartford was sold for $10,000 in 1830 (Watkins 1968:194). Also, it seems fairly certain that the archaeological excavations did recover most of the wasters from the pottery and, if these do in fact represent most of the refuse from 50 years of operation, then the pottery was either quite small or very, very careful.

By contrast with the Goodwin pottery, other Hartford-area potteries were quite large. Watkins (1968:193) and Pitkin (1918:84) probably err when they state that Nathaniel Seymour built a kiln in West Hartford in 1790, because he did not purchase the land itself until 1802 and the deed makes no mention of any buildings on the site. Nevertheless, the Seymour pottery became quite

active, operating four wheels and firing its kiln about 50 times a year. Until about 1825 the Seymour pottery produced only domestic wares made from the local red clays, sometimes decorated with variously colored glazes. About this time, the demand for many of the locally produced items fell off sharply, but the Seymour pottery continued to operate, firing mostly unglazed flower pots.

This particular adaptation to a change in market conditions was one made by a number of the area's redware potters, including the Goodwins. However, the Goodwins did more than this to change their product line—they also expanded into the production of stoneware, which the Seymour pottery did not. These adaptations will be discussed in greater detail below.

Little documentary evidence is available concerning the wares produced by Seth during the time from 1796 to 1820 when he operated the pottery alone. As far as is known, he produced only redware during this period. Four pieces of pottery in the Wadsworth Atheneum in Hartford have been attributed to him by a former curator there, but the accuracy of at least two of these assignments seems doubtful. Like most early Connecticut redware potters, Seth evidently started out producing mostly utilitarian wares, including items such as milkpans, pudding pans, jugs, jars, and pots (Warner 1978). It was not long, however, before he was producing more elaborate forms as well. There are a number of sherds of combed slipware, slip-trailed pans, and pie plates (Figure 10.1), notched-edge plates, and molded or colored pieces in the archaeological sample. There are also a number of vessels which had very dark brown or black glaze (Warner 1978).

It was Seth's son, Thomas O'Hara Goodwin, who began to produce stoneware as well as redware at the pottery. The decision to manufacture stoneware must have been a very deliberate one. The clay for Seth's redware had come from the local clay pits in West Hartford and involved little more than driving the wagon less than a mile down the road and bringing a load home. By contrast, all stoneware clay had to be brought in from out of state, mostly from the South Amboy, New Jersey, area (Pitkin 1918:98-99; Watkins 1968:179). Transportation was normally by coastal barge, but even after the clay arrived in Hartford there was the long wagon trip from the docks to home. Since there was a considerable cost differential between the imported stoneware clay and the local redware clay, it became common practice to mix some of the cheaper local material with the stoneware clay (Osgood 1971:58; Webster 1971:38). There seems to have been considerable experimentation with this because many of the sherds recovered from Connecticut sites show varying mixtures of stoneware and redware clays. Some of the items from the Goodwin Pottery look like nothing more than hard-fired redware, while others show the very clear gray typical of pure stoneware clay.

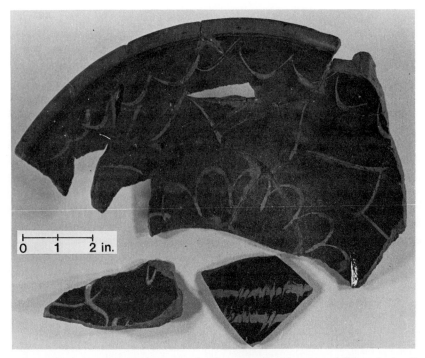

Figure 10.1 Decorated redware sherds, illustrating the eclecticism of Connecticut potter Seth Goodwin.

The firing of stoneware pottery is a more complicated procedure than the firing of redware. Ideally, ceramics should be heated to a point where the surface, but only the surface, melts. This is the process of sintering and is what makes a vessel watertight (Osgood 1971:33). Once the sintering point is reached, however, the body of the piece itself begins to melt, or vitrify, and eventually the piece will become distorted or even collapse from too much heat. Moreover, because most redware clays contain various substances that flow easily, such pottery tends to vitrify almost as soon as sintering temperatures are reached. This is why most redwares are not fired to their sintering point and why they need some sort of glaze if they are to be made waterproof. Stoneware, on the other hand, has a much slower vitrification rate and can be fired to the sintering point with less risk of collapse. To reach this point, however, the stoneware kiln must be fired at temperatures some 200° C higher than those used for redware and must be built to withstand these higher temperatures (Osgood 1971:33).

It is almost certain that the Goodwins had to construct a new kiln to permit the changeover from redware to stoneware, but the exact sequence of events

is not completely clear from the archaeological or historical record. Many, if not most, of the early redware kilns were constructed of bricks made from the same clay used for the pottery; if the redware pots would collapse at stoneware temperatures, so would the kilns. None of the documentary research or the archaeological investigations suggest that anything but a single kiln ever existed on the Goodwin property, and, if this is true, the original kiln must have been rebuilt or replaced sometime in the 1820s when Thomas started to produce stoneware.

Although Thomas purchased the property surrounding the pottery before his father died and bought the pottery itself from his father's estate, it does not appear that he pursued the pottery business with as much energy as his father. It is not clear just exactly when Seth turned the operation of the pottery over to Thomas but it was probably in the mid-1820s, which would mean that each man would have had responsibility for the pottery about the same length of time. The number of redware sherds recovered, however, was greater than the stoneware sherds by a ratio of almost 6 to 1 (see Table 10.1).

Under Thomas, the pottery continued to produce both redware and

Table 10.1
Ceramic Artifact Inventory of the Goodwin Pottery

Redware sherds		
glazed	9,606	
unglazed	10,625	
water pipe	153	
kiln tripods	1,071	
other kiln furniture	248	
	21,703	(81.7%)
Salt-glazed stoneware sherds		
probable jug sherds	1,080	
probable crock sherds	1,909	
flat kiln furniture	518	
lump kiln furniture	410	
	3,917	(14.7%)
Miscellaneous		
pieces of brick or kiln	732	
pearlware	2	
whiteware	109	
flat glass	87	
charcoal irons	14	
	944	(3.6%)
	26,564	(100.0%)

stoneware, evidently using the same kiln for both pottery types. Our analysis of the materials recovered has suggested a waster disposal pattern which, if accurate, reveals a significant decrease in the number of decorated redware sherds over time but an increase in the number of undecorated and unglazed redware sherds from items such as flowerpots and flat dishes. This change was accompanied by the steady increase in the number of stoneware sherds from crocks and jugs (Warner 1978).

THE ARCHAEOLOGICAL INVESTIGATIONS

As mentioned earlier, knowledge of the Seth Goodwin Pottery property came through an archaeological survey being performed at the Sarah Whitman Hooker house in West Hartford. After permission to excavate the Goodwin pottery was received, about 1½ acres of the property were gridded and a series of test pits excavated. The testing clearly isolated a fairly small area containing a heavy concentration of sherds from other sections of the property, which yielded few artifacts. This small area coincided nicely with the original half-acre site identified from the documentary research. The testing also revealed a plow zone throughout the entire 1½ acres tested. It was later learned that the property had been used for victory gardens during World War II, but there seemed to be little lateral displacement of artifacts.

In all, twenty-one 2 × 2-m squares were excavated, mostly to a depth of 60 cm, well below a layer of sterile yellow clay loam. The number of artifacts recovered from individual squares ranged from 333 in Square NOE2 to 2915 in Square N2E5. Almost all of the cultural material recovered was from six squares aligned along a NE–SW axis. A summary of the material recovered is included as Table 10.1.

Of the 732 pieces of kiln brick found, many were coated with a heavy layer of salt glazing. These kiln pieces were rather tightly grouped in a 6 × 9-m section along the NE–SW axis. One of the puzzling aspects was that the heaviest concentrations of both sherds and kiln pieces were in the same squares, raising the possibility that the kiln collapsed while being fired. An attempt was made to determine the type of pottery found in direct association with the kiln pieces, but the distribution of redware and stoneware seemed to be rather equal throughout the six affected squares. There was a heavier concentration of redware sherds in the northeastern squares and of stoneware sherds in the southwestern squares but no clearly defined separations. Also running diagonally through the middle of four squares along this NE–SW axis was a concentration of fieldstone. Since there was no evidence of any mortared joints between the stones and they did not extend down to the

normal frost line, they may have been either part of a walkway or part of a building, possibly the potting shed itself. They certainly were not substantial enough to be a foundation for the kiln.

From the pieces of kiln recovered it was possible to make a tentative reconstruction of at least the lower part of the kiln used by Thomas O'Hara Goodwin to fire both the stoneware and redware (Warner 1978). Although most of the kiln pieces found were single unmortared bricks, there were several blocks still held together by the thick coating of glaze, including some with 8 or 10 firebricks. Several of these pieces contained the wedge-shaped bricks normally used in thrust arches, and a rough calculation of their radii suggested an arch of between 4 and 5 ft. This would indicate that the building itself was probably about 8 to 10 ft in diameter or width, which would agree nicely with the description of the kiln used by Nathaniel Seymour less than two miles away. The glaze coating also contained a number of redware sherds cemented into it. Thus, Thomas was almost certainly using a single kiln for both redware and stoneware. There were no kiln pieces found which could only have come from a redware kiln, and no bricks which measured 9" × 4" × 2½", which are the dimensions Watkins (1968:9) says were universally used for redware kilns.

If this analysis of the kiln remains is correct, it is apparently in direct contradiction with the only known possible "picture" of the kiln (Figure 10.2). At the top of the order form used by Thomas O'Hara Goodwin are two cuts, one of a kiln and one of a potter working at his wheel. The kiln is a rectangular brick structure with a thrust arch roof, a traditional type of kiln frequently used for small redware potteries but not generally acceptable for stoneware production (Norton 1932:22–25). The explanation for this is probably that Thomas's printer used standard printing cuts for both the kiln and the potter's wheel instead of more expensive custom engravings. It happens that the two cuts on Thomas's bill are identical with two that were used in New Haven on Absalom Stedman's bills.

The furniture used in the firing of the Goodwin kiln is typical of most kilns of the period. The stoneware furniture consisted mostly of flat bars, which were reusable, and small hand-fashioned lumps, which were not generally saved. There was a smaller number of doughnut-shaped pieces, and these also show evidence of having been used more than once (Figure 10.3).

The redware furniture was quite different. Most of the pieces of redware furniture excavated were from the spurs, or stilts, used to separate pieces in a stack. Most of the other pieces were variously sized wedges or flat U-shaped lengths, but there were also a few of the massive hollowed-out triangles which were stacked up to support the unglazed rim of a flat plate or shallow dish. Although it is fairly obvious that none of the redware furniture, which was meant to be fired at 1000°C, could be used to fire the stoneware at 1200°C

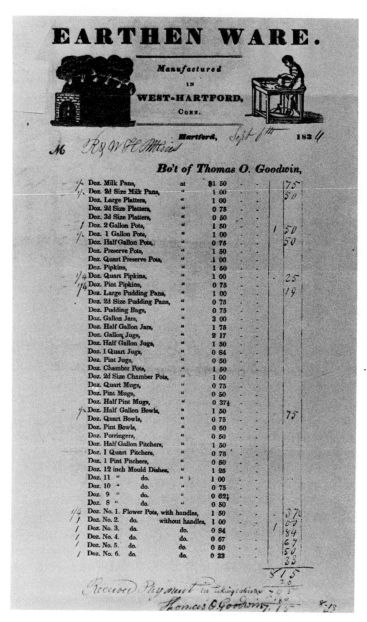

Figure 10.2 Thomas O. Goodwin order form.

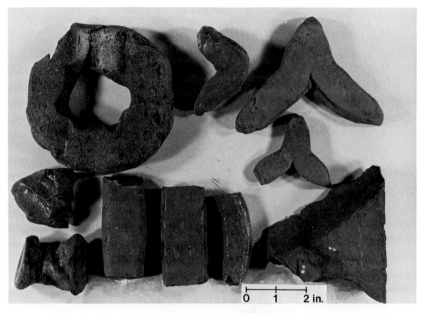

Figure 10.3 Stoneware and redware kiln furniture, demonstrating continued traditionalism of production.

without melting, it is not so clear why the stoneware furniture was not used to fire the redware. There are significant differences in both the types of ware being fired and in the process, but none of the flat stoneware bars had any redware glaze on them, though much of the redware furniture had glaze drippings.

THE WARES

We have no documentary evidence of the items produced while the pottery was operated by Seth Goodwin, but we do have two of Thomas O'Hara Goodwin's order forms which list the pieces being sold by him in 1833 and 1834 (Figure 10.2). Of the 45 different items listed on the bills, almost all could be identified from the recovered sherds. Although the few items included on Thomas's bill which could not be identified from the recovered sherds were probably not large-volume items, it is still puzzling that, from an inventory of almost 22,000 redware sherds, none of their distinctive shapes could be found. The unidentified items were pipkins, pitchers, mold dishes, and pudding bags. Since similar discrepancies occur at other potteries, it is

entirely possible that some of these items, although listed, were never manufactured at this site (Webster 1971:206).

Perhaps the most surprising result of the entire project was the realization that the range of products found at the Goodwin pottery could in no way be anticipated from any study of the historical resources. During the course of the research, both local and state libraries were searched for material regarding Hartford potteries; newspaper files were examined, and every collection of local redware and stoneware that could be located was checked for items that might be compared with the material excavated. The largest collection of local redware is held by the Wadsworth Atheneum, most of which was collected early in this century by the chief curator Albert Pitkin (1852–1917). The fact that there is so little of the utilitarian redware left is not particularly surprising, since most was meant for daily use and the easily broken redware does not stand up well under such usage (Osgood 1971:53). Stoneware from the pottery has fared better. Not only was the product more durable in its own right, but most stoneware items were essentially storage vessels and not subjected to everyday use, as were the redware pieces.

For whatever reasons, the paucity of vessels remaining and the poor documentation of types manufactured has led to some erroneous conclusions about local redware potteries. Watkins (1968:8–9), for instance, was convinced that "notched-edge plates . . . with elaborate trailings and combings of black, white, and green slips" were all "made outside of New England" since she "never found the slightest evidence in the form of shards of its manufacture here" (1968:8). However, at the Goodwin site there were sherds from notched-edge plates and others decorated with combed slipware (Figure 10.1).

In the collections at the Wadsworth Atheneum, a 1-pint mug with dark brown glazing was identified as being from New Jersey, but an identical mug was found at the Goodwin site (Warner 1978). Furthermore, the elaborately decorated slip-trailed pie plates were supposed to have been made only in the southwestern part of the state (Watkins 1968:192), and a pie plate in the Wadsworth collection is attributed to that area. However, there are sherds from the Goodwin pottery so similar that it is highly probable that the pie plates were both made and decorated by the same artist (Warner 1978:Fig. 5).

There were also discrepancies between the Goodwin order forms and the material recovered. The largest pot, or crock, listed on the order form was the 2-gallon size, but sherds were found from 3-gallon crocks. Likewise, the largest jug listed was the 1-gallon size, but 2-gallon sherds were identified. Thomas O'Hara Goodwin does not list any butter churns but there is a churn in the Noah Webster house with his "T. O. Goodwin" imprint on it.

One item that did not appear in any listing but was certainly being produced at the Goodwin Pottery was a redware pottery water pipe (Figure 10.4). As early as 1807 Nathaniel Seymour, operating the pottery about two miles from the Goodwin Pottery, became licensed to manufacture and sell a conduit of clay "superior to any other for conveying water, and for keeping it clear, and is judged to be very durable" (Burr 1976:38). Four years later, Seth Goodwin purchased a machine similar to Seymour's which compressed a charge of clay in a cylindrical barrel and then hydraulically drove a punch through the center of it to form the bore (Burr 1976:38). The machine formed a 1¾" male taper on one end of the pipe and a similar female taper on the opposite end. The pipes were then dried, glazed on the inside, and fired.

Another item not listed on the 1833 order form but found during excavation was what may be a decorated butter pot lid. Whereas many jars had flat knobbed lids inset to a shoulder (Watkins 1968; Webster 1971) and a number of these lids were found, there were also a few lids which covered the entire pot, being held in place by a vertical flange. Several sherds from one of these wide lids were found at the Goodwin pottery with an unusual decoration. The lid appears to have one circle of molded stars inside of another ring of molded figures, and a ring of raised dots outside of all of these. The cover was similar to those seen from a number of other potteries (Webster 1971:211, 212), but nothing similar to this was listed on the Goodwin order form.

It is quite probable that most inconsistencies between the product lists and the pieces actually recovered can be accounted for by the addition or subtraction of pottery types as the demand for them rose or fell through the decades. It is somewhat more difficult to reconcile the multiple categories of redware platters, milkpans, pudding pans, chamber pots, and other items which are only listed by numbered sizes, with no dimensions given. When the number of categories coincide, as they do with chamber pots, it is fairly easy to distinguish a "2nd size" from the regular-sized chamber pot. There

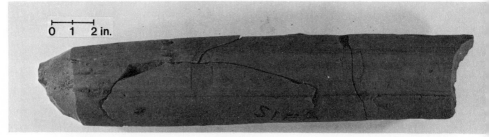

Figure 10.4 Redware water pipe, illustrating economic adaptability through mass production of this industrial form.

are, however, several cases where the observed series does not seem to match the printed series at all, as with the "large," "2nd size," and "3rd size" platters, or even with the series of flowerpots.

As noted by Watkins (1968:34–38), the various attempts to make stoneware in Massachusetts from local clays were something less than rewarding, to say the least. Several unsuccessful efforts were made to burn the clay at temperatures high enough to make stoneware. Evidently the same sort of experimentation was going on in Connecticut, because in 1789 the General Assembly received an application for funds to start a stoneware pottery using Connecticut clay (Spargo 1974:106), but the funds were never authorized. Stoneware clays continued to be imported, mostly from the Staten Island and South Amboy areas, but the transportation charges made such clays so expensive that the potters frequently found it difficult to pass along the increased costs. At the same time the consumer was being exposed to the higher-quality products from the stoneware potteries and from the expanding British ceramics industry. The local potteries consequently were caught in a price–quality squeeze.

To satisfy this need for a more durable product at a lower price, it became common practice for Connecticut potters to stretch the expensive stoneware clay by mixing some of the local red clay with it. When Thomas O'Hara Goodwin started to bring in stoneware clays, presumably from the South Amboy, New Jersey, region, he evidently experimented with the amount of red clay that could be mixed in and still have the properties of stoneware (Warner 1978). The stoneware sherds recovered from the pottery range from the neutral gray (Munsell N 8/0) of the unadulterated imported clays to an almost buff (Munsell 5YR 7/3) admixture of imported and local clays (Munsell 1975). The body or paste of the buff sherds tends to be much more porous and friable than the grays, with a less pronounced surface-to-body distinction. The presence of a few badly warped sherds which appear to be hard-fired redware suggests that Thomas either overfired a redware kiln load or mixed too much redware clay in some of his stoneware. There are even a few sherds from a slip-trailed pie plate where the red and gray clays are combined but not thoroughly mixed, there being clear lines of separation between the two.

The excavations also produced far more variation in pottery decoration than earlier historical research suggested would be found. There were many more of the lead-glazed redware pieces than expected, and a number of these had some other type of decoration added to the clear lead glaze. Most redware is glazed to provide a normally nonvitrified porous surface with enough vitrification to make it waterproof. The two basic types of glaze used by Connecticut potters to do this were the lead glazes used on redware and the alkaline, including salt, glazes used on stoneware (Spargo 1974:44). The

lead glazes were not suitable for stoneware because they would burn off at the higher temperature needed for stoneware firing, and the salt glazes could not be used on redware because they needed the higher temperatures to work.

Since none of the redware sherds uncovered at the nearby Sarah Whitman Hooker house showed any unusual decoration or glazing, we expected a comparable situation at the small nearby Goodwin pottery, which we assumed was using local clay to make utilitarian objects for a neighborhood clientele. All the documentary evidence and museum collections indicated that, other than some rather plain slip-trailed pie plates which had been made in several of the Hartford potteries, there was little artistic work flowing from local potteries.

The excavated material did not substantiate these assumptions. Over 43% of the redware sherds had the typical clear lead glaze, and there were many other decorative forms as well, including sherds from yellow slip-trailed milk-pans, combed ware, brushed blotching on molded handles, brushed brown glaze on yellow-green glaze, and black glazed mugs, to name a few. One of the nicest examples was a yellow slip-trailed pie plate with two rows of squiggles around the bevel and a starburst in the center (Warner 1978). Despite the wide variety of slipped decoration on the recovered sherds, fewer than 10 sherds were found with any incised or tooled decoration.

Conversely, most of the stoneware was totally undecorated. The Goodwin stoneware did not exhibit any of the fancy cobalt designs seen on many nineteenth-century jugs and pots. This may largely be an indication of the times in which it was produced or of the market for which it was intended. Stoneware produced during the first half of the nineteenth century was much more apt to have the decorations incised or incised and then splashed with cobalt, a very tedious process. It was not until after the 1840s that the more elaborate but less time consuming cobalt-painted designs became popular (Osgood 1971:128-66). Since the Goodwin pottery did not extend into this later period, none of these painted designs were expected or found. On the other hand, the Goodwin pottery was producing stoneware during the heyday of decorative incising (1800-1850), but no stoneware sherds with any elaborate incising were found either. The only two additions to the clear salt glazing which might be considered decorative were the brown stain or slip found on a number of pieces and the cobalt brushing around the handles and stamped name (Figure 10.5).

Apparently the Goodwin pottery was enough in the mainstream of New England pottery traditions to reflect the typical vessel shapes of the nineteenth century (Osgood 1971:116; Webster 1971:21-22). There is ample evidence at Goodwin of redware vessels with the globular form common before 1840 (Warner 1978) and also a variety of vertical-sided redware pots, none of

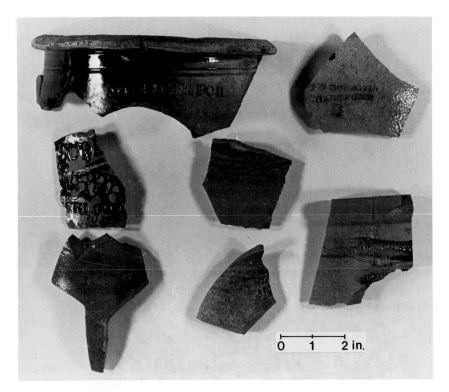

Figure 10.5 Standardized marking of stoneware sherds from Goodwin Pottery.

which is over 4″ high. There were literally thousands of unglazed flowerpots sherds, of many sizes and styles.

The situation was not significantly different for the stoneware items. There were many sherds from globular stoneware jugs and jars with inset covers and from a variety of vertical-sided pots, or crocks. There were, however, no other stoneware forms identified. Thus, the Goodwin stoneware corresponds nicely to the evolution of form observed throughout New England (Osgood 1971:110–128; Webster 1971:21–23). Jug forms from all periods prior to 1845 exist and none of the later vertical-sided jugs were found. The vertical-sided pots, or crocks, which either appeared first or increased significantly in the 1830s, are present but there was no evidence of any of the bulging, wide-mouthed vessels sometimes called jars and sometimes called pots (Watkins 1968:238).

A caveat should be entered here to the effect that it is virtually impossible to differentiate between a sidewall sherd from a globular jug and one from a bulging jar, or between a sidewall sherd from a vertical-sided jug and one

from a vertical-sided pot, or crock. Statements concerning these forms are based on the presence or absence of diagnostic sherds—rim sherds, base sherds, cyma curves—and are, at best, tentative. Another problem which has not been addressed here is the definition of terms used to describe vessel forms and functions (Deetz 1973:26–27; Osgood 1971:50; Spargo 1974:6; Watkins 1968:238). As quickly becomes evident from the literature on this subject, the terminology one uses is academic until the need arises to match excavated sherds with inventory lists.

One further note in passing: Although two bill heads are certainly not enough to permit any definitive conclusions, it seems that Thomas O'Hare Goodwin was not inclined to give the 25–40% discounts on his ware that many potters gave (Figure 10.2; Webster 1971:210, 214). On one bill for $18.94 he apparently gave no discount, and on another he gave only 10%.

INTERPRETATIONS AND CONCLUSIONS

During the late eighteenth and early nineteenth centuries there was a noticeable decline in the demand for locally produced redware for a number of reasons:

1. *Frangibility.* The early redwares were almost invariably soft bodied and brittle surfaced—easily chipped or broken (Watkins 1968:1). Although this shortcoming was basically inherent in the product and method of manufacture, a number of redware potters tried to overcome it by mixing small amounts of stoneware clay with the local red clays and firing at a somewhat higher temperature. This is apparently what the Goodwin pottery did with some of its wares, as is indicated by the archaeological evidence (Warner 1978).

2. *Safety.* Lead-glazed redware vessels, although initially used for milk, water, and table foods, were never suitable as storage containers for anything containing vinegar, wine, or other substances which would attack the glaze (Ramsay 1931:224–229). Eventually, even the use of lead as a glaze for table ware was recognized as being dangerous. One solution to this problem was to use the hard-bodied stoneware for storage vessels and other types for table ware, and this is what happened in many communities. Even though the stoneware clays had to be imported from New Jersey and significantly increased the costs (Webster 1971:38), the Goodwin pottery began to manufacture the stoneware vessels.

3. *Competition.* As early as the mid-eighteenth century pottery from England was being imported to America in quantity (Weatherill 1971:87), and, by 1760, "an astounding amount of the wares made in Staffordshire reached

America" (Wedgwood and Ormsbee 1947). With the development of their hard-bodied whitewares, the English potters were supplying America with pottery at prices local American potters could not compete with (Cushion 1976:130). Also available to Connecticut consumers were the cheaper grades of Chinese blue-and-white porcelain (Osgood 1971:60). There was little the local potters could do about this competition. Englsih clays were better, the workmanship was superior, and the Staffordshire pottery district production methods far outstripped the capabilities of the Hartford potteries. One of the changes the local potters could and did make was to improve the appearance of their wares. This is seen later at the Goodwin pottery in the appearance of the slip-trailed decorations, the scalloped-edge pie plates, and the variegated glazes on a number of pieces.

Despite these obstacles, Seth Goodwin did start a pottery in 1796 which first produced redware and later, under his son Thomas O'Hara Goodwin, both redware and stoneware. It appears that the pottery was never more than a one- or two-man operation, probably using the Goodwin children or relatives as helpers. Since the assessed valuation of the pottery was only $200 in 1828, 30 years after its founding, it can not be considered to have been a resoundingly successful business venture. Whether it was ever meant to be is not clear; both Seth and Thomas were apparently successful in other ventures (*West Hartford News*, September 26, 1959:4) and the pottery business never seems to have been actively pursued on a full-time basis. Nonetheless, the Goodwin pottery is typical of the early nineteenth-century redware and stoneware industry in New England. For its size the Goodwin pottery produced a surprisingly large variety of items, many of which were evidently not produced at other Hartford potteries. The fancy notched and slip-trailed pie plates and pudding pans, for example, were not objects that have been recorded previously for this area of Connecticut. Innovative with the production of redware water pipes, and certainly above the local norm in the decoration of his redwares, Seth seems to have been more aggressive than some, remaining economically viable by adapting the business to changing tastes and cultural needs.

11

Chapter

Regional Variation and Drift: Late Eighteenth- and Early Nineteenth-Century Requa-McGee Site Coggle-Edged Trail Slipware

Nancy S. Dickinson

INTRODUCTION

The interpretation of poorly documented but artifactually rich disturbed archaeological sites can seldom rely on *in situ* associations and must approach the archaeological data in as many other ways as possible. The present study analyzes a poorly documented, archaeologically derived artifact category—drape-molded, coggle-edged slipware—and considers it beyond the household level of description. The study tries to place the artifact category within the context of a production-distribution system through time and space and examines regional variation of styles as an example of drifting ceramic tradition.

An archaeological collection from the Requa-McGee site (ca. 1720-1970) on the Hudson River in Tarrytown, Westchester County, New York, includes a sample of drape-molded, coggle-edged, trail-slipped, lead-glazed red earthenware (drape-molded, coggle-edged slipware) partial vessels and rim sherds. This domestic site may provide a late eighteenth- and early nineteenth-century provenience for the production, distribution, use, and dis-

189

posal of the coarse ceramic ware that comprises the total domestically pro-
duced slipware sample.

The large sample of drape-molded, coggle-edged slipware rim sherds and
partial vessels excavated and catalogued during an ongoing "block" exca-
vation presents the opportunity to study an artifact category as well as con-
sumption and disposal patterns for at least four generations of tenant and
freehold farmers who occupied the site. At the same time, the literature of
American folk pottery tends to be very general and has been written primarily
for the collector of antiques and crafts. Therefore, the absence of a compre-
hensive literature for and by archaeologists and social historians, combined
with the presence of the sizable slipware sample (12,750 sherds), provides a
chance to observe an artifact category from a specific archaeological site and
then to make general comparisons with other documented samples of the
same ceramic ware.

The Requa-McGee site's total slipware sample is composed of 108 partial
vessels and mutually exclusive rim sherds of plates and platters. These vessels
are grouped into 15 varieties, plus 1 miscellaneous group, based on deco-
rative techniques and motifs (Table 11.1). These varieties are described,
wherever possible, using 22 attributes. Two attribute clusters seem to be pres-
ent and comprise two slipware types. Comparison of the Requa-McGee site
artifacts with the available literature as well as with documented museum and
private collections suggests that the artifact category under study includes
neither wheel-thrown nor sgraffito-, relief-, or figurative-decorated ware. In-
stead, there seems to be a cluster of attributes that suggests southwestern
Connecticut, New York City, and New Jersey proveniences for the produc-
tion of the red-bodied slipwares.

Historical Background

Conventional wisdom suggests that this coarse earthenware was produced
and used locally. Not much is known about Philipsburgh Manor or Tarrytown
eighteenth- and early nineteenth-century potters and their wares (Ketchum
1970, 1971; J. J. Smith, personal communication, 1980). Something is
known, however, about the Requa family who occupied the site. Tenant
farmers until after the Revolutionary War, the Requas were able to purchase
the land in 1785 from the Commissioners of Forfeiture (Brennan 1980). For
more than 100 years the Requa name was associated with the area that, then
and now, fronts on the Hudson River and is just off the Albany Post Road,
now Route 9A (Broadway), in the southern part of Tarrytown, New York
(Figure 11.1). Unless otherwise noted, the following history of the family and
land is based on Louis A. Brennan's data and interpretation (1980). Brennan

Table 11.1

Coggle-Edged Trailed Slipware Excavated from the Requa-McGee Site

Attribute	a (7)	b (1)	c (10)	d (1)	e (16)	f (4)	g (10)	h (3)	i (6)	j (1)	k (13)	l (3)	m (1)	n (4)	o (3)	misc. (25)	Total 108
1. redware, drape molded, ¼ to ⅜ inches thick	7	1	10	1	16	4	10	3	6	1	13	3	1	4	3	25	108
2. plan view, circular	7	1	10	1	16	4	10	3	5	1	13	3	1	4	3	24	105
3. vertical profile, shallow	7	1	10	1	16	4	10	3	6	1	13	3	1	4	1	25	106
4. rim, edged by shallow coggling tool	3	1	8	1	8	4	10	3	5	1	13	1	1	3		21	83
5. body, slip trailed directly on	7	1	10	1	16	4	10	3	6	1	13	3	1	4	3	25	108
6. slip cup, 1 to 3 quills		1	1							1	8	1	1				36
7. design motifs do not fill the field				1					2								21
8. design motifs, nonrepresentational	7	1	10	1	16	4	10	3	5	1	13	3	1	4	3		82
9. word motifs																1	1
10. overall design radially symmetrical							5	2									8
11. green spots or wash in glaze	2					3	4	3	1	1							14
12. clear, lead glaze over trailed-slipped body	7	1	10	1	16	4	10	3	6	1	13	3	1				81
13. redware, not drape molded																	0
14. plan view, not circular			1					1	1								3
15. vertical profile, deep																	0
16. rim, edged by not shallow-toothed tool	4		2		8				1				1	1	1	4	21
17. body, slip trail not directly on																	0
18. slip cup, 4 or more quills	7	1	1		4						13		1	1	3		27
19. design motifs do fill field	7				16		10		4				1				32
20. design motifs, representational																	0
21. overall design bilaterally symmetrical	7		5	1		4			2		13	1	1				33
22. diameter: / height:																	
10 inches	1		2	1	1	1	2		1		1		1	1	1	1	7
12 1½ inches	2		1		6	3	8	1	1		1			2	2	19	18
14 1½	4		7		7				3	1	11	1				3	69
16 2					2												5

[a] See pp. 198–201 for description of varieties.

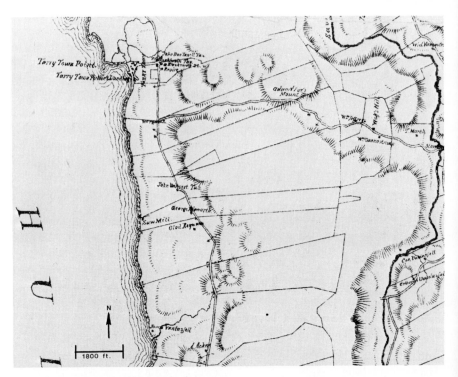

Figure 11.1 A portion of Philipsburgh Manor, New York, 1785. Owners purchased the land from the Commissioners of Forfeiture (from Scharf 1886, after John Hill 1785; courtesy, The New-York Historical Society, New York City).

was Director of Material Archives Laboratory of Archaeology (MALFA) and Project Director for the Requa-McGee site.

The Requas, French Huguenots, were apparently the first European set-tlers on a 296-acre tract of land approximately three miles south of Adolph Philipse's (grain and lumber) Upper Mills (Brennan 1980). The immigrant Gabriel Requa (1677–17??) married a fellow shipmate, Jeanne, and some time after 1720 they were tenants on Adolph Philipse's manor. Documentary evidence is scarce, but it has been deduced that Gabriel and Jeanne named a son Glode (1700?–1759?) after Glode's paternal grandfather. Town, mar-riage, and manor records place the Requas in the area from 1729 on (Haacker 1951; New York Genealogical and Biographical Record [NYGBR] 1928).

Probably during the 1760s Glode's son, Glode II (1727–1806), one of eight children, took over the farmstead. He could have inherited or else bought the land and improvements. In 1785 it was Glode II, by then Captain

Glode, who purchased the 296-acre parcel of land from the Commissioners of Forfeiture (see Figure 11.1).

After Glode died in 1806, his sons Samuel (17??–1826) and Daniel, two of nine siblings, divided the land in half, Samuel taking the northern acreage and Daniel taking the southern. The northern half is the site of the twentieth-century archaeological investigation. Samuel's and Daniel's shares of the property, livestock, tools, and equipment were noted in documents and suggest their interest in farming. The division of household effects is not listed in the extant records (R. Wingerson, personal communication, 1981).

As unmarried adults, four of Samuel's seven children bought out their siblings' interests in the northern acreage and lived in the house. In 1853, after further subdivisions, Samuel's sons Isaac and Nathaniel sold the house and the remaining 35 acres out of the family. During the "Pink Stone" country estate period, a caretaker, William McGee, was a tenant in the house.

Brennan (1980) refers to the Reverend Amos Requa, a late nineteenth-century family genealogist, who mentioned that Samuel may have built or rebuilt a house sometime after 1806. This house is one of the two standing structures that in 1976 came to the attention of Suzanne Danielson of the Historical Society of the Tarrytowns. After researching the structures, Danielson concluded (personal communication, 1978) that the standing dwelling was the Samuel Requa house, built or rebuilt, that Amos Requa mentioned and that it was also the inked-in square marked "Glod. Requa" on the John Hill map in Scharf (Figure 11.1). In 1977 architectural historians from Sleepy Hollow Restorations investigated the dry stone wall foundation, the mortised and tenoned summer beam and other wood structural members, and also the split lath with animal-hair-tempered plaster of the two-story shingle and clapboard gambrel roofed house. The architectural historians suggested an early nineteenth-century date for the building.

Nineteenth-century federal census data give a general picture of the fluctuations in the number of household members of two generations of Tarrytown Requas (McLaughlin 1959a, 1959b). This documentation reveals the bare bones of the Requa family history and their building construction on the property known as the Requa–McGee site. In addition to the documented house standing on the site, there are also some very poorly documented or even undocumented features. One is a standing structure and three others are subsurface features uncovered during the 1980 and 1981 field seasons. Nineteenth- and early twentieth-century data from renderings of proposed landscape designs, business directories, atlases, and insurance maps give conflicting and confusing information and do not corroborate what has been found on or in the ground.

This ground, though—this land—has a long history. The bedrock is Ford-

ham gneiss, and a soil buildup occurred when the area was a glacial lake during Pleistocene times. Since aboriginal times this land has been put to several uses: tenant farm on an "English" manor system (1690-1785; Kim 1978), freehold farm (1785-1853), speculation property (1853-1855), "country" estate (1855-1972), and at present a corporate campus for General Foods Technical Center.

SITE EXCAVATION

During the first six field seasons (1977-1982) one standing structure, the extant Samuel Requa house, having been unoccupied for at least five years prior to the field work (B. Aziel, personal communication, 1982), deteriorated extensively and exposed construction not otherwise visible. The outside perimeter of this 9.6 × 8.5-m full-basemented house was chosen as the initial locus for excavation to test the assumption that the house was built in the early eighteenth century and rebuilt in the early nineteenth century (Louis A. Brennan, personal communication, 1978). The presence of both a scatter pattern and pit deposition of material culture as well as builders' trenches was predicted. A pattern of scattered cultural material, primarily ceramics with eighteenth-century initial manufacturing dates, appeared below nineteenth- and twentieth-century architectural demolition debris. Neither stratified pits of any kind nor builders' trenches were observed.

The second standing building was the "stone shed," a fieldstone and ashlar block, dry stone and concrete-pointed one-story sloped-roof building, 4.6 × 13.7 m. Several episodes of construction and alteration were apparent. Excavation around the stone shed began late in the 1980 field season. During the 1977-1979 field seasons the emphasis was on establishing an eighteenth-century Requa context for the site, and the stone shed seemed to represent a mid-nineteenth-century McGee context.

The "stone house" and "mid-house", two subsurface features unearthed in 1980, modified the prediction of the early eighteenth-century Requa context for the standing house. Instead of there being one house, built early in the eighteenth century and rebuild or added to in the nineteenth century, it was thought that perhaps there were two different houses built at separate times. This revision in thinking allowed for an investigation of loci beyond the 3-m strip immediately surrounding the standing house. In 1981 a third subsurface feature was discovered, the 4.6 × 18.3-m dry stone foundation that underlay the fieldstone and ashlar block stone shed. Excavation has proceeded within the foundation walls or piers of the three subsurface features as well as around the perimeter of the two standing structures. No undisturbed feature has been encountered nor primary deposition found.

In 1980 it was realized that the expected and perceived scatter pattern represented not an eighteenth-century primary deposition but rather a nineteenth-century secondary or tertiary deposition. There had been repeated cycles of construction, occupation, alteration, and destruction (Hunter 1981). Soil moving is evident throughout horizontal and vertical space. Through space, the color and type of soil changes, but the mixture of cultural material within the soil matrix does not. Within any one locus or level on the site, cultural material is present that has initial manufacturing dates throughout the eighteenth century and into the first half of the nineteenth century. In the midhouse locus, one of the subsurface features, are three distinct soil layers plus a fourth stratum which apparently also represents redeposition. In the stone house locus, another of the subsurface features, is a single episode of redeposition of architectural debris and other cultural material with dates ranging from the early eighteenth century to the mid-nineteenth century. Such soil moving and grading around structures has often been noted as common in the Northeast (Handsman 1981b; Huey 1981; Hutchinson and Wentworth 1981).

SITE CERAMICS

Of the 82 ceramic types used by South (1978a:210-212) to construct his mean ceramic dating analysis tool, 57 are present in the Requa-McGee site collection. Ceramics (12,750 sherds) account for about 85% of the 15,000 artifacts catalogued between 1977 and 1981. Brennan (1982) argues that the presence of the ceramics, which can be seriated, represents a continuum: The Requa-McGee householders evidently purchased the newest and most popular styles and ware types. Table and tea ware ceramics present in the sample include almost every available type imported from England, ranging from delft to dotted, trailed, and combed buff-bodied earthenware (slipware) and white salt-glazed stoneware through creamware, pearlware, and Jackfield types to ironstone. Although there are many buff-bodied slipware bowls or mugs, there are only two or three buff-bodied slipware plates or chargers. Except for several bisque dolls' heads and extremities, English and Continental porcelains are absent. However, some Chinese export porcelain and some late Japanese porcelain are present. Ceramics made in Germany are very sparsely represented, and French-made ceramics are absent.

Domestically produced coarse stonewares and earthenwares are included in the ceramic collection. Gray and buff-bodied salt-glazed stonewares are represented, some of which might be attributed on the basis of paste, form, and decoration to New Jersey and New York City potters, such as Morgan, Crolius, Remmey, and Commeraw (Guilland 1971; Ketchum 1970, 1971;

J. J. Smith, personal communication, 1981). Albany slipped (interior) stoneware is also present. Most of the ceramic froms represented are utilitarian and were probably used for food preparation and storage.

Domestically produced redwares present in the archaeological sample include interior-exterior lead-glazed wares. In addition to these vessels, which probably functioned in food storage, preparation, and service, there are Jackfield types that are table and tea service earthenwares. Exterior-only glazed redware vessels are very few and represent food storage and service shapes. Interior-only lead-glazed redwares include some milkpans, pudding pans, crocks, and, of course, the 108 coggle-edged plates and platters, all forms used in food preparation and service.

Vessel shapes such as chamber pots used in hygiene-related activities are present in both interior-exterior glazed coarse and fine earthenwares and stonewares. Moreover, New Jersey-marked ironstone and ironstone china table and tea service forms are part of the archaeological collection.

As for the unglazed redwares, both flowerpots and handmade and factory-made red bricks show up throughout the excavated levels. Some factory-made bricks have embossed names that help narrow down the production place and period of manufacture, but neither embossed nor incised stamp marks are present for the domestically produced lead-glazed redware, an artifact category that shares a clay source with the common building brick.

Drape-Molded, Coggle-Edged Slipwares

Redware production processes are described elsewhere in this volume (Worrell, Chapter 5; Pendery, Chapter 6), but a brief mention of vessel form and decoration is included here. The total sample of coggle-edged slipware from the Requa-McGee site is drape molded. It seems to have been made from locally available clay that was glacially deposited. After the clay was shaped and allowed to dry, the leather hard body or paste was removed from the mold, inverted, and the rim was incised with a rouletting or coggling tool. The slip was then applied directly to the interior—and only the interior—of the earthenware body. This slip, a creamlike mixture usually of white clay and water, was trailed through quills fitted into a hand-held slip cup. Sometimes the trailed slip was combed with a pointed or tined tool. The trail-slipped body was again dried. Powdered or liquid lead glaze was then applied over both the slip trailing and earthenware body. This glaze generally fired to a transparent lemon yellow over the slip and to a transparent ginger to cinnamon over the earthenware body.

With one exception, all redware plates and platters in the entire Requa-McGee sample are interior-only lead-glazed slipware that is drape molded

and coggle edged. The exception is one 20-cm interior-exterior lead-glazed slipware plate that is molded in imitation of the royal pattern found in cream-ware (Noël Hume 1970:116) and is decorated with trailed slip on the narrow marli. The assumption, based on the vessel forms excavated in association with food remains, is that most of the Requa-McGee drape-molded, coggle-edged slipware was used daily in the kitchen or at the table. All the milk and pudding pans are lead glazed on the interior only and are wheel thrown with rounded or everted rims. Some are decorated with trailed slip. These coarse ceramic wares were excavated in association with the molded coggle-edged slipwares and with other fine earthenware, stoneware, and porcelain vessels. All the slipwares probably would have been used for dairying, for food stor-age, preparation, or service, or for hygienic purposes.

As has been stated, the conventional wisdom says that lead-glazed red-wares were made, used, and disposed of locally. Yet Ketchum (1970) searched historical records and ceramic collections and found very little either to locate eighteenth- or early nineteenth-century Tarrytown potters or to sub-stantiate their specific wares. With neither the documentary evidence for local pottery production nor a tightly dated site, the archaeological collection needed to be studied in another way.

METHOD AND ANALYSIS

The question of time span and possible location of drape-molded, coggle-edged, pottery-making loci was unanswerable for many years. But when the nineteenth-century provenience for the ware, suggested in Guilland (1971) and Watkins (1950), was combined with sherds excavated at the Requa-McGee site (ca. 1720-1970), it opened up possibilities for research. Pieces of information and artifacts began to fit together. By positing a late eighteenth- and early nineteenth-century provenience for pottery production, use, and disposal, there began to be a way to look sensibly at the family history record, the deposition pattern, and known regional potteries. Each set of information was used against the others in an effort to find a reasonable explanation. Because this approach is tenuous, the earthenware sample was also treated in another way.

The lack of historical documentation and the inability to tightly date the deposition of material culture at the Requa-McGee site led to the treatment of the total sample in terms of itself, its apparent production and decorative techniques. After consideration of the archaeological context, the attributes of the partial vessels and the varieties of decoration were described. The col-lection was tentatively put within the context of the Requa family's use over

roughly a 65-year period (1785-1853). It then was considered within the context of regional potteries.

Before describing the attributes and varieties of the drape-molded, coggle-edged slipware, it should be noted that the total archaeological sample from the Requa-McGee site is actually a "variable" (George R. Hamell, personal communication, 1981). Yet this total sample has been considered a "control" against which museum and private collections and other archaeological examples were compared. Well-documented collections of potters' kiln sherds and the like ideally should have formed the control against which the Requa-McGee sample was compared, but an attribute analysis of such controlled museum, private, and archaeological collections has not yet been made. The Requa-McGee sample exists; it has been studied to describe variation in production and decorative technique within the total sample of the site; and it will be compared, as a variable, against a control once such a controlled study has been made. The present study should be considered only as an initial step which demonstrates a useful method of analyzing and interpreting this type of redware, a ware that seems to be found on many domestic sites in the Northeast, though little else but its presence on these sites is known.

Variety and Attribute Description

In the description and analysis of the Requa-McGee site drape-molded, coggle-edged slipware, the presence, absence, and frequency of 22 attributes were considered, as well as the frequency of the minimum number of plates and platters, based on partial vessels and mutually exclusive rim sherds. The sample being considered consists of the entire collection of domestically produced drape-molded, coggle-edged slipware rim sherds excavated at the Requa-McGee site from 1977 through 1981. The sherds were excavated from every locus and level and then were cross-mended to create partial vessels. The total ceramic sample (12,750 sherds) includes 83 partial vessels and 25 miscellaneous or mutually exclusive rim sherds. The tradition is reminiscent of equivalent British wares (Guilland 1971) from which the domestic and German wares probably derive.

Slip decoration on these coggle-edged wares was created using two distinct techniques, trailing and trailing plus combing. As represented in this sample, these two methods comprise a total of 15 varieties of linear decorative motifs that form 12 separate decorative groups. Figure 11.2 illustrates the classification system developed for these data and used to describe the 15 linear decorative motifs encountered in the total sample. The motifs can be divided into two technological categories or types: trailed lines (**a-j**), and trailed plus combed lines (**k-o**).

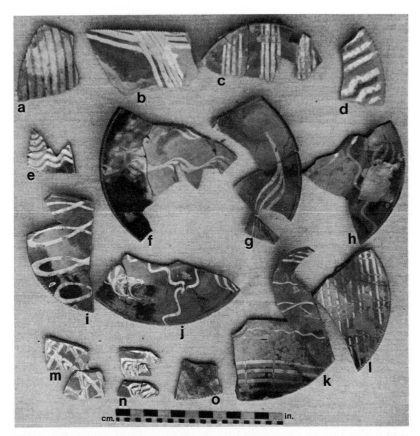

Figure 11.2 Requa-McGee site (ca. 1720-1970). Fifteen varieties of drape-molded, coggle-edged slipware (see individual descriptions in text). There seems to be a clustering of attributes that reflect a mid-Atlantic regional variation in production and decoration for these red-bodied slipwares. The region reaches from coastal southwestern Connecticut through Manhattan and coastal New Jersey to Philadelphia.

The trailed-line type seems to be made up of 7 groups of 10 varieties. The groups are

1. multiple straight parallel lines (**a, b,** and **c**)
2. multiple straight and undulating parallel lines (**d**)
3. multiple undulating parallel lines (**e**)
4. multiple undulating parallel and converging lines (**f** and **g**)
5. multiple and single, undulating, parallel, and converging lines (**h**)
6. single looping lines or words (**i**)
7. single, undulating, parallel, and converging lines (**j**)

The trailed- plus combed-line type seems to be made up of 5 groups with 5 varieties. The groups are

1. multiple parallel combed lines combined with undulating parallel and converging lines (**k**)
2. multiple parallel lines, combed in two opposite directions (**l**)
3. multiple parallel and converging lines, combed in more than two directions (**m**)
4. multiple parallel and converging lines, combed and feathered (**n**)
5. multiple lines, swirled and marbled (**o**)

In this trailed plus combed type, the combing, feathering, swirling, or marbling was probably done with a pointed or toothed instrument of wood or metal.

Table 11.1 compares 22 attributes with each of the 15 decorative varieties (a-o) seen in Figure 11.2. The 22 attributes of shape, form, and decoration are also compared with a miscellaneous group which includes mutually exclusive rim sherds and partial vessels whose overall design could not be described because of weathering, chipping, and other damage. In Table 11.1 the number beside each letter indicates the minimum number of partial vessels included in a given variety.

According to Table 11.1, shallow plates seem to be of similar thickness and tend to be circular. Most have a diameter of 35.5 cm. Most of the plates exhibit rims with shallow coggle edging (83) as opposed to those whose rims are more deeply incised with a rod or fork-like tool (21). About 33% of the plates have motifs made by one to three quills, while 25% show motifs, made by four or more quills. The remaining 42% of the plates includes varieties that combine one to three with four or more quills on any one vessel, in addition to varieties in which either sherd size or complicated line elements make attribution difficult. Every decorative motif is linear, based on straight and undulating line elements. With the exception of one oval platter with the word "Peace" trailed in script (variety **i**), all the trailed decorative motifs are abstract. More plates have decorative motifs that fill the concave field than do not, in a ratio of 3 to 2. Overall, bilaterally symmetrical designs outnumber radially symmetrical ones 4 to 1.

Two separate attribute clusters seem to be present within the Requa-McGee molded slipware sample. One attribute cluster includes attributes 1–12; the other, attributes 1–3 and 16–21. Most varieties cluster under attributes 1–12 (**c, f, g, h, i, l, n,** and **o**), or else they cluster under attributes 1–3 and 16–21 (**a, e, i,** and **k**). Variety **i** can be found in each cluster, but no variety clusters entirely under attributes 13–21. Varieties with only one partial vessel are not included, but if they were, they would also follow the pattern of clus-

tering under attributes 1-12 (**j**) or else under attributes 1-3 and 16-21 (**b, d,** and **m**).

It would have been the Glode II and Samuel Requa families who purchased, used, and discarded the plates and platters at the Requa-McGee site. Family size may be related to the size of the molded, coggle-edged slipware sample. The Requa household size went from 17 in 1790 (U.S. Government Printing Office [USGPO] 1908:198) to 15 in 1810 (McLaughlin 1959a, Vol. 18:1120) to 3 in 1820 (McLaughlin 1959b, Vol. II:236) to 4 in 1830 and 1840 (Brennan 1980). These plates and platters were friable, and in everyday use they broke easily. A very low frequency of sherds exhibiting mending holes and glue (n = 1) suggests that the plates and platters were not mended for reuse. Presumably less expensive than imported ceramic wares, the plates would have been quickly replaced. Continual purchase and disposal of plates and platters would seem reasonable. At the Requa-McGee site, these plates may have been purchased in sets. It may only be the way the attribute list is set up, but certain varieties appear to represent sets of 6 or 12 vessels (Table 11.1). When day and account books in addition to documented museum, private, and other archaeological collections are studied, perhaps more can be said.

Variety and Attribute Frequency and Production Loci

The study now considers variety and attribute frequency and possible pottery production loci. Apparently there is a greater frequency of varieties **c, e, g,** and **k** (10, 16, 10, and 13 partial vessels respectively) than there is of any other varieties in the collection. Decreasing in order of frequency are the partial vessel varieties **a** (7); **i** (6); **f** and **n** (4); **h, l,** and **o** (3); and **b, d, j,** and **m** (1). Eight of these varieties (**d, e, f, g, h, i, m,** and **o**) can tentatively be identified with earthenware production places. The remaining seven varieties (**a, b, c, j, k, l,** and **n**) cannot yet be linked with any particular pottery-making areas.

Taken together, 17 plates display decorative motifs that may not be mutually exclusive. Variety **f** (4 plates) is not unlike varieties **g** (10 plates) and **h** (3 plates). Variety **f** is very similar to an "earthenware pie plate probably made in New England between 1800 and 1825" (Guilland 1971:143). Watkins (1957:72) observed that the "pie plate shaped over a rounded mold and having a notched edge was introduced into southwestern Connecticut about 1800 by potters from New Jersey trained in the Pennsylvania style." J. J. Smith (personal communication, 1981) felt that these design motifs in the Requa-McGee total sample can be ascribed to the work of Norwalk, Con-

necticut, or to Norwalk-trained potters (Smith 1974; Watkins 1950; Winton and Winton 1934, 1981). The Norwalk Hoyt Pottery (ca. 1780-1820) sherds photographed in the Wintons' pamphlet (1934:85, Figure 14) show a remarkable resemblance to some of the Requa-McGee site sherds (varieties **f** and **g**). Sherds from the two samples look as if they could be cross-mended. Unfortunately, the whereabouts of the photographed Hoyt Pottery sherds is now unknown (Ralph C. Bloom, personal communication, 1981) and further comparisons are not possible at this time.

Molded slipwares reminiscent of variety **e** (16 plates) are described as being made in nineteenth-century Trenton and Barbadoes Neck (now Hackensack), New Jersey (New Jersey State Museum [NJSM] 1956:18, 20; 1972:Numbers 106 and 109; Newark Museum 1947:18). These are primarily historical references to the existence of such a variety. The few illustrations observed do not necessarily substantiate the correspondence between the New Jersey pieces and variety **e** from the Requa-McGee site. While the concept of the design is similar, the execution is not. That notwithstanding, some partial vessels within variety **e** may have a New York City provenience.

Variety **e** as well as varieties **d** and **l** (16, 1, and 3 pieces respectively) resemble sherds excavated in the waster layers of 4 Fulton Street at the Schermerhorn Row Landfill site in lower Manhattan (Kardas and Larrabee 1978:5). Number 4 Fulton Street was built on landfill in 1811, and a pottery manufactory was known to have existed in the neighborhood (P. R. Huey, personal communication, 1983).

While varieties **e** and **d** are classified under the trailed-line type, variety **l** is grouped with the trailed- plus combed-line type. Still, the decorative motifs in variety **l**, like those in variety **e**, can be assigned cautiously to two or three separate pottery-making areas. Not only New York City potters but also Pennsylvania and perhaps even New Jersey ones seem to have produced similarly conceived trailed- plus combed-line types. The technique of combing in varieties **l, k,** and **m** (3, 13, and 1 vessel respectively) has been easy to observe in the total sample yet difficult to document in the written and pictorial record. A trailed plus combed plate similar to one in variety **l** (3 vessels) has been assigned a Philadelphia, Pennsylvania, provenience (Myers 1980:3). A written reference, with no photograph, ascribed a Trenton, New Jersey, provenience to another piece of trailed and combed earthenware (NJSM 1956:18). Varieties **k** and **m** have yet to be placed in any manufacturing context.

Only three references to examples of marbled trailing comparable to variety **o** (3 plates) have been noted: Two are attributed to western New York, the other to Pennsylvania. Barber and Hamell (1974:12) and Smith (1974:Figure 28) both picture a coggle-edged, marbleized slipware plate from a nineteenth-century Bloomfield, New York, pottery works site. Myers (1980:3) illustrates

a coggle-edged, marbleized slipware plate which has been given an early eighteenth-century context and a Philadelphia place of manufacture.

Varieties **c** (10 plates) and **a** (7 plates) have not, even tentatively, been assigned to any pottery-making area. These varieties, in addition to variety **k** (13 plates), have a relatively high frequency within our total sample, but examples of similar ware have not yet been found. The same is true for varieties **b**, **j**, and **n**.

On the other hand, a singular platter within variety **i** (6 vessels) has an attribute that seems to be prevalent from southern New England south. Trailed slip word motifs (Table 11.1, Attribute 9) can be found on pottery made in Connecticut, New Jersey, and Pennsylvania (Lasansky 1979; Newark Museum 1947; NJSM 1956, 1972; Smith 1974; Spargo 1926; Watkins 1950, 1957, 1959). Variety **i** contains word motifs in addition to looping lines. These single-quill slip cup designs have been assigned the geographical provenience of both Connecticut and New Jersey (Newark Museum 1947; NJSM 1956, 1972; Spargo 1926).

In summary, of the two slip decorating techniques represented in the total sample from the Requa-McGee site, trailed lines (57) appear more frequently than do trailed plus combed lines (24). More variation of design elements exists within the trailed-line type than within the trailed-plus combed line type. Wheel-thrown, coggle-edged slipware is absent. No drape-molded examples are deep in vertical section, nor do any have relief, engobe, or sgraffito decoration. Absent, too, are representational motifs such as birds and flowers. Additionally, not only are undecorated plates absent but so also are plates with an overall concentric design.

Present in the Requa-McGee sample are vessels whose shape, form, and decoration may show the influence of southwestern Connecticut potters, or at least of Connecticut-trained potters. Other vessels in the total sample display shape, form, and decoration reminiscent of some New York City and New Jersey slipwares. Also present are still other vessels that resemble better-documented Pennsylvania and New York examples. These similarities are not surprising if it is remembered, as has been noted earlier, that southwestern Connecticut potters were influenced by New Jersey potters who had been trained in the Pennsylvania style (Watkins 1957:72). Perhaps future research on slipwares from kilns and household sites will document more conclusively the existence of a strong regional drape-molded, coggle-edged tradition in Connecticut as well as in New Jersey, New York, and Pennsylvania.

When attribute analyses have been completed for local and regional museum and private collections and similar analyses have been done for discrete archaeological data, then the two attribute clusters noted in the Requa-McGee site's total sample can be used as variables and tested more conclusively for relationships of transference and transformation of technological methods and

stylistic elements. Although the attribute list was set up to consider regional variations in decorative techniques, further studies are necessary before anything very conclusive can be said about the movement of the potters, the "pots," or the concept of these pots.

Regional Interaction

Drape-molded, coggle-edged slipware functioned in Connecticut as a means of exchange for its producers. Meanwhile, for the Requas, as consumers, the slipware was used in the daily activities of food preparation and service. The utilitarian and brittle nature of the ware served to increase the chance of breakage. The ware was excavated within the context of food remains and food and beverage processing and serving ceramics, implying that the slipware was valued more for its practicality than for its decorative or social qualities.

Although it is generally believed that domestically produced ceramics were produced, used, and disposed of locally, it has been demonstrated, at least for the eighteenth century, that some earthenware potters' wares had a wide distribution (Pendery 1977; Watkins 1950; Watkins and Noël Hume 1967). Domestically produced stoneware attributed to New York and New Jersey potters has been found at the Requa-McGee site (Guilland 1971; Ketchum 1970, 1971). The Requa-McGee site drape-molded, coggle-edged slipwares bear physical similarities to New Jersey and New York as well as to Connecticut and Pennsylvania wares, and commerce between these regions is documented. J. J. Smith (personal communication, 1981) mentioned a nineteenth-century Long Island Sound-Hudson River intercoastal-riverine trade route for furniture. Ralph C. Bloom (personal communication, 1981) has located marked pieces of nineteenth-century Norwalk lead-glazed redwares, as well as stonewares, in private collections, assembled from along the Hudson River. This evidence suggests a historical regional interest in coastal Connecticut ceramics.

Norwalk-made earthenwares and stonewares were primarily "export" commodities (R. Bloom, personal communication, 1981). Few pieces are listed in the historical inventory and probate records extant (R. Bloom, personal communication, 1981). The pottery, though, seems to have played an integral part in the overall economic development of a local producer in regional and world trade. Credit and capital from sales of local merchandise enabled the potter-merchant to participate in the regional and world markets. Norwalk and New York City merchants' and potters' families intermarried and carried on trade between Norwalk, Connecticut, and the South Street area of Manhattan (Winton and Winton 1934, 1981). New Jersey potters trained

in the Pennsylvania style also influenced some southwestern Connecticut potters. The coastal Connecticut potter-merchants reflected a late eighteenth- and early nineteenth-century adaptation of a small-town merchantile system in a world market when they used family networks and combined the manufacture of ceramics with the distribution as well as the wholesale and retail trade of the consumer goods.

A ceramic trade connection between New York City and some Hudson River towns is more difficult to substantiate than a Norwalk-Manhattan link, but early business correspondence between a Manhattan merchant and a small-town merchant on the Hudson shows that sloops sailed three times a week from the East River and stopped at a town on the lower Hudson River. Cargo included all manner of goods and produce associated with local, regional, and world markets (Philips & Seymour 1818). Early nineteenth-century Hudson River settlements seem to have had access to intercoastal regional trade and also to transshipped items from regional and world markets.

INTERPRETATIONS AND CONCLUSIONS

It is supposed, then, that the data from the attribute list and the evidence from other archaeological and historical materials place drape-molded, coggle-edged slipware in a late eighteenth- to early nineteenth-century southern New England to mid-Atlantic regional context. If so, then several interpretations can be postulated about the ware's production, use, and disposal. Drape molding may be seen as a stage in the development from a part-time supplementary income-producing activity to a more important income-producing, artisan-business activity. The evolution of this folk tradition or "folk transfer phenomenon" (Glassie 1968) may have for its basis economic realities or a changing world view, or both.

A change in production focus from handcrafted toward machine-made redware occurred during the first half of the nineteenth century (Myers 1980). Most redware pottery works in the Northeast were no longer in business by the mid-nineteenth century (Pendery 1981; Watkins 1950). Those that were still in operation were producing mostly bricks, flowerpots, and conduits. The drape-molded wares can be interpreted as a regional variation or as a step toward mass production. New England, except for Connecticut, tended to produce wheel-thrown vessels. Connecticut, New Jersey, New York, and Pennsylvania tended to produce drape-molded plates and platters (Barber 1926; Cooper 1968; Guilland 1971; Ketchum 1970, 1971; Myers 1977, 1980; Noël Hume 1970; Pollex 1979; Ramsay 1939; Smith 1974; Spargo 1926; Stradling and Stradling 1977; Watkins 1950, 1957, 1959). The part

and full-time potters with young apprentices may have found that molded ware required less skill and time to produce. The resulting increase in productivity could be turned to economic advantage.

Economics may also have had something to do with the operation of a "folk transfer phenomenon." A "folk transfer" is a borrowing by the popular culture of an idea or artifact that has evolved in the folk tradition (Glassie 1968). The use made by and the meaning for the popular culture of an idea or artifact may differ from its use and meaning for the folk tradition. Perhaps American potters took advantage of economic crises and wars when trade with England was minimal or curtailed. Regional and local potters could have imitated European folk designs and decorative techniques. The molded slipware could have filled a utilitarian need while also cutting into the import market.

After 1783 there was a change in the structure of freight charges for the heavy coarse earthenwares and stonewares imported from Europe: Instead of being fixed according to the value of the cargo, they were based on weight or measurement (Myers 1977). The relative increase in shipping costs that took place after the Revolutionary War may have had a positive impact on domestic coarse earthenware manufacturing, making Northeast potters' wares more competitive.

Changing world views as well as changing economic situations may also have influenced the choice of a folk design that would be transferred. The use of predominantly bilaterally rather than radially symmetrical design motifs on drape-molded, coggle-edged slipware (Table 11.1) may suggest a shift from the medieval to the Georgian–Federalist mindset. The existence of such a shift has been suggested for other archaeological contexts as well (Deetz 1973). Finally, another reason for the choice of folk motifs on artifacts associated with the popular culture may simply have been nostalgia. The motifs could have served to remind people of an earlier time that was seemingly simpler. Choosing motifs from the past may have eased people's struggles with their rapidly changing world.

ACKNOWLEDGMENTS

Cece Kirkorian introduced me to Northeast archaeology and J. J. Smith introduced me to drape-molded, coggle-edged slipware. Roberta Wingerson and the late Louis A. Brennan shared their knowledge and time. Their patience and understanding kept me going. Mary Beaudry and George R. Hamell heard or read earlier versions of this paper and gave constructive criticism and encouragement. Sarah Peabody Turnbaugh clarified and tightened the text and illustrations. Constant, Sarah, and Andrew Dickinson put up with me and this project. I thank them all.

Legacy:
Emergence of an American Industry

Part III addresses the legacy of ceramic production in the Northeast during pre- and early Industrial Revolution times. The traditional family-based pottery-making craft which was initially transplanted from the Old World to the Northeast colonies subsequently was subject to dispersion, drift, and transformation. The continual in-migration of Old World potters and importation of techniques, forms, and functions remained influential throughout the centuries as well, as these ceramic traditions eventually developed into distinctly American entrepreneurial industries (see also Barber and Hamell 1971, 1974; Hamell 1981). Part III considers geographic, social, and economic factors that permitted a full-blown business-oriented American ceramic industry to develop in some communities of the Northeast but not in others. This treatment adds specifically to our understanding of the growth and development of ceramic traditions in the Northeast and more generally to our understanding of related cultural processes in operation there. As will become evident from the following chapters, many of these trends were occurring throughout the eastern area of the United States.

Part III comprises four chapters, by Turnbaugh, Hunter, Teller, and Bower. All of these chapters treat communities or potters that had developed the potential to catapult their ceramic enterprises into viable American industries. Yet, not all succeeded in achieving this level of development, as is exemplified by the Turnbaugh and Hunter chapters. Turnbaugh defines corresponding English and domestic Bay Colony lead-glazed redware traditions that

flourished, yet drifted from one another, between ca. 1630 and 1800. She then examines the entrepreneurial potential of some late eighteenth-century potters working in Essex County, Massachusetts. The tension existing between subsistence-oriented yeomen and independent entrepreneurs during this period is addressed. Hunter considers a cluster of nineteenth-century redware-making sites in New Jersey that occupied a transitional position between the small regional rural pottery craft of earlier times and the later urban-style industrialization of the skill. He discusses the initial importance of geographic proximity to clay and lumber resources and the later inability of many kilns to complete the transition to industrialization due to depletion of these natural resources and lack of efficient transportation and extensive markets.

Chapters by Teller and by Bower illustrate the attainment of industrialization of pottery manufacture from the perspectives of a family dynasty and a cosmopolitan community, respectively. Teller uses historical and archaeological data to treat the changing role of potters in the late eighteenth and nineteenth centuries. The Hews family effectively makes the transition from part-time traditional pottery making to full-time entrepreneurial production. Finally, Bower focuses on the social and economic contexts of late seventeenth- and eighteenth-century ceramic production and distribution in Philadelphia. It was in this city, of all the communities in the Northeast, that the industrial potential of the ceramic industry perhaps was developed most fully and earliest. Bower delineates the gradual change of the Philadelphia enterprise from a folk craft that catered to a local clientele to a full-blown industry with a market encompassing the whole of the Eastern seaboard. This achievement, in effect, is the legacy: the late eighteenth- and early nineteenth-century attainment of entrepreneurial mass production of ceramic wares that were truly "made in America," though they were still subject to the influences of inmigration of European potters and imported technologies, forms, and functions.

12
Chapter

Imitation, Innovation, and Permutation: The Americanization of Bay Colony Lead-Glazed Redwares

Sarah Peabody Turnbaugh

Types, varieties, and forms that were of conceptual or functional signifi-
cance to their makers and users often are well documented for ceramic prod-
ucts of the colonial period. Sherds of these wares are found in significantly
large quantities on seventeenth- to early nineteenth-century residential sites
in Massachusetts (for example, Baker 1980a; Bradley et al. 1983; Deetz
1973:Figure 1; Moran et al. 1982; Starbuck 1979, 1980; Turnbaugh
1976:Figure 16). As a result, analyzing this category of material culture pro-
vides a useful and reliable way to better understand changing cultural pat-
terns.

This chapter specifically considers the ceramic type of wheel-thrown, lead-
glazed, red-bodied earthenware (or lead-glazed redware), particularly those
lead-glazed redwares made in the Massachusetts Bay Colony between about
1635 and 1800. It presents an explanatory model for understanding the re-
lation of these domestically produced redwares to comparable English-made
redwares created contemporaneously. Both historical and archaeological data
are used to examine the specific nature of these traditions. This model of
domestic–English redware relationships is intended only as preliminary and

is open to critical evaluation, revision, and improvement. Many of the inter-
pretations presented need corroborative validation by other researchers work-
ing elsewhere with comparable data during future years. Yet, despite potential
specific weaknesses in this general argument, perhaps it will inspire historical
archaeologists and ceramic historians both to describe domestic lead-glazed
redwares and to interpret their cultural significance and possible English par-
allels in new, more precise ways. If so, this presentation will have achieved
its major goal.

The model is presented by proposing three critical hypotheses. These
premises have been formulated by using comprehensive primary historical
documentation for the Massachusetts Bay Colony (Deetz 1973; Turnbaugh
1976, 1977) and for England (for example, Hodgen 1974; Noël Hume 1970;
South 1972).

HYPOTHESIS 1. Both the culture and the lifeways of the initial colonizing
population of the Massachusetts Bay Colony were conservative and tradi-
tional; they were similar to those of the Puritans' parent English society, from
which the British colonial subsystem was transplanted.

HYPOTHESIS 2. Early domestic Bay Colony lead-glazed redwares are sim-
ilar in type, form, and function to contemporary English counterparts, and
they reflect a common cultural origin.

HYPOTHESIS 3. Similarities and differences between contemporary seven-
teenth- and eighteenth-century Massachusetts Bay Colony and English lead-
glazed redware traditions can be defined and measured in terms of typological
and formal attributes, thus shedding light on changing production and con-
sumption patterns and marketing conditions.

THE EXACT TRANSPLANTATION: HYPOTHESIS I

With the help of extensive primary documentation, historians can dem-
onstrate both the conservative, imitative culture of the early Bay Colony set-
tlers and their initial success in transplanting the best of traditional English
society (as examples, Bailyn 1955; Morgan 1958). The self-conscious, imi-
tative worldview of the Puritans persisted through the early eighteenth cen-
tury, at which time more general ideological changes accompanied the Great
Awakening in New England and the Enlightenment in Europe. The seven-
teenth-century colonist John Winthrop in particular played an important role
in ensuring the success of this "exact transplantation."

Between 1628 and 1630, three waves of Puritans (about 1900 persons)
emigrated from England to Salem, the first permanent settlement in the Mas-
sachusetts Bay Colony (Robotti 1958:13-17). The influx of these Puritans

marked the beginning of the 10-year "Great Migration" to Bay Colony shores. In this planned colonization venture, John Winthrop himself, the elected governor under the royal charter, handpicked the first of an eventual 16,000 immigrants to represent the occupations of every facet of traditional English society, including carpenters, brickmakers and potters, weavers, smiths, merchants, and ministers (Morgan 1958:66).

The expressed intent of this venture was not simply to populate the new colony and exploit it commercially but to transplant the best aspects of English society to this continent while leaving the less ideal elements of society behind in England (Morgan 1958). Most of the early colonists emigrated from nine counties in southern and eastern England: Cornwall, Devon, Dorset, Somerset, Gloucester, Lincoln, Norfolk, Suffolk, and Essex. These immigrants to the Bay Colony looked to the socioeconomic, political, and religious organization of their parent counties when devising the model or ideal society that they tried to transplant to the Massachusetts Bay Colony. By consciously selecting Puritans with occupations representing every aspect of English society needed to found an imitative and self-sufficient colony, Winthrop hoped to ensure the exactness of this transplantation (Morgan 1958), just as other prominent early settlers elsewhere did (Bradford 1952).

Since Salem harbored the first populations selected for transplantation during the "Great Migration," we may assume that this community probably most completely reflected and aspired to the "ideal" English society that was so zealously transplanted. Through subsequent years, these colonists continued to emulate and imitate traditional English ways. Yet, digressions or changes from the static concept of ideal society inevitably occurred within a generation or two. The Puritans viewed these changes not as progress or improvements but as societal degeneration (Bernard Bailyn, personal communication, 1973). As a result, the strongly traditional, conservative people strove even harder to retain and recapture the "ideal" they had initially transplanted.

COMPARABLE ENGLISH AND DOMESTIC BAY COLONY
LEAD-GLAZED REDWARES: HYPOTHESIS 2

Consideration of the second hypothesis depends upon acceptance of a secondary proposition that assumes both an existing linkage between behavior and material culture and the theoretical validity of classificatory methods. The secondary proposition is as follows: Historically undocumented lead-glazed redwares can be classified both by form and by type and variety in a way that will accurately reflect the makers' *mental templates* (Deetz 1967) by establishing culturally valid forms (Beaudry et al. 1983; Turnbaugh 1983) and *cognitive types* (Thomas 1974:11-14). In actuality, such a typological-modal

classificatory system has been devised and used successfully to describe Bay Colony lead-glazed redware types and varieties (Turnbaugh 1976:43-67, 1977:182-183, 1983). Since the secondary proposition is adopted on this basis, we can now develop Hypothesis 2.

Archaeologists often have assumed that the redware traditions established in the Massachusetts Bay Colony during the second quarter of the seventeenth century resembled English traditions from which they were transplanted. Indeed, the products of this early colonial craft certainly are like English wares, both in types and forms (Brennan 1982; Deetz 1973; Noël Hume 1970; South 1972, 1977; Turnbaugh 1976, 1977, 1983; Watkins 1968). The similarity of mid-seventeenth-century potters' redwares on the two continents is now outlined.

England

In 1629, when the "Great Migration" to the Massachusetts Bay Colony began, redware manufacturing was already well established in England. The earliest dated instances of pottery making are recorded for the twelfth century for Leicester, Derby, and Hertford counties in central England and Sussex county in the southeast (Hodgen 1974:Table 5). During subsequent centuries, pottery making spread outward from these counties to encompass a wider geographic area of England. This technological *innovation,* or the formation of a new habit by an individual (Hodgen 1974:19), probably diffused via contemporary communication and travel networks—namely, roads, waterways, and urban contexts (Hodgen 1974:88-89). Historical documentation indicates that pottery was being made in more than 50% of England's counties by the year 1600. At least six of the nine counties represented in the initial colonizing population of the Bay Colony—Gloucester, Somerset, Devon, Norfolk, Lincoln, and Essex—were making pottery by the time of emigration (Hodgen 1974:Table 5). Absence of documentation for the remaining three counties—Suffolk, Cornwall, and Dorset—does not mean they were not also making pottery by the seventeenth century but only that Hodgen (1974) could not document the innovation for these counties by this time.

The early English lead-glazed, red-bodied earthenware vessels were mostly jugs and utilitarian articles (Wills 1978:11). Most typical English and early Bay Colony redware forms are comparable, and are illustrated in Figure 12.1. Bulbous-bodied drinking mugs, pipkins, and pans also were among the popular English forms of the late sixteenth to early seventeenth centuries (see Figure 12.1; Noël Hume 1970:102). These utilitarian forms remained dom-

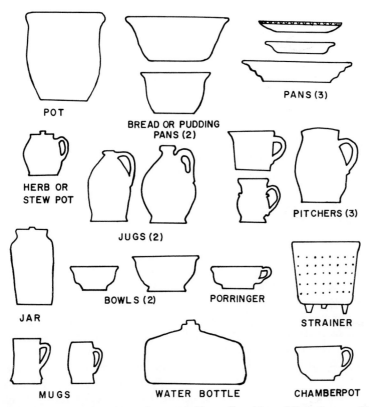

POT

BREAD OR PUDDING PANS (2)

PANS (3)

HERB OR STEW POT

JUGS (2)

PITCHERS (3)

JAR

BOWLS (2)

PORRINGER

STRAINER

MUGS

WATER BOTTLE

CHAMBERPOT

Figure 12.1 Selected domestic redware vessel forms (for additional illustrations, see Beaudry *et al.* 1983; Turnbaugh 1976, 1977; Watkins 1950).

inant into the seventeenth century and were primarily associated with food storage, preparation, and serving or dining functions.

Prior to 1740 or 1750, when liquid clear lead glaze was invented (Hughes 1961; Lewis 1969), powdered lead ore (smithum) was applied to the vessel before firing in the kiln to make it watertight (Wills 1978:12). A high degree of technological precision is evident in the application of these glazes. Glaze color occasionally might be affected due to firing vagaries or accidents, but, for the most part, glaze colors seem to fall within limited discrete ranges of Munsell color designations (Munsell Soil Color Charts 1949), suggesting that most modal glaze colors were selected deliberately. By the time of initial colonization, many vessels sported yellow or bright apple green (copper) glazes. Others had dark or mottled (manganese or ferric oxide) glaze, some with trailed slip decoration (Deetz 1973:Figure 1; Lewis 1969; Noël Hume 1970).

Specific information on the origin of trailed slip redware remains undocumented for England (Brennan 1982:122), but the technique was used on Wanfried slipware at least as early as 1580 (Noël Hume 1970:139; South 1972).

The specific English redware manufacturing traditions and their periods of manufacture are listed in Table 12.1 and are considered in greater detail subsequently. As with Bay Colony wares, most of these traditions can be distinguished from one another on a descriptive typological basis at the "variety" level (Turnbaugh 1977:183, 1983:5–6), with glaze color, glaze application (location), and ornamentation method the most critical distinguishing attributes. English redwares categorized in Table 12.1 include North Devon gravel-tempered and sgraffito wares and those wares with dusted copper or manganese glazes, such as Tudor Green or white sandyware; Cistercian ware and English manganese mottled ware; slipwares including Wanfried, Metropolitan, and combed and dotted yellow slipwares; Buckley ware and Astbury ware; and black-glazed tea service prototypes and Jackfield- and Whieldon-type black-glazed redwares. These seventeenth- and eighteenth- century English wares are considered further, under Hypothesis 3, in relation to redware developments in the Massachusetts Bay Colony. In general, it seems that the first generations of colonists in the Bay Colony imitated many of these wares. However, as is discussed later under Hypothesis 3, some were not reproduced precisely by Essex County and Bay Colony potters.

Other developments in eighteenth-century English ceramics are important to our later considerations as well. Documented English innovations increased greatly in number after ca. 1750 (Hodgen 1974:Table 5), corresponding to an impressive increase in industrial mechanization and speed of technological replacement for other innovations recorded for the mid-eighteenth to nineteenth centuries (Hodgen 1952:65). Eighteenth-century documentation from various sources suggests that the stage was being set in the American colonies for what would become the Industrial Revolution in the nineteenth century, complete with mechanization and mass-production techniques for making ceramics as well as other products (see Hodgen 1974; Hughes 1961; Noël Hume 1970; Lewis 1969; South 1972, 1977; Wills 1978). By the mid-eighteenth century, redwares were declining in importance in England, as various buff-bodied earthenwares (including delftware), salt-glazed stonewares, and cream-colored earthenwares quickly increased in popularity. By ca. 1750, redwares in England were confined mostly to purely utilitarian pieces (Wills 1978:27).

Contrary to eighteenth-century England, which had an increasing variety of available ceramic wares, lead-glazed redwares remained important household items in the Bay Colony throughout the eighteenth century. From about 1650 to 1775, the 1651 Navigation Act and the Staple Act of 1663 severely

restricted the types and quantities of European imports available to the colony (Noël Hume 1970:140). In addition to domestically produced lead-glazed redwares, essentially only a few English ceramic wares and some German stonewares were used. The domestic lead-glazed redwares remained the most inexpensive type of ceramic available. Judging from the archaeological record (for example, Deetz 1973:Figure 1), these domestic redwares remained more popular than contemporary English imports through the eighteenth century.

Massachusetts Bay Colony

Redware vessels produced in the Bay Colony are similar in form and function to contemporary redware vessels produced in England. For example, 15% of the domestically produced lead-glazed redware sample excavated at the Salem Village Parsonage site (1681-1784) in Danvers, Massachusetts (Turnbaugh 1977:207, 1983, Table 8:13), could be classified on the basis of vessel form and function for an early (1681-1731/33) and a late (1731/33-1784) period of site occupation. Of the early period vessels, 56.5% functioned in food storage or preparation contexts and 43.5% in serving or dining roles. Later period redware forms functioned in more diverse contexts (5.5% in food storage or preparation, 80.3% in serving or dining, 6.6% in social contexts, and 7.6% in hygienic contexts) (Turnbaugh 1983, Table 8:13). This shift in functional context parallels the similar but unquantified temporal change described above for English usage. Furthermore, the size, shape, and form of domestic vessels imitate their English counterparts well into the eighteenth century (Turnbaugh 1976:125-127).

Potters' kiln and waster dump samples also support this interpretation of similarities in form and function. Quantified data on forms represented in about a dozen potters' sherd samples (see Turnbaugh 1977, Figure 9:189-193 for a description of these samples) are not available at present. Yet, these redware samples seem to support the trend. The late seventeenth- to early eighteenth-century Bay Colony potters (Vinson, Kettle, Gardner, and Joseph Bayley) made mostly jugs, pots, pans, and some mugs, all of which are associated with food storage or preparation and serving or dining functional categories. Again, many early forms and rims directly imitated English styles (Turnbaugh 1976:125-127; also Figure 9). The middle to late eighteenth-century potters (Daniel Bayley, Southwick, Osborn, Benner, and Purinton) supplied wares in broader functional contexts, placing increased emphasis on mugs and adding teapots, table wares, and chamber pots to their utilitarian lead-glazed redware inventories (Turnbaugh 1977:Figure 9).

Similarities between Bay Colony and English lead-glazed redware types

Table 12.1
Corresponding Bay Colony and English Traditions[a]

Category	Bay Colony description	Bay Colony date range	English description or name	English date range
1a	yellow-red glazed redware (sherd samples: Vinson, Gardner, Kettle, J. Bayley, Osborn, D. Bayley, Southwick, Benner, Purinton)	ca. 1650-1800	plain lead-glazed redware, common in England from 13th century on (Wills 1978:12)	ca. 1200 on
1b	yellow-red glazed slipware [style of English Metropolitan slipware] (sherd samples: Kettle, J. Bayley, D. Bayley)	ca. 1685-1800	Metropolitan slipware from Essex (Noël Hume 1970:103; South 1972, 1977)	ca. 1630-1660
1c	yellow-red glazed slipware, with light and dark slip and green speckling and (optional) incising [style of Wanfried slipware] (sherd samples: Kettle, J. Bayley, D. Bayley)	ca. 1685-1800	Wanfried slipware (Noël Hume 1970:139; South 1972, 1977)	ca. 1580-1625
1d	yellow-red glazed slipware, with white slip reserved for bands at rims and bases [style of Astbury slipware] (sherd samples: D. Bayley, Benner)	ca. 1763-1800	Astbury slipware from Bristol and Newcastle-under-Lyme (Noël Hume 1970:123)	ca. 1724-1744
2a	olive glazed redware [reminiscent of glaze color used on some North Devon wares] (sherd samples: Vinson, Kettle, J. Bayley, D. Bayley, Southwick)	ca. 1650-1800	reminiscent of medieval European olive yellow glazed redwares (UNEP 1984) including some North Devon wares (South 1972; Noël Hume 1970: 104-105; C. M. Watkins 1960:14)	ca. 1650-1775
2b	olive glazed slipware (sherd samples: Kettle, J. Bayley, D. Bayley, Benner)	ca. 1685-1800	no English prototype yet identified	—

3a	ferruginous gray black glazed redware [style of Cistercian redware] (sherd samples: Kettle, J. Bayley)	ca. 1685-1735	Cistercian redware (Lewis 1969)	ca. 1540-1700
4a	black glazed redware [style of Jackfield-Whieldon redwares and tea service prototypes] (sherd samples: J. Bayley, Osborn, D. Bayley, Southwick, Purinton)	ca. 1725-1815	black glazed Jackfield-Whieldon-type and English black glazed tea service prototypes (Watkins 1950:58)	ca. 1715-1780
4b	black glazed slipware [style of Wrotham slipware] (sherd samples: Kettle, J. Bayley)	ca. 1685-1735	Wrotham slipware (Noël Hume 1970:102, 103-104; South 1972, 1977)	ca. 1612-1700
5a	mottled glazed redware [style of English manganese mottled redware] (sherd samples: J. Bayley, Osborn, D. Bayley, Southwick, Benner, Purinton)	ca. 1725-1815	English manganese mottled redware (Kelly and Greaves 1974)	ca. 1680-1750
6a	bright green glazed redware [style of Tudor Green or white sandyware] (sherd samples: Vinson, Gardner, J. Bayley)	ca. 1650-1750	Tudor Green or white sandywares (Moorhouse 1970:42-59)	ca. 1540-1645
7a	yellow slipware with sponged-splashed brown design elements [style of yellow combed slipware] (sherd samples: D. Bayley)	ca. 1763-1800	combed and dotted yellow slipwares of Bristol and Staffordshire (Noël Hume 1970:107, 134-136; South 1972, 1977)	ca. 1670-1795

aSee Turnbaugh (1983:10) for individual potters' date ranges and Munsell color descriptions for paste and glaze colors.

and varieties also can be documented on the basis of differences in techno-
logical attributes such as glaze color, glaze application (location), and deco-
ration techniques (slip, tooling, etc.). Turnbaugh (1983) has presented a
specific discussion of the methodology used. By combining the results of ap-
plying this methodology to a large lead-glazed redware sample from a do-
mestic site with similar descriptions of Bay Colony potters' kiln and waster
dump samples, descriptive redware *categories,* or groups of varieties, that
may constitute *traditions* can be identified (Turnbaugh 1983:11). Interesting
patterns are still emerging as the range of lead-glazed redware varieties pro-
duced in the Bay Colony continues to be defined in this way. Tentative man-
ufacture periods also have been determined for each category, based on its
presence or absence in the dated kiln and waster dump samples that have
been studied.

To explain this work briefly, 12 categories of lead-glazed redwares have
been established thus far. Dated Bay Colony lead-glazed redware categories
are summarized in Table 12.1 (for Munsell descriptions of paste and glaze
colors, see Turnbaugh 1983). These data are based on a study of about a
dozen kiln and waster dump samples, or between 5% and 8% of the total
number of documented Bay Colony kilns that were operating independently
of one another (Watkins 1950, Checklist:249–270). Periods of manufacture
for these categories may need to be revised somewhat as the data base in-
creases and more kiln samples from the Bay Colony are available for study
in the future. At present, however, the chronology of Table 12.1 provides a
useful beginning.

As an interesting and possibly quite useful side note, the Mean Ceramic
Date Formula (South 1972, 1977) may be used to test the validity of eight
of the dated lead-glazed redware categories included in Table 12.1 (see Table
12.2). For the Salem Village Parsonage site (Trask 1971, 1972), the inclusion
of these redware categories in the Mean Ceramic Date Formula calculations
yields a mean ceramic date of 1733.88 (Table 12.2). Furthermore, inclusion
of these data almost doubles the sample size of sherds that can be considered
in the Mean Ceramic Date Formula's application, increasing the total sample
size from 3523 to 6338 sherds. The new mean ceramic date of 1733.88 fits
well with other independent dates for the site, such as for kaolin pipe stems
(1731.40), median occupation (1732.5), and former mean ceramic date (cal-
culated without including these new redware categories) of 1731.66. This
good fit suggests that both the periods of manufacture and the construction
of these categories of lead-glazed redwares are valid in real cultural terms and
probably are not unreliable constructs or fabrications of the data (compare
Turnbaugh and Turnbaugh 1979). As such, these dated categories would
seem to constitute true domestic traditions, by definition.

To conclude this discussion of Hypothesis 2, early domestic Bay Colony

Table 12.2

A Test of the Validity of the Domestic Redware Categories

Category	f_i	\overline{X}_i	$(\overline{X}_i - 1730)$	$(\overline{X}_i - 1730)(f_i)$	\overline{X} date
Standard Mean Date[a]	3,523			5,845	1731.66
Modified Mean Date[b]					
1a	1,444	1725	−5	−7,220	
1b	471	1742.5	12.5	5,887.5	
2a	148	1725	−5	−740	
2b	33	1742.5	12.5	412.5	
3a	113	1710	−20	−2,260	
4a	480	1770	40	19,200	
4b	26	1710	−20	−520	
5a	100	1770	40	4,000	
	2,815			18,760	
Combined Modified					
Mean Date	6,338			24,605	1733.88

[a]Mean Ceramic Date Formula data for the Salem Village Parsonage site, 1681-1784 (see Turnbaugh 1977: Figure 15, 204-205).
[b]Modified Mean Ceramic Date Formula includes dated Bay Colony lead-glazed redware categories (see Table 2.1).

lead-glazed redwares do indeed appear to be similar in type and form to contemporary English counterparts. This resemblance probably reflects their common cultural origin. The only major difference between the English and domestic redwares seems to be in the duration of their popularity. The popularity of lead-glazed redwares was waning in England by ca. 1750 as new ceramic wares became increasingly available. At the same time, redwares remained the dominant ceramic subclass on Bay Colony sites throughout the eighteenth century (Deetz 1973:Figure 1; Turnbaugh 1976:Figure 16). This major discrepancy brings the discussion to Hypothesis 3.

DIVERGING ENGLISH AND BAY COLONY TRADITIONS: HYPOTHESIS 3

As is evident from Table 12.1, many seventeenth- and eighteenth-century English lead-glazed redwares have been named and their periods of manufacture established with the help of existing historical documentation (Noël Hume 1970; South 1972, 1977). In effect, each of these named and dated

redware categories may be considered to constitute an English lead-glazed redware tradition. Similarly, the groups of varieties, or categories, of Bay Colony lead-glazed redwares described in Table 12.1 are equivalent to discrete Bay Colony lead-glazed redware traditions. These technological traditions are defined as principal lead-glazed redware groupings or categories, characterized by definite patternings of attributes in space and time with a long chronological persistence of the patterns discerned (compare Willey and Phillips 1958:34–39, 42–48).

All the English and Bay Colony lead-glazed redware traditions can be contrasted with one another to determine the extent to which the Bay Colony traditions imitated the English models that were both transplanted at the time of colonization and subsequently imported to the Bay Colony. This comparison is also summarized in Table 12.1. These patterns are based on ceramic data for England (Brennan 1982; Cotter 1968; Hodgen 1974:Table 5; Hughes 1961; Kelly and Greaves 1974; Lewis 1969; Moorhouse 1970; Noël Hume 1970; South 1972; Watkins 1960; Wills 1978; and others) and on archaeological lead-glazed redware data from more than a dozen Bay Colony kiln and waster dump sites and features (Turnbaugh 1976, 1977, 1983; Watkins 1950). The diverging industry in England and the Bay Colony is now discussed and the associated time lag in Bay Colony production is observed. It should be noted that all of these traditions represent modal patterns discerned on the "variety" level of typological description discussed above. Not all individual lead-glazed redware sherds—whether English or domestic—will be glazed, spattered, colored, incised, tooled, or slip decorated as precisely as these modal descriptions suggest.

Regrettably, the visual distinctions between categories do not photograph well in black and white. Consequently, photographic illustrations of these categories or traditions are not included in this chapter. Munsell color designations and data included in Table 12.1 should be sufficient to provide researchers with replicable types, varieties, and categories or traditions for their own redware samples.

As Table 12.1 indicates, many seventeenth- and eighteenth-century domestic lead-glazed redwares are reminiscent of popular English traditions. Most Bay Colony potters probably were consciously imitating the specific English redware traditions, since the domestic traditions seem to lag behind and change more slowly than the English prototypes. Furthermore, many of the English lead-glazed redware varieties that Bay Colony potters imitated originated in the nine counties from which the initial generation of Puritans had emigrated. This fact reinforces the probable imitative quality of the early domestic lead-glazed redwares.

Category 1a, plain redware with a clear lead glaze that gives the vessel a

warm yellow-red coloration, is the most numerously represented category of redware found on seventeenth- and eighteenth-century Bay Colony sites. For example, this category alone comprises 27% of the entire lead-glazed redware sample excavated at the Salem Village Parsonage site (see Turnbaugh 1983:7, 11). This domestic lead-glazed redware tradition was long-lived (ca. 1650-1800) and is represented in the sherd samples for every Bay Colony potter studied (Turnbaugh 1977:189-193). While Category 1a does not correspond to a specific named English tradition, it is probably equivalent to the plain lead-glazed redware tradition in vogue from the thirteenth century on (Wills 1978:10).

Clear (yellow-red) lead-glazed slipware constitutes Category 1b. Kettle, Joseph Bayley, and Daniel Bayley are among the Bay Colony potters who practiced this domestic tradition. Category 1b is reminiscent of English Metropolitan slipware from Essex, ca. 1630-1660, which it probably imitates. However, potters' sherd samples indicate the domestic tradition lagged behind its English prototype by quite a few years. The late period changeover from quill- to brush-applied slip decoration (Watkins 1950) may be interpreted as an innovation or permutation as potters tried to speed production due to increasing demands.

Category 1c represents clear (yellow-red) lead-glazed slipware, sometimes featuring an optional combination of both light (white) and dark (red-brown) trailed slip, plus occasional plain incising under the glaze. This category of slipware is distinguished from other similar categories by the presence of bright green speckling or spattering under the glaze but over the slip decoration. In the Bay Colony, this tradition lasted from 1685 to 1800. It is represented mostly by pans made by Kettle, Joseph Bayley, and Daniel Bayley and possibly also by wares of Joseph Wilson, a Dedham potter working between ca. 1764-1767 (Watkins 1968:Illustration 26). In England, a similar tradition, Wanfried slipware, persisted from ca. 1580-1625, a much earlier time period. The most popular Wanfried form also was the pan. Wanfried decoration usually consisted of heavy white trailed slip bands, swags, and crosses, sgraffito incising, and copper green splashes under the glaze (Noël Hume 1970:139). The intermixture of copper (green) and manganese (purple) decoration was popular in late medieval Europe (UNEP 1984).

A refined clear (yellow-red) lead-glazed slipware constitutes Category 1d. In the Bay Colony, this tradition is short in duration (ca. 1763-1800) and is represented mostly by mug and cup sherds in samples of Daniel Bayley and Benner. White slip is confined to bands at the rims, the bases, or both the rims and bases of these vessels and is, in addition to vessel form, the distinguishing trait of this category. Category 1d is reminiscent of English Astbury slipware, particularly the banded slipware style made between 1724 and 1744

(Noël Hume 1970:123). Again, the domestic tradition occurs later than its English prototype. Contemporary English Buckley ware also may be decorated only with simple bands of slip.

Several potters in the Bay Colony—Kettle, Joseph Bayley, Daniel Bayley, and Southwick—fashioned Category 2a, an olive yellow-brown lead-glazed redware, between ca. 1650 and 1800. This tradition cannot be linked conclusively to a corresponding English tradition, though this glaze color was popular in medieval Europe (UNEP 1984). The distinctive glaze color is reminiscent of that found on some North Devon sgraffito slipware, ca. 1680-1710, and gravel-tempered redware which was imported frequently to these shores up until ca. 1730 (Noël Hume 1970:104-105, South 1972; C. M. Watkins 1960). Yet the domestic tradition does not use any slip under the glaze to obtain the distinctive olive yellow color. The sgraffito incised technique is not found on domestic lead-glazed slipwares in the Bay Colony. Only a handful of early probable Essex County, Massachusetts, pots exist that are glazed on the inside only and have an incised band of four wavy lines (somewhat reminiscent of the sgraffito incising technique) running around the dry-bodied outside surfaces of the vessels. With these possible exceptions, Bay Colony potters apparently did not duplicate the sgraffito incised decorative technique of England.

Category 2b, olive brown lead-glazed slipware, was made ca. 1685-1800 in the Bay Colony by such potters as Kettle, Joseph Bayley, Daniel Bayley, and Benner. Although the tradition flourished after ca. 1750 (D. Bayley and Benner sherd samples contain a greater quantity of this slipware), this domestic tradition cannot be linked clearly to an English equivalent. Both the absence of a specific English prototype and the increased popularity of this ware after 1750 suggest that it possibly may represent a somewhat more innovative variety than other categories.

Category 3a, ferruginous gray black lead-glazed redware, was fashioned in the Bay Colony between about 1685 and 1735 (Kettle, J. Bayley). This distinctive tradition resembles English Cistercian ware, ca. 1540-1700. The English redware usually dates prior to about 1700 on Plymouth and Bay Colony sites (Deetz 1973:Figure 1).

Black lead-glazed redware, Category 4a, appears in potters' sherd samples in the Bay Colony between about 1725 and 1815 (J. Bayley, Osborn, D. Bayley, Southwick, Purinton). Refined table wares such as mugs and bowls and tea service wares such as teapots are the dominant forms. This domestic tradition almost undoubtedly corresponds to English Jackfield-Whieldon (ca. 1740-1780) types and English black lead-glazed table wares and tea service prototypes, which date to about 1715 and later in the Bay Colony (Stone 1970; Watkins 1950:58).

Black lead-glazed slipware constitutes Category 4b and dates to ca. 1685–1735 in the Bay Colony (Kettle, J. Bayley). This domestic tradition is in the style of Wrotham slipware, a tradition that persisted in England between ca. 1612 and 1700. Wrotham slipware is characterized by a dark glaze with white slip pads and a "busyness" of slip ornamentation (Noël Hume 1970:102–104).

Category 5a, mottled lead-glazed redware, is a distinctive tradition that lasted from about 1725 to 1815 in the Bay Colony (D. Bayley, Southwick, Osborn, Purinton). Domestic mottled redware forms, like their English counterparts, are mostly refined table wares such as mugs. English manganese mottled lead-glazed redware, which dates to ca. 1680–1750 (Kelly and Greaves 1974), almost certainly inspired the development of this tradition in the Bay Colony.

A bright green lead-glazed redware, Category 6a, appears in early domestic potters' samples from ca. 1650–1750 (Vinson, Gardner, Joseph Bayley). This domestic tradition may correspond to the popular English Tudor Green or white sandyware tradition, ca. 1540–1645 (Moorhouse 1970:42–59). The distinctive bright green lead-glazed variety dates mostly prior to 1730 on Plymouth and Bay Colony sites (Deetz 1973:Figure 1).

A sparsely represented tradition, yellow lead-glazed red-bodied slipware with brown sponged or splashed designs under the glaze, constitutes Category 7a. It dates to about 1763–1800 (D. Bayley) in the Bay Colony. This domestic tradition closely resembles combed and dotted yellow lead-glazed buff-bodied slipware from Bristol and Staffordshire, ca. 1670–1795 (Noël Hume 1970:107, 134–136). The English slipware probably was not imported to these shores after about 1775–1780 (Noël Hume 1970:136). Daniel Bayley's creation of yellow slipware is significant for several reasons. Perhaps most important, his slipware permitted Bayley to compete economically with the fashionable and popular Bristol-Staffordshire varieties being imported at the same time. Also, despite his use of a red-firing clay, Bayley was able to make a ware that, for all intents and purposes, accurately mimicked the contemporary English equivalent. This late eighteenth-century slipware also illuminates the Bay Colony's continuing desire for Anglican and Anglican-style products. Yet Bayley departed from strict imitation of the English tradition and created his own customized or idiosyncratic brown sponged and splashed design elements.

To conclude this comparison, most of the domestic lead-glazed redware traditions seem to lag behind their English counterparts, suggesting that they were consciously imitative of the corresponding English prototypes. The rate of this time lag also seems to differ depending upon each potter's community location and degree of access to domestic ports of trade. As revealed by Bay

Colony potters' sherds, rural potters changed their wares more slowly than their more cosmopolitan, entrepreneurial counterparts. English manganese mottled lead-glazed redware, for example, was produced between 1680 and 1750. Domestic potters in Essex County, near the major eighteenth-century international port of Salem, may have begun to experiment with producing a local mottled version as early as 1709 or 1710. But the earliest *true* domestic mottled lead-glazed redware first appears in the Daniel Bayley and Osborn sherd samples in Essex County from about 1725 to 1800. Mottled redware was probably made for the first time at a somewhat later date in the more isolated inland community of Abington, which is situated halfway between Boston and Plymouth, Massachusetts. In Abington, it appears in the sherd sample of potter John Benner between 1765 and 1815 (Turnbaugh 1977:189-193).

The wares of every domestic potter studied seem to have lagged behind the date ranges for the corresponding English traditions. Community location and degree of access to or isolation from major ports of trade may account for specific differences in the rate and duration of this temporal lag within Bay Colony communities. Cultural and geographic location may also have affected the exactness of Bay Colony imitation of English lead-glazed redware traditions. During the seventeenth century, imitative domestic redwares were fairly exact and true to English prototypes. By the late eighteenth century, Bay Colony redware traditions were still Anglican in focus but with the addition of distinctively American traits. Lead-glazed redwares created in the more isolated, landlocked Bay Colony communities usually changed the most slowly and also seem to have drifted the most from the English traditions that had been initially transplanted. This trend is due, in part, to the length of time a community or potter continued to produce a certain variety of redware. For example, Daniel Bayley was situated near ports and cosmopolitan communities and began to fashion Category 7a (Table 12.1) in the mid-eighteenth century. Yet, this tradition was never adopted by potters working in more isolated communities, who continued to produce only those earlier traditions with which they were familiar. Still, changes occurred in these earlier traditions as well (see Part II of this volume). Theoretically, the longer a tradition exists in relative isolation, the more likely the tradition is to drift from its prototype.

Intracultural variation is an important consideration, but more detailed discussion is peripheral to the present argument. Other more specific treatments of this topic from the perspectives of Plymouth Colony and Bay Colony ceramics (Deetz 1973; Turnbaugh 1976:130-133) and gravestone decorative traditions (Deetz and Dethlefsen 1965) clearly illustrate the exciting potential of such considerations for achieving a better understanding of the colonial culture process in the Bay Colony.

INTERPRETATIONS AND CONCLUSIONS

The foregoing treatment has developed three hypotheses and, with the aid of historical and archaeological data, has shown each to be valid. Not only was the culture of the initial colonizing population conservative and traditional, but the lead-glazed redwares early Bay Colony settlers made and used were imitative of the redwares used by the culture from which the colony was derived. Subsequent divergence of Bay Colony lead-glazed redware traditions from English prototypes occurred during the late seventeenth and eighteenth centuries, and this digression has been defined and measured in a preliminary way. The model that has been presented in this chapter helps to explain the demonstrated similarity of contemporary English and early Bay Colony lead-glazed redware traditions in terms of a basic, conservative, English-oriented focus that was transplanted to the Bay Colony in the seventeenth century. The strength of this conservative, imitative worldview lasted despite isolation and cultural change and is reflected in the later domestic lead-glazed redware traditions. These same traditions suggest that for the mid- to late eighteenth century, the Bay Colony still looked to England for inspiration but was making uniquely American modifications.

On a more specific level of discussion, the existence of lead-glazed redwares made by two eighteenth-century Essex County potters—Joseph Bayley and his son Daniel—helps to advance subsequent socioeconomic and cultural interpretations of these diverging domestic and English traditions. Redware sherds made by Joseph Bayley, potter from 1722-1735, are almost deliberately exact in their imitation of popular English varieties. But late eighteenth-century domestic lead-glazed redwares, such as those of Daniel Bayley, began to change significantly. Although they were still modeled on English prototypes, Daniel's lead-glazed redwares diverged from strict emulation of English techniques and forms.

Daniel Bayley worked at two different kiln sites a few miles to the north of Salem (Watkins 1938, 1939). One was in Gloucester (1749-1753) and the second in Newburyport (1763-1799). Lead-glazed redwares from Daniel's second and later kiln in Newburyport show comparatively greater experimentation and innovation and permutation in technology (and, to a lesser degree, in style and form) than is present in samples from either his earlier kiln or that of his father Joseph. Daniel Bayley, and likewise Benner, fashioned a possibly new lead-glazed slipware, Category 2b, that has not yet been related to English traditions. Daniel Bayley, and also Southwick and Osborn, made comparatively greater use of speckled, mottled, and colored glazes than earlier potters. Daniel also successfully produced a yellow slipware with brown decorative elements probably of his own invention (Category 7a). Similar sponged and circular splotched (manganese) design elements are found in

other Northeast potters' sherd and vessel samples, such as in that of Brooks (Worrell, Chapter 9, this volume), well into the 1800s. Although the sherd sample from Daniel Bayley's second kiln in Newburyport most probably is Anglican inspired, it includes an overall greater representation of tooling and white (kaolin clay) slip decorative elements than either his father or other earlier potters apparently used. Many of these elements have no exact identifiable antecedents in corresponding English slipware traditions. The kaolin clay may have been obtained nearby, from West Kent's Island, Newbury (Sears 1905:357). Furthermore, most of Daniel Bayley's slip elements were executed quickly with a brush, not trailed with the quill cup more typical of traditional English slipware decoration (see Figure 12.2).

The lead-glazed redwares of Joseph and Daniel Bayley specifically reflect a shift from conservative and conscientious imitation of English prototypes to more creative, innovative modeling of Anglican traditions. This shift may be due to general cultural changes or may simply have been an attempt to stay economically viable in light of changing ceramic preferences. Imported porcelain, stoneware, creamware, and pearlware table wares were inundating Essex County markets by the last quarter of the eighteenth century. These ceramics were superior in quality to the lead-glazed redwares local potters could produce. Essex County potters lacked most of the raw materials needed to make these more durable and fancier wares, and most also lacked the mercantile ability to import quantities of the necessary materials. As a result,

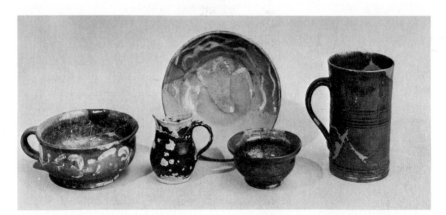

Figure 12.2 Lead-glazed redware porringer, creamer, deep dish, sugar bowl, and cider mug from the Daniel Bayley pottery site, Newburyport, Massachusetts, 1763–1799. These wares combine traditional English-derived forms and glaze colors with brush-applied white kaolin slip decoration. This decorative technique is an example of innovation or permutation and appears to have been a distinctive American trait (gift of Lura Woodside Watkins; courtesy, Smithsonian Institution).

potters like Daniel Bayley resorted to other, more innovative tactics to keep their lead-glazed redware trade economically viable.

In the case of Daniel Bayley, glaze and decoration innovations seem to have served the purpose. Daniel Bayley's wares were popular and, like Swansea (Massachusetts) potter Preserved Pearse's similar slip-decorated wares (Watkins 1939), were traded up and down the New England coastline from Maine to Rhode Island and Connecticut. In fact, redwares highly similar to Daniel Bayley's kiln sherds were even retrieved during excavation of the British frigate HMS *Orpheus* that was scuttled in Narragansett Bay, Rhode Island, during the Battle of Rhode Island in 1778 (Turnbaugh *et al.* 1979:49). Daniel Bayley also created very thinly turned vessel walls and bases of such fine workmanship that the finished lead-glazed redware products compared favorably to fancier and usually more expensive contemporary English imports.

Other adaptive strategies were used by some potters working elsewhere in the Bay Colony and the Northeast. These adaptations include, for example, more streamlined mass-production techniques like drape molding, decreased ornamentation, and a more limited repertoire of glaze colors and redware varieties and forms. Other redware potters expanded into stoneware production and often succeeded in remaining economically viable by this means (see Part II, this volume). Still other potters abandoned table wares toward the close of the eighteenth century and in the early nineteenth century and secured their livelihood by supplying small firms with unglazed industrial redwares such as tiles, pipes, and bricks (Watkins 1950).

In general, the economic viability of the late eighteenth-century Bay Colony lead-glazed redware potter most certainly was threatened. Selected probate inventory data for the eighteenth century demonstrate deepening socioeconomic differentiation between occupations within Essex County (Turnbaugh 1977:210). Of 4 eighteenth-century Salem Village ministers (Parris, Green, Clark, and Wadsworth) and 4 eighteenth-century Essex County potters (Kettle, Joseph Bayley, Daniel Bayley, and Southwick), all of the ministers were well off for their respective time periods, whereas the potters' estates generally decreased in real value through the decades. Although each of the three later potters appears to have lived a comfortable life, only the earliest potter and farmer, James Kettle, would have been considered wealthy by his contemporaries. Consequently, the later potters may have been under greater socioeconomic and cultural pressure to adapt, to innovate, and to produce desirable wares by which to secure their livelihoods.

The seventeenth-century Bay Colony potters enjoyed economic success simply by observing fairly rigorous emulation of English prototypes, which they often fashioned while pursuing other part-time occupations (Watkins 1950). But by the middle of the eighteenth century, this imitative, conserv-

ative orientation began to change on a general cultural level. These later Bay Colony potters were forced to innovate and to adapt to these changes. By dint of sheer hard work and imagination, volume of production, decorative innovations, and catering to increasingly rapid changes in tastes and fashions, the best the late eighteenth-century Bay Colony lead-glazed redware potters could achieve was a comfortable existence and survival of their business in their evolving social and economic order.

13

Chapter

The Demise of Traditional Pottery Manufacture on Sourland Mountain, New Jersey, during the Industrial Revolution

Richard Hunter

INTRODUCTION

From at least the first decade of the nineteenth century until ca. 1880, utilitarian redware manufacture was carried on within a confined and isolated area on Sourland Mountain in Hillsborough Township, Somerset County, New Jersey. At its peak, in the mid-nineteenth century, this industry comprised three separate potteries and a tile works, all located within an area approximately 2 km square. These factories were situated close to their two chief raw materials (clay for potting and wood for fuel) in a thinly settled part of the state where the land is of marginal agricultural utility (Figures 13.1 and 13.2).

The Sourland Mountain redware industry is of more than purely local historical interest, since this cluster of sites achieved a scale of operation greater than that of the typical rural redware pottery situated alone in the landscape. One unusual feature is that the growth of the redware industry was closely linked to the lumber industry which developed in the neighboring community of Rock Mill during the same period. However, due mainly to its poor lo-

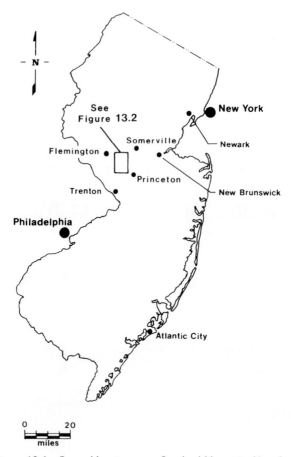

Figure 13.1 General location map, Sourland Mountain, New Jersey.

cation, the depletion of resources, and its relatively poor-quality products, the industry fell far short of, and was eventually eclipsed by, the large-scale and innovative urban potteries in nearby Trenton which were beginning to mass-produce much higher quality white earthenwares around the same time. The Sourland Mountain redware industry in effect occupies a transitional position in the development of the regional ceramics industry, showing signs of incipient urban-style industrialization within the context of a distinctly rural and imitative potting tradition.

Archaeologically, all three of the pottery sites appear to be undisturbed and worthy of preservation for future research. One, the Boozer Pottery, was subjected to a detailed field survey and a small excavation in connection with a class in archaeological field methods taught by the author at Rutgers Uni-

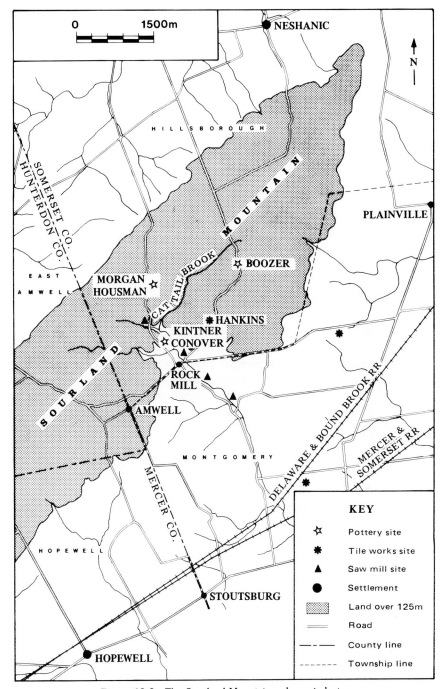

Figure 13.2 The Sourland Mountain redware industry.

versity in 1981. The condition of the tile works is unknown because the site is occupied by a modern house and garden. The survival of the pottery sites is due chiefly to the remote location of this industry in an area that today is densely wooded and lightly settled, and structural remains of kilns, workshops, and at least one potter's dwelling have been identified. Abundant waste material on each pottery site shows that a wide range of redware items was produced, including lead-glazed, manganese-glazed, slip-trailed, and unglazed vessels for use on the farm, in the garden, and in the home; roofing tile, drainpipe, and stovepipe collars; and numerous articles of kiln furniture (particularly saggars, setting tiles and bars, trivets, and pips) used for stacking products in the kilns during firing. Bricks are also found in abundance at each site and it is possible that the potteries were also manufacturing small quantities of brick for their own use (e.g., in kilns, workshops, and the potters' houses).

ENVIRONMENTAL SETTING

Sourland Mountain, a flat-topped igneous outcrop flanked by metamorphosed sedimentary formations, extends in a southwest-northeast direction for approximately 25 km between the Delaware and Raritan Rivers in Hunterdon, Mercer, and Somerset Counties, central New Jersey (Figure 13.1). It lies within the Piedmont physiographic province and averages between 125 and 150 m in elevation, rising up to 125 m above the adjacent land. The southwestern portion of the mountain has been broken up by erosion into a number of smaller hills. The mountain's northeastern end, however, stands out as a well-defined plateau up to 3 km in width. This part of the mountain remains essentially rural today and is mostly covered by deciduous woodland and dense undergrowth. The few agglomerated settlements on the mountaintop are little more than hamlets and many of the communities in the valleys to the northwest and southwest are of similar size. There are one or two larger settlements at the foot of the mountain, such as Hopewell and Neshanic, but the nearest towns of any size—Princeton, Flemington, and Somerville—all lie roughly 15 km away. The sites of the three potteries and one tile works that made up the Sourland Mountain redware industry lie midway along the plateau in the southwestern corner of Hillsborough Township, Somerset County (Figure 13.2).

The spine of Sourland Mountain is composed of a hard, fine-textured diabase (trap rock) and was formed as an intrusive sill during the Triassic period. As erosion has worn away the deposits overlying the sill and cut down into the less resistant sedimentaries in the Millstone and Neshanic valleys, the northeastern section of Sourland Mountain has gradually taken on its present-

day form (Bascom *et al.* 1909; Rogers 1840:152-153; Widmer 1964:76; Wolfe 1977:246-248).

The northeastern section of the mountain is better suited to forestry and mineral extraction than to agriculture. The soils, which are overlain by many large boulders, consist chiefly of the very stony silt loams of the Neshaminy-Mount Lucas and Mount Lucas-Watchung series. As a result, large-scale clearing for agriculture is generally impractical. The inhospitable soils are traditionally regarded as being responsible for the mountain—and the Harlingen area to the southeast—receiving the appellation "sourland," a term used to describe soils that need sweetening with lime to increase their fertility (Kirkham 1976).

The drainage of the northeastern portion of the mountain is dominated by Rock Brook, a tributary of the Millstone River. Rock Brook is a fast-flowing perennial stream whose headwaters (known as Cat Tail Brook) drain a substantial portion of the plateau. In some locations, Cat Tail Brook and its tributaries flow through clusters of large diabase boulders; in other areas they flow through patches of orange brown gravelly clay and silt. The diabase boulders are formed as a result of frost action and mechanical weathering of the sill and have accumulated along the streambeds through downhill creep. The clays and silts are also derived from the decomposition of the sill and contain a high proportion of feldspathic and iron minerals eroded from the diabase. This isolated and distinctive clay source and samples from the kiln sites might lend themselves well to "fingerprinting" by trace element or petrological analysis. Sourland Mountain products might then be identified with greater certainty in the region (Figure 13.2; Banino 1969; Tite 1972; Markewicz, personal communication, 1983).

Significantly, the sites of all three of the redware potteries and the tile works lie on the diabase on the mountaintop within 0.8 km of the eastern branch of Cat Tail Brook. Neither marketing nor transportational considerations can have been uppermost in the potters' minds when they located their earthenware manufactories here. The nearest towns and villages lay some distance away and the mountaintop was both thinly settled and relatively inaccessible. Proximity to clay and fuel is therefore believed to have been the primary factor governing the siting of the Sourland Mountain redware industry.

The mountain clearly possessed a suitable fuel source in its vast tracts of woodland, while the locations of the three potteries and tile works (and field evidence) imply that the diabase clays along the eastern branch of Cat Tail Brook were being worked. In some of the areas along the creek where the clays and silts are visible, there are shallow depressions which may have been caused by clay digging. The configuration of the historic lane network linking the potteries and Cat Tail Brook also suggests that the clays being used were close to the creek. It is unlikely that the clay source lay much further than

this from the factories, as transportation of such a heavy, bulky raw material for any greater distance would have involved a laborious and uneconomic uphill journey.

HISTORICAL BACKGROUND

In the late seventeenth and early eighteenth centuries, English and Dutch farmers began settling the fertile lowlands to the southeast and northwest of Sourland Mountain. By the mid-eighteenth century the first nucleated settlements in the area had been established around churches, mill sites, and nodes in the developing road network. However, with the exception of a few isolated farmsteads and a grist- and sawmilling complex which was apparently established at Rock Mill in the 1760s, the northeastern portion of the Sourland Mountain plateau remained largely unsettled until the end of the eighteenth century. Throughout the colonial and early Federal periods, this wilderness functioned primarily as an area of woodlots linked to the farms in the adjacent lowlands and traversed by a few poorly maintained, winding trails (Batchelder 1935; Brecknell 1972; Snell 1881; Wacker 1975).

Settlement began to spread onto the plateau in the late eighteenth and early nineteenth centuries when roads across the mountain were formally surveyed for the first time. The expansion of both the settlement pattern and the formalized road network onto the mountaintop was perhaps partly due to localized population pressure on the farmland in the adjacent valleys. However, in view of the limited agricultural potential of the mountaintop, it is hypothesized that these developments were stimulated chiefly by exploitation of the mountain's natural resources, in particular by the exploitation of the timber, clay, and waterpower around Rock Mill.

A map of Somerset County of 1850 shows the extent of the industrial development on the mountain most effectively. No less than three sawmills and three earthenware manufactories are depicted within 205 km of Rock Mill. Rock Mill itself centered on the intersection of Long Hill, Montgomery, Hollow, and Dutchtown–Zion Roads, where a store, gristmill, and chapel were located. This community provided a minor focus for the two major industries, but most residences, some services (schools and blacksmiths' and wheelwrights' shops), and other chapels were more widely dispersed over the mountaintop and along the Rock Brook valley (Otley and Keily 1850).

The population schedules of the federal census of 1850 provide a useful complement to the historic map data and give a good indication of the local economy and society of the Rock Mill area. Aside from those individuals listed as potters and millers, a number of woodchoppers and laborers and even a millstone maker were living in the area. Some of those listed as la-

borers were presumably employed digging clay or carting clay and timber to the potteries and mills. On the whole, householders on the mountain were noticeably poorer than their counterparts in the valley as reflected in the values of real estate owned. Very few of the mountain residents appear in the agricultural schedules of the 1850 census, thus confirming that the timber- and clay-related industries rather than farming were the main reasons for their living there. A relatively high proportion of those listed in the census were blacks and mulattoes, some of them probably moving into the vicinity originally as freed slaves. During the course of the nineteenth century, the Rock Mill area developed as a major focus of rural settlement for free blacks; the area still has a substantial black community today (Table 13.1; *United States Census of New Jersey* [USCNJ] 1850).

Industrial activity in the Rock Mill area appears to have peaked during the 1850s and early 1860s with the New York Bay shipbuilding industry proving an important market for Sourland Mountain lumber. The local building trades no doubt made use of the lumber as well and the redwares were probably distributed within a 15-25-km radius of Rock Mill. In comparison with the 1850 data, the census and historic maps for 1860 show increases in the number of industrial operations, the amount of capital invested in the industries, the value of the annual product, and the number of individuals working in the timber- and clay-related industries. However, decline came rapidly, particularly to the redware industry. Two of the three potteries were out of business by 1870, as only one is listed in the industrial schedules for that year. The final pottery appears to have closed down around 1880. The sawmills lingered on almost to the end of the century. Indeed, sometime between 1860 and 1873, a new mill which was functioning as a steam bending mill around 1880 was established on Montgomery Road on Cat Tail Brook. However, the area of exploitable timber became depleted fairly rapidly during the mid- to late nineteenth century, and the demise of the Sourland Mountain lumber industry must have been foreseen by at least some by this time (Tables 13.1 and 13.2; Batchelder 1935; Beers 1873; Hughes 1860; Lake and Beers 1860; USCNJ 1860, 1870, 1880).

HISTORICAL DETAIL OF
THE SOURLAND MOUNTAIN REDWARE INDUSTRY

No primary documents have been found indicating that the Sourland Mountain redware industry was in existence in the eighteenth century. The pottery for which the earliest documentation has been found is the Morgan-Housman site, ca. 1800-1880. The site lies on a 116.75-acre tract acquired by Charles and Aaron Morgan of Hillsborough for $1600 in 1810 (*Somerset*

Table 13.1
Population Data Relating to the Nineteenth-Century Redware Industry on Sourland Mountain[a]

Name[b]	Age	Place of birth	Occupation	Value of real estate	Value of personal estate	No. in household	Notes
1850 census							
William F. Boozer	44	New Jersey	schoolteacher	$ 380	nd	8	owner of the Boozer Pottery
George Boozer[c]	22	New Jersey	potty baker	—	nd	—	son of William Boozer, working in the Boozer Pottery
Joseph Boozer[c]	17	New Jersey	potty baker	—	nd	—	son of William Boozer, working in the Boozer Pottery
Robert Bath	50	England	potter	$ 150	nd	2	working in the Boozer Pottery
Asher Morgan	41	New Jersey	potter	—	nd	7	operator (later owner) of the Morgan-Houseman Pottery
Jacob Kintner	60	Pennsylvania	potty manufacturer	$ 500	nd	7	operator (later owner) of the Kintner-Conover Pottery
1860 census							
George Eaters	45	New Jersey	potter	$ 250	$ 20	2	? working in the Boozer Pottery
Robert Bath	62	England	potter	$ 100	$ 100	3	working in the Boozer Pottery
Morris Jackson[c]	29	New Jersey	brickmaker	—	—	—	? working in the Hankins Tile Works
William F. Boozer	52	New Jersey	potter	$1000	$ 400	4	owner of the Boozer Pottery
Dennis Conover	42	New Jersey	lumber dealer	$3000	$2000	4	owner of the Kintner-Conover Pottery
John Bigley	53	Pennsylvania	potter	$ 500	$ 300	5	? working in the Kintner-Conover Pottery
Samuel Housman	40	Virginia	potter	$1500	$ 300	5	owner of the Morgan-Housman Pottery
Richard Hankins[d]	49	New Jersey	farmer	$1500	$ 200	3	owner of the Hankins Tile Works
1870 census							
Abraham Lowe	66	New Jersey	potter laborer	—	$ 150	3	? working in the Morgan-Housman Pottery
Samuel Hosman	51	Virginia	potter	$1000	$ 300	8	owner of the Morgan-Housman Pottery
1880 census							
Abraham Lowe	77	New Jersey	"works in pottery"	—	—	2	? working in the Morgan-Housman Pottery

[a]Population schedules, federal censuses 1850, 1860, 1870, and 1880.
[b]Names are listed in the order in which they appear in the census.
[c]Not a householder.
[d]Listed under Montgomery Township (all others under Hillsborough Township).

County Deeds [SCD] 1810, Vol. F:201). This pottery appears to have been operating before 1810; a road return of that year makes reference to Montgomery Road as the "road from James Miller's potter's shop to Rock Mill" (*Somerset County Road Returns,* Vol. B:39). James Miller is not listed in the tax ratable records of this period, and although conclusive evidence is still lacking, he was probably a potter in the employ of the Morgans. Tax ratable records show that the Morgans were living in the area by 1802 and their pottery may have begun operation around that time (*Hillsborough Township Tax Ratables* 1797, 1802-09, 1815-17).

An inventory of Charles Morgan's estate in 1820 provides the first incontrovertible evidence that the Morgans were manufacturing pottery on the property. Itemized in this inventory are "Unfinished Ware" valued at $20 and "One Stone to grind glase on" valued at $4 (*Somerset County, Inventories* [SCI] 1820, Vol. C:225). No connection has been established between the Morgans of Sourland Mountain and the well-known Morgan family associated with the Cheesequake potteries in Monmouth County, New Jersey (Mitchell 1973; Morgan 1869).

The Otley and Keily map of Somerset County in 1850 shows "J. Morgan" at the earthenware manufactory on the Morgan-Housman site. The population and industrial schedules of the federal census for that year indicate that Asher Morgan, "Potter," owned the site, which at that time boasted a total of 10 kilns (Tables 13.1 and 13.2). The pottery remained in the Morgan family until 1857 when John B. Morgan of Ohio sold a 15-acre lot containing the pottery and two small associated tracts to Samuel J. Housman of Jersey City for $550 (SCD 1857, Vol. A3:481).

Housman, a native of Virginia, owned this property until his death in 1882. He and his wife Charity raised six daughters in their house, which was located a short distance to the east of the pottery. By 1860 Housman was manufacturing tile in addition to earthenware, and in 1870 the product was described as "earthenware in every variety." While the industrial schedule for 1860 indicates that the pottery had increased in value and expanded its output since 1850, the data for 1870 show that some recession had occurred. Housman was also active as a farmer and his farm is enumerated in the agricultural schedule of 1870 as being worth $1000 and consisting of 10 acres of improved land and 30 acres of unimproved land (Tables 13.1 and 13.2; Hughes 1860; Lake and Beers 1860; USCNJ 1860, 1870).

The Housman Pottery is not listed in the industrial schedule of the federal census of 1880 and Housman himself is recorded as a "farmer" in the population schedule, implying that he had abandoned his earlier livelihood as a potter. However, there are some indications that the pottery may still have been operating around this time. The 1880 population schedule records one Abraham Lowe, aged 77, whose occupation was given as "works in pottery."

Table 13.2

Industrial Data Relating to the Nineteenth-Century Redware Industry on Sourland Mountain

		Raw material					
Site	Capital invested ($)	Qty clay loads	Value ($)	Qty lead	Value ($)	Qty wood cords	Value ($)
Boozer Pottery							
William T. Busar 1850	340	nd	nd	500 cwt	40	25	100
William F. Boozer 1860	1000	100	150	nd	nd	nd	nd
Morgan-Housman Pottery							
Asher Morgan[c] 1850	386	nd	nd	600 cwt	36	35	50
Samuel Houseman 1860	500	200	50	100 lb	85	25	65
Samuel Hosman 1870	400	nd	nd	900 lb	180	nd	nd
Kintner-Conover Pottery[b]							
Dennis Conover 1860	500	100	100	700 lb	100	25	75
Hankins Tile Works							
Richard Hankins 1860	500	nd	nd	nd	nd	125	nd

[a]Industrial schedules, federal censuses 1850, 1860, and 1870.
[b]Kintner-Conover Pottery was in operation in 1850 but was not listed in the industrial schedule of that year.
[c]Asher Morgan was not the owner in 1850, he became so in 1856.
[d]Total paid in wages during the year was $4000.

Lowe had been noted as a "Potter Laborer" in the 1870 population schedule, and as Housman's appears to have been the only pottery still functioning at that time, Lowe presumably worked there (Tables 13.1 and 13.2). Lowe and possibly Housman himself may have continued working part time in the pottery into the 1880s. The inventory of Housman's estate in 1882 makes reference to "a shop" and to "42 large Earthen Pots" valued at $6.00, "25 Earthen Pots" valued at $5.00, "100 small Pots" valued at $10.00, "450 Flour Pots" valued at $45.00, "5 Doz. Earthen Dishes" valued at $2.50, and "1 Potters wheel" valued at $3.00 (SCI 1882, Vol. N:59). Although these items could have been unsold stock and equipment from earlier years, it is perhaps more likely that production continued intermittently until Housman's death. Housman's widow sold her late husband's property of 60 acres in 1882 and the pottery, after at least 60 years of operation, presumably closed down around this time (SCD 1882, Vol. C6:590).

The other two redware potteries on Sourland Mountain, the Boozer Pottery, ca. 1845–1862, and the Kintner-Conover Pottery, ca. 1850–1862, appear to have been established later and to have closed down earlier than the Morgan-Housman Pottery. Both were in existence by the 1840s but neither appears to have survived the 1860s; the federal census of 1870 gives no indication that they were still operating at the time.

The earliest documented reference to the Boozer Pottery occurs in a deed

Table 13.2 (*continued*)

Motive power	Average no. of hands employed	Average monthly cost of male labor ($)	No. of kilns	Product	Annual value of product ($)
horse & hand	3	33	5	earthenware	500
horse & hand	4	100	nd	earthenware & tile	500 (earthenware); 300 (tile)
horse & hand	3	32	10	earthenware	800
horse	4	80	nd	earthenware & tile	1300
horse & hand	2	nd[d]	nd	earthenware in every variety	1100
horse	3	200	nd	earthenware	500
horse	7	140	nd	tile (250,000 annually)	2500

of 1845 in which William F. Boozer of Hillsborough acquired for $301 from Enoch Phillips of Hopewell a 19-acre tract known as "the Poat house Lot" (SCD 1845, Vol. C2:246). While a pottery was clearly in existence on this site prior to Boozer's purchase of the property, the date of its original establishment is unknown. Boozer is recorded as the owner of his earthenware manufactory on the Otley and Keily map of Somerset County of 1850 and in the industrial schedule of the 1850 federal census. In the population schedule of 1850, however, his occupation is recorded as "schoolteacher" and he apparently ran the school located just south of his pottery. The pottery, which included five kilns, appears to have been operated at this time by Robert Bath, a potter from England who lived across the road from the factory, and by two of Boozer's sons, George and Joseph, each listed as "Potty Baker" in the population schedule. Boozer and his wife Susan raised three sons and two daughters and lived in a house located immediately west of the pottery (Tables 13.1 and 13.2; Beck 1962:279–280; Hughes 1860; Lake and Beers 1860; Otley and Keily 1850).

The Boozer Pottery had expanded its operations slightly by 1860 according to the industrial schedule of that year, which shows increases in the capital invested, the number of hands employed, and the value of the annual product. The pottery was producing tile as well as earthenware at this time and the former accounted for almost 40% of the value of the annual product.

The population schedule of 1860 lists Boozer as a potter rather than a school-teacher, although he may well have pursued the two occupations concurrently. Robert Bath still worked at the Boozer Pottery in 1860, while another potter, George Eaters, who lived close by, may also have been employed there. Boozer's two eldest sons were no longer in the area at this time as they are not enumerated in the population schedule. During the 1850s Boozer acquired three neighboring tracts of land, parts of which may have contained additional potting clays and timber for fuel (Tables 13.1 and 13.2; Hughes 1860; Lake and Beers 1860; SCD 1851, Vol. Q3:259-260, 1859 Vol. Q3:262).

The Boozer Pottery ceased operation in the early 1860s. One secondary source dates the closure to 1862, noting that the Union had drafted Boozer's employees to fight in the Civil War and that the ship sawyers had depleted the timber he needed to fire his kilns (Batchelder 1935). Boozer had left the area by 1865; he is described as being a resident of Newark in the deed of that year in which he sold his Sourland Mountain property to Catherine Johnson, the wife of John Johnson (SCD 1865, Vol. Y3:243). John Johnson is listed as a "farmer" in the population schedule of the federal census of 1870; the accompanying agricultural schedule shows his farm as consisting of 10 acres of improved land, 5 acres of woodland, and 27 acres of other unimproved land. The relatively small area of woodland and the large area of other unimproved land are perhaps indicative of the depletion of the mountain's timber resources by the potteries and mills. There is no evidence in the 1870 or 1880 census data to suggest that the Johnsons were ever involved in the manufacture of redware (USCNJ 1870, 1880).

The earliest indisputable evidence of the existence of the Kintner-Conover Pottery occurs in 1850. In the population schedule of the federal census for this year, Jacob Kintner, a "Potty Manufacturer," is recorded in Hillsborough Township. Kintner's household in 1850 numbered seven individuals, all of whom were born in Pennsylvania. The youngest child was aged five, which probably means that the Kintners did not move to Sourland Mountain until after 1845 (Table 13.1). Also dating to 1850 is an inventory of the estate of the late John Kintner. This makes reference to a "Lot of halfe burnt Erthen were" worth $12 and another lot of half-burnt "greene were" worth $15 (SCI 1850, Vol. G:212). The Otley and Keily map of Somerset County of 1850 depicts the Kintner-Conover Pottery as being in the hands of "J. Kintner," although it is not known whether this refers to John or Jacob Kintner. Both John and Jacob were presumably related to Charles Kintner of Bucks County, who in 1850 owned the 50-acre tract of land on which the pottery was located. Charles Kintner had acquired this tract from Henry Conover in 1841 for $700 (SCD 1841, Vol. B2:278) and in 1852, shortly after Charles Kintner died, 23 acres of this tract, including the pottery, were sold to Jacob Kintner

(Somerset County Division of Land [SCDL] 1852, Vol. B:59; *Somerset County Orphans Court Minutes* [SCOCM] 1852, Vol. G:333). Following Jacob Kintner's death in 1853, the 23-acre tract was acquired cheaply the next year by John Dockerty, who, in 1856, sold the same property at a handsome profit to Dennis Conover (SCD 1854, Vol. S2:590, 1856, Vol. X2:384; SCDL 1854, Vol. B:103).

In the industrial schedule of the 1860 federal census Dennis Conover is given as the owner of the pottery, which at that time was producing only earthenware (Table 13.2). In the 1860 population schedule Conover is listed as a lumber dealer (rather than a potter) with real estate valued at $3000 and personal estate at $2000. He was considerably wealthier than his potter neighbors and perhaps, as a lumber dealer, he served as a middleman for both the potteries and the sawmills. Analysis of the census data and the 1860 maps suggests that the potter at the Kintner-Conover Pottery was John Bigley, who lived across the road from the site. Bigley was a Pennsylvania native whose entire family, including the youngest child, aged eight, had been born in that state. Bigley apparently moved to Sourland Mountain after 1852, perhaps at the request of his fellow Pennsylvanians, the Kintners (Table 13.1; Hughes 1860; Lake and Beers 1860).

Dennis Conover died in 1861 or 1862 and the pottery appears to have ceased operation around this time as there are no subsequent references to earthenware manufacture on the site. John Bigley is recorded in the 1870 and 1880 population schedules as, respectively, a "farmer" and "farmer laborer" (USCNJ 1870, 1880). The site retained some identity, however, since a deed of 1874 for part of the property refers to the "Pot House," implying that this structure was still standing then (SCD 1874, Vol. C6:197).

The fourth redware manufacturing site on Sourland Mountain was the Hankins Tile Works, ca. 1855–1865. There is no evidence on the 1850 Otley and Keily map of Somerset County or in the 1850 federal census to suggest that the works was in existence at this time. The tilery appears to have been established sometime during the 1850s and the industrial schedule of the federal census of 1860 reports that the factory was producing 250,000 tiles annually valued at $2500 (roughly twice the value of the largest of the three potteries' production). The output of the Hankins Tile Works was therefore considerable; this factory was probably envisaged from the beginning as a fairly large-scale industrial venture rather than a localized folk craft operation. Richard Hankins, while given as the owner of the tile works in the industrial schedule, was listed as a "farmer" in the population schedule. He is also shown as the owner of the Rock Mill store on one of the two historic maps of the area of 1860, so the manufacture of tiles was evidently one of a number of commercial enterprises he was involved in. One brickmaker, a black named Morris Jackson, was recorded in the area and was probably one of

the seven employees at the Hankins Tile Works in 1860. The factory appears to have closed down during the 1860s. It is not listed in the industrial schedule of the 1870 federal census and Hankins, in the population schedule for that year, gave his occupation as "Dry Goods Merchant and Grocer," presumably reflecting his continuing control of the Rock Mill store (Tables 13.1 and 13.2; Beers 1873; Hughes 1860; Lake and Beers 1860; Otley and Keily 1850; USCNJ 1850, 1860, 1870).

The history of the Hankins Tile Works is paralleled closely by two slightly smaller tile works located in Montgomery Township in the valley to the southeast of Sourland Mountain (Figure 13.2). Both of these tile works, the Jern-Stryker-Apgar factory, ca. 1855-1875, and the Vanzant-Lyons factory, ca. 1855-1865, appear for the first time in the industrial schedule of the 1860 federal census. Both reported an annual production of 150,000 pieces of draining tile valued at $1800, the same capital investment of $1700, and an average labor force of five employees. The Jern-Stryker-Apgar factory outlived the Hankins and Vanzant-Lyons tileries, as it alone is recorded in the 1870 industrial schedule, albeit with a reduced level of production (Lake and Beers 1860; USCNJ 1860, 1870).

DISCUSSION

The Sourland Mountain redware industry dates from at least the first decade of the nineteenth century. The early history of the industry is obscure and it is theorized that the first potteries emerged after intensified exploitation of timber resources and early attempts at agriculture on the plateau exposed workable clay sources. Indeed, the industry may have developed partly as a result of the poor agricultural potential of the mountain, providing a much-needed supplementary livelihood for those struggling to farm the inhospitable soils. The industry flourished particularly between the mid-1840s and the early 1860s, probably reaching a peak during the late 1850s. Decline set in during and after the Civil War, although the largest and oldest of the factories, the Morgan-Housman Pottery, may have lingered on in a greatly reduced form until ca. 1880. The reasons for this decline (discussed in greater detail below) were manifold and included the depletion of timber and perhaps also clay resources on the mountain; the drafting of labor to fight in the Civil War; a reduced demand for red earthenware products spurred by an increased demand for the superior white earthenware and stoneware products; and the inability of the Sourland Mountain potteries and tile works to complete the transition from a loosely bound group of rural folk craft businesses to a fully fledged industrial complex functioning within a broader context of raw material and fuel sources, labor patterns, transportation networks, and markets.

By the mid-nineteenth century, the Sourland Mountain redware industry had developed a number of well-defined traits, many of them typical of traditional country potteries elsewhere in the United States. For example, proximity to raw material and fuel sources was the major influence on the siting of the industry. This is a characteristic feature of small-scale rural industries (Lasansky 1979:3; Newlands 1979:26). Each pottery site also contained the three basic elements—workshop, kilns, and potter's residence—all clustered together. Most other employees lived close by. Thus, residential, raw materials procurement, and processing and manufacturing functions were all performed in close proximity to one another. Again, this use of space is characteristic of many small rural industrial sites (Watkins 1959:1-2).

The industry also exhibited social and economic patterning typical of country potteries. For example, for a number of the pottery owners and potters, the manufacture of earthenware was not their only economic activity and in some cases may even have been of secondary importance. In 1850 William Boozer regarded himself as a schoolteacher, not a potter, while in 1860 Dennis Conover was listed in the census as a lumber dealer and Richard Hankins as a farmer. In all three cases, these pottery owners hired others to produce the wares, probably performing a general overseeing function themselves. Some of those employed in the potteries (potters like John Bigley and laborers) worked their own small farmsteads and tenant properties, and, significantly, none of the potteries operated year round. The logistics and fluctuating labor needs of small-scale pottery manufacture prior to industrialization required that many of those working in this line of business pursue a second occupation such as farming (Lasansky 1979:5; Myers 1977:4; Springsted 1977:57).

The documentary evidence points to an overwhelmingly white labor force at the potteries. This may be misleading. While middle- and lower-class whites were the dominant socioeconomic groups behind the Sourland Mountain redware industry, the possible role of the sizable black community that emerged in the Rock Mill vicinity in the nineteenth century should not be overlooked. The census enumerators reported only a single black being involved in the manufacture of redware (Morris Jackson, a brickmaker at the Hankins Tile Works in 1860), but it is reasonable to assume that many of the blacks listed in the population schedules as laborers and woodchoppers were in the employ of the potteries (and sawmills). The number of blacks on Sourland Mountain may indeed be considerably greater than the censuses would lead us to believe, as the enumerators undoubtedly neglected to record some of those residents, most of whom were black, living deep in the woods some distance from the roads.

The products of the Sourland Mountain potteries were for the most part utilitarian in function and imitative in style, thereby representing the contin-

uation into the nineteenth century of an essentially European and medieval potting tradition. However, despite the potteries' proximity to one another and their relatively high level of production, there are no indications of innovative products or production techniques being developed. Indeed, as the effects of the Industrial Revolution began to reach New Jersey, these potteries, rather than innovate and experiment, strove instead to adapt and diversify within already existing industrial patterns. This is noticeable in the 1860 census, when production included the manufacture of tile and drainpipe and probably also brick. During the 1850s, both the Boozer and Morgan-Housman potteries appear to have initiated or expanded production of tile. It is not known whether new purpose-built tile kilns were erected on these sites or whether the existing pottery kilns were adapted for firing tiles. The diversification of production was almost certainly a response to the decline in demand for their traditional redware household and farm vessels. These items were rapidly becoming obsolete in the face of the more popular and durable white earthenwares and stonewares that were being produced in vast quantities by the urban industrial potteries in nearby cities, particularly Trenton.

Even more significant than diversification of production in the potteries was the establishment of the Hankins Tile Works on the mountaintop and the two tile works in the nearby lowlands. These three factories were all founded in the 1850s as fairly large-scale industrial operations. In 1860, their combined annual product totaled 550,000 tiles valued at $6100. By comparison, the combined annual product of the three potteries was worth only $2600 (USCNJ 1860). Clearly, the foundation of these tile works reflected a conscious attempt to develop a new line of business in redware production. The pressure to mass-produce in order to compete with the industrial potteries in the region may have been an important issue here, since the manufacture of simple moldmade items like tiles, drainpipes, and bricks would have been far better suited to mass production than the manufacture of a wide range of wheelthrown and moldmade domestic and farm vessels.

This overall shift to tile, drainpipe, and brick also made sound economic sense in the 1850s and 1860s in view of the flourishing building trade and the widespread improvement of land through the laying of field drains. The reorientation of rural redware potteries towards the production of ceramic building materials and the establishment of new tile works are common features of the mid-nineteenth century throughout much of the United States. Similar changes were also occurring around the same time in many of the smaller urban and rural potteries in England (Brears 1971:79). Ironically, in the case of the Sourland Mountain redware industry, diversification perhaps hastened its decline by accelerating the depletion of the clay and timber resources on the mountain. The forming and firing of tile, drainpipe, and brick

likely resulted in a heavier consumption of both clay and wood than the form-ing and firing of pottery vessels.

Despite conforming to many of the cultural patterns observed for rural red-ware potteries in general, the Sourland Mountain redware industry during its floruit was uncharacteristically large and complex. The clustering of the three potteries, while clearly related to a specific clay source, was unusual. Rural redware potteries were more often scattered across the landscape, their dis-tribution reflecting the frequently occurring low-grade clay deposits, the dis-persed rural settlement pattern, and the geographically limited markets that each pottery commanded. One would normally expect the Cat Tail Brook clay source on Sourland Mountain to have been worked by a single pottery perhaps catering to a market extending from Neshanic to Hopewell and Wertsville to Harlingen. This may have been the case in the early nineteenth century when the Morgan-Housman Pottery apparently existed alone. Why, then, by 1860, had three potteries and a tile works all been established in what was an unusually isolated area possessing few incentives for settlement and agriculture?

The answer lies not so much in the soil as in the broader social and eco-nomic forces that were shaping Rock Mill into a protoindustrial focus in the mid-nineteenth century. The growth of the redware industry around Rock Mill occurred contemporaneously with the growth of the lumber industry and it can be assumed that the two industries interacted on various levels. Both drew on a common resource—the mountain woodland—which provided the sawmills with their basic raw material and supplied the potteries and tile works with fuel. Earlier in the nineteenth century, when raw materials were still plen-tiful, the growth of one industry need not have posed a threat to the growth of the other. Indeed, the redware industry probably made use of the smaller trees and tree limbs that the sawmills rejected and would also have benefited from the clearance of vegetation overlying clay sources. Entrepreneurs who dealt in lumber such as Dennis Conover probably encouraged development in both sectors, while the unskilled labor force of woodchoppers, clay diggers, and other laborers had some flexibility in that they could make themselves available to either industry. For a brief period during the 1840s and 1850s the Rock Mill area must have shown some promise as a potential industrial center and the Sourland Mountain redware industry perhaps expanded be-yond the customary single country pottery as this "mini-boom" was realized.

In assessing the level of industrial and technological development attained by the Sourland Mountain redware industry, evidence of any linkages be-tween the potteries and tile works is crucial. For instance, did the four busi-nesses operate independently and in direct competition with one another or did they work in concert, with each site specializing in certain products? Did they supply each other with, for example, specific items of kiln furniture?

Such questions require much more intensive documentary and archaeolog-
ical study but it is notable that one secondary source reports that the Boozer
Pottery "made triangular crows feet [trivets] for other potteries and patent
roofing tile" (Batchelder 1935).

Although Rock Mill did in a sense become a protoindustrial center, it never
attained full-blown urban–industrial status because of certain inherent dis-
advantages. The area did not possess either the raw material or fuel resources
necessary to support an extended period of industrial activity. Nor did the
area have the necessary transportational facilities for importing additional raw
materials and distributing large quantities of manufactured goods to the out-
side world. Up until the very end, the Sourland Mountain redware industry
continued to use horse and hand power for clay preparation and forming
processes and timber for firing kilns (Table 13.2). The industry never switched
to coal for firing kilns or as a source of power in the pottery workshops.
Transportation of coal onto the mountaintop was evidently considered too
impractical. Not surprisingly, limitations such as these severely affected the
ability of the Sourland Mountain redware industry to grow and mass-produce
and enter the mainstream of the Industrial Revolution. Thus, although the
Sourland Mountain potteries stumbled a few steps along the trail from small-
scale family business to large-scale industrial concern, they failed ultimately
because their location limited them to a certain level of output and efficiency
which other industrial potteries easily surpassed.

Apart from the inherent locational and material disadvantages that the Rock
Mill area labored under, other external factors contributed to this failure.
Towards the end of the nineteenth century alternative methods of storing and
processing farm and household produce began to be developed: iceboxes,
mechanical cream separators, and glassware rendered many earthenware
products obsolete (Newlands 1979:27–28). Thus there was an overall de-
cline in demand for traditional redware products. Even more important, how-
ever, in the case of the Sourland Mountain industry was the competition from
other ceramic manufacturing centers. The Sourland Mountain potteries blos-
somed briefly in the very decade that Trenton, only 25 km away, began to
emerge as one of the nation's foremost pottery-producing cities. By 1860
Trenton, with its advantageous canal and rail connections giving access to
sources of clay and tempering materials, to the coal of eastern Pennsylvania,
and to markets throughout the country, boasted six large industrial potteries.
These were producing yellowware (which soon faded into obscurity) and the
forerunners of the ironstone china that within a few years had cornered the
domestic market across the nation. Growth and innovation in the Trenton
pottery industry were even more marked in the 1860s and 1870s. By the
end of the century a wide range of materials, including utilitarian earthen-
wares, sanitary earthenware, porcelain hardware trimmings, electrical por-

celain, art pottery, and various fireclay products, was being manufactured (Hunter 1982; Mitchell 1977:17-19).

Even with their diversification into tile, drainpipe, and brick manufacture, the Sourland Mountain redware industry stood little chance of competing effectively against the industrial potteries in Trenton and other better-situated redware and stoneware potteries. Coupled with the effects of the Union draft for the Civil War on the labor supply and what must, by the 1860s, have been severely depleted supplies of clay and timber, it is no surprise that by 1880 the Sourland Mountain redware industry was reduced to a single individual, 77-year-old Abraham Lowe, eking out a living at the Morgan-Housman Pottery.[1]

ACKNOWLEDGMENTS

Thanks are extended to the following individuals who have contributed to the completion of this chapter: Richard Porter, Historian, Heritage Studies, Inc., for doing most of the primary documentary research and for considerable assistance in the excavation and analysis of the Boozer Pottery; Charles Ashton, Architectural Historian, Heritage Studies, Inc., and Jonathan Gell, Archaeologist, Office of New Jersey Heritage, for reading and commenting on this chapter in its draft form; Beverly Weidel,

[1]Since the original preparation of this chapter, continuing research has brought to light another probable redware pottery on Sourland Mountain. Approximately 4.5 km southwest of Rock Mill, in the woods southwest of Rileyville Road in Hopewell Township, a number of pits (now water-filled) have been dug into the clay deposits along the headwaters of another creek named Rock Brook. Local inhabitants have reported finding pottery and kiln remains in this vicinity. Although this evidence is still largely circumstantial and the location of the kiln has yet to be precisely pinpointed, the geological and topographic conditions closely resemble those along Cat Tail Brook. The presence of a pottery here will very likely be confirmed before not very long.

There are other interesting parallels between the Rock Mill and Hopewell areas. The site of the probable Hopewell pottery is historically associated with property owned by the Trues, a black family prominent in the nearby black community of Minnietown. Blacks are documented in the immediate vicinity from at least the first quarter of the nineteenth century (Hunterdon County Deeds 1822, Vol. 34:17). Questions can again be raised concerning the possible involvement of blacks with traditional pottery manufacture on Sourland Mountain. There were also no less than three sawmills within 1.5 km of the True property (two of them downstream along Rock Brook), suggesting further linkage between the pottery and lumber industries in this area.

No clear documentary evidence has yet been found for this Hopewell pottery. The industrial schedules and other basic sources are silent on the subject. Either this pottery went out of operation before 1850 or, perhaps more likely, it was a small-scale, part-time affair that was not considered worthy of mention by the census takers. If the latter is true, one wonders how many other rural potteries lie unrecognized in the hills of central New Jersey and elsewhere in the Northeastern United States.

Curator of the Hopewell Museum, for allowing access to the museum's files; Frank Markewicz, Bureau of Geology and Topography, State of New Jersey Department of Environmental Protection, for his comments on the geology of Sourland Mountain; Robert Fryauff of the 3M Company for arranging permission for excavations on the site of the Boozer Pottery; the Rutgers students in the 1981 class in archaeological field methods for their assistance in the field; and members of the Van Harlingen Historical Society, particularly Ursula Brecknell, for their interest in this project. Roxanne Carkhuff of the Hunterdon County Historical Society has also shown great interest in this research and was largely responsible for drawing the author's attention to the possible pottery in neighboring Hopewell Township.

14
Chapter

The Founding of a Dynastic Family Industry: The Hews, Redware Potters of Massachusetts

Barbara Gorely Teller

The town of Weston, Massachusetts, has had the distinction of once harboring not only one of the early New England redware potteries but also one of the few such potteries to be kept in the same family for four generations. In ca. 1765, at about the time of his marriage, Abraham Hews I began his simple pot works (Bond 1855, Vol. I:296). It was to grow to such industrial proportions that by the end of the nineteenth century, in a new location in North Cambridge, its annual output of flowerpots alone was estimated to be about 20 million (Watkins 1950:43).

Lura Woodside Watkins first wrote about this dynastic family of potters in 1950. Since that time it has been assumed that the kiln site owned and worked by the father, Abraham Hews I (1741–1818), from ca. 1765 to 1810, when he retired, was the same as that owned by his son Abraham Hews II (1766–1854). Recent research in deeds and tax lists disproves this theory and indicates that Hews I and Hews II operated successive pot works at separate locations in Weston (*Middlesex County Registry of Deeds* [MDB] 1795, Vol. 160:169, 1821, Vol. 237:154; Nylander 1974; *Weston Tax List* [WTL] 1801:178).

The separate locations of these related potworks and the consequent distinctions made in primary historical documentation are of great importance

249

for cultural and socioeconomic reconstruction and interpretation. In particular, new evidence from the business ledger of the father, Abraham Hews I, demonstrates the changing role of potters in late eighteenth-century New England. For Abraham Hews I, potting was a part-time concern. For his son and two later generations it became a full-time business. Their changing roles appear to typify the successful potter's life in late eighteenth-century New England, and, as such, are important to consider further.

THE HISTORICAL RECORD

"Abraham Hews's Book," a ledger kept by Hews I from 1780 until his complete retirement from the business about 1810 (Teller 1974), is of significance because it gives some insight into the life of a redware potter in the Boston area. The limited variety of vessel forms, the prices charged, the types of buyers, as well as the many other commodities and services that supplemented the pottery income are here recorded.

Although this ledger was begun in the year 1780 and is inscribed "Abraham Hews's / Book Weston / 1780," all pages up to May 1788 unfortunately have been cut or torn out. Thereafter the record continues to 1810 with occasional page missing. Beyond that date it is blank. If held upside down the back pages have bills and accounts marked "Settl'd." It is obvious that after 1806 the sales rapidly dwindled and that Abraham Hews I was retiring at age 69 to the simple farming life, leaving his son to carry on the pottery works in the new location. Finally, inside the front cover is pasted a sheet of sales of "ware" dated between April and July of 1774.

The multiple roles played by Abraham Hews I in his small eighteenth-century community must have made his name a household word. As his ledger reveals, it was to Hews I that the residents turned to rent a horse or cart or sleigh for a trip to Framingham, Lincoln, Dedham, or Boston. It was Hews who had a pair of oxen to rent out for spring plowing or for carting apples to the mill in the fall. It was Hews who had extra bushels of wheat, rye, corn, potatoes, or beans to sell as well as fresh pork, cheese, butter, or bread. Shingles and "Clabbords" were kept in stock and he himself could be hired to do a little carpentry or to split rails. Whether one mug or two milk-pans or a whole cartload of earthenware was needed, Hews could supply it. It was this great diversity of his skills and labors that kept up a year-round cash flow for his family and also made him an indispensable member of his tightly knit little community. Hews I also found time to serve the town as Warden, Surveyor of Highways, Surveyor of Hemp, Assessor, and Fence Viewer (*Weston Town Records* [WTR] 1893:262, 349, 387, 411, 503, 521).

The majority of pottery entries in this daybook-type ledger are specified

only as "ware." With careful study there can be found mentioned only eight specific types of utilitarian vessel forms: mug, jug, chamber pot, pot, porringer, platter, bank, and milkpan. Size is noted only very rarely in the ledger, and entries are not always precise. For example, on June 11, 1789, Joel Stone purchased "1 bushel potatoes (£0.1.6), 16 quart mugs (£0.4.7), and 2 large pots (£0.0.9)." "Small pots" are mentioned in an entry of June 17, 1801, and in July 1799 "Esqr Ward" bought some "half mugs" (possibly pint or half-pint size). The next month he obtained "one large mug 0.0.6." Some vessel forms are illustrated in Figure 14.1.

Most frequently specified of Hews's redware items are milkpans, as in the following entries:

July 30 (1789)	Doct Ward	3 Milkpans	0.1.9
June 24 (1794)	Levi Dakin	$\frac{1}{2}$ Doz milkpans	
		1 platter	0.4.5
July 13 (1798)	Esqr Ward	2 Milkpans	0.1.10
July 23 (1803)	Isaac Flagg	2 Milkpans 1 pot	0.2.3
June 16 (1806)	Abr'm Fisk	$\frac{1}{2}$ Doz milkpans	2.9.0
June 4 (1810)	Ira Whittemore	1 Doz Milkpans	4.8.4

With 535 cows in Weston in 1773 (Lamson 1913:151) and probably 600 by 1800, there was an evident need for dairy ware. Hews could supply that need very quickly and conveniently. There is evidence in the ledger that he even delivered large or small orders to widows or other townspeople unable to transport them themselves. For example, Josiah Cary, elderly and living some distance south of the town, gave a large order for ware in the winter of 1788. The total cost, including "Sledding to your house," came to £3.10.10.

The hay, grains, vegetables, wood, and other staples that Hews could supply were of a seasonal nature and would have limited his income during the winter months if he had depended solely on these products of his farm. The need for replacement of cracked or broken kitchen or dairy redware items, however, knew no season. As long as residents could get about by sleigh or pung, Hews was just as likely to sell a load of pots or a single mug in January as in June.

Extent of Market

Hews I appears to have made no attempt at this time to market his ware in Boston or to advertise. It was mainly on word-of-mouth recommendation that he depended for expansion of demand. His good name and character,

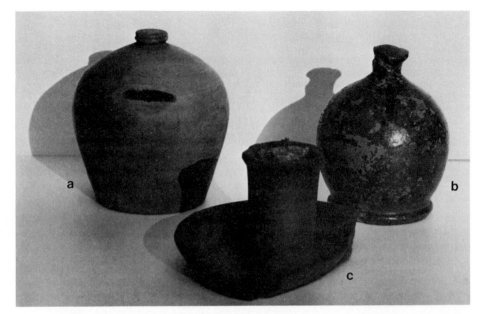

Figure 14.1 Redware forms possibly made by Abraham Hews I of Weston, Massachusetts: a, larger coin bank, 3¾" × 3¼", coin slot horizontal; b, smaller coin bank, 3½ × 2¾", lead-glazed, coin slot vertical; c, fragment of unglazed redware chamber candlestick, handle and portion missing, 2½" × 4". Pieces excavated near back door of house owned by Enoch Green-leaf in Weston. According to the Hews ledger, Greenleaf purchased ware from Hews I until his death in 1805.

the quality of the "pots," and the accessibility of his shop from all points west and northwest along "The Great Country Road" had to "sell" his wares.

An analysis of all names of customers given in the ledger reveals that in the 20-year period covered by the entries, 105 individual names of local residents of Weston appear repeatedly as customers. Fifty-six other names were found to be nonresidents. The ratio of resident to nonresident customers would appear to have been roughly 2 to 1.

The locus of Hews's market, therefore, was primarily of a local nature. Judging from the many repeat entries of identifiable Weston names, the majority of Hews's simple jugs, mugs, and chamber pots found a ready market among local buyers. With several busy taverns in Weston, there would have been a steady demand for replacements of broken kitchenware as well as a need for outfitting new households in the area. Of the 56 nonresidents, only 16 had a location given, probably because most were known to Hews and had been customers in previous years.

Table 14.1 indicates that several of Hews's nonresident customers came from towns west and northwest of Weston, up to a distance of about 80 km.

Table 14.1

Nonresident Customers from Identified Towns

Name	Town	Name	Town
Capt. Jewet	Ashburnham	Phineas Gregory	Princeton
John Dexter	Berlin	Josiah Allen	Sudbury
William Tucker	Framingham	—— Eames	Sudbury
——Eaton	Framingham	Ebenezer Eaton	Sudbury
——Ward	Framingham	Mr. Nolen	Sudbury
Moses Clark	Hubbardston	—— Johnson	E. Sudbury
Gregory & Bannister	Hubbardston	Jonathan Fairbanks	W. Sudbury
William Cogswell	Marlborough	Mr. Moredock	Westminster

The concentration of buyers in five towns of Worcester County is of some interest. Hews's willingness to trade "pots" for shingles to sell to his local customers made the long trips worthwhile for Moses Clark and Captain Jewet. Clark came several times from Hubbardston with a load of hand-cut shingles in bundles to be credited toward a load of redware. On June 4, 1794, he brought 8000 shingles for which he was allowed £4.16.0. This load paid for all but 1 shilling of his return load of ware worth £4.17.0. On later trips his loads of Hews's redware came to totals of £6 or £8. Gregory & Bannister of Princeton, probably country store owners, sent a wagon for a load of ware in 1794 worth £8 and received a 19-shilling discount for "Sundries" brought to Hews. Now and then a discount for paying cash is recorded. Hews even accepted a load of rags for discount on a $31.33 load of ware in 1802.

Other large purchases were made by residents of unspecified surrounding towns. Undoubtedly well known to Hews, they probably came from nearby towns just north, south, or east of Weston. It is quite possible that one or two of those listed in Table 14.2 were itinerant traders or "peddlers" so common on the back-country roads of that period. Names of two paper mill owners, Captain William Mills and Solomon Curtis, can be recognized as coming from the nearby Needham and Lower Falls areas.

Because of the lack of evidence from the ledger of sales during Hews's peak years of production in the 1770s and 1780s, it is difficult to arrive at any more specific conclusions about the extent or scope of his market. Tables 14.1 and 14.2 suggest that his ware was well known and sold well within the area of a day's trip to Weston.

Socioeconomic Status

Research of some of the 105 names recorded provides a wide variety of individuals of differing social and economic status. Two of Hews's most active accounts were those of Dr. William Ward and the blacksmith David Brackett.

Table 14.2

Large Purchases Made by Residents of Unspecified Towns

Date	Name	Quantity	Value
Nov. 22, 1784	Mr. Lazarus Labaron	Load of Ware	£7.16.8
April 1786	Capt. William Mills	Load of Ware	£7.5.0
July 20, 1786	Capt. William Mills	Hogshead of Ware	£1.17.3
August 1786	Capt. William Mills	Ware	£2.0.3
July 1787	Mr. Caleb Wilder	Hogshead Ware	£1.4.0
August 17, 1787	Mr. Caleb Wilder	Hogshead of Ware	£1.12.6
Feb. 1788	Mr. Caleb Wilder	Load of Ware	£4.1.3
Feb. 1788	John Whitcam	Barril Ware	£0.18.0
March 1788	John Whitcomb	Load Ware	£3.8.0
July 1788	Ebenezer Roby	Load of Ware	£2.16.0
Jan. 12, 1789	Simon Crosby	Load of Ware	£8.5.0
Jan. 21, 1789	John Williard	Load Ware	£7.10.0
Feb. 1789	Mr. Ashley	Load Ware	£6.0.0
June 1802	Thomas Volontine	Load Ware	$31.33
June 1803	Solomon Curtis	Load Ware	$21.32

Entries appear almost monthly from 1788 until 1793 under the name of "Doct Wm Ward" or simply "Doct Ward." The same regular buying pattern continues until 1795 under the name of "The Widow Ward," his young wife. Most of these small household purchases came to only a few pence or a shilling. The quantity and regularity of small redware purchases made by this family with young children mirrors the constant needs of a busy household at a time when breakage was high and speed of replacement of utmost concern.

The second very active account lasted until Hews retired and included a wide variety of farm products as well as redware items. David Brackett, a village blacksmith, had little time for farming and relied on Hews not only to supply his redwares but also to provide him with farm products and a hired horse.

On the other end of the economic scale were the gentlemen that Hews respectfully listed as "Esqr Artemas Ward," "Deacon Fiske," or "Capt Isaac Jones." These men could have purchased all their ceramic needs in Boston. Instead, they chose to purchase from Hews their utilitarian redware pieces, undoubtedly because of the convenience and cheaper price.

An even closer look at customers in one year alone reveals an interesting socioeconomic cross section of Weston residents. During 1789, for instance, the ledger records 151 sales to 16 nonresidents and 47 residents. If the Weston residents who made repeated purchases of ware are listed according to status categories derived from town and probate records, we find a diversified profile of Hews's customers (Table 14.3). Table 14.3 suggests that utilitarian redware was useful and acceptable in most households, regardless of soci-

Table 14.3

Socioeconomic Profile of Weston Customers, 1789

Category[a]	Number	Category	Number
Gentlemen	11	Housewright	1
Minister	1	Carpenters	2
Doctor	1	Blacksmiths	2
Lawyers	2	Wheelwright	1
Schoolmaster	1	Shoemaker	1
Cordwainers	3	Tailor	1
Tanners	2	Yeomen (farmers)	10
Innkeepers	2	Widows	3
Storekeeper	1	Unspecified	2

[a]Categories ranked in descending order of socioeconomic status.

oeconomic status, in the eighteenth-century community of Weston, Massachusetts.

This indication can be further tested by an inventory survey of ownership at time of death of "Lots" of "earthenware." Of the 47 Weston customers investigated for 1789, less than half had inventories recorded in the *Middlesex County Registry of Probate* (MPR). Of these, only 18 had specific references to "earthenware," which usually were located near the bottom of the listing or mentioned as "in the kitchen." We can be fairly certain that they were referring to local redware products because all "crockery," glass, and "china," if owned, appeared higher on the list or in the best rooms in the house and bore a higher valuation. During the Federal period, "Crockery" was a favorite generic term describing imported English earthenware (Teller 1980:2-8). The specific references to "earthenware" in these household inventories are charted in Table 14.4.

Evidence of ownership, meager though it is, of some of the same earthenware vessel forms made by Hews and recorded in his ledger as sold to these same individuals in the sample year 1789 is conclusively shown by this inventory survey (Table 14.4). The low valuations are consistent with the low prices charged for the new ware as recorded in the ledger. Of the specified forms mentioned, milkpans are again the most numerous. Dairying and food preparation and storage functions seem predominant. In a rural community where ownership of at least one cow per family was the general rule, this trend is not surprising.

It will be noticed that only one of the "gentlemen," Samuel Fisk, had food service vessels specified, such as plates and mugs. This probably indicated the presence of farmhands or servants who had meals in the kitchen. The low status of late eighteenth-century local redware food service vessels as

Table 14.4

Earthenware References in Household Inventories of 18 Weston Residents
Who Purchased Ware from A. Hews I in the Sample Year 1789

Name	Title	Estate value	Ware reference	Valuation
Amos Bigelow, 1795	Miller	£681.16.2	earthenware	9s.
Ebenezer Brackett, 1806	Cordwainer	$1,743.00	lot earthenware	$.75
			6 juggs	$.30
Samuel Fisk, 1814	Gentleman	$2,670.00	4 earthen milkpans	$.50
			4 earthen plates	$.25
			1 mug, 1 half mug	$.25
			1 earthen jug,	
			and 2 pans	$.16
			4 earthen pots	$1.00
Isaac Flagg, 1808	Yeoman	$1,723.00	1 lot brown earthen	$1.67
Isaac Gould, 1817	Carpenter	$ 123.22	2 earthen pots	$.30
			2 juggs	$.25
Uriah Gregory, 1818	Gentleman	$4,107.28	12 earthen milkpans	$.96
			lot coarse ware	$.32
Enoch Greenleaf, 1805	Gentleman	$ 411.35	lot earthenware	$1.17
Phineas Hagar, 1817	Yeoman	$1,230.63	3 milkpans	$.40
			brown earthenware	$1.00
			earthenware in	
			kitchen	$.50
Abraham Harrington,	Gentleman	$5,200.00	earthenware and	
1811			bottles	$1.67
Isaac Jones, 1813	Gentleman	$6,250.00	earthen milk pans,	
			pots and pudding pans	
			in Back Kitchen	$2.00
Samuel Lamson, 1795	Gentleman	$5,838.66	earthenware	$1.00
William Lawrence, 1814	Yeoman	$1,920.72	earthen in kitchen	$.75
Samuel Livermore, 1819	Yeoman	$1,390.15	lot earthenware	$.25
Thomas Rand, 1795	Housewright	£824.18.0	earthenware	4s.
Abraham Sanderson,	Miller	$ 972.69	milkpans, pots,	
1808			earthen	$.75
Jonas Sanderson, 1807	Gentleman	$3,680.00	earthenware	$2.00
Elisha Stratton, 1817	Gentleman	$3,206.65	earthenware	$1.50
Hezekiah Wyman, 1803	Blacksmith	$1,530.00	earthenware	$1.25

compared to vessels of imported English earthenware is clearly expressed by
their location. If mentioned at all, these local redware vessels are listed at the
end of the inventory, lumped with old bottles, or specified as "coarse ware"
or just "earthenware in kitchen."

In other well-to-do households, coarse redware was probably present in
the kitchen but, because of its low status and value, was omitted on the in-
ventory. This was true of the inventory of the "Widow Rebecca Baldwin"
(MPR 1795, Vol. 81:312), whose name appears in Hews's ledger until her
death in 1795 as purchasing his wares. This omission of redwares was also
the case with her husband, Samuel Baldwin, tavern-keeper and gentleman,
who had died in 1779, leaving an estate of £5000. Baldwin's name appears

in the Hews ledger in the fragmentary 1774 list. His detailed probate inventory (MPR 1779, Vol. 60:322) itemizes china and glass in the "West Lower Room," "71 lbs pewter" and brass candlesticks in the "Barr room," and the ownership of three slaves, Caesar, Cato, and Milo, who were given freedom at his death. No mention is made of any earthenware in his kitchen, yet when the estate accounting was made in 1784, a bill of Abraham Hews I for £7.9.1 was paid in cash (MPR 1784, Vol. 70:71), indicating that redware had been owned but overlooked as too insignificant in value.

As the estate valuations where earthenware was present ranged from a low of $123.22 to a high of $6250.00, it can be seen that in the rural village of Weston socioeconomic status had little to do with the choice and ownership of utilitarian redware vessels. Since so few forms of the ware are specified it is impossible to make a true comparison between the vessel types purchased by the higher economic group and the less affluent. Based on the foregoing evidence and a study of rural and urban ceramic purchasing patterns in the New England area (Teller 1980), it can be projected that there would have been less difference among the food preparation and storage types and greater difference among the food service forms purchased by different socioeconomic classes.

The greatest variable would have been in the total quantity purchased of either vessel type according to economic status. For instance, Isaac Gould, carpenter and customer of the lowest economic status of the group surveyed, died in 1817 (MPR 1817, Vol. 128:291) possessed of "Two earthen pots" and "Two Juggs" valued at 55 cents. In the test year of 1789 Gould had made only three purchases of ware from Hews at a cost of two shillings. By contrast, Abraham Harrington, with an estate valued at $5200 (MPR 1811, Vol. 111:156), shopped for redware eight times that year and charged them on his account. On January 1, 1790, he paid Hews his bill for ware of six shillings. Like Harrington, Isaac Jones, gentleman and former innkeeper of The Golden Ball Tavern between 1770 and 1793, had a running account with Hews I and later with Hews II. One bill, recorded in the back pages of the ledger, covered the period June 1782 to June 1784 for ware purchased from Hews I while the tavern was in operation. The total came to over five pounds and was marked "Paid." After his death in 1813 his executors paid in 1819 the "balance of account with Abraham Hews $5.93" (MPR 1819, Vol. 132:169). His imported china, glass, and crockery were reported in his inventory as being in the closet in the front room. In the "Back Kitchen," however, could be found "earthen milkpans, pots, and pudding pans" (MPR 1813, Vol. 116:531).

To summarize, all the foregoing evidence suggests that locally made redware was purchased and owned primarily for food preparation and storage by all socioeconomic levels in Weston, a late eighteenth- and early

nineteenth-century rural New England village. As with many contemporary part-time rural potters, Abraham Hews I created traditional redware forms in traditional technologies (Figure 14.2).

HEWS I AS FARMER-POTTER

By providing his community with the useful commodity of utilitarian redware as well as other staples and services, Hews I became an important part of the interlocking economic network that made Weston a thriving rural town. At the same time he assured himself and his family of a steady income, something farming or one trade alone could not always provide.

To clarify and amplify this point, an analysis was made of sales recorded in the ledger of both farm produce and earthenwares for each month of the sample year 1789. This study revealed a fairly steady demand for ware during the nine months from April through December, averaging 12 sales per month. February was the lowest month that year with only six sales, possibly because of very stormy weather. January and March, however, were the peak months, with 20 sales in January and 26 in March, ranging in value from five pence for a pot to six pounds for a full load of ware.

The sales of farm produce for that same year were concentrated in the eight months from February through September. There were no sales of it at all in the October through January period. This slack season was helped by rental of horse and sleigh and sales of candles, cords of wood, and large bundles of hand-cut shingles which Hews had earlier taken in trade for his earthenwares.

If the one month of June is used as a test sample and both ware and produce sales are listed (Table 14.5), a comparison of relative values can be made.

The number of sales of ware and farm products for that month were very similar, as Table 14.5 shows, but the farm products were slightly ahead in actual total cash value. It is interesting to note that a half-bushel of potatoes was equal in value to "2 Large pots" and that "16 quart mugs" were worth only one shilling and seven pence more than a half-bushel of wheat.

Since sales of farm products were seasonal and peaked in the summer months and his pottery sales continued strong in the winter months, Hews appears to have managed to keep up a steady cash flow all the year round. One resource without the other probably would have meant a very meager and uncertain income. By supplementing the pottery income even further by the rental of horse, sleigh, wagon, and oxen for carting or plowing and harrowing, and by hiring out his own services for splitting rails for fences or doing odd carpentry jobs, Hews I assured his family of a comfortable existence.

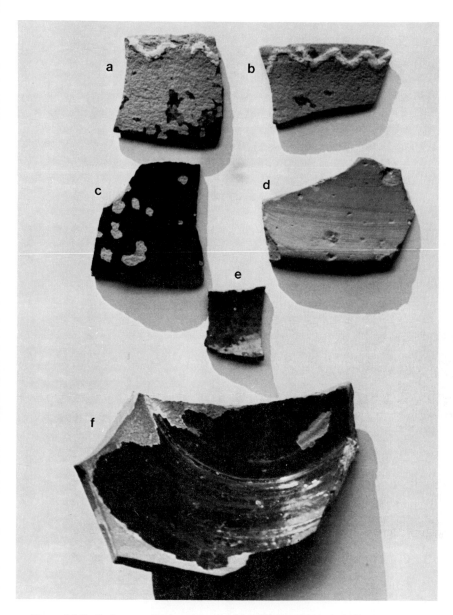

Figure 14.2 Redware technologies practiced by Abraham Hews I of Weston, Massachusetts, probably included traditional glaze colors and kaolin slip trailing: a, b, two sherds with clear lead glaze and trailed slip decoration traces; c, sherd probably from a mug with dark brown to blackish lead glaze on outside and mottled lead glaze on inside; d, rim sherd from a large vessel, unglazed; e, small sherd, mottled lead glaze on both sides; f, large sherd from a flaring-sided bowl or pudding pan, dark brown lead glaze on both sides. These sherds found near the foundation of an Enoch Greenleaf-owned house in Weston. Greenleaf was a Hews I customer.

Table 14.5

Comparison of Sales of Ware and Farm Products Recorded in Ledger during June 1789

	Ware	£ s d		Farm products	£ s d
Joseph Jewet	Load of ware	3.15. 0	Thomas Rand	9 Bunches Shingles	4. 0. 0
Edward Brinley	Ware	0. 0. 5	Daniel Eaton	$\frac{1}{2}$ Bushel Wheat	0. 3. 0
Thomas Rand	Ware	0.10. 0	John Kingman	$\frac{1}{2}$ Bushel Wheat	0. 3. 0
John Kingman	Ware	0. 0. 8	John Kingman	5 lbs pork	0. 2. 7
Eli Smith	Ware	0. 2. 1	Joel Stone	1 Bushel potatoes	0. 2. 8
Joseph Pierce	to ware	0. 1. 7	Daniel Eaton	$\frac{1}{2}$ Bushel potatoes	0. 0. 9
Joel Stone	to ware	0. 1. 0	Joel Stone	1 Bushel potatoes	0. 1. 6
Jonathan Fairbanks	to ware	0. 2. 8	A. Harrington	2 Calves skins	0.15. 0
Esqr Ward	ware	0. 0. 7	John Kingman	1 Calves head	0. 1. 0
Joel Stone	16 quart mugs	0. 4. 7	Isaac Flagg	Meat	0. 2. 6
	2 Large pots	0. 0. 9			
Isaac Flagg	to ware	0. 4. 0	Isaac Flagg	Honey	0. 2. 0
Ephraim Livermore	Ware	0. 3. 3	Ab. Harrington	half Calves head	0. 0. 7
Lot Jennison	ware	0. 6. 0	Ab. Harrington	Meat	0. 1. 9
Ebenezer Brackett	ware	0. 0. 5	John Kingman	Pork	0. 0. 10
Ebenezer Eaton	ware	0. 0. 3	John Kingman	$\frac{1}{2}$ Bushel of Rye	0. 2. 6
John Kingman	ware	0. 0. 10	John Kingman	3 lb. cheese and	
				2 lb butter	0. 1. 3
		5.14. 1			6. 0. 11

A rough idea of his total income for the year 1789 can be achieved by several calculations. By adding the totals of farm products sales and ware sales for the test month and multiplying by 8, the number of farm productive months, the result is £94.0.0. If the ware sales for the four winter months, totaling £8.11.2, are added, the figure becomes £102.11.2. To this is added an estimated £3 for rentals and personal services during the year, and the final total becomes £105.11.2. In the year 1789 the town of Weston voted (WTR 1789:407) to pay the minister, the Reverend Mr. Kendall, a salary of £90 and 20 cords of wood. With an estimated income that year of £105.11.2 and all the wood and farm products his family needed, Hews was therefore even a little better off than the well-educated and respected minister of the town.

When Abraham Hews I died in 1818 he had reverted to his old title of "Yeoman," as his eldest son was then designated "Potter." The total value of his real and personal estate was $2550.09, which would have placed him in the middle economic bracket of his community if $2624.56, the average in Table 14.4, is taken as the median. His will provided relatively well for his four married and two unmarried daughters, and also for his four sons. His "beloved" eldest son, Abraham, was appointed Executor. Among the usual furnishings listed in his own inventory (MPR 1818, Vol. 130:422) were a desk, a clock, tables, chairs, beds, linens, fireplace equipment, and also "9 green fan back chairs" valued at $4.50 and a fashionable "Field Bedstead" valued at $25.00. Tea could have been served by his wife on a square tea table in English earthenware cups using "6 silver tea spoons" and "3 silver washed spoons." The dining ware consisted of 20 pewter plates, platter, and basin, worth $3.75, and an unspecified lot of "Crockery." This lot could have included some plain "cream-color" or blue or green "edged ware," since in the inventory of his fellow townsman and customer, Uriah Gregory (MPR 1818, Vol. 130:412), his "Crockery" is described as "25 edged plates" and "8 c.c. plates." In Hews's kitchen several "Lots" of earthenware, jars, and jugs, probably all of his own manufacture, were valued at $2.50.

As a part-time potter-farmer, Abraham Hews I had literally wrested a living from the earth. His 53 years of constant hard work had won him a very respected place in his community.

HEWS II AS FULL-TIME POTTER AND GENTLEMAN

For the ambitious son, however, moderate success was not enough. Hews II appears to have been confident that he could make potting a successful career in itself. He never bought farm land for his own use and, as executor, immediately sold off most of his father's village holdings on both sides of the

Post Road (MDB 1821, Vol. 237:154). The exact date that Hews II actively began to operate his own pot works at the new site has not been previously documented. But we know he bought his small lot of land in 1795 (MDB 1795, Vol. 160:169). By 1801, according to the tax lists (WTL 1801:178), he had a house, barn, and separate shop completed. The southern boundary of a lot sold by Joseph Smith to Isaac Fisk in 1802 was described as starting on "The Great Road 8 Rods from Abraham Hews jr Workshop " (MDB 1802, Vol. 147:415). In another 1802 deed for an additional 1-acre lot he is named as "Potter" (MDB 1802, Vol. 160:274). This documentary evidence indicates that his pottery was in operation soon after 1800.

By 1814, when Hews II paid off his mortgage, he is listed as "A. Hews jr of Weston, Gent." (MDB 1814, Vol. 206:438). As a witness to the will of Isaac Jones and other close friends he also appears as "Abraham Hews, Gent." These references indicate that he was employing several hands besides his own sons and that the business was expanding and increasing in value. At the age of 48, therefore, he had achieved his goal of making the pottery business a full-time concern that could support his large family of six sons and seven daughters in the new brick-ended house on the Post Road.

By 1832, at age 66, Abraham II had deeded half his property and house to his son Marshall (MDB 1832, Vol. 315:26), who succeeded to the title of "Potter" and continued to run the business. The town records show that "Capt Abraham Hews, Gentleman" frequently served the town in various capacities, such as postmaster, assessor, school committeeman, and deacon of the First Parish Church. He died in 1854 at age 88 greatly respected and probably quite proud of the full-time pottery business that he had built up from the small beginnings of his father.

THE LEGACY

Horatio, the fifth son of Hews II, finally inherited the pottery about 1860 and established a third site with greater work space even farther west on the Post Road. In 1870 it employed 15 men and was producing 800,000 pieces of ware (Watkins 1950:43). The demand for utilitarian household redware vessels had been constantly decreasing, but the demand for plain red flowerpots and ornamental plant containers of all types for gardens and conservatories had been constantly increasing. Horatio must have been a man of vision who could see the potential new markets if changes were made in their line of products, for under his guidance the flowerpot department expanded and the business continued to grow. Early in the twentieth century some residents of Weston could remember having seen as children Horatio's shining

"Hews Pottery" wagons, drawn by teams of two or four strong horses, taking loads of ware to the Boston market (Ripley 1961:179).

By 1871 the ever-expanding business was moved to North Cambridge where it could be near rail transportation to all sections of the United States. In ca. 1873, Albert Horatio of the fourth generation next succeeded as owner and manager. A display of the Hews wares at the 1876 Centennial Exposition in Philadelphia brought them a medal, greater publicity, and many more orders. By 1889 the firm of A. H. Hews and Company employed about a hundred men and could produce nearly 20 million flowerpots per year as well as the line of popular ornamental wares (Watkins 1950:43). The productions of this period are well documented in catalogues, now very scarce, that illustrated the Hews garden urns and pedestals, fern stands, hanging baskets, and jardinieres, as well as the very familiar mass-produced patented stacking flowerpots.

According to Edwin Atlee Barber (1901), this firm claimed to have manufactured more hand- and machine-made flowerpots than any other establishment in the world. On December 1, 1891, a disastrous fire destroyed part of the factory and all of the machinery. By 1901, however, it had been rebuilt and was running again with even better facilities for producing not only the flowerpots but also all the ornamental wares, such as umbrella stands, cuspidors, lampstands, vases, art pottery, reproductions of antique shapes, and plain or embossed pieces in the biscuit state for amateur home decorators (Barber 1901:89-90). The early ware was never signed and only a few marked examples of late ware have turned up.

After the sudden death of Albert Horatio in 1904, the firm continued under other management until plastic containers completely replaced redware flowerpots in the 1960s. Changing times, tastes, and technology had finally brought to an end the 200-year-old enterprise that began in a shed on a farm in eighteenth-century rural Weston.

To conclude, no serious study to help distinguish between the wares produced by the founders, Abraham I and Abraham II, has been carried out to date. The finding and analysis of the early Hews ledger and the deed and inventory evidence presented here are merely a first attempt at identifying the separate sites and distinguishing between the role played by the father as part-time potter-farmer of the late eighteenth century and the contribution made by Abraham Hews II in his successful full-time venture of the Federal period. These records not only reveal ways in which the pottery trade changed through four generations of the Hews family but they also provide insights into the marketing sphere, the functional nature, and the domestic importance of the Hews family's utilitarian redwares.

15
Chapter

The Pottery-Making Trade in Colonial Philadelphia: The Growth of an Early Urban Industry

Beth A. Bower

INTRODUCTION

Historical archaeologists rely heavily on the ceramic contents of their sites for chronological and functional information. Until recently, their attention focused on datable English ceramics rather than the often more numerous "undatable" sherds of redware. But since 1967, more study has been given to researching, identifying, and dating the American pottery found on archaeological sites.

This documentary study considers the social and economic context of pottery production and distribution in Philadelphia for the period 1685 to 1775. It is argued that this type of study is an important and necessary part of the historical archaeologist's attempt to refine the identification and dating of domestically produced ceramics. The present chapter presents a summary and interpretation of documentary evidence of the colonial Philadelphia pottery trade. It also illustrates that during the 90 years under study, from 1685 to 1775, pottery making in Philadelphia was gradually transformed into an industry made up of potters whose identity changed from that of craftsmen

catering to a local market to one of diversified entrepreneurs participating within a market covering the entire Eastern seaboard.

Documentary Research

Initial documentation of the names, locations, and products of Philadelphia colonial potters relied on early surveys of American potters and pottery by Barber (1901, 1907a, 1970), Clement (1943, 1946, 1947), Ramsay (1939), Spargo (1926), and Watkins (1950). Published collections of colonial advertisements by Dow (1927), Gottesman (1938), and Prime (1929) were also useful sources. Little has been written on Philadelphia potters in general (Bower 1975; Gillingham 1930; Myers 1980 are the exceptions). Ceramic historians have focused most of their attention on the Duché family (Giannini 1981; Hommel 1934–1935; Hood 1968; Leland 1882; Wells 1957) and on the Bonnin and Morris porcelain factory (Hood 1972).

Primary sources such as daybooks and collections of personal papers or letters have not yet been located for any of these Philadelphia potters. So, the documentary evidence presented in this paper is the result of piecing together clues from advertisements in the *Pennsylvania Gazette,* deeds, probate records, tax lists, scattered personal papers, and insurance surveys. These yield different types of information which taken together create a more complete picture of the pottery industry in the period under study. Newspaper advertisements and personal papers give information on the types of wares produced. Probate records, deeds, insurance surveys, private papers, and tax lists detail the potter's tools and the socioeconomic aspects of his trade. Indentures, advertisements for runaways, and tax lists provide information about the colonial work force. By using these several types of documents, the biases inherent in each type alone are minimized.

Archaeological Data

The present study was prompted by archaeological excavations at Franklin Court, the site of Benjamin Franklin's mansion (1763 to 1787), and Market Street tenements (ca. 1722 to 1787). Three privies, Features 9, 22, and 25, excavated behind the Market Street houses (Cosans 1975; Liggett 1973) held mid-eighteenth-century deposits that contained a large number of locally made wasters, kiln furniture, saggar fragments, and potting debris. After some deliberation and research, it was concluded that these potting remains were a secondary deposit (Cosans 1975). They could have been produced at any of a number of potteries producing domestic wares in Philadelphia during the colonial period (see Figure 15.1). While these sherds do not necessarily sig-

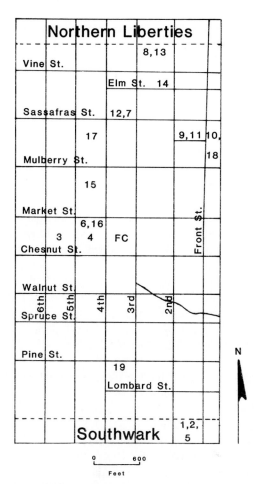

Figure 15.1 Location of colonial period Philadelphia potteries: 1, Alexander Bartram; 2, Bonnin and Morris Porcelain Factory; 3, William and John Crews; 4, Anthony Duché and Sons; 5, Anthony Duché, Jr.; 6, Jonathan Durell; 7, Matthias Gilbert; 8, George Peter Hillegas; 9, Michael Hillegas; 10, Edward Hughes; 11, Matthias Meyer; 12, Thomas Meyer, Jr.; 13, Christian Piercy; 14, Jacob Roat; 15, Richard, Valentine, and William Stanley/Standley; 16, Valentine Standley; 17, John Thompson; 18, Joshua Tittery; 19, William Young; FC, Franklin Court.

nify the work of a single potter, they do add to the documentary evidence by providing tangible examples of the products of Philadelphia potteries.

Of the locally made earthenwares identified at Franklin Court, 26.5% were identified as wasters, or vessels that were cracked, misshapen, fused to kiln supports, misfired, or improperly glazed (Cosans 1975, Vol. IV:45). The date range assigned to these locally made earthenware artifacts is 1730–1760

(Cosans 1975, Vol. III:26, 40). This date range spans two major periods of development in the Philadelphia pottery industry, the middle period and the late period. The selection of the three periods of development described below is based on each potter's period of work. These periods have been grouped into generations. For complete information on each potter see Bower (1975:46–124).

PHILADELPHIA POTTERY, 1685–1775

Early Period, 1685–1720

Potteries were started within the first 10 years of English settlement at Philadelphia. Seven individual potters, who appear to have operated only two separate potteries, were found in the records for the early period, 1685 to 1720. The earliest potter is William Crews of Southwark, Surrey, England, who bought land "for the making of potter's work" between Fifth and Sixth Streets north of Chestnut Street in 1688 (Gillingham 1930:102). When he died in 1695 he left his workhouse, toolhouse, and tools to his son, John Crews (*Philadelphia Registry of Wills* [PRW] 127). John Crews continued his father's work, at least for a short time (*Philadelphia Registry of Deeds* [PRD] I-6-170).

Another pottery was started by John Witt around 1690. He sold this pottery to Joshua Tittery, a glassmaker, in 1700 (PRD H-18-180). By 1700 Tittery also had an apprentice, Dennis Rochford, and was importing lead ore for glaze from London (Gillingham 1930:101). Tittery's will of 1709 indicates that his lead-glazed earthenware business had been quite prosperous, as he left an estate of £1479 (PRW 131). The pothouse was kept repaired after Tittery's death and was probably run by Edward Hughes, a potter, who rented a house from Tittery and later from his estate (PRW 131). Hughes died in 1721, and his estate inventory contains numerous parcels of "refuse earthenware" (PRW 223).

Dennis Rochford and his brother Solomon were both born in Philadelphia. They are listed as potters in 1714 (PRD H-7-61), but no other indication of their potting activity was found in the documentary records.

The scanty records for the potters in the early period indicate that at least three—William Crews, Joshua Tittery, and Edward Hughes—were full-time potters. Both Crews and Tittery were trained craftsmen and both trained apprentices, Crews, his son John, and Tittery, Dennis Rochford. This suggests that from the beginning pottery making in Philadelphia was practiced as a full-time business. Tittery's importation of lead ore from London also documents a seriousness of purpose present by 1700 (Gillingham 1930:101). Ear-

thenware is the only type of pottery mentioned in these documentary records, and form and decoration are not specified.

Middle Period, 1721–1750

During the middle period, dating from 1721 to 1750, the number of potters and pottery locations identified through documentary research expanded greatly. During this period, stoneware began to be produced in addition to earthenware. Three dynastic pottery families were founded, and Philadelphia potters started to market their products outside of Philadelphia.

One of the most important potters was Anthony Duché, the son of a French Huguenot immigrant, who came to Philadelphia from London with William Penn ca. 1700 (Giannini 1981). He is listed as a glover for his first 20 years in Philadelphia, but during the 1720s he started producing earthenware and began experimenting with the production of stoneware. In 1731, he and his four sons petitioned the Philadelphia Assembly for a stoneware monopoly (Pennsylvania Archives [PA] 1898:2047–2049). Although the petition was rejected, there is every indication that Duché continued to make stoneware behind his house on Chestnut Street until his death in 1762 (Figure 15.1). Examples of his stoneware pottery exist in the archaeological collections of the Independence National Historic Park (Giannini 1981). Duché not only had a pottery business with three apprentices but also ran a dyeing business and a dry goods store (Pennsylvania Gazette [PG] February 4, 1752; PRW 177).

Three of Duché's sons were also potters: Anthony Jr., James, and Andrew. Anthony Jr. moved to Wicacao (Southwark), south of Philadelphia, around 1739, where he is listed as a potter until his death in 1787 (PRD G-2-60; PRW 351). Andrew moved to South Carolina and then to Georgia in the late 1730s, where he experimented with making porcelain (Hood 1968:168–184) before retiring to Philadelphia around 1769. James was apprenticed to Isaac Parker, a potter in Charlestown, Massachusetts, to manufacture stoneware. He apparently succeeded, but only after importing a sloop load of clay from Philadelphia to Charlestown. James returned to Philadelphia in 1746 and died in 1749 (Watkins 1950:245–246).

Richard Stanley started a pottery behind his Market Street houses between Fourth and Fifth Streets in 1730. Stanley produced earthenware with the help of his brother, Valentine Standley, his nephew William, various servants, and five African slaves. Stanley also owned a dry goods shop and was co-owner of two 60-ton sloops.

Michael Hillegas, a French Huguenot, arrived in Philadelphia from Germany in 1727 (Minnich 1894–1895:85–89). His pottery was probably on Gilbert's (later Elfreth's) alley, where he mortgaged a lot with a pot house

and a potter's kiln in 1729 (PRD F-4-534). There is no other documentation of his potting activities except that he called himself a potter in almost every legal document and advertisement found for him. Hillegas owned 22 tracts of land at the time of his death, including an inn and a gristmill (*Philadelphia Orphan's Court Records* [POC] 4:14). Michael Hillegas's brother, George Peter, had a pottery at his farm in the Northern Liberties until his death in 1746 (POC 2:171-175).

John Rogers, an English potter, worked in Philadelphia from 1725-1727. He married Deborah Read, who later became Benjamin Franklin's common-law wife. Rogers fled Philadelphia in 1727 because of debts and suspicion that he was a bigamist (Labaree 1972:296). Samuel Hale, potter, appears in the documentary record from 1729 to 1756. He had at least one apprentice, but no records have been found to indicate the location of his pottery (PG June 14, 1734). Thomas Meyer is also listed as a potter, from 1736 to 1757. Little is known of his activity, although he apparently trained his son, Thomas Meyer, Jr., who owned a pottery later in the century (PRD I-7-305).

Late Period, 1751-1775

The greater number of records postdating 1750 has enlarged the quantity and quality of the information available for late period Philadelphia potters. The increase in the actual number of documented potters and potteries in existence is also due to Philadelphia's ascendancy as the largest British port in North America (Nash 1979:178-179). Beginning in the 1740s, immigration and rapid population growth resulted in an increased demand for earthenware and stoneware pottery, both for the city of Philadelphia and for inland settlements in Pennsylvania and New Jersey. This demand was met by a greater number of potters.

Some potteries started during the middle period were continued by later generations. Richard Stanley's pottery, for example, was continued by his nephew William until 1807. According to the tax lists of 1769 and 1774 in the *Archives of the City and County of Philadelphia,* the Stanley/Standley family potteries were the most prosperous for their period (*Philadelphia County Tax Assessment Ledgers* [PCT] 1769, 1774). William Standley supplied earthenware to his local customers, the colonial government, shopkeepers, and ship's captains (PG August 1, 1751, May 1, 1760, June 7, 1785; PRD G-10-45). William also had a store and a county seat in Richmond County called "Point-no-Point" (Parsons 1893:84). William's uncle, Valentine Standley, also operated an earthenware pottery. When he died in 1781, Valentine also owned a brewery and was part owner in several ships which traded with the West Indies (*Pennsylvania Magazine of History and Biography*

[PMHB] 1902:129; PRW 150). The Standleys were well enough established that other potters, such as James Clulow and his son Thomas, were associated with them (PG April 5, 1749; POC 6:128).

Two other potters seem to have been well off. John Thompson, who owned a house and pot house on the west side of Fourth Street between Mulberry and Sassafras Streets, is listed in the records between 1769 and 1774 (PCT 1769, 1774). An insurance survey of his house in 1772 indicates that he was a well-to-do craftsman (*Philadelphia Contributionship Surveys* [PCS] 1555). Alexander Bartram arrived in Philadelphia sometime before 1765 and located his pottery business on Second Street, next door to Anthony Duché, Jr. He had a shop on Market Street and was part owner of stores in Nova Scotia and in Paxton, Pennsylvania. Bartram produced "Pennsylvania penciled teapots, bowls, and sugar dishes" (Historical Society of Pennsylvania Manuscript Collections [HSP] 1644-1884, Vol. V:342; PG April 2, 1767; PMHB 1889:254), and probably catered to a middle- and upper-class clientele.

Other potters began their businesses during the late period. These businesses appear to have been successful, though for the most part less lucrative. Jonathan Durell had a pottery in Petty's Alley from ca. 1744 to 1769, when he moved to New York City and opened a pottery that produced Philadelphia earthenware (Gottesman 1938:84-85). Henry Gilbert had a house and pot house on the west side of Third Street between Sassafras and Vine Streets between 1769 and 1774 (PCT 1769; PCS 1557). William Young owned a house and pot house from 1756 to 1788 on Lombard Street between Third and Fourth Streets (PCS 351; PCT 1769, 1774). Three potteries were identified as being owned by German immigrants: Matthias Meyer, ca. 1750-1775 (PRW 123; Prime 1929:124-125); Jacob Roat, ca. 1739-1777 (PRW 137); and Jacob Utteree/Udery, ca. 1745-1774 (Gillingham 1930:106; PCT 1769, 1774). Interestingly, Meyer's will indicates that he did not own his pottery, though he owned all of the tools of his trade (PRW 123). Another potter, John Snowden, rented the land for his pottery in North Ward between 1769 and 1774 (PCT 1769, 1774). Christian Piercy bought land in the Northern Liberties from Michael Hillegas in 1764 and took an apprentice (Gillingham 1930:114). Tax lists of 1756, 1769, and 1774 identify Henry Brunner, Anthony Elton, George Looker, Benjamin Pollard, Peter Smith, Peter Bennett, Matthias Gilbert, Thomas Jackson, and Daniel Topham as potters with small assessments, indicating that they were not master potters at this time (PCT 1769, 1774).

Thus, during the late period, the number of potters operating in and around Philadelphia increased. These individual and family potters produced both earthenware and stoneware. Of these potters, those that were most successful were either engaged in other mercantile businesses or able to partic-

ipate in a larger marketing sphere than encompassed by Philadelphia alone. Toward the close of the late period, a group of unrelated potters was found to operate the Bonnin and Morris porcelain factory, thus serving as a harbinger of mass-production and industrial techniques that would become commonplace in later decades (Myers 1980).

SOCIOECONOMIC CONTEXT OF THE POTTERY TRADE

Organization of Labor

Analysis of documentary sources suggests that the general organization of labor in the Philadelphia potteries followed English tradition (Wetherill 1971:96-101) but added unique colonial elements. The major colonial element was an apparent lack of restrictions on who practiced a trade. No serious attempt was made to set up guilds to regulate membership in the trade. Philadelphia city officials tried to control who practiced a trade and the quality of the products in 1715 by resolving that only admitted freemen of the city could "keep open shops, or be master workmen" (Minutes of the Common Council [MCC] 1847:34). The trades were therefore authorized to incorporate themselves after the manner of English guilds. This resolution was not adopted by potters, for only the cordwainers, tailors, and carpenters incorporated themselves (Bridenbaugh 1950:144). As a result, city officials had no way of regulating the trades unless the craftsmen wanted to be regulated. Consequently, products were produced according to demand, and persons were hired or apprenticed according to the availability and need for labor, not according to the formal direction of a guild. Even the cordwainers and carpenters who formed their organizations only succeeded in setting prices for their work, not in regulating their membership (Warner 1968:8). Unlike such trades in England, membership was particularly difficult to control. In 1718, for example, a resolution was passed that "notwithstanding tradesmen took out their freedom, strangers came in, settled and practiced their trades without being freemen" (Sharf and Wescott 1884, Vol. I:199f). What this meant for those involved in the pottery trade was that anyone with capital and materials could pot.

A second major colonial element was the diverse and ever-present labor source. As in England, apprentices were bound to potters for a certain number of years with the purpose of learning a skill. Scattered bonds of apprenticeship and advertisements for runaways show that six potters owned the times of nine apprentices from 1698 to 1774. The potters were Anthony Duché, Sr. (3), Jonathan Durell (2), Matthias Gilbert (1), Christian Piercy (1), Joshua Tittery (1), and Jacob Udery (1) (Gillingham 1930:101, 106,

114; HSP 1745-1746:March 12, 1745; October 5, 1745; PMHB 1910:117; PRW 177). This is probably but a fraction of the total number of apprentices bound to potters in Philadelphia because only bonds for scattered years were found. Apprentices' agreements often were very general in the colonies and seem to have continued that way throughout the eighteenth century, with no specialization of skills apparent, as in the following example:

> James Thomson late of New Brunswick in the province of East [Jersey] bind himself as apprentice to Jonathan Durell of Philadelphia, Potter, to learn the art and mystery of potter . . . for five years from 10 September 1745. And have two quarters of your night schooling and at the expiration of the said term to have two suits of apparel one which of to be new. (HSP October 5, 1745)

In Philadelphia not only were apprentices available but indentured servants and slaves were used. These two additional labor sources provided cheap labor with no obligation to pass on skills. Many emigrants willingly indentured themselves to a ship's master or an agent in order to acquire passage to Philadelphia, known as a land of opportunity (Nash 1979:103). When the ship arrived in port, their skills were advertised and their indenture sold to colonists looking for servants, craftsmen, and laborers (Herrick 1926:73). Here, for example, is such a contract:

> Nathaniel Amber assigns Miles Ashe a servant from Ireland in the Snow George himself Master to Jonathan Durell, Philadelphia, Potter and his assigns for seven years from August 2, 1746. Cost £16. (HSP August 12, 1746)

From 1731-1774 six potters were found to have seven indentured servants. They were William Standley (2), Jonathan Durell (1), Samuel Hale (1), Michael Hillegas (1), Richard Stanley (1), and Valentine Standley (1) (HSP October 2, 1746, August 12, 1746; PCT 1769, 1774; PG June 30, 1734, July 1, 1731; PMHB 1910:117). Again, this is probably only a fraction of the indentured servants owned by potters during this period, but the lack of bond records limits further documentation.

Four Philadelphia potters owned 11 black slaves: Michael Hillegas (1), Richard Stanley (5), Valentine Standley (1), and William Standley (4) (Gillingham 1930; PCT 1769, 1774; PRW 222). This was the cheapest form of labor for the potters, since they owned the labor and could pass it on to later generations. Richard Stanley's will suggests that the five African slaves he owned were involved with his pottery business (PRW 222). It is tempting to assume that the slaves would have done most of the menial labor at the potteries, but the possibility exists that in some potteries "Philadelphia earthenware" may have been manufactured by African slaves.

No information on journeymen or craftsmen appeared in the records studied. With a constant source of cheap labor in the form of apprentices, indentured servants, and slaves, the journeyman status may not have been

institutionalized in the colonies as it was in England. Bridenbaugh suggests that the cost of keeping a journeyman was high (Bridenbaugh 1950:129), and this could have discouraged masters from using them in Philadelphia.

Technology

Information on potting technology was the most difficult to obtain from documentary sources, and no pottery manufacturing features or potter's tools were found during the Franklin Court archaeological excavations. Probate records, tax lists, and scattered personal papers supplied all of the information found. Two essentials for a pottery-making operation were the workhouse or pothouse in which to make the pots and the kiln in which to fire them. A kiln could be built into the pothouse or it could be constructed as a separate building. The Philadelphia tax lists of 1769 and 1774 simply listed a "pot-house," suggesting that in Philadelphia the kiln was incorporated into the pothouse. However, deeds, probate records, and advertisements, which often are more descriptive, offered additional information for a few potters. The records of Valentine Standley, Richard Stanley, Anthony Duché, Joshua Tittery, and Michael Hillegas all refer to either a pot-kiln, kiln house, or kiln. Consequently, both methods of construction appear to have been used in Philadelphia (Gillingham 1930:109, PG February 4, 1752; PRW 131, 222; PRD F-4-534).

Probate records of eight potters mentioned business-related items: potter's wheels (4), clay mills with traces for a horse (4), potter's tools (3), potboards (2), a maul and wedges (1), and a glaze mill (1) (PRW 123, 37, 222, 177, 223, 127, 131; POC, Bk. 2:171-175). The lead used for glazing was probably imported from England, as an order in 1700 to England by Isaac Norris for Joshua Tittery indicates:

> J. T. for whom I write for ye lead oare has it all and I expect 20 shipping per cwt for it. If any Vessels come hither this fall please to send half tun more for another potter who has engaged to take it. (Gillingham 1930:101)

Red lead, litherage, magnus (manganese), and lead ore are specific types of lead mentioned in the probate records. Many potters also sold the lead for other businesses.

An aspect of the potting operation for which we have no direct evidence is the potters' source of clay. Clay was listed in inventories of three potters: Richard Stanley, Anthony Duché, and Jacob Roat (PRW 222, 123, 137). Deposits of clay occurring naturally in and around Philadelphia were of good quality for potting redware vessels, if cleaned and bludgeoned (Ries and Leighton 1909). Before 1720, most of the brickmaking establishments of the

city were located to the north and west (Gillingham 1929:1-29). Close ties existed between potters, brickmakers, and clay pipe makers, for they witnessed each other's wills, deeds, and indentures and intermarried. It is probable that these closely allied professions owned rights or made agreements to dig clay in and around the city limits. One indication of this practice is the petition of Daniel Topham, potter:

> The Priveledge of Digging clay for the purpose of making bricks and Potter's Ware on a Certain Lot Situate on the North Side of Race Streets, and between Tenth and Eleventh Streets in the City. . . . He is the more emboldened to ask, and hopes to be granted this priviledge, as the said Ground has been occupied and used for the said purpose for Thirty years past is now unoccupied and he thinks will be of publick Utility; Bricks being very Scarce and much wanted. (*Records of the Supreme Executive Council,* April 4, 1780)

It is clear that Anthony Duché had a source of clay which was more plastic and could be mixed with the local clays, thereby withstanding the high temperatures of stoneware firing. This clay was later exported to Charlestown, Massachusetts Bay, for use by his son, James Duché, in his efforts to make stoneware at the Parker pottery (Watkins 1950:245-246). White residual clays and kaolin were available in Delaware and Chester counties in Pennsylvania and were probably used by clay tobacco pipe makers and by Philadelphia potters for white slip decoration. These clays also may have been used by Bonnin and Morris for making porcelain (see Hood 1972).

Market

The ability of Philadelphia's pottery trade to expand and support so many operations suggests that there was an ever-increasing market for their products. Colonial newspaper advertisements indicate that the pottery made in colonial Philadelphia was marketed on three levels: local, regional, and colonial. Philadelphia and the neighboring areas of New Jersey (then West Jersey) and Delaware constituted the local market, which, until the 1730s, was probably the area primarily served by Philadelphia potters. With the growth of the city and the inland migration of settlers, the marketing sphere expanded. By mid-century, Philadelphia served as "the chief center for organizing the external trade of Pennsylvania and adjacent areas" (Lemon 1967:507). Back-country traders and farmers brought in fur and produce to trade for import items and necessities. Even though colonization proceeded rapidly after 1720, the new settlers had to rely on the trading post or country store for many commodities, since the inland migration of craftsmen lagged

behind the influx of farmers. One man advertised land near Bordentown, New Jersey, suitable for a potter.

> . . . also a fine country round it, which make a Great Consumption of Earthenware, which is now at this time obliged to sent to Philadelphia for ware, which makes it come high, and consequently would come 15 per cent lower here which would induce the Country to buy here. (PG June 28, 1764)

Advertisements for earthen pots of "the coarsest sort, such as commonly used in the country" (Prime 1929:126), suggest that different products were produced for the country trade. The Philadelphia potters also solicited orders from country storekeepers, as in the following advertisement:

> The subscriber has on hand . . . a large and general assortment of country made Earthen Ware, which he will sell for cash or short credit. Orders from country store keepers etc. will be gratefully complied with at the shortest notice, by their humble servant William Standley (Prime 1929:129)

Some potters also filled and solicited orders from ship's captains and the military (PA 1898). Another Philadelphia potter, Alexander Bartram, owned a store on what was then the frontier which he probably supplied with his earthenware (HSP 1644-1884, Vol. V:442).

Starting in the 1730s, the Philadelphia potters expanded their market to include colonies in New England and the South. The first indication that Philadelphia pottery was being exported from the Philadelphia region is in a petition of Isaac Parker, potter, of Charlestown, Massachusetts. In 1742 he asked the Massachusetts Assembly to subsidize his efforts to make stoneware, saying that "there are large quantities of said [stone] Ware imported into this province every year from New York, Philadelphia and Virginia," and that Boston merchants were losing money in these transactions (Watkins 1950:245). By 1756, newspaper advertisements in Rhode Island, New York, and Maryland advertised "Philadelphia earthenware," suggesting that the Philadelphia potter's product had become unique and distinguishable from other earthenwares produced in the colonies and Britain. Advertisements described it as "of the same kind as imported from Liverpool" (Prime 1929:112).

By the 1750s, potters in other colonial ports and towns started to advertise that they made "Philadelphia earthenware." A potter in Providence, Rhode Island, advertised in 1767 tht he had "Earthenware at a cheap rate, made in the best Manner and glazed in the Same Way as Practised in Philadelphia" (Watkins 1950:209). Some of these potters, like Jonathan Durell, may have been trained in Philadelphia and moved on to other cities. Durell was a potter in Philadelphia from about 1744 to 1770. By 1773 he had moved to New York and was advertising his "Philadelphia Earthenware," made "by the manufacturer late from Philadelphia" (Gottesman 1938:84-85).

PRODUCTS

During the colonial period, Philadelphia potters produced three ceramic wares: earthenware, stoneware, and porcelain. Earthenware production started in the 1680s and was the only ware produced during the early period. By the mid-eighteenth century, Philadelphia had developed into a major colonial ceramic production center, the majority of the production being of "Philadelphia earthenware." Anthony Duché and his sons began producing stoneware in the 1720s, during the middle period, and continued until the Revolution. Porcelain was produced in the late period for only a short period of time, being manufactured in 1769 by the Bonnin and Morris porcelain factory.

The following discussion describes the range of Philadelphia products, when they were produced, and their appearance and is based on documentary research and artifact analysis. The documentary evidence is primarily from advertisements in late period of colonial newspapers from 1750-1780. The archaeological evidence was excavated at the Franklin Court site and analyzed by Elizabeth Cosans (1975).

Earthenware

Throughout the colonial period the primary product of Philadelphia's potteries was earthenware. Advertised in New England and the South as "Philadelphia earthenware," it is apparent that by the 1750s the Philadelphia potters had developed a distinctive product. Little specific documentary information is available on the vessel types and forms produced by early period potters. There is no evidence to indicate that they produced anything but coarse earthenwares for a market in and around Philadelphia. Their earthenware was probably red bodied, resembling English coarse earthenwares of the period. Much of it was probably lead glazed (Gillingham 1930:101). No archaeological evidence from this time period was analyzed for this discussion.

With the rapid growth of Philadelphia and its hinterland, demand increased for cheap locally made goods, such as coarse earthenwares. During the middle period, Philadelphia potters seem to have realized that they could meet this demand with a better-than-average product known as "Philadelphia earthenware," a general class of ware of varied forms and colors (Gottesman 1938:84-85). This product was red bodied with a lead glaze. A wide range of shapes and forms were produced. Table 15.1 lists the vessel forms found in various advertisements for Philadelphia earthenware and in a bill of sale

Table 15.1

Vessel Forms of Philadelphia Earthenware from Documentary Sources

Butter pots[a]	Colored dishes[a]
Water pots	Pudding pans (2 sizes)
Pickle pots	Wash basins
Oyster pots	Sauce pans
Porringers[a]	Pitchers
Milkpans (3 sizes)[a]	Churning pots
Jugs[a]	Painted dishes[a]
Open-mouth jugs	Plates[a]
Chamber pots[a]	Sugar pots with lids
Quart and pint mugs	Skillets[a]
Quart, pint, and half-pint bowls[a]	Pipkins[a]
Dishes (4 sizes)[a]	Tankards[a]
Striped dishes[a]	

[a]Found at Franklin Court.

of Valentine Standley (HSP 1748–1887). Forms identified at the Franklin Court site are noted. The amount of glaze on a pot, the color of the glaze, and the type of decoration, if any, depended on the vessel form. Table 15.2 is a summary of the vessel forms and their glaze and decorative attributes (Cosans 1975, Vol. IV, VI).

Table ware forms are the dominant functional category and (with only one exception) are the only slip-decorated forms. Combed, marbled, trailed, coated, sponged, and swirled white slip decorations occur on some or all table ware forms except porringers and tankards (Figure 15.2). Slip-trailed motifs such as birds or a leaf and flower appear only on bowls and plates. Only slip-decorated bowls have sgraffito decoration. All table ware forms were also found as plain-glazed vessels. The food preparation and storage forms are much plainer, probably due to their utilitarian purposes. Tooling and incising rarely occur on slipwares and appear most frequently on vessels for which no slip-decorated examples were found, such as tankards, butter pots, milkpans, porringers, jugs, and pipkins (Figure 15.3).

Both plain and slip-decorated bowls were found with an oriental shape, suggesting that Philadelphia potters were imitating imported mid-eighteenth-century forms. A few other fragments of locally made earthenware recovered from the three privies also suggest that Philadelphia potters were trying to make more refined vessels than ordinary kitchenwares. Several earthenware tea bowls, an earthenware saucer, a punch pot or coffee pot decorated with slip, and a small milk jug were found (Cosans 1975, Vol. VI). Experimentation with clays is evident as the bodies of two bowls and a tankard are made of red-and-cream agate bodies (Cosans 1975, Vol. VI). One of these vessels is a waster and the other two are underfired, suggesting that at least at first

Table 15.2
Attributes of Franklin Court Site Vessel Forms

Function/Form		Plain glazed wares		Slipwares	
		Plain	Tooling/Incising	Plain	Tooling/Incising
Tableware					
bowls	64	18	2	44	0
dishes	26	13	3	10	0
porringers	24	16	8	0	0
tankards	32	8	24	0	0
plates	15	2	0	13	0
platters	06	1	1	3	1
	167 (64.2%)				
Food Preparation and Storage					
butterpots	42	28	14	0	0
milkpans	04	0	4	0	0
jugs	16	10	5	1	0
jars	02	2	0	0	0
pipkins/skillets	08	6	2	0	0
	72 (27.7%)				
Hygienic					
chamber pot	21 (8.1%)	6	15	0	0
	260	110	78	71	1
		188 (72.3%)		72 (27.7%)	

the experimentation was not very successful. Two white- or buff-bodied tankard wasters were found which are similar in form to locally made redware examples (Cosans 1975, Vol. V). These sherds suggest that Philadelphia potters may also have been trying to imitate popular buff- or cream-bodied English wares.

Stoneware

In Philadelphia, Anthony Duché and his sons began stoneware manufacture in the late 1720s. Although no other Philadelphia potters were documented as stoneware manufacturers, the ware probably was being produced throughout the city. In 1770, a Rhode Island potter advertised that "having engaged two Workmen from New York and Philadelphia, he proposes shortly to Manufacture all kinds of Stone Ware in the Neatest and best manner"

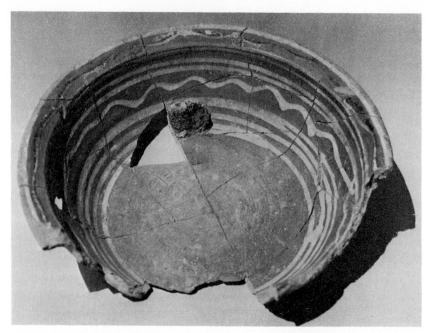

Figure 15.2 Redware dish with white slip-trailed decoration. Advertised as "striped dishes," these products were made in imitation of Liverpool earthenware, but with their own distinctive "Philadelphia" look. They were sold all along the Eastern seaboard (courtesy, Smithsonian Institution).

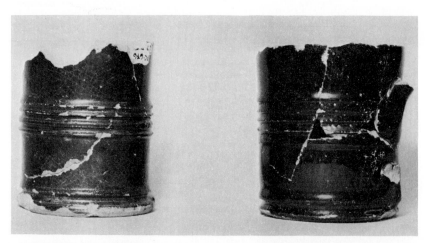

Figure 15.3 Black-glazed earthenware tankards excavated at Franklin Court in a 1730–1760 context. The vessel form and use of incising is modeled after English earthenware and stoneware tankards of the period, but with a "Philadelphia" body (courtesy, Independence National Historic Park).

(Teller 1968:573). Patrick M. Roberts, who visited Philadelphia in 1775, wrote, "They have made great advances in most of the British manufacture here, such as making kinds of hardware, clocks, watches, locks, guns, flints, glass, stoneware, nails, paper, cordage, cloth, etc. etc." (Bridenbaugh 1950:142–143).

The archaeological evidence for Duché's stoneware production has been documented by Giannini:

> Over the years various excavations around Independence Hall have unearthed some two thousand fragments of saggers and other kiln furniture and shards of the bases, rims and lids of stoneware vessels that can be tentatively attributed to Anthony Duché. Three of the shards bear the cipher AD in cartouche. In 1977 a group (Daniel Crozier, Temple University) working near Chestnut Street found large fragments of four salt-glazed stoneware chamber pots also marked by Duché and about the same time the archaeologists Barbara Liggett and Betty Cosans found a nearly complete chamber pot with the same mark in a privy at South Front Street. (1981:199)

Most of the vessels and sherds recovered have gray bodies, are salt-glazed, and bear blue decoration similar to Rhenish stoneware. The Franklin Court collection contains 18 vessels identified as locally made stonewares, primarily tall jugs, tankards, and chamber pots (Cosans 1975, Vol. IV:43, 60) (see Figure 15.4). Two cream-colored, salt-glazed tankards, tentatively attributed as local, were also found at Franklin Court (Giannini 1981:201). Also, a portion of a salt-glazed stoneware tankard marked with "AD" in cartouche has been found. This vessel looks identical to English brown stoneware mugs made in London, Bristol, and elsewhere in the eighteenth century (Giannini 1981:199). It is clear that Duché imitated English forms and experimented with many styles.

Porcelain

In 1769, Gousse Bonnin and Anthony Morris started the first American porcelain factory in the Southwark section of Philadelphia. This venture has been well documented by Hood (1972). After raising capital and experimenting, the manufactory began producing porcelain in 1770. It quickly experienced the ups and downs of a new and experimental manufactory. English potteries, wary of colonial competition for skilled workers and the colonial market, quickly flooded the market with china. The factory closed shortly thereafter in 1772. Its product could not compete in quality or price with the Chinese and English imports.

What is most significant about this venture is that Bonnin and Morris felt that they could marshal the labor force expertise and materials needed for a porcelain manufactory in colonial Philadelphia. There is no indication that

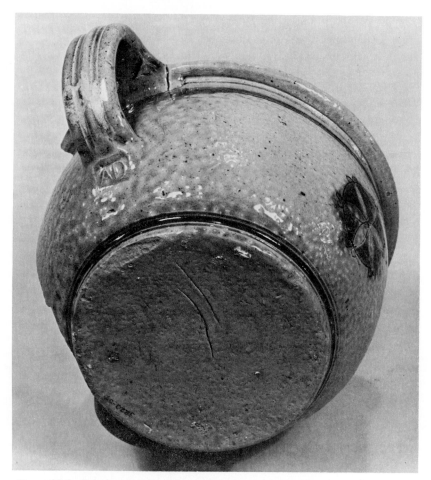

Figure 15.4 Salt-glazed stoneware chamber pot made by Anthony Duché, Sr., Philadel-
phia, 1730-1750. Note that the vessel is marked below the handle with "AD" in cartouche.
Made in imitation of popular German Westerwald stoneware products, the Duché wares differ
slightly in that Duché did not use a template to smooth the body of his vessels before glazing
(Giannini 1981:198). The Duché pots probably were exported throughout the British colonies
(courtesy, Independence National Historic Park).

either Bonnin or Morris had any training as a potter. This was solely a com-
mercial venture for both of them. They were able to lure some of Wedg-
wood's workers from England, but some expertise and vision on the local
level must have been present to convince them that porcelain could be pro-
duced in the area. Alexander Bartram and Anthony Duché, Jr., potters who
lived and worked near the factory, may have provided that expertise. Most

coincidental of all is the fact that Andrew Duché, who had conducted porcelain experiments in Georgia, moved from his home in Virginia to Philadelphia in 1769 just as the venture began (Wells 1957). However, no documentary evidence is known that directly connects the porcelain manufactory with these or any other Philadelphia potters.

No Bonnin and Morris porcelain sherds were found during the Franklin Court excavation. However, Dr. John Cotter and his students excavated the site of the pottery in 1967–1968 and uncovered pottery, chiefly saggar and waster fragments. The porcelain found included glazed and unglazed fragments, transfer-printed scenes, painted designs and numerous footrings, saucer fragments, bowl rims, and portions of molded ware (Cotter and Orr 1975:5–6; Hood 1972:34–45). In addition, scattered pieces of Bonnin and Morris porcelain have been found during archaeological excavations around Philadelphia (Giannini, personal communication, 1983).

CONCLUSION

To conclude, pottery making in Philadelphia began around 1685 and changed considerably during the subsequent 90 years considered here. During the early period (1685–1720), a small number of individual craftsmen worked full time to supply a local market with redwares. The number of Philadelphia potters increased during the middle period (1721–1750) to meet the demands of a rapidly increasing population. Families of potters began to produce stoneware as well as earthenware, and their high-quality products soon were being marketed outside of Philadelphia. During the late period (1751–1775), Philadelphia potters regularly supplied the local market with "Philadelphia earthenware" and stoneware. Several innovative potters and businessmen also succeeded in making porcelain toward the end of this period. But only a few potters, who participated in other mercantile ventures, grew wealthy. These entrepreneurs were able to supply a larger marketing sphere, encompassing most of the Eastern seaboard, with the popular Philadelphia wares.

Research in documentary sources such as newspapers, probate records, deeds, tax lists, insurance surveys, indentures, and private papers has provided a quantity of information on Philadelphia's colonial potters. The documents provide information on who potters were, where they lived and worked, what they made, their wealth, their marketing spheres, and their other occupations. The documents were least illuminating on the potters' methods of potting, the actual appearances and sizes of the products, and the sources of raw materials. Some of these gaps in information were filled by Cosans's analysis (1975) of locally made earthenwares and stonewares

recovered during archaeological excavations of the Franklin Court site. These artifacts indicated the existence of a local potting tradition, and documentary research has outlined the scope and nature of the industry.

The locally made earthenware artifacts excavated from the three features at Franklin Court have been dated by context to the period 1730 to 1760. Documentary sources suggest that during this period "Philadelphia earthenware" became a marketable export item for Philadelphia's potters. The evidence from advertisements in colonial newspapers along the Eastern seaboard indicates that Philadelphia earthenware and stoneware was exported to many areas. "Philadelphia earthenware" and stoneware may be a component of archaeological collections from these areas as well as from inland Pennsylvania and New Jersey sites. Further complementary archaeological and historical research should center around the way forms and functions changed over the three periods, how the potteries evolved toward mass production and larger regional markets, and the differentiation of ethnic or family styles.

Bibliography

Amsden, Grace P.
 1950 A capital for New Hampshire. Ms. on file, Concord, NH: New Hampshire Historical Society.

Archdeacon, Thomas J.
 1976 *New York City, 1664-1710, conquest and change.* Ithaca, NY: Cornell University Press.

Baart, Jan, Wiard Krook, Ab Lagerweij, Nina Ockers, Hans van Regteren Altena, Tuuk Stam, Henk Stoepker, Gerard Stouthart, and Monika van der Zwan
 1977 *Opgravingen in Amsterdam.* Haarlem, The Netherlands: Fibula-Van Dishoek.

Bailyn, Bernard
 1955 *The New England merchants in the seventeenth century.* Cambridge, MA: Harvard University Press.

Baker, Vernon G.
 1978 Historical archaeology at Black Lucy's Garden, Andover, Massachusetts: ceramics from the site of a nineteenth-century Afro-American. *Papers of the Robert S. Peabody Foundation for Archaeology* 8:110-121.
 1980a Archaeological overview and evaluation, Minute Man National Historical Park, Massachusetts. *Cultural Resource Management Studies* No. 2. Boston, MA: National Park Service.
 1980b Archaeological visibility of Afro-American culture: an example from Black Lucy's Garden, Andover, Mass. In *Archaeological perspectives on ethnicity in America,* edited by Robert L. Schuyler, pp. 29-37. New York: Baywood.

Banino, George M.
 1969 *Origin of Roaring Brook.* Trenton, NJ: Bureau of Geology and Topography, State of New Jersey Department of Conservation and Economic Development.

Barber, Daniel M., and George R. Hamell
 1971 The redware pottery factory of Alvin Wilcox—at mid-nineteenth century. *Historical Archaeology* 5:18-37.
 1974 *Clay in the hands of the potter: an exhibition of pottery manufactured in the Rochester and Genesee Valley Region, ca. 1793-1900.* Rochester, NY: The Rochester Museum and Science Center.

Barber, Edwin A.
 1901 *The pottery and porcelain of the United States* (second ed.). New York: Putnam.
 1907a *Lead-glazed pottery.* Philadelphia: Pennsylvania Museum.
 1907b *Salt-glazed stoneware.* New York: Doubleday, Page.
 1907c *Tin-enamelled pottery.* New York: Doubleday, Page.
 1926 *Tulipware of the Pennsylvania-German potters* (second ed.). Philadelphia: Pennsylvania Museum.
 1970 *Tulipware of the Pennsylvania Germans: an historical sketch of the art of slip decoration in the United States* (republication of the second [1926] edition). New York: Dover Books.

Barka, Norman F.
 1973 The kiln and ceramics of the "poor potter" of Yorktown: a preliminary report. In

Ceramics in America, edited by Ian M. G. Quimby, pp. 291-318. Charlottesville, VA: University Press of Virginia.

Barka, Norman F., and Chris Sheridan
 1977 The Yorktown pottery industry, Yorktown, Virginia. *Northeast Historical Archaeology* 6(1-2):21-32.

Barka, Norman F., E. Ayres, and C. Sheridan
 1984 The "Poor Potter" of Yorktown (Vol. III)—Ceramics. *Yorktown Research Series No. 5.* Williamsburg, VA: College of William and Mary.

Barton, Kenneth J.
 1975 *Pottery in England.* South Brunswick, NJ: Barnes.
 1981 Coarse earthenwares from the Fortress of Louisburg. *History and Archaeology* 55:1-143.

Bascom, F., N. H. Darton, H. B. Kummel, W. B. Clark, B. L. Miller, and R. D. Salisbury
 1909 *Geologic atlas of New Jersey: Trenton folio.* Washington, DC: United States Geological Survey.

Bassett, Preston R.
 1965 The local potters of Long Island. *The Long Island Current* 1(1):5-14.

Batchelder, Grace E.
 1935 "Sourlands not the home of a decadent race" says resident. *Hunterdon County [NJ] Democrat,* 7 Mar. 1935.

Beaudry, Mary C.
 1978 Ceramics in York County, Virginia, inventories, 1730-1750: the tea service. *Conference on Historic Site Archaeology Papers, 1977* 12:201-210.
 1982 Northeast region research reports: New Hampshire, the Hazeltine Pottery site. *Newsletter, Society for Historical Archaeology* 15:36-37.

Beaudry, M. C., J. Long, H. M. Miller, F. D. Neiman, and G. W. Stone
 1983 A vessel typology for early Chesapeake ceramics: the Potomac Typological System. *Historical Archaeology* 17(1):18-43.

Beck, Henry C.
 1962 *The Jersey midlands.* New Brunswick, Canada: Rutgers University Press.

Beers, F. W.
 1873 *Atlas of Somerset County.* New York: Beers, Comstock & Cline.

Biographical Review Publishing Company
 1896 *Biographical review: the leading citizens of Litchfield County, Connecticut.* Boston, MA: Biographical Review.

Bishop, R. L., R. L. Rands, and G. R. Holley
 1982 Ceramic compositional analysis in archaeological perspective. In *Advances in archaeological method and theory* (Vol. V), edited by Michael B. Schiffer, pp. 275-330. New York: Academic Press.

Bivins, John F., Jr.
 1972 *The Moravian potters of North Carolina.* Chapel Hill, NC: University of North Carolina Press.

Blalock, Hubert
 1972 *Social statistics.* New York: McGraw-Hill.

Blood, Henry A.
 1860 *History of Temple, New Hampshire.* Boston, MA: Rand and Avery.

Bond, Henry
 1855 *Genealogies of early settlers of Watertown, Waltham, and Weston, Massachusetts* (Vol. I). Boston, MA: Little, Brown.

Bower, Beth A.
 1974 The potter and his trade in colonial Philadelphia, 1685-1775. Ms. on file, Department of Anthropology, Brown University, Providence, Rhode Island.

1975 The pottery-making trade in colonial Philadelphia: the growth of an early urban industry. Unpublished M. A. thesis, Department of Anthropology, Brown University, Providence, Rhode Island.

Bradford, William
1952 *Of Plymouth Plantation, 1620-1647*, edited by Samuel Eliot Morison. New York: Knopf.

Bradley, J. W., N. DePaoli, N. Seasholes, P. McDowell, G. Kelso, and J. Schoss
1983 The Bostonian Hotel site. *Occasional Publications in Archaeology and History* No. 2. Boston, MA: Massachusetts Historical Commission.

Bragdon, Kathleen
1981 Occupational differences reflected in material culture. *Northeast Historical Archaeology* 10:27-39.

Brain, Jeffrey P.
1979 *Tunica treasure.* Cambridge, MA: Peabody Museum, Harvard University.

Braudel, Fernand
1979 *The structures of everyday life.* New York: Harper and Row.

Branin, M. Lelyn
1978 *The early potters and potteries of Maine.* Middletown, CT: Wesleyan University Press.

Brears, Peter C. D.
1971 *The English country pottery: its history and techniques.* Devon, United Kingdom: David & Charles, Newton Abbot.

Brecknell, Ursula
1972 *Montgomery Township: an historic community 1702-1972.* Montgomery, NJ: Montgomery Township Bicentennial Committee.

Brennan, Louis A.
1980 Requa Farmstead. Ms. on file, Material Archives Laboratory for Archaeology (MALFA), Katonah, NY.
1982 A chronological glossary of eighteenth and nineteenth century ceramics of English and American manufacture for the historical Northeast. *Archaeology of Eastern North America* 10:118-148.

Bridenbaugh, Carl
1950 *The colonial craftman.* New York: New York University Press.
1961 *The colonial craftsman.* Chicago: University of Chicago Press.

Brongers, Georg A.
1964 *Nicotiana tabacum.* Groningen, The Netherlands: Theodorus Neimeyer.

Brooks, Hervey
1802- Account books, private papers and records. In *Brooks family collection, Litchfield,*
1873 *Connecticut, and the Old Sturbridge Village Research Library.* Sturbridge, MA: Old Sturbridge Village.
1858 *A History of South End Goshen, Connecticut.* Goshen, CT: John Norton Brooks, for the Goshen Tercentenary Committee, 1935.

Brown, Ephraim
1882 Lowell and Monadnocks. *Contributions of the Old Residents' Historical Association, Lowell, Massachusetts* II (2). Lowell, MA: Old Residents' Historical Association.

Brown, Marley R., III
1973 Ceramics from Plymouth, 1621-1800: the documentary record. In *Ceramics in America,* edited by Ian M. G. Quimby, pp. 41-74. Charlottesville, VA: University Press of Virginia.

Bugler, Caroline
1979 *Dutch painting.* New York: Mayflower Books.

Burr, Nelson R.
1976 *From colonial parish to modern suburb.* West Hartford, CT: Noah Webster Foundation.
Burrison, John A.
1975 Alkaline-glazed stoneware: a deep South pottery tradition. *Southern Folklore Quarterly* 39(4).
Caiger-Smith, Alan
1973 *Tin-glaze pottery in Europe and the Islamic world.* London: Faber.
Carlisle, Ronald C., and Joel Gunn
1977 Idiosyncratic behavior in the manufacture of handwrought nails. In *Research strategies in historical archaeology,* edited by Stanley A. South, pp. 287-305. New York: Academic Press.
Carmine, George, and Anthony Zeller
1978 Validity and reliability assessment. *Publications in Quantitative Analysis* No. 9. Beverly Hills, CA: Sage University Press.
Carr, Lois Green
1973 Ceramics from the John Hicks site, 1723-1743: The St. Mary's Town Land Community. In *Ceramics in America,* edited by Ian M. G. Quimby, pp. 75-102. Charlottesville, VA: University Press of Virginia.
1977 The uses of inventories: a warning. *Conference on Historic Site Archaeology Papers, 1976* 11:64-68.
Caywood, Louis R.
1955 *Excavations at Green Spring Plantation.* Yorktown, VA: Colonial National Historical Park, National Park Service.
Celoria, F. S. C., and J. H. Kelly
1973 A post-medieval pottery site with a kiln base found off Albion Square, Hanley, Stoke-on-Trent, Staffordshire, England. *City of Stoke-on-Trent Museum Archaeological Society Report No. 4.* Stoke-on-Trent, England.
Chace, Paul G.
1972 Ceramics in Plymouth Colony: an analysis of estate inventories, 1631-1675. *Occasional Papers in Old Colony Studies* 3:1-12.
Chappell, Edward A.
1975 Morgan Jones and Dennis White, country potters in seventeenth-century Virginia. *Virginia Cavalcade* 24(4): 148-155.
Clark, Daniel
1789- *Diary.* Ms. on file, New Hampshire Historical Society, Concord, NH.
1828
Clark, Victor S.
1916 *The history of manufactures in the United States, 1607-1860.* Washington, DC: The Carnegie Institution.
Clement, Arthur W.
1943 *Notes on American ceramics, 1607-1943.* Brooklyn, NY: Brooklyn Museum.
1946 *Notes on early American porcelain, 1738-1838.* New York: The Court Press.
1947 *Our pioneer potters.* New York: Maple Press.
Cohen, David
1981 How Dutch were the Dutch of New Netherland? *New York History* 62:43-59.
Cooper, Ronald G.
1968 *English slipware dishes, 1650-1850.* New York: Transatlantic Arts.
Copeland, Robert
1982 *Blue and white transfer-printed pottery.* Haverfordwest, England: Shire.
Cortes, F., A. Przeworski, and J. Sprague
1974 *Systems analysis for social scientists.* New York: Wiley.

Cosans, Elizabeth J.
1975 *Franklin Court IV final report* (Vols. I-VI). Philadelphia: Independence National
 Historical Park.
Cotter, John L.
1968 *A handbook for historical archaeology (Parts I and II)*. Wyncote, PA: J. L. Cotter,
 8125 Heacock Lane.
Cotter, John, and David Orr
1975 Historical archaeology of Philadelphia. *Historical Archaeology* 5:1-10.
Crofut, Florence S. M.
1937 *Guide to the history and the historic sites of Connecticut*. New Haven, CT: Yale
 University Press.
Crossman, Carl L.
1976 *A design catalogue of Chinese export porcelain for the American market, 1785-
 1840* (third printing). Salem, MA: Peabody Museum.
Cummings, Abbott Lowell
1964 *Rural household inventories, 1675-1775*. Boston, MA: The Society for the Pres-
 ervation of New England Antiquities.
Cushion, John P.
1976 Pottery and porcelain tablewares. London: Studio Vista.
Dallal, Diane
1984 *English pipes to New Amsterdam, Dutch pipes to New York*. Paper presented at
 the Society for Historical Archaeology meetings, Williamsburg, Virginia.
Daniels, Bruce C.
1973 Defining economic classes in colonial New Hampshire, 1700-1770.
 Historical New Hampshire 28(1): 59-60.
de Brouard, M.
1974 Observations on the treatise of Eraclius, de coloribus et artibus romanorum. In
 Medieval pottery from excavations, edited by Vera Evison, H. Hodges, and J.
 Hurst. London: Baker.
Deetz, James J. F.
1967 *Invitation to archaeology*. New York: Doubleday.
1970 Archaeology as a social science. In *Current directions in anthropology, Bulletin of
 the American Anthropological Association* 3(3), Part 2:115-125.
1973 Ceramics from Plymouth, 1620-1835: the archaeological evidence. In *Ceramics
 in America*, edited by Ian M. G. Quimby, pp. 15-40. Charlottesville, VA: Uni-
 versity Press of Virginia.
1976 Black settlement at Plymouth. *Archaeology* 29:207.
1977 *In small things forgotten*. New York: Anchor Books.
Deetz, James J. F., and Edwin Dethlefsen
1965 The Doppler Effect and archaeology: a consideration of the spatial effects of ser-
 iation. *Southwestern Journal of Anthropology* 21(3):196-206.
de Kleyn, Tekst J.
1977 *Pot-Sierlijk: Versierd Volksaardewerk*. Arnhem, The Netherlands: Openluchtmu-
 seum.
Dempsey, Claire
1982 *Historic overview: Phase II archaeological site examination of the project area
 for the Central Artery, North Area, Charlestown, Massachusetts*. Cambridge,
 MA: Institute for Conservation Archaeology, Peabody Museum, Harvard Univer-
 sity.
Dow, George F.
1927 *The arts and crafts in New England, 1704-1775: gleanings from Boston news-
 papers*. Topsfield, MA: Wayside Press.

Durkheim, Emile
 1915 *The elementary forms of religious life* (translated by Joseph Ward Swain). London:
 Allen and Unwin.
Ferguson, Leland G.
 1977 An archaeological-historical analysis of Fort Watson: December 1780-April 1781.
 In *Research strategies in historical archaeology*, edited by Stanley A. South, pp.
 41-71. New York: Academic Press.
 1980 Looking for the "Afro" in Colono-Indian pottery. In *Archaeological perspectives
 on ethnicity in America*, edited by R. L. Schuyler, pp. 14-28. New York: Bay-
 wood.
Flint, William
 1927 The Millville Pottery, Concord, New Hampshire. *Old-Time New England*
 XVII(3):99-106.
Friedman, Jeffrey
 1978 Maintaining a functional woodfired kiln in the historic village. *National Endowment
 for the Humanities Internship Report*. Research Department, Old Sturbridge Vil-
 lage, Sturbridge, Massachusetts.
Giannini, Robert L., III
 1981 Anthony Duché, Sr., potter and merchant of Philadelphia. *Antiques* 119(1):198-
 203.
Gillingham, Harold E.
 1929 Our early brickmakers. *Pennsylvania Magazine of History and Biography*, 53:1-
 29.
 1930 Pottery, china, and glassmaking in colonial Philadelphia. *Pennsylvania Magazine
 of History and Biography* 54:97-129.
Glassie, Henry
 1968 *Patterns in the material folk culture of the eastern United States*. Philadelphia: Uni-
 versity of Pennsylvania Press.
 1972 *Folk housing in middle Virginia*. Knoxville, TN: University of Tennessee Press.
Godden, Jeffrey
 1963 *British pottery and porcelain, 1780-1850*. England: Barnes.
Goggin, John M.
 1949 Culture traditions in Florida prehistory. In *The Florida Indian and his neighbors*,
 edited by John W. Griffin, pp. 13-44. Papers delivered at an Anthropology Con-
 ference held at Rollins College, Winter Park, FL, April 9-10, 1949.
Goldscheider, Ludwig
 1958 *Vermeer* (complete edition). London: Phaidon Press.
Goodfriend, Joyce
 1975 *Too great a mixture of nations: the development of New York society in the sev-
 enteenth century*. Unpublished Ph.D. dissertation, University of California, Los
 Angeles.
Gorman, Frederick J. E.
 1982 Quality control of crucible technology in an eighteenth-century glass factory. In
 Historic technologies of North America, edited by Lester A. Ross. Cambridge, MA:
 MIT Press.
Gorman, Frederick J. E., and S. Terry Childs
 1981 Is Prudden's unit-type of Anasazi settlement valid and reliable? *North American
 Archaeologist* 3(2):1-31.
Gottesman, Rita Susswein
 1938 The arts and crafts in New York, 1726-1776. *New York Historical Society Col-
 lections* 69.

Grant, Alison
 1983 *North Devon pottery: the seventeenth century.* Exeter, England: University of Ex-
 eter.
Greer, Georgeanna H.
 1979 Basic forms of historic pottery kilns which may be encountered in the United States.
 Conference on Historic Site Archaeology Papers, 1978, 13:133-147.
 1981 *American stonewares, the art and craft of utilitarian potters.* Exton, PA: Schiffer.
Grousset, René
 1935 *The civilizations of the East, Volume 3: China.* New York: Knopf.
Guilland, Harold E.
 1971 *Early American folk pottery.* New York: Chilton.
Haacker, Frederick C. (transcriber)
 1951 *Philipsburgh Manor, New York: records of the Manor of Philipsburgh, Westchester
 County, New York.* Ms. on file, Westchester County Historical Society Library,
 Valhalla, NY.
Hall, William H.
 1930 *West Hartford.* Hartford, CT: James Reid.
Hamell, George R.
 1975 Review of "Folk Pottery of the Shenandoah Valley (Wiltshire)." *Antiques*
 108(6):1116-1117.
 1976 *A short bibliography relating to North American ceramic history and related sub-
 jects, c. 1635-1900.* Council for Northeast Historical Archaeology conference.
 1981 Earthenwares and salt-glazed stonewares of the Rochester-Genesee Valley region:
 an overview. *Northeast Historical Archaeology* 7, 8, 9:1-14.
Hammond, Martin
 1981 *Bricks and brickmaking.* Aylesbury, England: Shire.
Handsman, Russell
 1981a *The development of the center village, Goshen, Connecticut.* Typescript on file,
 American Indian Archaeological Institute, Washington, CT.
 1981b Early capitalism and the center village of Canaan, Connecticut: a study of trans-
 formations and separations. *Artifacts* 9(3):1-22.
Herman, Lynne L., John O. Smith, and Daniel Schecter
 1975 Ceramics in St. Mary's County, Maryland, during the 1840's: a socioeconomic
 study. *Conference on Historic Site Archaeology Papers, 1973* 8:52-93.
Herrick, Cheesman A.
 1926 *White servitude in Pennsylvania: indentured and redemption labor in colony and
 commonwealth.* Philadelphia: John Joseph McVey.
Hews, Abraham, I
 1780- *Abraham Hews' Book, Weston.* Manuscript ledger with missing and mutilated
 1810 pages. Cambridge, MA: Baker Business Library Archives, Harvard University.
Hewes, Robert
 1780 Hewes' Deed to Clark. *Deeds* 132(51). Boston, MA: Massachusetts State Ar-
 chives.
 1781a Petition to the Legislature of New Hampshire, 1 Jan. 1781. Concord, NH: New
 Hampshire State Archives.
 1781b Petition to the Legislature of New Hampshire, 27 Jan. 1781. Concord, NH: New
 Hampshire State Archives.
 1781c Petitions to the selectmen of Temple, New Hampshire, Mar. 11, 1781, and Mar.
 24, 1781. Temple, NH: Historical Society of Temple.
 1781d New England Glass-works advertisements. *Independent Chronicle and Universal
 Advertiser,* 17 May 1781, 24 May 1781, and 31 May 1781.

1781e New England Glass-works advertisements. *Boston Gazette and Country Journal*, 29 Oct. 1781, 5 Nov. 1781, and 19 Nov. 1781.

1782a Petition to the Legislature of Massachusetts, January 1782. *Petitions* 187:292-293. Boston, MA: Massachusetts State Archives.

1782b Petition to the Legislature of Massachusetts, May 1782. *Legislative Acts 1782*, Chapter 48. Boston, MA: Massachusetts State Archives.

Hibbard, A. G.
1897 *History of the town of Goshen, Connecticut.* Hartford, CT: Case, Lockwood, and Brainard.

Hillsborough Township Tax Ratables
1797- Boxes 106 and 107. Division of Archives and Records Management, New Jersey
1817 Depertment of State.

Historical Society of Pennsylvania Manuscript Collections
1644- Stauffer Collection, Vol. V. Philadelphia: Historical Society of Pennsylvania.
1884
1745- Servants and apprentices bound before Governor James Hamilton (individual dates
1746 noted). Philadelphia: Historical Society of Pennsylvania.
1748- Levi Hollingsworth Papers. Philadelphia: Historical Society of Pennsylvania.
1887

History of Litchfield County, Connecticut (HLC)
1881 Philadelphia: Lewis.

Hodgen, Margaret T.
1952 Change and history: a study of the dated distributions of technological innovations in England. *Viking Fund Publications in Anthropology*, No. 18. New York: Wenner-Gren Foundation for Anthropological Research.
1974 Anthropology, history, and cultural change. *Viking Fund Publications in Anthropology*, No. 52. Tucson, AZ: University of Arizona Press.

Hommel, Rudolf P.
1934- First porcelain making in America. *Chronicle of the Association of Early American*
1935 *Industries* I(8-11).

Hood, Graham
1968 The career of Andrew Duché. *Art Quarterly* 31:168-184.
1972 *Bonnin and Morris of Philadelphia: the first American porcelain factory, 1770-1772.* Chapel Hill, NC: University of North Carolina Press.

Hoover Presidential Library (HPL)
1983 Chinese porcelain exhibit. West Branch, Iowa.

Hudson, J. Paul, and C. Malcolm Watkins
1957 The earliest known English colonial pottery in America. *Antiques* 71(1):51-54.

Huey, Paul R.
1981 Archaeological exploration of the Louw-Bogardus site, Kingston, New York. *The Bulletin and Journal of Archaeology for New York State* No. 82:4-24.

Hughes, George Bernard
1958 *English glass for the collector, 1660-1860.* New York: Macmillan.
1961 *English and Scottish earthenware, 1660-1860.* New York: Macmillan.

Hughes, Matthew
1860 *Farm map of Hillsboro.* Philadelphia: Wagner.

Hugo-Brunt, Michael
1961 Portsmouth: prototype of Canadian maritime settlement, II. *Plan: Journal of Town Planning* 2(2):58-74. Toronto.

Hunnewell, James F.
1888 *A century of town life: a history of Charlestown, Massachusetts, 1775-1887.* Boston, MA: Little, Brown.

Hunter, Richard
 1981 *Archaeologitecture at Glencairn: archaeological interpretation of standing build-ings.* Paper presented at the Council for Northeast Historical Archaeology meetings, East Granby, Connecticut.
 1982 *The history and archaeology of the Trenton potteries.* Paper presented at the Society for Historical Archaeology meetings, Philadelphia, Pennsylvania.

Hunterdon County Deeds
 1822 Deeds, Vol. 34. Hunterdon County Courthouse, Flemington, NJ.

Hutchinson, Sandra J., and Dennis L. Wentworth
 1981 Archaeological test excavations at the Canal Store, Schoharie Crossing State Historic Site, located in the town of Florida, Montgomery County, New York. *The Bulletin and Journal of Archaeology for New York State,* No. 82:46-58.

Ingersoll, Daniel, J. E. Yellen, and W. McDonald
 1977 *Experimental archaeology.* New York: Columbia University Press.

Jelks, Edward B.
 1958 Ceramics from Jamestown. Appendix A to *Archaeological excavations at James-town, Virginia,* by John L. Cotter, pp. 201-212. Washington, DC: National Park Service (Archaeological Research Series, No. 4).

Jenkinson, Richard
 1981 Summary of the 1980 kiln firing season (typescript). Sturbridge, MA: Department of Interpretation, Old Sturbridge Village.

Kane, Electa
 1977a Ceramic analysis for computer coding: New England Glass-works, Temple, New Hampshire. Ms. on file, Department of Anthropology, Boston University, MA.
 1977b The cultural significance of historic ceramics: an introduction to the problem. Ms. on file, Department of Anthropology, Boston University, MA.
 1977c An introductory guide to American domestic site ceramic analysis. Ms. on file, Department of Anthropology, Boston University, MA.

Kardas, Susan, and Edward Larrabee
 1978 Eighteenth century land fill in Manhattan: an archaeological analysis of tests in the Schermerhorn Row Block (typescript). Albany, NY: Historic Preservation, New York State Parks and Recreation.

Kelly, J. H., and S. J. Greaves
 1974 The excavation of a kiln base in Old Hall Street, Hanley, Stoke-on-Trent, Staffordshire, England. *City of Stoke-on-Trent Museum Archaeological Society Report* No. 6. Stoke-on-Trent, England.

Kelso, William M., and Edward A. Chappell
 1974 Excavation of a seventeenth-century pottery kiln at Glebe Harbor, Westmoreland County, Virginia. *Historical Archaeology* 8:53-63.

Ketchum, William C.
 1970 *Early potters and pottery of New York State.* New York: Funk and Wagnalls.
 1971 *The pottery and porcelain collectors' handbook: a guide to American ceramics from Maine to California.* New York: Funk and Wagnalls.

Kim, Sum Bok
 1978 *Landlord and tenant in colonial New York manorial society, 1664-1775.* Chapel Hill, NC: University of North Carolina Press.

Kindig, Joe, Jr.
 1935 A note on early North Carolina pottery. *Antiques* 27(1):14-15.

Kingery, W. D.
 1981 Plausible inferences from ceramic artifacts. *Journal of Field Archaeology* 8:457-467.

Kirkham, Wendell C.
 1976 *Soil survey of Somerset County, New Jersey.* Washington, DC: U.S. Government
 Printing Office.
Labaree, Leonard W., *et al.* (editors)
 1972 *The autobiography of Benjamin Franklin* (fourth printing). New Haven, CT: Yale
 University Press.
Lake, D. J., and S. N. Beers
 1860 *Map of the vicinity of Philadelphia and Trenton.* Philadelphia: Stone & Pomeroy.
Lamson, Col. Daniel S.
 1913 *History of the Town of Weston.* Boston, MA: Ellis.
Lamson, Everett C., Jr.
 1978 *The old Exeter pottery works.* Barre, VT: Modern Printing.
Langacker, Ronald W.
 1968 *Language and its structure: some fundamental linguistic concepts.* New York: Har-
 court, Brace, and World.
Langdon, George D., Jr.
 1966 *Pilgrim colony, a history of New Plymouth, 1620-1691.* New Haven, CT: Yale
 University Press.
Larkin, Jack
 1978 Interim center village report. Ms. on file, Department of Research, Old Sturbridge
 Village, Sturbridge, MA.
Lasansky, Jeanette
 1979 *Central Pennsylvania redware pottery, 1780-1904.* University Park, PA: Penn-
 sylvania State University Press.
Leland, Gus
 1882 The Duché family. *Our Ancestors* I(2). Philadelphia: Genealogical Association of
 Pennsylvania and New Jersey.
Lemon, James T.
 1967 Urbanization and the development of eighteenth century southeastern Pennsyl-
 vania. *William and Mary Quarterly* 24:502-542.
Lewis, Griselda
 1969 *Collector's history of English pottery.* New York: Viking Press.
Lewis, Kenneth E.
 1984 *The American frontier: an archaeological study of settlement pattern and process.*
 New York: Academic Press.
Lewis, Scott P.
 1984 A technological approach to archaeological ceramics: error analysis of kiln wasters.
 In *Forgotten places and things: archaeological perspectives on American history,*
 edited by Albert E. Ward. Albuquerque, NM: Center for Anthropological Study.
Liggett, Barbara
 1973 *Archaeology at Franklin's Court.* Harrisburg, PA: MacFarland.
Long, George A.
 1964 Excavations at Panama Vieja. *Florida Anthropologist* 17(2):104-109.
Lord, Albert B.
 1960 *Singer of tales.* Cambridge, MA: Harvard University Press.
Lyford, James O. (editor)
 1903 *History of Concord, New Hampshire.* Concord, NH: Rumford Press.
Lynn, Paul
 1969 *Hervey Brooks, Connecticut farmer-potter: a study of earthenware from his blot-
 ters, 1822-1860.* Unpublished M.A. thesis, Cooperstown Graduate Program, State
 University of New York, Oneonta.

MacFarlane, Janet R.
1951 Nathan Clark, potter. *Antiques* 60(1):42-44.

McKendrick, N., J. Brew, and J. H. Plumb
1982 *The birth of a consumer society.* London: Europa.

McKinley, Samuel J.
1931 The economic history of Portsmouth, New Hampshire, from its first settlement to 1830, including a study of price movements there, 1723-1770 and 1804-1830. Ph.D. dissertation, Harvard University.

McLaughlin, K. R.
1959a Index heads of families 1810 census, Greenburgh, Westchester County, New York 18:1116-1126. Ms. on file, Westchester County Historical Society, Valhalla, NY.
1959b Index heads of families 1810 census, Greenburgh, Westchester County, New York II: 231-249 Ms. on file, Westchester County Historical Society, Valhalla, NY.

Main, Gloria L.
1975 Probate records as a source for early American history. *William and Mary Quarterly* 32(1):89-99.

Massachusetts Archives (State House, Boston, MA)
1742 Volume 59, pp. 332-333a, 347-349, 415-417.

Matson, Frederick R. (editor)
1965 *Ceramics and man.* Chicago: Aldine.
1981 Archaeological ceramics and the physical sciences: problem definition and results. *Journal of Field Archaeology* 8:447-456.

Mellor, J. W.
1935 The crazing and peeling of glass. *Transactions of the English Ceramic Society* 34:18.

Merrimack County Registry of Probate (MCRP)
1827- *Probate* 1:258. Concord, NH: Merrimack County.
1880

Middlesex County Registry of Deeds and Probate
1713- *Deeds* (MDB) Vols. 16-315. Cambridge, MA: Middlesex County Courthouse.
1832
1743- *Probate* (MPR) Vols. 60-132, Docket 16584. Cambridge, MA: Middlesex County
1819 Courthouse.

Miller, George L.
1980 Classification and economic scaling of 19th century ceramics. *Historical Archaeology* 14:1-40.
1984a George M. Coates, pottery merchant of Philadelphia, 1817-1831. *Winterthur Portfolio* 19(1):37-50.
1984b Marketing ceramics in North America: an introduction. *Winterthur Portfolio* 19(1):1-6.

Miller, J. Jefferson, II, and Lyle M. Stone
1970 *Eighteenth-century ceramics from Fort Michilimackinac.* Washington, DC: Smithsonian Institution Press.

Minnich, Michael
1894- John Frederick Hillegas, 1685-1765. *Pennsylvania Magazine of History and Biography* 18:85-90.
1895

Mitchell, James R.
1973 The potters of Cheesequake, New Jersey. In *Ceramics in America,* edited by Ian M. G. Quimby, pp. 319-338. Charlottesville, VA: University Press of Virginia.
1977 Industrial pottery of the United States. *Northeast Historical Archaeology* 6(1-2):14-20.

Moorhouse, Stephen
 1970 Finds from Basing House (ca. 1540-1645): Part I. *Post-Medieval Archaeology*
 4:42-59.
Moran, G. P., E. F. Zimmer, and A. E. Yentsch
 1982 Archaeological investigations at the Narbonne House, Salem Maritime National
 Historical Site. *Cultural Resources Management Study* No. 6. Boston, MA: Na-
 tional Park Service.
Morgan, Edmund S.
 1958 *The Puritan dilemma: the story of John Winthrop.* Boston, MA: Little, Brown.
Morgan, Nathaniel H.
 1869 *A history of James Morgan of New London, Connecticut, and his descendants*
 from 1607 to 1869. Hartford, CT: Case, Lockwood, and Brainard.
Mountford, Arnold
 1971 *The illustrated guide to Staffordshire salt-glazed stoneware.* New York: Praeger.
 1973 Staffordshire salt-glazed stoneware. In *Ceramics in America,* edited by Ian M. G.
 Quimby, pp. 197-215. Charlottesville, VA: University Press of Virginia.
Munsell Soil Color Company
 1949 *Munsell soil color charts, hues 7.5 R through 5.0 Y.* Baltimore: Munsell Color
 Company.
 1975 *Munsell soil color charts.* Baltimore: Kollmorgen.
Musty, John
 1974 Medieval pottery kilns. In *Medieval pottery from excavations,* edited by V. Evison,
 H. Hodges, and J. Hurst. London: Baker.
Myers, Susan H.
 1977 A survey of traditional pottery manufacture in the mid-Atlantic and northeastern
 United States. *Northeast Historical Archaeology* 6(1-2):1-13.
 1980 *Handcraft to industry: Philadelphia ceramics in the first half of the nineteenth cen-*
 tury. Washington, DC: Smithsonian Institution Press.
 1984 The business of potting, 1780-1840. In *The craftsman in early America,* edited
 by Ian Quimby, pp. 190-233. New York: Norton.
Nash, Gary
 1979 *The urban crucible.* Cambridge, MA: Harvard University Press.
New Hampshire Census
 1850 *New Hampshire census.* Concord, NH: New Hampshire State Library.
 1850, *New Hampshire census: industry* (NHCI). Concord, NH: New Hampshire State
 1860 Library.
New Hampshire Deeds and Probate Records
 1736- *Deeds* (NHD). Exeter, NH: Rockingham County Registry of Deeds.
 1796
 1750- *Probate records* (NHPR). Exeter, NH: Rockingham County Registry of Probate.
 1850
New Jersey State Museum (NJSM)
 1956 *Early arts of New Jersey: the potter's art, ca. 1680-1900.* Trenton, NJ: State
 Museum.
 1972 *New Jersey pottery to 1840.* Trenton, NJ: State Museum.
New York Genealogical and Biographical Record (NYGBR)
 1928 *Town book of the manor of Philipsburgh* (Vol. LIX). New York: New York
 Genealogical and Biographical Society.
Newark Museum
 1947 *The pottery and porcelain of New Jersey, 1688-1900.* Newark, NJ: Newark Mu-
 seum.

Newlands, David L.
 1979 *Early Ontario potters: their craft and trade*. Toronto: McGraw-Hill Ryerson.
Nie, N. H., D. Bentley, and C. Hull
 1980 *SPSS: Statistical package for the social sciences* (third ed.). New York: McGraw-Hill.
Noël Hume, Ivor
 1962 An Indian ware of the colonial period. *Quarterly Bulletin Archaeological Society of Virginia* 17(1).
 1970 *A guide to artifacts of colonial America*. New York: Knopf.
 1973 From creamware to pearlware. In *Ceramics in America*, edited by Ian M. G. Quimby, pp. 217-254. Charlottesville, VA: University Press of Virginia.
 1982 *Martin's Hundred: the discovery of a lost colonial Virginia settlement*. New York: Knopf.
Norton, F. H.
 1932 The Exeter pottery works. *Antiques* 22(1):22-25.
Nylander, Robert H.
 1974 Deed search of estates adjoining the Great Country Road. Ms. on file, Weston Historical Commission, Weston, MA.
Old Sturbridge Village Curatorial Files (OSV)
 1961 The Hervey Brooks pottery shop, Goshen, Connecticut. Ms. on file, Old Sturbridge Village, Sturbridge, MA.
Olin, Jacqueline S., and Alan D. Franklin (editors)
 1982 *Archaeological ceramics*. Washington, DC: Smithsonian Institution Press.
Orton, Clive R.
 1970 The production of pottery from a Romano-British kiln site: a statistical investigation. *World Archaeology* I(3):343-358.
 1978 Is pottery a sample? Sampling in contemporary British archaeology. *British Archaeological Research Series* No. 50:399-402.
 1980 *Mathematics in archaeology*. England: Collins.
Osgood, Cornelius
 1971 *The jug and related stoneware of Bennington*. Rutland, VT: Tuttle.
Otley, J. W., and J. Keily
 1850 *Map of Somerset County*. Camden, NJ: Van Der Veer.
Otto, John S.
 1977 Artifacts and status differences: a comparison of ceramics from planter, overseer, and slave sites on an antebellum plantation. In *Research strategies in historical archaeology*, edited by Stanley A. South, pp. 91-118. New York: Academic Press.
Outlaw, Alain C.
 1974 Preliminary excavations at the Mount Sheppard pottery site. *Conference on Historic Site Archaeology Papers, 1973* 9:1-12.
Parker, John
 1747- *Account book, 1747-1757*. Manuscript on file, Baker Library of the Harvard
 1757 School of Business Administration, Harvard University, Cambridge, MA.
Parsons, Jacob Cox
 1893 *Extracts from the diary of Jacob Hiltzheimer of Philadelphia, 1765-1798*. Philadelphia: Fell.
Peabody, Berkley
 1975 *Winged word*. Albany, NY: State University of New York Press.
Pendery, Steven R.
 1977 Urban process in Portsmouth, New Hampshire: an archaeological perspective. In *New England Historical Archaeology, Dublin Seminar for New England Folklife:*

Annual Proceedings, edited by Peter Benes, pp. 24–35. Boston, MA: Boston University Press.

1981 *Ceramics in New England: an archaeological perspective.* Paper presented at "The English Connection: Ceramics and Social Customs" seminar, Stamford Historical Society, Stamford, Connecticut, 19 Sept. 1981.

Pendery, S. R., and H. Chase
1977 Preliminary report, historical archaeology of the Marshall Pottery site, Strawbery Banke, Portsmouth, New Hampshire. Ms. on file, Youthgrants Program, National Endowment for the Humanities, Washington, DC.

Pendery, S. R., C. Dempsey, E. Gordon, J. Cheney, and R. Barber
1982 Phase II archaeological site examination of the project area for the Central Artery North Area, Charlestown, Massachusetts. Ms. on file, Institute for Conservation Archaeology, Peabody Museum, Harvard University, Cambridge, MA.

Pennsylvania Archives
1898 *The votes of the assembly of the Province of Pennsylvania* (Series 8, Vol. 3):2047–2049. Harrisburg, PA: State of Pennsylvania.

Pennsylvania Gazette
1729– *Pennsylvania Gazette* (Vols. 1–9). Philadelphia: Historical Society of Pennsylvania.
1785

Pennsylvania Magazine of History and Biography (PMHB)
1889 *Notes and queries* (Vol. 13):254. Philadelphia: Historical Society of Pennsylvania.
1902 *Ships' registers for the Port of Philadelphia, 1726–1775* (Vol. 26):126–143. Philadelphia: Historical Society of Pennsylvania.
1910 *Records of servants and apprentices bound and assigned before Hon. John Gibson, Mayor of Philadelphia, 5 Dec. 1772–21 May 1773* (Vol. 12):99–122. Philadelphia: Historical Society of Pennsylvania.

Philadelphia, Archives of the City and County
1769– *County tax assessment ledgers* (PCT).
1774
1770– *Orphan's Court records* (POC) (docket or book numbers identified).
1775
1780 *Records of the Supreme Executive Council,* April 4, 1780.
1680– *Registry of deeds* (PRD) (book, leaf, page number identified).
1805
1693– *Registry of wills* (PPD) (probate docket numbers identified).
1801
1847 *Minutes of the Common Council, City of Philadelphia* (MCC) (date, page number identified).

Philadelphia Contributionship Surveys
1754– *Philadelphia contributionship surveys* (Series 2, Vols. 11 and 21). Microfilm on file
1790 at Independence National Historic Park, Philadelphia, PA.

Philbrick, Samuel
1796– *Account book, 1796–1820.* Ms. on file, Exeter Historical Society Library, Exeter,
1820 NH.

Philips & Seymour, Merchants
1818 Day, Downes, and Eastburne Collection—business correspondence. New York: New York Historical Society.

Pickman, Arnold, and Nan Rothschild
1981 *64 Pearl Street: an archaeological excavation in seventeenth century landfill.* Ms. on file, Albany, NY: New York State Division of Historic Preservation.

Pickman, A., D. Rockman, and N. Rothschild
 1981 *The 7 Hanover Square Block: a preliminary report.* Paper presented at the Council for Northeast Historical Archaeology meetings, Windsor, Connecticut.
Pitkin, Albert Hastings
 1918 *Early American folk pottery.* Hartford, CT: Case, Lockwood, and Brainard.
Plog, Fred T.
 1975 Systems theory in archaeological research. *Annual Review of Anthropology* 4:207-224. Palo Alto, CA.
Pollex, John
 1979 *Slipware.* London: Pitman/Watson-Guptill.
Portsmouth Annual City Tax Records (PACTR)
 1830- *City tax records.* Portsmouth, NH: Portsmouth Public Library.
 1865
Portsmouth Directories (PD)
 1821- *Directories.* Portsmouth, NH: Portsmouth Public Library.
 1864
Pred, Allan
 1970 Toward a typology of manufacturing flows. In *Economic geography: selected readings,* edited by F. E. Dohrs and L. M. Sommers, pp. 267-286. New York: Crowell.
Prime, Alfred Cox
 1929 *The arts and crafts in Philadelphia, Maryland, and North Carolina, 1721-1785.* Philadelphia: The Walpole Society.
Quimby, Ian M. G. (editor)
 1973 *Ceramics in America.* Charlottesville, VA: Univesity Press of Virginia.
Rackham, Bernard, and Herbert Read
 1924 *English pottery: its development from early times to the end of the eighteenth century.* New York: Scribner's.
Ramsay, John
 1931 Early American pottery: a résumé. *Antiques* 20:224-229.
 1939 *American potters and pottery.* Clinton, MA: Colonial Press.
Rathje, William J.
 1974 The garbage project: A new way of looking at the problems of archaeology. *Archaeology* 27:236-241.
 1978 Modern material culture studies: myths and a manifesto. In *Advances in archaeological method and theory 2,* edited by Michael Schiffer, pp. 1-37. New York: Academic Press.
Rathje, William J., and Michael McCarthy
 1977 Regularity and variability in contemporary garbage. In *Research strategies in historical archaeology,* edited by Stanley A. South, pp. 261-286. New York: Academic Press.
Redman, Charles L.
 1978 Multivariate artifact analysis: a basis for multi-dimensional interpretations. In *Social archaeology,* edited by Charles L. Redman, pp. 159-192. New York: Academic Press.
Rhodes, Daniel
 1968 *Kilns: design, construction, and operation.* Radnor, PA: Chilton.
 1973 *Clay and glazes for the potter* (revised ed.). Radnor, PA: Chilton.
Rice, Prudence M.
 1982 Pottery production, pottery classification, and the role of physiochemical analysis. In *Archaeological ceramics,* edited by J. Olin and A. Franklin, pp. 47-56. Washington, DC: Smithsonian Institution Press.

Ries, Heinrich, and Henry Leighton
 1909 *History of the clay-working industry in the United States.* New York: Wiley.
Rink, Oliver A.
 1981 The people of New Netherland: notes on non-English immigration to New York
 in the seventeenth century. *New York History* 62:5-42.
Ripley, Emma F.
 1961 *Weston: a Puritan town.* Weston, MA: First Parish Benevolent-Alliance.
Ritchie, Robert
 1976 London merchants, the New York market and the recall of Sir Edmond Andros.
 New York History 57:4-29.
Robotti, Frances Diane
 1958 *Chronicles of Old Salem.* New York: Bonanza.
Rockman, Diana diZ., and Nan A. Rothschild
 1980 Excavating New York: the Big Apple. *Archaeology* 33:56-58.
 1984 City tavern, country tavern: an analysis of four colonial sites. *Historical Archae-*
 ology 18(2):112-121.
Rogers, Henry D.
 1840 *Description of the geology of the state of New Jersey, being a final report.* Phila-
 delphia: Sherman.
Roth, Rodris
 1961 Tea drinking in America: its history and equipage. *U.S. National Museum Bulletin*
 No. 225, Paper 14:67-91. Washington, DC: Smithsonian Institution.
Rye, Owen S.
 1981 Pottery technology, principles and reconstruction. *Manuals on Archaeology* 4.
 Washington, DC: Taraxacum.
Sapir, Edward
 1949 *Language, an introduction to the study of speech.* New York: Harcourt, Brace and
 World.
Scharf, J. Thomas (editor)
 1886 *History of Westchester County, New York, including Morisiana, Kings Bridge, and*
 West Farms. Philadelphia: Preston.
Scharf, J. Thomas, and Thompson Wescott
 1884 *History of Philadelphia.* Philadelphia: Lippincott.
Schuyler, Robert L.
 1974 Sandy Ground: Archaeological sampling in a black community in metropolitan
 New York. *Conference on Historic Site Archaeology Papers, 1972* 7:13-52.
 1980 *Archaeological perspectives on ethnicity in America.* Farmingdale, NY: Baywood.
Schwartz, Marvin D.
 1969 *Collectors' guide to antique American ceramics.* Garden City, NY: Doubleday.
Sears, John Henry
 1905 *The physical geography, geology, mineralogy, and paleontology of Essex County,*
 Massachusetts. Salem, MA: The Essex Institute.
Shadel, Jane S.
 1970 Robert Hewes, glass manufacturer. *Journal of Glass Studies* 12:140-148.
Shepard, Anna O.
 1965 Ceramics for the archaeologist. *Carnegie Institution of Washington Publication* 609.
 Washington, DC: Carnegie Institution.
 1968 Ceramics for the archaeologist. *Carnegie Institution of Washington Publication* 609
 (fifth ed.). Washington, DC: Carnegie Institution.
Smith, Daniel Scott
 1975 Underregistration and bias in probate records: an analysis of data from eighteenth-

century Hingham, Massachusetts. *William and Mary Quarterly* (Third Series) 32(1):100-110.

Smith, Joseph Johnson
 1974 *Regional aspects of American folk pottery*. York, PA: Historical Society of York County.

Snell, James P.
 1881 *History of Hunterdon and Somerset counties, New Jersey*. Philadelphia: Everts and Peck.

Somerset County Deeds (SCD)
 1810- *Deeds* (Vols. F, A3, B2, C2, C6, Q3, S2, X2, and Y3). Somerville, NJ: Somerset
 1882 County Courthouse.

Somerset County Division of Land (SCDL)
 1852- Volume B. Somerville, NJ: Somerset County Courthouse.
 1854

Somerset County Inventories (SCI)
 1820- *Inventories* (Vols. C, G, and N). Somerville, NJ: Somerset County Courthouse.
 1882

Somerset County Orphans Court Minutes (SCOCM)
 1852 *Minutes* (Vol. G). Somerville, NJ: Somerset County Courthouse.

Somerset County Road Returns
 1810 Volume B. Somerville, NJ: Somerset County Court House.

South, Stanley A.
 1962 The ceramic types at Brunswick Town, North Carolina. *Southeastern Archaeological Conference Newsletter* 9(1). Cambridge, MA.
 1965 Excavating the 18th century town of Bethabara, North Carolina. *Florida Anthropologist* 18(3):45-48.
 1967 The ceramic forms of the potter Gottfried Aust at Bethabara, North Carolina, 1755 to 1771. *Conference on Historic Site Archaeology Papers, 1965-1966* 1:33-38.
 1970 The ceramic ware of the potter Rudolph Christ at Bethabara and Salem, North Carolina, 1786-1821. *Conference on Historic Site Archaeology Papers, 1968, 3* (Parts 1 and 2): 70-72.
 1972 Evolution and horizon as revealed in ceramic analysis in historic archaeology. *Conference on Historic Site Archaeology Papers* 6(Part 2):71-116.
 1974 Palmetto parapets, exploratory archaeology at Fort Moultrie, South Carolina, 38CH50. *University of South Carolina, Institute of Archeology and Anthropology, Anthropological Studies* 1.
 1977 *Method and theory in historical archaeology*. New York: Academic Press.
 1978a Evolution and horizon as revealed in ceramic analysis in historical archaeology. In *Historical archaeology: a guide to substantive and theoretical contributions*, edited by Robert L. Schuyler, pp. 68-82. Farmingdale, NY: Baywood.
 1978b Pattern recognition in historical archaeology. *American Antiquity* 43(2):223-230.
 1978c Contemporary patterns of material culture or Hansel and Gretel in the modern world: following the trail of pull tabs to "The Pause that Refreshes." *Conference on Historic Site Archaeology Papers, 1977* 12:87-106.
 1979 Historic site content, structure, and function. *American Antiquity* 44(2):213-237.

Spargo, John
 1926 *Early American pottery and china*. New York: Century.
 1974 *Early American pottery and china* (reprint of 1926 edition). Rutland, VT: Tuttle.

Springsted, Brenda L.
 1977 Ringoes: an eighteenth century pottery site. *Northeast Historical Archaeology* 6(1-2):55-71.

Starbuck, David R.
1977 The excavation of the New England Glass-works in Temple, New Hampshire. In
 *New England Historical Archaeology, Dublin Seminar for New England Folklife:
 Annual Proceedings*, edited by Peter Benes, pp. 75-86. Boston, MA: Boston Uni-
 versity Press.
1979 *Seventeenth century survey of Dorchester.* Boston, MA: Boston University.
1980 *Seventeenth century historical archaeology in Cambridge, Medford, and Dor-
 chester.* Boston, MA: Boston University.
1983 *The New England Glassworks.* Concord, NH: New Hampshire State Historic Pres-
 ervation Office.
State of Connecticut Registry of Deeds (SCRD)
1819 *Deeds* (Vol. 13):197. Hartford, CT: State Library.
Stone, Garry Wheeler
1970 Ceramics in Suffolk County, Massachusetts, inventories 1680-1775: a preliminary
 study with divers comments thereon, and sundry suggestions. *Conference on His-
 toric Site Archaeology Papers, 1968* 3(2):73-90.
1977 Artifacts are not enough. *Conference on Historic Site Archaeology Papers, 1976*
 11:43-63.
Stone, Garry W., J. G. Little III, and S. Israel
1973 Ceramics from the John Hicks Site, 1723-1743: the material culture. In *Ceramics
 in America*, edited by Ian M. G. Quimby, pp. 103-139. Charlottesville, VA: Uni-
 versity Press of Virginia.
Stradling, Diana, and J. Garrison Stradling (editors)
1977 *The arts of the potter: redware and stoneware.* New York: Universe Books.
Teller, Barbara Gorely
1968 Ceramics in Providence, 1750-1800: an inventory survey. *Antiques* 94(4):570-
 577.
1974 Abraham Hews's book, Weston 1780. *Weston Historical Society Bulletin* XI(1).
 Weston, MA.
1980 *Horace Collamore and the ceramics market in Boston.* Paper presented at "Mar-
 keting of Ceramics" conference, Winterthur Museum, Delaware.
Thomas, David Hurst
1974 *Predicting the past: an introduction to anthropological archaeology.* New York:
 Holt, Rinehart, and Winston.
1976 *Figuring anthropology.* New York: Holt, Rinehart, and Winston.
Thornton, Peter
1978 *Seventeenth century interior decoration in England, France, and Holland.* New
 Haven, CT: Yale University Press.
Tite, Michael S.
1972 *Methods of physical examination in archaeology.* New York: Seminar Press.
Trask, Richard B.
1971 *The Devil amongst us, a history of the Salem Village Parsonage, 1681-1784.* Dan-
 vers, MA: Danvers Historical Society.
1972 Raising the devil. *Yankee* 36(5):74-77, 190, 192, 195-6, 198-9, 201.
Turnbaugh, Sarah Peabody
1976 *An anthropological historical archaeology inquiry into cultural variation and change
 based on ceramic assemblages from the Massachusetts Bay Colony.* Unpublished
 B. A. thesis, Department of Anthroplogy, Harvard University, Cambridge, Mas-
 sachusetts.
1977 Ideo-cultural variation and change in the Massachusetts Bay Colony. *Conference
 on Historic Site Archaeology Papers, 1976* 11:169-235.

1983 Seventeenth and eighteenth century lead-glazed redwares in the Massachusetts Bay Colony. *Historical Archaeology* 17(1):3-17.

Turnbaugh, William A.

1984 *The material culture of RI-1000, a mid-17th century Narragansett Indian burial site in North Kingstown, Rhode Island.* Kingston, RI: University of Rhode Island.

Turnbaugh, William A., and Sarah Peabody Turnbaugh

1979 Alternative applications of the Mean Ceramic Date Concept for interpreting human behavior: Fort Independence. *Historical Archaeology* 11:90-104.

Turnbaugh, W. A., S. Peabody Turnbaugh, and A. P. Davis, Jr.

1979 Life aboard HMS Orpheus. *Archaeology* 32(3):43-49.

Unearthing New England's Past (UNEP)

1984 *Unearthing New England's past: the ceramic evidence* (exhibition catalogue). Lexington, MA: Museum of Our National Heritage.

United States Census for New Jersey (USCNJ)

1850- *Census.* Trenton, NJ: Division of Archives and Records Management, New Jersey
1880 Department of State.

United States Government Printing Office (USGPO)

1908 *Index heads of families 1790 census, Greenburgh, Westchester County, New York State.* Washington, DC: U.S. Government Printing Office.

Vescelius, Gary S.

1977 Office of the Territorial Archaeologist. *Information* 2(3):1-3. Newsletter of the Virgin Islands Bureau of Libraries. Museums, and Archaeological Services.

Wacker, Peter O.

1975 *Land and people.* New Brunswick, Canada: Rutgers University Press.

Warner, Frederic W.

1978 Preliminary report of the Goodwin Pottery excavations. Unpublished manuscript in possession of author.

Warner, Samuel Bass Jr.

1968 *The private city: Philadelphia in three periods of growth.* Philadelphia: University of Pennsylvania Press.

Watkins, C. Malcolm

1960 North Devon pottery and its export to America in the seventeenth century. *U.S. National Museum Bulletin 225, Contributions from the Museum of History and Technology,* Paper 13:17-59. Washington, DC: Smithsonian Institution.

Watkins, C. Malcolm, and Ivor Noël Hume

1967 The "poor potter" of Yorktown. *U.S. National Museum Bulletin* 249, Paper 54:73-112. Washington, DC: Smithsonian Institution.

Watkins, Lura Woodside

1938 The Bayleys, Essex County potters: Part I, chiefly biographical. *Antiques* 34(5):253-255.

1939 The Bayleys, Essex County potters: Part II, their products. *Antiques* 35(1):22-27.

1940 The Brooks Pottery in Goshen, Connecticut. *Antiques* 37:29-31.

Watkins, Lura Woodside

1945 Early New England redware potters. *Chronicle of Early American Industries* 3(3):21-36.

1950 *Early New England potters and their wares.* Cambridge, MA: Harvard University Press.

1957 New England pottery in the Smithsonian Institution. *Antiques* 3:232-236. Reprinted in (1977) *The art of the potter,* edited by D. Stradling and J. G. Stradling, pp. 70-74. New York: Universe Books.

1959 *Early New England pottery.* Sturbrudge, MA: Old Sturbridge Village Booklet Series.

1968 *Early New England potters and their wares* (reprint of 1950 ed.). Hamden, CT:
 Archon Books.

Watson, David
1850 *A directory containing names, occupations and residences of the inhabitants of
 Concord centre village.* Concord, NH: Ervin Tripp.

Watson, Patti Jo, Steven A. LeBlanc, and Charles A. Redman
1971 *Explanation in archaeology.* New York: Columbia University Press.

Weatherill, Lorna
1971 *The pottery trade and North Staffordshire, 1660-1760.* Manchester, England:
 Manchester University Press.

Webster, Donald Blake
1969 *Early slip-decorated pottery in Canada.* Toronto: Mussor.
1971 *Decorated stoneware pottery of North America.* Rutland, VT: Tuttle.

Wedgwood, J. C., and T. H. Ormsbee
1947 *Staffordshire pottery.* New York: McBride.

Wells, E. D.
1957 Duché the potter. *Georgia Historical Quarterly* 41:383-390.

West Hartford Land Records (WHLR)
1795- *Land records* (Vols. 20-24). West Hartford, CT.
1802

West Hartford News
1954- *West Hartford News,* 3 June 1954, 8 June 1954, 26 Sept. 1959. West Hartford,
1959 CT.

Weston Tax Lists (WTL)
1897 *Town of Weston tax lists, 1757-1827* (compiled by Mary Frances Peirce). Boston,
 MA: Mudge.

Weston Town Records (WTR)
1893 *Records of the first precinct, 1746-1754, and of the Town of Weston, 1754-1803*
 (compiled by Mary Frances Peirce). Boston, MA: Mudge.

Whiter, Leonard
1970 *Spode: a history of the family, factory, and wares from 1733-1833.* New York:
 Praeger.

Widmer, Kemble
1964 *The geology and geography of New Jersey.* Princeton, NJ: Van Nostrand.

Willey, Gordon R.
1945 Horizon styles and pottery traditions in Peruvian archaeology. *American Antiquity*
 11:49-56.

Willey, Gordon R., and Philip Phillips
1958 *Method and theory in American archeaology.* Chicago: University of Chicago Press.

Wills, Geoffrey
1978 *English pottery and porcelain* (reprint of 1969 edition). New York: Sterling.

Wilson, Kenneth M.
1972 *New England glass and glassmaking.* Sturbridge, MA: Old Sturbridge Village Press.

Winship, Stephen W.
1965 *At the bend in the river: a history of Concord, New Hampshire.* Concord, NH:
 Evans.

Winton, Andrew L., and Kate Barber Winton
1934 Norwalk potteries. In *Old-time New England.* Boston, MA: Society for the Pres-
 ervation of New England Antiquities.
1981 *Norwalk potteries* (compiled by Ralph C. Bloom). Published for the Friends of
 Lockwood House, Inc., Norwalk, Ct. Canaan, NH: Phoenix.

Wobst, H. Martin
 1977 Stylistic behavior and information exchange. In *For the Director: Research essays in honor of J. B. Griffin,* edited by C. E. Cleland, pp. 317–342. *Anthropological Papers* No. 61. Ann Arbor: Museum of Anthropology, University of Michigan.

Wolfe, Peter
 1977 *The geology and landscapes of New Jersey.* New York: Crane Russak.

Wood, Joseph
 1978 *The origin of the New England village.* Unpublished Ph.D. dissertation, Department of Geography, University of Pennsylvania, Philadelphia, Pennsylvania.

Woodbury, George
 1966 Glass industry that failed. *Manchester Union Leader,* 12 Mar. 1966. Manchester, NH.

Worrell, John
 1979 How do you test history in a lab? *Rural Visitor* Summer:4–7.
 1980 Research and resource management priorities for Northeast historical archaeology: a plea for the common man. *Proceedings of the Conference on Northeastern Archaeology,* Research Reports No. 19, pp. 173–178. Amherst, MA: University of Massachusetts.
 1982a The archaeological investigation of the James Moore Pottery site. Ms. on file, Department of Research, Old Sturbridge Village, Sturbridge, MA.
 1982b Synergistic report on the Hervey Brooks Archaeological Project. Ms. on file, Department of Research, Old Sturbridge Village, Sturbridge, MA.
 1983 *People lived in those houses, and they recorded their personalities in the dirt.* Paper presented at the Conference on New England Archaeology meetings, Sturbridge, MA.

Worrell, J., L. Ammons, J. Blackaby, and W. S. Gates
 1980 *The cultural resources of historic Phoenixville* (typescript). Hartford, CT: Connecticut Historical Commission.

Worrell, John, and Richard Jenkinson
 1981 The work of the potter's hands. *Rural Visitor* 21(2):4–6. Old Sturbridge Village, MA.

Wright, Louis B.
 1957 *The cultural life of the American colonies, 1607–1763.* New York: Harper and Row.

Wyman, Thomas Bellow
 1879 *The genealogies and estates of Charlestown in the County of Middlesex and Commonwealth of Massachusetts 1629–1818* (two volumes). Boston, MA: Clapp.

Index

307